The New Competitors

THE NEW COMPETITORS

How Foreign Investors Are
Changing the U.S. Economy

NORMAN J. GLICKMAN

DOUGLAS P. WOODWARD

Basic Books, Inc., Publishers

NEW YORK

Library of Congress Cataloging-in-Publication Data

Glickman, Norman J.
 The new competitors.

 Bibliography: p.
 Includes index.
 1. Investments, Foreign—United States. 2. United
States—Economic conditions—1981– . I. Woodward,
Douglas P. II. Title.
HG4910.G547 1989 332.6′73′0973 88–47901
ISBN 0–465–05005–0

CONTENTS

v

PART II

The Domestic Consequences of Foreign Investment

PART III

Policies Toward Foreign Investment

Contents

PREFACE

T HE MEDIA REPORT almost daily about the rise of foreign direct investment in the United States. About $30 billion was spent in 1987 alone, bringing the total to about $262 billion, or triple the amount of direct investment at the beginning of the decade. Direct investment came through buyouts of our companies, the construction of new plants and offices, and joint ventures between foreign and American companies. Adding foreign ownership of stocks, bonds, and other assets brings the total foreign investment to more than $1.5 trillion.

When we started our research on direct investment a few years ago, no one paid much attention to the phenomenon, but today foreign investment is highly controversial. It is being debated within the business community, among trade unionists, and in the press, and has received increasing attention among policy makers in Washington and in state capitals. Academic economists and political scientists have jumped into the fray as well. Now foreign investment is a passionate political issue among the American people.

Some believe that foreign investment is creating jobs and revitalizing the economy. Others fear that foreigners are taking over our country and with it our economic sovereignty. As we approach the 1990s, economic nationalism—the sense that the United States is no longer number one, and that foreigners are responsible for many of our economic problems—has taken firm root.

Is foreign investment good or bad for this country? Should we limit foreign investment or should we encourage it? Do foreign companies create jobs or are they taking jobs away from American workers? These are but some of the heated political and economic questions we answer in this book. We present the facts about foreign investment and interpret them objectively. We find that many boosters and lobbyists for foreign multinational corporations have overstated the benefits of for-

eign investment, particularly the capacity for these companies to create jobs. At the same time, we find others—also guilty of exaggeration—who see foreigners as the main source of our economic dilemmas and cry out against their investments. To us, foreign investment brings a mixture of challenges and opportunities. It is neither the nemesis decried by economic nationalists nor the panacea its boosters claim. It brings both good and bad, but crucially it brings a set of challenges to us all. In an increasingly internationalized economy, foreign investment is here to stay. Since we must learn to live with it, we must begin to understand it so that we may make informed and intelligent policy decisions upon which to base our economic and political future.

Despite a growing recognition of foreign direct investment, there has been little or no systematic examination of foreign direct investment in the United States that places it within the context of the general internationalization of the economy and its relationship to domestic policy. We will examine the reasons for the explosion of direct investment in the last decade and at the same time look at why American companies continue to invest abroad. To date, no book has done this effectively.

Our interest in foreign investment began several years ago when our focus was on its effects on the cities and regions of this country. Over time, we realized that the issues raised by our initial research were broader and more politically significant. Our study gained breadth and scope as we saw ever more complexities to this subject. Although other voices will speak on foreign direct investment, we hope to have advanced the debate through our presentation of solid facts and their reasoned interpretation.

This work began with a research grant from the Economic Development Administration (EDA) of the U.S. Department of Commerce and continued with additional funds from EDA, the Aspen Institute for Humanistic Studies, and the Ford Foundation. We are indebted to David Geddes and Leonard Wheat from EDA, and to Susan Sechler from the Aspen Institute, for their support. We also received financial assistance from both the University Research Institute and the Policy Research Institute at the University of Texas at Austin; we express our gratitude to deans William Livingston and Max Sherman of the University of Texas at Austin.

We also thank several people who read parts of the manuscript and made helpful comments: Geoffrey Bannister, Michael Crowley, Susan DeMarco, Josh Farley, James K. Galbraith, Amy Glasmeier, Bennett Harrison, Ellen Herr, Ned Howenstine, Michael Katz, Blaine Liner,

William Luker, Ann Markusen, Doug Nigh, Elyse Pivnick, Alicia Quijano, Juliet Schor, Gloria Talcove-Woodward, and Robert H. Wilson.

In addition, we had help from Marian Barber, who made critical editorial comments and helped with the development of chapter 8. Geoffrey Bannister, Michael Crowley, Paulo Guimaraes, William Luker, and Rob McGregor provided invaluable research assistance along the way. Ned Howenstine and Ellen Herr of the Bureau of Economic Analysis helped us interpret some of the data in chapter 5. Yayoi DiSanto tirelessly and accurately typed and retyped our manuscript. Our editor at Basic Books, Martin Kessler, helped guide us; Basic's copy editor, Phoebe Hoss, made our writing more clear and concise; and Pat Cabeza, our project editor, patiently saw the book to its completion. We thank all of these people and, of course, hold none of them responsible for what you are about to read.

Finally, we dedicate this book to our families, who put up with us through many months of work on weekends, holidays, and evenings and who provided their moral support and love: our wives Elyse Pivnick and Gloria Talcove-Woodward, and our children Katy Rose Glickman and Christopher and Andrew Woodward.

—Norman J. Glickman
Austin, Texas

—Douglas P. Woodward
Columbia, South Carolina

The New Competitors

1

IS AMERICA FOR SALE?

────────────────

IN a chilling episode of the 1960s television program "The Twilight Zone," aliens arrive on Earth promising a millennium free of poverty, disease, and war. In spite of initial skepticism, many people begin to accept the intruders after they make good on their promises, with remarkable advances in health care, agricultural productivity, industrial growth, and global peace. Still, no one really knows much about the space visitors. The only source of information on them is a book they leave behind at the United Nations before they set out to reform the world. The text is hard to decipher, but a dedicated American team manages to translate the title: *To Serve Man*. The noble objective implied by the book's title allays any lingering fears, and Earthlings willingly accept invitations to visit the Other Planet. In the final scene, just as one of the former skeptics is boarding a spaceship to go there, a translator rushes up and shouts, "Don't go! I've decoded more of *To Serve Man*! It's a cookbook!"[1]

The possibility of alien takeover, a theme often portrayed in the Golden Age of television, remains part of American popular culture to this day. Whether from other nations or other worlds, external forces, perhaps more powerful than our own, are viewed simultaneously with awe and distrust. Fascinated though we are by the unknown, our ignorance of outsiders heightens our fears.

In today's economy, such an external force looms large: foreign investment in the United States. For a generation after the Second

World War, America* was the unquestioned leader of the world economy. Today it is no longer pre-eminent but shares power with many nations. As the United States's economic might declined, powerful multinational corporations (MNCs) from Europe and the Far East bought pieces of the economy—a company here, some real estate there. Then in the 1980s, non-American investment in our factories, real estate, and stocks and bonds surged. Across the nation, from Oregon to Georgia, from Texas to Minnesota, foreigners† have been acquiring existing businesses and starting new ones. Between 1980 and 1987, MNCs like Mitsubishi, Seagram, Siemens, and Philips tripled their ownership of American industry. MNCs make everything from cars to clothing and sell everything from insurance to zippers. They also refine oil, operate vineyards, lend money, and write advertising copy. Carnation, Mack Trucks, Brooks Brothers, Smith & Wesson, *TV Guide*, and Pillsbury are some of the familiar "American" names owned by foreign investors. Moreover, this wave of investment carries new management practices, labor relations, and technology. Not only do foreign firms control more of the American economy, but they have become actively involved in politics, culture, philanthropy, and other aspects of community life.

Such investment has begun to change the way we live and work, although we may not be always aware of its influence. An American can buy Chicken-of-the-Sea tuna (owned by an Indonesian company) from A&P (Britain) or dresses from Bonwit Teller (Canada) with a credit card from Marine Midland Bank (Hong Kong). She may drive a Plymouth Laser (Japan), fill up at a Texaco station (Saudi Arabia), read a Doubleday book (West Germany), swig a Lone Star beer (Australia), and listen to Willie Nelson on CBS Records (Japan). The book you are now reading is published by an American subsidiary of the Australian-based News Corporation owned by Rupert Murdoch. Until recently, few Americans knew that they were dealing with foreign companies operating in this country. Many probably did not care.

But now this "buying of America" has made people as apprehensive as the Earthlings when the aliens arrive in the "Twilight Zone" story. For suddenly there is an American fixation with what we call the "New

* We apologize to neighbors in North and South America for using *America* to refer to the United States; the term is simply convenient and conventional, if regrettably chauvinist.

† Although the term *foreigner* may be used pejoratively to denote "alien" or "strange," we refer to foreigners or foreign companies in a strictly neutral sense, using the definition given in the *Random House Dictionary of the English Language* of "pertaining to, or derived from another country or nation."²

Competitors," or foreign companies that have acquired U.S. companies or built new plants or offices here. A 1988 public opinion poll showed 74 percent of Americans believing that foreign investment means that America has less control over the economy, and 78 percent in favor of a law limiting foreign investment in business and real estate.[3] There are valid reasons for concern. After all, many of America's largest companies have come under foreign influence and control—Standard Oil of Ohio, Du Pont, and Firestone among them. Huge real estate deals have been cut by foreigners, who now own such major buildings as the Exxon and ABC buildings in New York and ARCO Plaza in Los Angeles. Ted Bates (advertising), CS First Boston (finance), Bloomingdales (clothing), Manpower, Inc. (temporary help), and Hardee's (fast food) are only a few of the foreign-owned firms in the fast-growing service sector. The list is long, the industries diverse.

The Revolving Door of Foreign Investment

With all the recent attention paid to foreign investment in this country, it is easy to forget that international investment is like a revolving door—with capital moving in and out of the country simultaneously. Our firms invest overseas, just as foreigners invest here. American investment abroad has long been greater than foreigners' investment in this country, although the gap has been closing rapidly (see chapter 2).

Before we move on, however, it is important to clarify what we mean by *foreign investment*. Some writers use the term interchangeably with *foreign money*, lumping together all sorts of international economic transactions—from illegal money laundering to the establishment of new plants,[4] confusion abounds unless we carefully define our terms. There are two types of foreign investment—*portfolio* and *direct*—which together amounted to more than $1.5 trillion in 1987, up from $107 billion in 1970. This amount represents the total stake held by foreign companies, individuals, and governments. Portfolio investment, about four-fifths of the total, consists of the ownership of bank accounts, securities, and bonds of U.S. companies or governments. A typical example is the purchase of Treasury notes or General Motors bonds by a German pension fund or a French insurance company. This is passive in that foreign investors do not control the companies in which they invest, and the number of U.S. jobs is not directly affected. Portfolio investors park their excess cash in bank accounts and Treasury bills in order to

5

earn the best rate of return for a given amount of risk, to hedge against currency fluctuations, and to diversify their investment portfolios. Foreigners held nearly $1 trillion in private portfolio assets, and their governments had nearly $300 billion more in 1987.*

Though portfolio investment is passive in terms of direct control, it is active in that it is highly liquid. In a world of electronic transfer of investment funds, increases or decreases in portfolio investment can occur with the press of a button on a computer terminal in Frankfurt, London, or Tokyo. A slightly higher interest rate in Germany or France can mean a rapid outflow of foreign funds. It is nearly impossible to tell the exact amount of portfolio investment at any given moment because it moves among global markets so fast. Foreign portfolio investors played a significant role in the stock-market boom and bust of the 1980s. Many observers believe that investors abroad were the tail wagging the great bull market of the 1980s: their huge acquisitions of U.S. securities spurred the Dow Jones to record highs. Overseas financiers purchased a record net $18.9 billion in U.S. stock in 1986; and their pullback may have helped cause Black Monday, the day of the market's unparalleled collapse on 19 October 1987.[6]

The other kind of investment—and the focus of this book—is foreign *direct* investment in the United States (or FDIUS), which takes place when a foreigner purchases controlling interest in an American company or real estate.† This event is usually the product of the global strategy of a multinational corporation, not of financial movers and shakers. It is a more permanent type of investment than portfolio investment since it means command over the full range of a company's operations. A foreign multinational gains control by acquiring an existing U.S. company, by building a new plant, or by participating in a joint venture with an American company. The acquisition route is by far the most common for foreign multinationals. They have joined their American counterparts in pumping money into the over $200-billion-a-year

* Total foreign assets in the United States in 1987 were $1,536.0 billion, of which $283.1 billion were foreign official assets (owned by governments), leaving $1,252.9 billion in private foreign investments. Subtracting direct investment ($261.9 billion) from all-private foreign investment leaves $991 billion of private portfolio investment.[5]

† The U.S. Commerce Department defines a company as directly foreign owned when a "foreign person" holds a 10-percent interest. This "person" can be an individual, a company, or a government. The definition of a controlling interest was 25 percent until 1974, when it was changed to 10 percent. This figure is arbitrary—and to many readers may seem low; but that is the definition used by the Commerce Department and the basis for all data on foreign investment. Since most foreign owners hold far more than 10 percent anyway, the direct investment figure would not change substantially with a change in definition to 25 percent.

merger and acquisition contest.[7] Of *Business Week's* "top 200 deals in 1987," nearly one-fourth involved foreign companies, including the largest deal of them all, British Petroleum's $7.6-billion purchase of Standard Oil of Ohio.[8] Nestlé's $3-billion buyout of Carnation put the Swiss multinational in charge of Carnation's "contented cows" and its other food operations. Nestlé can increase or decrease the number of jobs, change product lines, sell off plants, or do a variety of other things that affect Carnation's future. Foreign buyouts of U.S. companies instantly put them into competition on American soil. When Seagram, the giant Canadian distiller, bought Tropicana, it not only created the Ultimate Multinational Screwdriver but positioned itself to go head to head with Coca-Cola and Procter & Gamble, the other major juice makers. The acquisition approach is decidedly easier and more popular for cash-rich foreigners—as it is for large American companies—than trying to start from the ground up.[9]

Other companies do build new, or "greenfield," plants, the best known being the many Japanese auto plants in the Midwest. Honda's facilities brought new jobs, incomes, and tax revenues to Ohio. The Japanese firm now competes from an American base instead of relying on imports—an especially good strategy in a period of high-valued yen. Hundreds of other plants have been built here. In addition, foreign companies form alliances with U.S. firms, pooling their capital and technology. Such joint ventures include Italy's Montedison and Hercules (resins), West Germany's Siemens and Corning Glass (fiber optics), and Sweden's L. M. Ericsson and Honeywell (switching).[10]

When all acquisitions, new plant investment, and joint ventures are considered together, the size of foreign direct investment in the United States appears significant. The 1987 book value of FDIUS was $262 billion, compared with just $13 billion in 1970. The last year for which complete data on assets, employment, sales, and other variables related to FDIUS are available is 1986. In that year, foreign firms—or affiliates of foreign companies—employed nearly 3 million workers, paying them $87 billion in compensation; exported $51 billion and imported $124 billion of merchandise; and owned 15 million acres of land, with mineral rights to an additional 52 million acres.[11]

Although these numbers sound large, FDIUS is still a very small piece of the vast American economy. Foreign firms employ, for instance, only 3 percent of all American workers and own only 0.7 percent of our land. Nonetheless, as we shall show in chapter 2, direct investment has grown spectacularly, more than 20 percent a year over the last decade and a half. It is particularly concentrated in manufac-

turing, where foreigners employ over 8 percent of all workers and control more than 12 percent of assets. These figures are twice what they were just a few years ago.[12] Most astonishing, Japanese investment in the United States was unheard of in the early 1970s; yet by 1986, about 216,000 Americans worked for Japanese companies. By the turn of the century, that figure may be well over 1 million.

Foreign-based multinationals come to the United States to exploit their "competitive advantages"—better management techniques, marketing, patents, and new products—which give them the necessary edge to make profits in this country (see chapter 3). They are attracted, first and foremost, by the $4-trillion-a-year market: it is not only the largest integrated economy in the world but also an outlet for sophisticated products for high-income consumers (see chapter 4). Americans simply have more income to buy cars, video recorders, and orange juice than has anyone else. "It's very difficult to be a world player without having a significant participation in the world's largest market," said the head of Britain's Plessey operations in the United States.[13]

The market, of course, could be served by exporting to the United States. But, as America's trade deficit increased during the 1980s, protectionist threats arose, and with them the fear of being shut out of the lucrative U.S. market. In response to import restrictions, some foreign multinationals quickly invested here in order to show their good will by hiring American workers, thereby quelling the protests and protecting their U.S. sales. For example, investment in the United States by Japanese auto makers rapidly followed the establishment of quotas on Japanese automobiles. Other factors encourage the flow of foreign capital to the United States—notably the political stability and open-door, laissez-faire attitude toward international investment which makes it easy for foreigners to make long-term commitments.

But, during the late 1980s, an important short-run influence affected the amount and timing of the foreign investment boom: a cheaper dollar, which allowed foreigners to buy American assets for the reasons just mentioned, but at far lower prices. The dollar's decline was a consequence of America's trade and federal budget deficits. To finance these "twin deficits," the United States turned increasingly to foreigners who lent us massive amounts of money. In 1986 alone, the nation borrowed $143 billion from abroad to cover the federal deficit. Since we could not allow the trade deficit to continue indefinitely, we engineered a fall in the value of the dollar beginning in 1985. The fall of

the dollar made U.S. exports cheaper and imports more expensive and was aimed at making American goods more competitive.

The dollar's fall affected foreign investment by making American assets cheaper at a time of growing interest in acquiring pieces of America. Thus, in buying Firestone in 1988, Japan's Bridgestone got the tire company for about half the price, measured in yen, it would have paid had the purchase been made two years earlier. At these inviting Fire Sale prices, foreigners have been busy buying up companies and real estate. Seeing those billions of dollars of portfolio investment in supposedly safe Treasury bonds decline in value as the dollar fell, many foreigners found it advantageous to put more money into factories and office buildings, which are less susceptible to the vagaries of exchange-rate fluctuations.[14] Portfolio investment was shifted to direct investment and, with it, came greater control of American companies and land.

The recent thrust of inward foreign investment represents a rapid turn in the revolving door of international finance. Just a few years ago, discussions of "foreign investment" concerned not FDIUS but U.S. direct investment abroad (or USDIA). As Ford, IBM, and other American giants built plants from Spain to Singapore, the spotlight was on American multinationals' "global reach."[15] USDIA is substantial and remains greater than FDIUS: $308 billion in 1987, about three and one-half times the 1970 level.[16] American firms employ 6.3 million workers and have about one-fifth of their capital overseas.* U.S. firms invested abroad for many of the same reasons foreigners invested here: prospering markets and as an escape hatch from trade sanctions.[17] In addition, the predominant economic position of the United States, the search for lower production costs, and tax laws favorable to outward investment all spurred American firms to invest abroad (see chapter 6).

Thus, international direct investment flows simultaneously into and out of the United States. Since foreign investment in this country has become so controversial and is growing so fast, we will focus most of this book on its consequences for the U.S. economy. However, we will also look at the consequences of outward investment by American-based corporations.

* Beginning in the 1960s, new technology, like satellite-computer communications networks and jumbo transport jets, freed MNCs to locate virtually anywhere: they could control far-flung operations from central headquarters and quickly and inexpensively move goods from factory to market. Flush with surplus capital, U.S. MNCs put technical advances into practice, traversing the globe in search of profitable sites.

Friend or Foe: The Debate over Foreign Investment

Never in this century has inward foreign investment aroused such interest. Like the aliens of "The Twilight Zone," the New Competitors raise both hope and suspicion. Some Americans see them as saviors of our industry; others, as a threat to our economic independence and national security. Additional issues simmer as the debate over FDIUS heats up. Does investment make the United States more or less competitive? Does it result in infusions of management expertise and new technology? Does it provide new jobs and good working conditions? Are the inducements state and local governments offer foreign firms worth the money expended? Although the debate over American investment abroad has been going on since the late 1960s, USDIA remains no less controversial. The debate still rages over its impact on domestic jobs: some arguing that it cuts jobs; others, that it is essential to American economic growth. On all of these issues, the battle lines have been drawn between those favoring and those opposing foreign investment. Let's begin with the debate over FDIUS.

Public awareness of inward foreign investment mushroomed with news reports in the mid-1980s. A 1987 *Time* magazine cover story was ominously entitled "The Selling of America: Foreign Investors Buy, Buy, Buy."[18] Other headlines screamed out, "Foreign Investors: Allies or Aggressors?" "Foreigners Buy America," "A Nation Hooked on Foreign Funds," and "European Firms on Buying Spree in U.S." The 1987 movie *Gung-Ho* depicted the joys and woes of work in a fictional Japanese auto factory in a depressed Pennsylvania town.

The political arena drew promoters and detractors of FDIUS. One organization is exclusively dedicated to arguing the merits of inward investment: the Association for Foreign Investment in America (AFIA), a Washington-based lobbying group funded by dozens of multinational corporations with large investments in the United States. Organized in 1988, AFIA wasted no time putting forth its position. In numerous editorials and essays, its chief spokesperson, Elliot L. Richardson (who held several cabinet-level posts in the Nixon and Ford administrations), argued strongly for promoting foreign investment. Richardson's articles, like "Why Foreign Investment in the U.S. Is Good for Us" and "Stop Worrying about Foreign Investors,"[19] stressed that foreign investment introduces new manufacturing techniques, managerial methods, and export know-how. In 1988 testimony before the House

10

Foreign Affairs Committee, Richardson argued that foreign investment promotes economic growth, helps keep domestic interest rates down, benefits consumers, and expands U.S. access to foreign markets.[20]

AFIA has been joined by other lobbying organizations. Japanese investors have felt more public pressure than those from other countries. To counter this, more than two hundred Japanese companies formed the Council for Better Investment in the United States (CBIUS) in 1988. An arm of the powerful Japanese business organization the *Keidanren*, the CBIUS is headed by Akio Morita, the president of Sony —a man with considerable prestige in this country. The organization's prime missions are to help integrate Japanese firms into the U.S. economy and to lobby with public officials on matters affecting FDI. It works with other foreign organizations—embassies, consulates, and trade organizations—to promote foreign investment and to stop barriers to it.

Many government leaders in Washington and elsewhere around the nation have hardly needed convincing: they have welcomed the influx of investment. For example, the Reagan administration's favorable reception of foreign capital was best summed up in 1986 by the former U.S. ambassador to the European Community, J. William Middendorf: "Send us your tired. Send us your poor. Send us your money."[21] Or, as he explained in another interview, "We have gotten into a habit of 'Buy Foreign.' Now we need the investment."[22] (After leaving his ambassador's post, Middendorf came back to the United States to head another foreign-sponsored lobbying group—the Association of Foreign Investors in U.S. Real Estate.)

The open-door attitude of the federal government, one shared by all administrations in memory, is mild compared with the active policy adopted by many states and cities. To state and local officials anxious to attract new sources of jobs and tax revenues, foreign multinational corporations are honored guests, eagerly recruited and favorably received. Foreign investment holds out hope for industrial rejuvenation. Kentucky, for example, ponied up more than $300 million in subsidies to corral a Toyota plant. Georgia's governor, Joe Harris, claimed that foreign companies in his state are "replacing jobs that have been lost from American manufacturing operations."[23] A Tennessee banker active in recruiting foreign companies said, "We rebuilt Japan. In effect, they're helping to rebuild us."[24] Many politicians formerly suspicious of outsiders now share these views.

Some observers, however, question the wisdom of global smokestack chasing and the free flow of capital into the United States. To them, the surge in foreign ownership signifies not the dawn of an industrial

renaissance but a surrender of our productive resources to foreign control. Perhaps, they say, future economic historians will look upon the period since the mid-1970s as a watershed—marking the onset of a de-Americanized economy, a time when the United States began to lose its economic independence. This theme has been amplified to jingoistic rhetoric by June M. Collier, the chief executive of National Industries, an auto-parts supplier. Collier has "nightmares" about U.S. businesses becoming subsidiaries of Japan, Saudi Arabia, or France. She founded Citizens Against Foreign Control of America (CAFCA) "to find out the truth about foreign control."[25] Editorials by the Citizens Against Foreign Control of America have appeared side by side in debate formats with those by the Association for Foreign Investment in America. In one, Collier insisted:

> My objection is to foreign bosses who have found out that it's cheaper to buy us than to bomb us—people who want to set our course from a different boat. . . . When thinking about this, there's really only one question to ask yourself: What sort of future—what legacy—do you want to leave for your children? The answer will convince you, as it has me, that it's time now to stop the foreign control of the USA.[26]

Few Americans have these "CAFCA-esque" nightmares. However, even thoughtful observers, such as the influential Wall Street financier Felix Rohatyn, are troubled by the rapid rise of foreign takeovers. In a 1988 speech, he said, "More than two hundred years after our Declaration of Independence, the United States has lost its status as an independent power."[27] Raising the specter of foreign control over major American companies like Time, Inc. and Morgan Bank, he proposed a new legal authority to review how major acquisitions would affect the national interest. Going further, Malcolm Forbes, America's self-proclaimed "Happy Capitalist" and noted free-marketeer, has called for a strict review of "*any* foreign purchase of *any* significance of *any* consequential U.S. company—regardless of size."[28] Such are the cautionary words from leaders of the business mainstream.

The schizophrenic reaction to FDIUS appears in government as well as business. Even as state governments pursued investments by foreigners, others considered many pieces of legislation that would control or restrict foreign ownership of real estate, financial institutions, and other forms of property. Although no significant legislation was enacted, this debate will arise again.

At the federal level, the congressional debate over the 1988 trade bill

also involved discussions of greater restrictions on and disclosure of foreign investment. Government officials have raised national security issues. The former CIA director William Casey warned that the Japanese could be using high-tech investments as a "Trojan horse" to get U.S. technology. The proposed acquisition of Fairchild Semiconductor by Fujitsu drew fire from the Defense Department on national security grounds because Fairchild made proprietary semiconductor chips for the military. The Fujitsu-Fairchild case also shows how America's trade deficit and trade friction have affected foreign investment. The proposed merger sent shock waves through American semiconductor companies which feared for their futures in this highly competitive industry. They opposed the deal, with the Commerce Department as an ally. The Reagan administration's opposition to the merger came despite its strong free-market views. The underlying anti-Japanese sentiment was clear, because Fairchild was already owned by a foreign company, Schlumberger. Most observers believed the real issue was America's large trade deficit with Japan. One industry official alleged that the national security argument was "hogwash." The complaints "came from people afraid of what Fairchild could do with Fujitsu's manufacturing know-how."[29] In early 1987, Fujitsu called the acquisition off.* The lesson of the Fujitsu-Fairchild saga is that U.S. policy toward FDIUS lacks a clear mechanism for reviewing controversial cases. If a similar case arose, the same sort of confusion would no doubt result (see chapter 9).[30]

Beyond national security is the question of economic security. There has been a revival of "economic nationalism," the often vague but widely felt sense that the United States is no longer number 1 economically: that our products are no longer the best in the world, that our living standards are not rising, that today's children will not be better off than their parents. A 1988 national poll showed that most Americans see economic problems as the greatest threat to our future, more serious than Soviet tanks or missiles.[32] There is recognition, as Paul Kennedy argues in *The Rise and Fall of the Great Powers*, that the United States cannot expect to remain on top in light of increasing economic competition from abroad and its overextended defense commitments.[33] The world economy has quickly become multipolar. The United States now shares economic power with Japan and Europe and cannot hope to dominate global markets as it did for the twenty-five years after the Second World War. In short, economic nationalism reflects the frustra-

* Later in 1987, Fujitsu announced plans to build a $70-million microchip plant in Gresham, Oregon; and Fairchild was bought by National Semiconductor.[31]

tion of recognizing that we have slipped. On a more positive note, many of its adherents argue that we must take steps to regain America's lost status.

Economic nationalism ran through much of the 1988 presidential campaign. While the Republicans had won power in 1980 in part because of the perception that the United States was vulnerable militarily, anxiety about the economy is now considered more significant as the decade draws to a close.[34] Michael Dukakis, for example, in a speech about the decline of living standards, said that the nation must start "buying back our bonds and land and factories from the Japanese and the Europeans and the Saudis and the Kuwaitis who have been buying them from us."[35] Later in the campaign, when Dukakis spoke at the Moog Automotive plant in Wellston, Missouri, he declared, "The Republican ticket wants our children to work for foreign owners and owe their future to foreign owners. But that's not the kind of future . . . all of you want for America."[36] The candidate's aides failed to inform him that a Luxembourg-based company owned the Moog plant. The Republican ticket and its media "handlers" tried to portray the economic nationalist position as naïve and groundless. In his October 1988 debate with Senator Lloyd Bentsen, the vice-presidential candidate Dan Quayle said that Americans need not worry about foreign investment, for Honda was exporting its Ohio-made cars to Japan and helping to reduce the trade deficit. Later, Senator Bentsen spun the issue around 180 degrees by pointing out that while the United States exported 950 cars to Japan, it imported 178,000 from that country during August 1988 alone.

Economic nationalism played itself out in a variety of political slogans: we must be "more competitive"; we must have "international economic justice"; international trade must be "fair"; and foreign markets must be "open" to American goods. The suspicion underlying these ideas is that foreigners are at the heart of our problems. In sum, the growing resistance to foreign investment stems from fear of external control.

Thus, there are two contradictory attitudes toward foreign investment. According to one, the New Competitors are friends who are revitalizing U.S. industry by creating fresh employment opportunities, introducing new managerial methods, bringing in advanced technology, and adding to the tax coffers. The other sees foreign MNCs as foes of domestic capitalism—as a shadowy menace intent on defeating the national purpose, confiscating the U.S. capital base in the bargain.

In this book, we argue that the truth lies somewhere between these two extremes. The facts of foreign direct investment in the United States

14

hardly support angst-ridden campaigns against outside ownership. Still, by any measure, the aggregate size and extent of foreign capital here, although not trivial, is still small. The de-Americanization of the economy has a long way to go before foreign investors will control U.S. assets anywhere near the extent that U.S. multinationals control assets in other nations.

But the debate over foreign ownership involves far more than economic nationalism and national security. It includes the bread-and-butter issue of employment: that is, do foreign companies add jobs to the American economy? This issue is particularly important because of the current decline in manufacturing employment, or "deindustrialization."* Beginning in the 1970s, many manufacturing jobs were cut and replaced with service jobs. Many of the lost jobs were unionized and paid relatively high wages. Analysts dispute whether services, a mixture of high-wage and low-wage occupations, provide on average jobs as good and high paying as those lost in manufacturing. During the 1988 presidential race, the Democrats argued that many of the jobs gained during the Reagan era were low paid and contributed to increasing income inequality.[40] Where do foreign investors fit into this debate? Promoters of FDIUS argue that foreign companies create millions of good jobs when they invest here. The majority of those polled by Smick-Medley agreed, even though they have deep concerns about foreign investment.[41] Foreigners, who have invested heavily in manufacturing, have the potential to "reindustrialize" this country. But are they actually doing so?

Some domestic firms fear that foreign companies put American firms out of business; in doing so, the New Competitors are hiring some Americans, while other workers are losing jobs when domestic firms go

* We use the term *deindustrialization*, most associated with the work of Barry Bluestone and Bennett Harrison, to denote the absolute and relative loss of manufacturing jobs in the United States. Bluestone and Harrison define it as the "widespread, systematic disinvestment in the nation's basic productive capacity";[37] and the term, used broadly, refers to the decline of manufacturing. We use this term because we believe it describes the problem of manufacturing job loss most simply, although we are aware that it is sometimes misunderstood and controversial.

Much of the debate is over whether the loss of manufacturing jobs is a secular or a cyclical phenomenon. Bluestone and Harrison argue that it is secular change. Other observers, such as Robert Lawrence, see it as more of a cyclical problem.[38] Another part of the debate is over whether employment or share of gross product originating (GPO) is the proper measure. Although many economists argue that GPO in manufacturing has been stable over the past fifteen years, 1988 studies by the Office of Technology Assessment and Lawrence Mishel show that the Commerce Department's GPO figures are biased and that, in fact, GPO in manufacturing has declined over the long term. Thus, both studies offer evidence of deindustrialization, even when measured by GPO.[39]

bankrupt. If that is the case, then the net effect on jobs is small. Auto-part makers, for example, contend that many of their firms have lost out to Japanese competitors with long and close ties to the large Japanese auto makers like Toyota or Nissan. The Americans say they cannot sell their products to Japanese firms, while the Japanese parts suppliers go aggressively after contracts with the American Big Three auto companies. The Japanese respond by pointing out that they are providing superior products and just trying to compete fairly.

In addition, some Americans believe that foreigners have an unfair advantage because they are subsidized not only by their home governments but also heavily by states and localities eager to attract new jobs (see chapter 8). House Democrat Marcy Kaptur of Ohio argues that local incentives are "giving foreign-owned companies an unfair advantage to produce over American-owned companies." As a result, Kaptur complains, "Too many home-grown companies are left out to dry and are ending up out of business."[42] Foreign investors reply that the same incentives given to them are also available to American firms, and that they are outcompeting their American rivals on a level playing field.

So we are left to unravel this controversy over reindustrialization, in particular the foreign contribution to jobs in this country. The question is complicated because the greatest share of FDIUS comes from acquisitions; when a foreign company acquires an American one, the result is not necessarily additional employment in the economy, only a shift in ownership. Thus, more jobs are *controlled* by the New Competitors. So the fact that foreigners employ about 3 million Americans does not mean that 3 million *new* jobs have been created.[43] As we shall show in chapter 5, all the job increases attributed to foreigners came through acquisitions and mergers. These were not new jobs, but the transfer of old jobs from an American to a foreign boss.

The reindustrialization debate also involves the issue of managerial quality and the nature of labor relations. How do foreigners organize their plants? Do they provide new management methods and technology? Sometimes, when a company is acquired, much of the same management team remains. Other times, a new management group takes over, but the lower-level supervisors—foremen, supervisors, and the like—remain in place, and few management changes occur. But foreigners have introduced new management techniques: for example, the joint venture between Toyota and General Motors, the New United Motor Manufacturing, Inc. (NUMMI). In 1982, Fremont, California, was the site of a shuttered GM plant, closed in part because of worker absenteeism and labor-management conflict. The arrangement to make

Chevy Novas* involved relatively little new equipment or technology but brought to Fremont a major infusion of Japanese management techniques. Productivity has increased, and shop floor grievances have declined. A United Auto Workers representative said, "We have the same members, the same building, the same technology—just different management and a different production system."[44]

While the Fremont plant has received praise for turning labor relations around, there is also a dark side of the foreign labor record. Often foreigners fight fiercely against organized labor and try to avoid heavily unionized states. BASF and the Canadian Development Corporation, among others, faced labor turmoil in their American affiliates. Other companies have been sued for their anti-union activity and discrimination. An AFL-CIO economist complained that "a lot of foreign investors tend to take on the worst characteristics of U.S. firms. Rather than following the positive labor-management relations they may have at home, in the U.S. they follow practices that are basically designed to inhibit workers from exercising their rights to organize."[45] Thus, relations between foreign bosses and their American workers are mixed.†

The economic and non-economic consequences of inward investment have shown up most visibly at the regional and local levels. While the foreign contribution to total U.S. employment is small, direct investment has played a large role in specific areas of the country. Foreign manufacturers have a distinct preference for southern states when they seek locations for new plants, as we show in chapter 7. This "southern scenario" results from that region's strong and growing markets, and little labor militancy. The mid-South, once dominated by textiles and small-scale agriculture, is becoming an automotive center, thanks to investments by Nissan, Toyota, and more than one hundred suppliers. Electronics firms have flocked to California's "Silicon Valley" and to "Silicon Forest" in Oregon. There are also pockets of chemicals and petrochemicals in the Southeast and Texas.

For states and cities, the debate intensifies around the incentives used increasingly to attract foreign investment in attempts to revitalize their industrial bases. Trade delegations go to Frankfurt, Paris, and Tokyo to woo firms. Localities offer MNCs lucrative incentives, such as tax abatements, low-interest loans, and subsidized training programs, in the hope of attracting new jobs. Politicians and scholars wonder whether

* Toyota Corollas are also built in the plant.
* The industrial relations record between American managers and workers is mixed as well, some U.S. companies having superlative labor-management relations and others poor ones.

the financial inducements used to attract firms pay for themselves in terms of greater tax revenues and employment. With many cities offering incentives, foreign MNCs are increasingly able to dictate terms in their bargaining with communities. They can easily "divide and conquer" in this mad scramble for the few jobs foreigners generate. As we have said, some also worry that portions of these public subsidies go to foreigners who compete directly with home-grown industry. Therefore, FDIUS can be a mixed blessing: it creates a few jobs and increases tax bases in some towns, but also raises serious economic and political questions (see chapter 8).

As the debate over inward investment spreads, another tug of war over jobs continues in discussions of American investment abroad. Many observers argue that U.S. MNCs contribute to the economy, creating many domestic jobs to supply their offshore operations. Others say that American MNCs displace our workers and help deindustrialize America. As we show in chapter 6, 3.4 million jobs were lost throughout the economy as a result of USDIA between 1977 and 1986—cutbacks borne most heavily by women, minorities, and blue-collar workers. MNCs' attitudes toward labor and the U.S. economy have also drawn attention. Some have argued that American MNCs adopted an "offshore" strategy, the better to bargain with labor by threatening to move overseas. At the community level, there is concern over the disinvestment that results when firms shift production facilities overseas.

U.S. offshore investment has been extremely controversial in other nations. While many countries welcomed U.S. investment, offering inducements such as tax holidays to attract it, others had objections to the presence of American multinationals. During the 1960s, the world reeled with campaigns against American MNCs by foreigners. Europeans and Latin Americans in particular feared American expansion into their economies. Overseas the U.S.-based multinational was cast as a mysterious, sometimes sinister force—a form of *dependencia*, or imperialist dependency, in Latin America; *le défi américain*, or the American challenge, in Europe. The French, notably alarmed, fervently sought to discover the "secrets of the American giants."[46] Jean-Jacques Servan-Schreiber's *American Challenge* was an eloquent call to action[47]—a call echoed, ironically, by many in this country who inveigh against today's "Japanese invasion."

But there is another irony here. American firms investing abroad increasingly produce for the United States and other markets. They, too, are New Competitors, but their nationality is American, not Dutch or

18

French. After all, American firms have been importing significant amounts into this country only since the Second World War—not a long time in the sweep of economic history. Their arena is the world marketplace, not just the United States. As a result, their goals are increasingly separate from those of the U.S. economy: that is, they have less concern about the success or failure of the United States economy than they did forty years ago when they were operating mostly in the American market and had fewer investments and markets abroad.[48]

Looking to the Future

Foreign investment has waxed and waned, but this time it is, rather than a passing phenomenon, a permanent feature of the greater internationalization of the U.S. economy. By and large, the New Competitors are here to stay. Accordingly, foreign direct investment will be crucial in shaping the future of the American economy. We should not sit idly by and watch these trends develop without trying to shape and direct them. As we move into the 1990s, we are more dependent on foreign capital than at any time since the nineteenth century. Many observers believe that the Reagan legacy is "America for Sale" at bargain-basement prices. By running up the twin deficits, we traded today's consumption for tomorrow's ownership in America. In short, we turned our twin debt problem into the greatest *debt-for-equity swap* in history. The United States, the world's most advanced industrial power, has become a *dependent* nation, a status once reserved for developing nations. We have not been able to compete internationally, especially in manufacturing.* Seizing the initiative, foreigners have carved out a position in manufacturing and other industries in this country.

Americans have legitimate concerns about both inward and outward foreign investment. As we have said, the most fundamental source of worry is the continued growth of foreign ownership of domestic industry. As investment grows, foreigners' power to affect both the economy and American life will be ever more apparent. Foreigners can flex political muscle that lets them influence legislation in Congress, in

* The dollar's fall beginning in 1985 did not bring about a revival of manufacturing exports until 1988. The three-year span was far longer than economists expected for increased exports to take. It will, according to many analysts, take a far larger fall to continue the 1988 export boom.

state capitols, and in city halls. Economic power has always been translated into political clout. American firms have used it at home and abroad for decades. Now foreigners are using it in this country.

While an extensive takeover of American assets remains only a remote possibility, the rise of FDIUS exposes chinks in the armor of domestic competitiveness: that is, the ability of this country and its firms to compete in international markets on terms that allow it to maintain and improve profitability and real incomes.* By that standard, the American economy has suffered considerable loss of competitiveness in recent years on a number of measures: we have not had a merchandise trade surplus since 1975; our share of world exports has fallen substantially; real wages and income have stagnated since 1973; investment as a share of gross national product has fallen; and productivity growth has slowed and is below that of many other countries.[50] The increasing presence of foreigners shows just how weak the economy has become: American companies that once dominated the world economy are now being outslugged on their own playing fields.

Like it or not, we have no choice but to accept foreign investment: a major reversal could trigger a sharp recession and a decline in our standard of living. The withdrawal or slowdown of foreign capital inflows would choke off the funds needed to finance continued domestic growth. Moreover, interest rates would inevitably rise, further retarding the economy. Any policy that severely restricts foreign investment would be counterproductive. Still, strong measures must be taken to reverse our competitive decline, since foreign investment could be withdrawn or slacken in the future.

It is our aim in this book to provide solid evidence on the extent and nature of foreign investment to serve as a basis for these measures and for realistic policies that will guide us into the next century.

In part I, we investigate foreign investors in detail: Who are they? What motivates them to invest? And why do they invest in the United States? Then, in part II, we turn to the impact on the U.S. economy of both foreign investment in the United States and U.S. investment

* The key element in this definition of competitiveness is real incomes—that is, income after inflation is accounted for. If real incomes deteriorate—even with a positive trade balance—a nation cannot be truly competitive. After all, Haiti has had a positive external trade balance—and the lowest standard of living in this hemisphere. The President's Commission on Industrial Competitiveness said in 1985, "Competitiveness is the degree to which a nation can, under free and fair conditions, produce goods and services that meet the test of international markets while simultaneously maintaining or expanding the real income of its citizens."[49]

abroad. Here we look in particular at the impact on jobs—on their number, their quality, and their location. Finally, in part III, we consider the policies regarding international investment open to the United States at the local, state, and federal levels to ensure that neither our people nor our resources provide a tasty recipe in some alien's cookbook.

PART I

The Rising Tide of Foreign Investment in America

2

INWARD INVESTMENT:

THE ESSENTIAL FACTS

THE obscure Jefferson Smurfit Corporation took first place in *Fortune's* 1986 catalogue of U.S. companies yielding the highest return to investors. Smurfit is not, as one might expect, a California biotechnology start-up or a New England software company, but the St. Louis-based subsidiary of an Irish multinational company known mainly for making such mundane products as cardboard boxes. Following a rapid succession of corporate takeovers in Ireland during the late 1960s and 1970s, the Jefferson Smurfit Group became that nation's largest enterprise. Then, in the 1980s, the previously unheard-of firm entered the United States. Snatching U.S. paper and packaging companies, it now has a solid position in American industry. Smurfit manages the Container Corporation of America's sixty-five mills and plants (backed by the New York investment house Morgan Stanley) and runs over ninety additional plants in the United States. It supplies the *Los Angeles Times* with newsprint, Kellogg and General Mills with cereal boxes, and Wendy's fast-food franchises with french-fry packaging.[1]

Smurfit wasted little time restructuring its growing roster of U.S. companies. Slashing costs and raising productivity, it turned listless old-line factories into paragons of modern American production. Now the Jefferson Smurfit Corporation (the U.S. subsidiary) is America's leading

manufacturer of folding cartons and plastic drums and one of the top three producers of corrugated containers, spiral tubes, and fiber partitions. After Smurfit auctioned off 22 percent of its U.S. subsidiary on the U.S. stock market in 1983, Wall Street went wild. The firm's stock price quadrupled over the next three years. "When they first got here," remarked a St. Louis executive who serves on Smurfit's board, "the reaction was, who are these people?"[2] The same question is often repeated as foreign companies like Smurfit quickly ascend the ranks of U.S. industry.

A "who's who" of foreign-based multinationals now operating in America would be a long and expanding list. Many of the New Competitors, like Smurfit, are novices in the United States. Largely unknown a decade ago, this group includes aggressive global upstarts like Great Britain's Sir James Goldsmith and Hanson Trust and Canada's Robert Campeau and the Belzberg family. Another group includes old-guard global companies that have suddenly raised their stake in American production—Unilever, Nestlé, Royal Dutch/Shell, Bayer, Siemens, Mitsubishi, Nippon Steel, Seagram, and many others. What is "new" about these established multinationals is their resolve to secure a stronger position in the U.S. economy. Bayer, for example, invested in the United States over a century ago, even before its labs invented aspirin in 1899. But in the 1980s, the German chemical giant decisively stepped up its U.S. operations. After reorganizing its foreign holdings, Bayer touted its U.S. subsidiary as the highest-ranked "new" company on the *Fortune* 500. Throughout the summer and fall of 1987, Bayer's advertisements in the *Wall Street Journal* appeared regularly next to the editorial page.

Despite the advertisements and ballyhoo in the business press, or perhaps because of them, a shortage of information about foreign investment has deeply troubled policy makers. In a speech before the Brookings Institution, Texas congressman John Bryant argued that "the information needed for sound analysis of the effects of foreign investment on our economy, our society, and our security is simply not available. Not to the experts, not to Members of Congress, not to anyone."[3] Unfortunately, Bryant and other critics are right: the ignorance gap on foreign investment in the United States is wide. When data are available, the published statistics are carefully designed to prevent detailed disclosure of individual foreign operations in the United States (as they are for domestic companies).

But we can get a sense of the "big picture" of FDIUS from government records. In the 1970s, the specter of Arab oil sheikdoms taking over

U.S. assets so frightened segments of the American public that Congress passed the International Investment Survey Act of 1976, and probes into foreign investment began for the first time in decades. Since then the government has tracked all U.S. affiliates of foreign companies; and we now have over ten years of data compiled by the U.S. Commerce Department's Bureau of Economic Analysis (BEA), the most complete and reliable source of information on inward investment*—data that, although highly aggregated, help cut through the fog shrouding the New Competitors. To draw out the "essential facts" of FDIUS, we shall combine the government data with other public and private information sources. Let us begin with a brief look at the history of inward investment.

The Ebb and Flow of Direct Investment: A Historical Perspective

The role of foreign capital has changed over the course of U.S. economic history. During the nineteenth century, foreigners helped underwrite U.S. economic development, contributing to the financing of the Louisiana Purchase, the first American railroads, and midwestern slaughterhouses.[5] Foreign outlays came, however, mostly in the form of portfolio investments like railway and state government bonds, not in direct investment like factories and large corporate takeovers. Foreigners contributed little to the day-to-day management and operations of most industrial projects.[6]

The British, who held the most extensive position in American mines, farm land, and other assets during the last century, were thus the first to incite the fear of alien ownership in the United States. Campaigns against foreign control of American resources reached a fever pitch in the 1880s, chiefly in the American West, where some 1,500 British companies had investments.[7] It was not uncommon to find cow-

* The definition of a "U.S. affiliate" parallels that of "foreign direct investment" given in chapter 1. According to the BEA, a U.S. affiliate is a "U.S. business enterprise in which a single foreign person owns or controls, directly or indirectly, 10 percent or more of the voting securities if an incorporated business enterprise or an equivalent interest if an unincorporated business enterprise."[4] The period over which comparable figures are available varies for different data series provided by the BEA. In all cases, we use the latest data. Where the BEA data is insufficient, we draw on other sources, including the U.S. International Trade Administration (see appendix A for a full discussion of data sources available for studying foreign direct investment in the United States).

boys, who would one day symbolize rugged individualism and self-reliance, working on the more than 4 million acres owned by the British cattle companies like Prairie Cattle or Powder River.[8] Besides cattle ranches and land companies, British investment during the nineteenth century was especially strong in grain elevators, stockyards, cotton farms, irrigation projects, breweries, and mines. More than ever, foreign investment became a highly charged political issue. "Are we the servile and supple tools of foreign capitalists," bellowed Congressman James B. Belford of Colorado in 1884, "or are we going to preserve this country for our own people?"[9] Perhaps the most famous remark of the anti-alien debate during the 1880s came from House Representative Lewis E. Payson of Illinois. In an argument over restrictions on foreign land ownership, Payson's patriotism could hardly be contained: "Not an acre of real estate, not a dollar's worth of real property under the flag that floats over you and me should be under the ownership of a foreigner. . . . I mean, America for Americans."[10] Anti-British agitation roused state and national politicians to introduce restrictive legislation. To this day, many states limit foreign ownership of agricultural land, a carry-over from the nineteenth century.

A surge of direct investment in U.S. manufacturing began just before the turn of the century and lasted about a decade and a half. During that period, foreign capital poured into chemicals, electronics, automobiles, and other rapidly developing U.S. industries. European manufacturers like Siemens, Bosch, and Lever Brothers (now Unilever) were major players; and in a joint venture with American capitalists, Italy's Fiat ran an automobile-assembly plant in Poughkeepsie, New York. Although international cartel arrangements of the early twentieth century limited investment in some markets, the foreign direct investment stake in America grew steadily. Great Britain's textile giant, Courtaulds, considered one of the most prosperous investors, established itself as the only supplier of rayon in America during the early twentieth century, a situation that aroused some concern.[11] When this initial boom peaked in 1914 with the onset of the First World War, foreigners claimed about 6.2 percent of U.S. manufacturing assets.[12] The British controlled about half of the total foreign claims on U.S. production.

The First World War abruptly halted the expansion of FDIUS as European capital was directed toward the war and many foreign assets were sold, often under orders from the home country's government.[13] After America entered the war in 1917, the U.S. Office of Alien Property Custodian expropriated Austrian and German capital, shattering the latter nation's dominating presence in U.S. chemical production. Many

TABLE 2.1

Inward and Outward Investment 1897–1950 (Millions of Dollars)

	1897	1914	1919	1929	1935	1950
Net Debtor (−) or Creditor (+) Status	−2,710	−3,686	12,562	19,738	18,799	36,724
Total U.S. Investment Abroad	685	3,514	16,938	28,669	25,128	54,359
U.S. Direct Investment Abroad (USDIA)	635	2,652	3,880	7,528	7,219	11,788
Total Foreign Investment in the U.S.	3,395	7,200	4,376	8,931	6,329	17,635
Direct Investment in the U.S. (FDIUS)	*	1,310	900	1,400	1,580	3,391

* A relatively small but undeterminable amount of direct investment (chiefly real estate, mortgage, cattle, and mining companies).
SOURCE: U.S. Department of Commerce, International Trade Administration.

other ventures established during the period collapsed on their own. Fiat, for example, sold its interest in its Poughkeepsie assembly plant in 1918, after failing to respond to the shift toward cheaper, mass-produced cars introduced by Henry Ford during the teens. Foreign-owned manufacturing assets plummeted to 2.2 percent in 1919.[14] That same year, America enacted Prohibition with the passage of the Eighteenth Amendment to the U.S. Constitution, the act quickly drying up the substantial flow of British funds into American breweries and distilleries.

Following the war, the movement of American capital abroad overshadowed the reverse flow of foreign capital to the United States. The United States had become a creditor nation, and by the eve of the Great Depression in 1929, U.S. citizens owned over $5 of direct investments overseas for every $1 owned by foreigners in this country (see table 2.1). Over the next five decades, America would remain a net capital exporter.

Nevertheless, FDIUS did begin to increase once again during the prosperous 1920s, rising from $900 million in 1919 to $1.4 billion a decade later. In the vanguard of this inward investment surge were Swiss and Dutch firms in pharmaceuticals and medical electronics. And the German chemical industry proved irrepressible. In 1924, Germany's Bayer, BASF, and Hoechst combined to form I.G. Farben. Soon thereafter the chemical juggernaut began operations in America and, at the outbreak of the Second World War, claimed almost 30 percent of the expanding U.S. synthetic dyestuff market.

However, with the breakdown of world trade and investment dur-

ing the Great Depression, followed by the Second World War, the rise of foreign direct investment in the United States was foiled once again. With the onset of the war, the U.S. government confiscated the U.S. assets of I.G. Farben and other German companies.* The British government forced Courtaulds, the British textile concern with a grip on the U.S. rayon market, to sell its interests in America. Indeed, many foreign operations set up during the interwar period failed to survive; for example, only twelve Continental firms owned U.S. manufacturing facilities in 1945, the same number as in 1913.[16]

The 1950s saw a renewal of foreign direct investment in the United States. Between 1950 and 1960, inward investment more than doubled. Then, with economic recovery in Europe, FDIUS picked up further in the 1960s, rising from $6.9 billion in the 1960s to $13.3 billion in 1970—and by 1975 more than doubled again.[17]

Still, as figure 2.1 shows, in the mid-1970s the stock of outward direct investment dwarfed inward investment. In 1975, American multinationals held about $4.50 dollars of direct investment abroad for every $1 invested by foreign MNCs in the United States. Then, as these graphs make clear, foreign-based multinationals steadily closed the gap on their American counterparts. Overseas investment by American multinational corporations rose by about 150 percent from 1975 through 1987, from $124 billion to $309 billion. But during the same period, foreign investment in this country increased by a staggering 845 percent, reaching $262 billion in 1987. American multinationals could claim only $1.18 invested abroad for every $1 invested by affiliates of foreign companies in the United States.† If current trends persist, inward investment will surpass outward investment during the 1990s.

* During the Nazi period, Farben discovered synthetic fuels, turning coal into rubber and gasoline to fuel the military expansion, and built synthetic rubber and oil plants next to the Auschwitz slave-labor camp. One observer noted, "When inmates were no longer able to work, they were returned to the camp for execution by a lethal gas manufactured by another Farben unit."[15] By the end of the Second World War, 80 percent of I. G. Farben's Ludwigshafen plant was decimated by the Allies.

† One problem with our comparison of inward and outward investment is that the BEA figures measure the *stock* of foreign assets at *historical cost*. Since much of the outward investment by American-based multinationals took place in the 1950s and 1960s, while much of the inward investment has come since the 1970s, the official figures understate the total value of outward investment.[18] If, however, we look at employment of foreign firms in the United States and American multinationals abroad, we still see the relative increase in the former is not an accounting fluke: while employment generated by American MNCs contracted in the late 1970s and early 1980s, employment of U.S. affiliates of foreign corporations grew steadily. Overseas employment for U.S. firms picked up again in the mid-1980s, however, as we shall see in chapter 6.

30

FIGURE 2.1

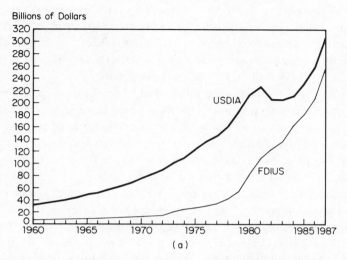

Billions of Dollars

*Total Foreign Direct Investment in the United States and U.S. Direct
Investment Abroad from 1960 to 1987.*

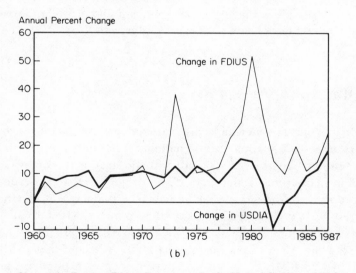

Annual Percent Change

*Change in Foreign Direct Investment in the United States and U.S.
Direct Investment Abroad from 1960 to 1987.*

SOURCE: U.S. Department of Commerce, Bureau of Economic Analysis.

The job picture shows the same remarkable trend. BEA employment data reveal that foreigners employed 3.0 million Americans in 1986 (the latest year available), rising by 147 percent since 1977. While more than twice as many foreigners work for American companies abroad, U.S. multinational employment overseas actually declined from 7.2 million in 1977 to 6.3 million in 1986, a 13-percent drop.

As foreign investment has ebbed and flowed, so too have American concerns. Summing up American attitudes toward inward foreign investment, one economic historian wrote, "The body of foreign claims thus accumulating against the American economy was looked upon with suspicion and disfavor, even in the early decades. The fear was ever present, and frequently expressed, that foreigners were acquiring too large a share in the control of American business, and an undue portion of the nation's income."[9] That assessment was written in the late 1930s. Fifty years later, many Americans again wonder: Are foreign investors poised to take over America? Clearly not, as they control very little of the vast U.S. economy. In 1986, for instance, foreigners employed approximately one out of every thirty workers in the private sector—twice the number of U.S. citizens who drew their paychecks from foreign companies only a decade earlier. What is significant about foreign investment in the United States is not its size, but its growth.

Who Are the Foreign Buyers?

It was perhaps inevitable that expanding foreign control over the American economy would arouse national xenophobia for the first time in a century. On the other hand, with foreign firm employment expanding many times faster than domestic job growth, governors and mayors traverse the globe, seeking new investments, as if they had discovered a Holy Grail for economic development. Thus we are led to another basic question about FDIUS: Which nations are investing in the United States? Here misconceptions abound. According to the poll taken by Smick-Medley in 1988, 73 percent of the respondents said the Japanese invest the most in American business, and 10 percent cited the Arabs. Only 3 percent of those polled named the British, and 2 percent believed the Germans invested the most.[20] Who is right?

Let's begin with the Arabs. The big fear in the 1970s was an OPEC takeover. Flush with cash following sudden leaps in world oil prices, the

OPEC cartel searched the world for places to recycle its mass of petro-dollars.* In the United States, OPEC investors seized chunks of energy assets and prime real estate. Oil-rich Kuwaitis bought several highly visible U.S. properties, including the posh Kiawah Island resort development off the coast of South Carolina (which they sold back to American investors in 1988) and a significant portion of office space in Houston, Texas. In 1981, Kuwait's state-owned oil company acquired Santa Fe International for $2.5 billion, one of the first multibillion-dollar deals of the decade. The true extent of the Kuwaitis' stake in the United States is not known, however, because they are highly secretive. They often buy less than 5 percent in a company's stock to avoid disclosing their operations to the U.S. Securities and Exchange Commission or filing a report with the U.S. Bureau of Economic Analysis.†

If government figures reflect OPEC's stake in America, however, the Arab threat turns out to be a paper tiger. Through direct investment, OPEC's employment in the United States reached only 47,000 in 1986, a tiny fraction (0.05 percent) of total U.S. private employment. Further, OPEC's share of all U.S. employment by foreign companies, although still growing, remains minor compared with other sources of inward investment—1.6 percent of all jobs controlled by foreign investors in 1986.‡

Replacing the oil-exporting nations, Japan appears as America's foreign nemesis in the 1980s. The facts support this vague feeling that Japanese investors are briskly buying up U.S. assets. In terms of sales, Japanese companies lead all other sources of FDIUS and, in total assets, hold third place. Once again it is the rate of growth, not the size of investment, that is most astonishing. The Japanese dramatically in-

* OPEC, the Organization of Petroleum Exporting Countries, is comprised of thirteen nations, mostly but not exclusively in the Middle East: Algeria, Ecuador, Gabon, Indonesia, Iran, Iraq, Kuwait, Libya, Nigeria, Qatar, Saudi Arabia, Venezuela, and the United Arab Emirates.

† The Kuwaiti position in the United States is matched or surpassed in other developed nations. Through the Kuwait Investment Office, the Reserve Fund for Future Generations, and the state-owned Kuwait Petroleum Corporation, they have bought a 14-percent interest in West Germany's Daimler-Benz and 24.9 percent of West Germany's Hoechst. The Kuwaitis caused the biggest stir in early 1988 when it was discovered that they bought up almost 20 percent of British Petroleum stock, making them the largest shareholder.[21]

‡ In terms of sales and assets, the OPEC share of direct investment is somewhat higher than it is in terms of employment (2.8 percent and 8.3 percent for 1986 affiliate sales and assets, respectively), because most of OPEC's investment is in real estate and energy-related endeavors, which are hardly labor-intensive (see Appendix A for the sources of these data).

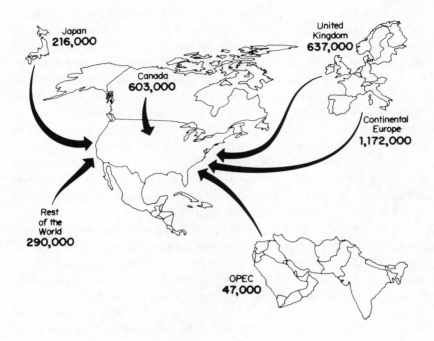

FIGURE 2.2
Who Hires American Workers.

SOURCE: Ned G. Howenstine, "U.S. Affiliates of Foreign Companies: Operations in 1986," *Survey of Current Business* (May 1988), p. 68.

NOTE: Figures show employment by U.S. affiliates of foreign companies in 1986.

creased their direct investment outlays in 1986 (see table 2.2). Employment by Japanese companies in the United States, meanwhile, rose almost twice as fast as the average for all nations from 1980 through 1986.* Nevertheless, the 216,000 Americans working for Japanese firms represents just 7.2 percent of all U.S. affiliate employment and only 0.3 percent of the total private work force.

Despite its rapid growth, the number of U.S. citizens employed by Japanese companies still pales in comparison with the number working for multinationals based in other nations. As figure 2.2 illustrates, more Americans work for MNCs of other advanced industrial nations: the

* Employment by Japanese companies rose by 88 percent, compared with 46 percent for all U.S. affiliates of foreign companies. Moreover, in terms of the annual dollar amount invested, the Japanese direct investment position has surpassed that of every other nation, growing at an average annual rate of 55 percent between 1974 and 1980, about twice as fast as FDIUS overall. The ball kept rolling between 1980 and 1986 at a 31-percent annual rate.

TABLE 2.2

New Foreign Direct Investment in the United States (Billions of Dollars)

	1980	1981	1982	1983	1984	1985	1986	1987
Total new investment	$12.2	23.2	10.8	8.1	15.2	23.1	39.2	30.5
United Kingdom	3.1	6.2	3.1	2.4	3.7	6.7	8.6	11.5
Other European countries	4.6	4.4	3.3	2.5	2.8	8.7	12.6	8.0
Canada	2.0	6.1	1.2	1.1	2.6	2.9	6.5	0.8
Japan	0.6	0.6	0.6	0.4	1.8	1.2	5.4	5.2

SOURCE: U.S. Department of Commerce, Bureau of Economic Analysis.

United Kingdom, Canada, and several nations of Continental Europe. Although MNCs based in these nations hire a substantial number of U.S. citizens, they are perhaps less conspicuous than the Japanese because of cultural, legal, and linguistic similarities. Further, as we mentioned earlier, many of these foreign companies have operated in the United States for decades. Some of Europe's old guard MNCs—like Shell—have been here so long that many Americans do not recognize their foreign affiliation.

The United Kingdom is, as it always has been, the leading foreign employer in America. British multinationals employed 637,000 U.S. workers in 1986 (0.8 percent of U.S. employment) and claimed over a fifth of all U.S. citizens on the payrolls of foreign companies, almost fourteen times that of OPEC and about three times the number of Japanese-controlled jobs. The British also top the list of foreign investors in terms of assets and rank second in overall sales. Like the Japanese, they stepped up their outlays for U.S. hard assets in the mid-1980s; indeed, British investors contributed 38 percent of all new investment outlays in 1987 (see table 2.2). Canada claims second slot in the foreign-controlled jobs, its 20.3 percent closely trailing Great Britain's 21.4 share of employment.* Measured by total assets, Canadians are the number-2 foreign investors.

Direct investment by multinationals based on the European Continent match those headquartered in English-speaking countries. Often neglected in discussions of foreign investment, Continental firms held 40.7 percent of U.S. affiliate employment in 1986, or close to Great Britain and Canada's combined share of 41.8 percent. Notwithstanding their abortive attempts to invest in the United States before the Second

* In their detailed profile of Canadian investment, Alan M. Rugman and John McIlveen point out that even if Canada were somehow to invest its whole economy south of the border, it would only end up with about one tenth of the U.S. economy.[22]

World War, West German companies still outstrip other Continental European investors, at least in jobs. German multinationals' employment reached 305,000 in 1986, accounting for 10.3 percent of all foreign-held jobs;* and they employed over 80,000 more American workers than the Japanese firms. Dutch affiliates also employ more of the U.S. workforce than the Japanese, accounting for 8.7 percent of foreign-controlled employment in 1986. France and Switzerland follow with 6.5 and 6.1 percent, respectively. Together the United Kingdom, the Netherlands, Japan, France, West Germany, and Switzerland account for over four-fifths of foreign-controlled employment. The remaining share of Continental investment is distributed primarily among Italy, Belgium, Sweden, and Denmark.

Other sources of FDIUS are meager, including all of Latin America, which held 4.5 percent of the foreign employment total in 1986. If it were not for the multinational tax havens of Panama, the Netherlands Antilles, and Bermuda, the share from the Western Hemisphere outside Canada would be less than 1 percent of employment. The share of all Pacific Rim nations other than Japan (Hong Kong, the Philippines, and Korea) was just about 1 percent, while Australia, New Zealand, South Africa, and Ireland collectively represented 3 percent of all affiliate jobs.

Essentially, what emerges from our examination of country sources is that global industrial power governs the flow of direct investment to the United States. This force apparently gives the United Kingdom its strong share and also explains why investment from advanced industrial nations like West Germany, Japan, the Netherlands, and Switzerland has grown far beyond OPEC's position. Moreover, if a nation is a major industrial trading partner with the United States, like Canada, then it is likely to be a leading source of direct investment as well. In fact, merchandise exports to the United States correlate strongly with a nation's dollar value of inward investment.† As we shall show in chapter 6, moreover, the direction of FDIUS is roughly associated with the direction of U.S. direct investment abroad. Canada, the United Kingdom, Germany,

* As we discuss in chapter 5, West German employment actually decreased by about 100,000 jobs during 1986 after the Flick Group sold its interest in W. R. Grace.

† The coefficient of correlation is 0.74. Clearly, the association between foreign trade and investment is not perfect. Canada's export share nearly equals its share of FDIUS, but British multinationals hold a substantially larger investment share. Continental investors (the Netherlands, Germany, France, and Switzerland) and Middle Eastern investors (Kuwait) follow the British pattern. Only the Japanese MNCs have a smaller share of the total investment pie than U.S. merchandise exports. Yet as Japan's industrial power builds, it is likely that its share of FDIUS will match or surpass its success in international trade.

and France, leading sources of jobs through inward investment, are the major sites of American production overseas.

How Do Foreign Companies Invest?

When a foreign company decides to step up investment in the United States, it must choose between starting an establishment from scratch or buying existing corporate assets. Through a new establishment, a foreign firm can build a U.S. unit to precise specifications—to ensure maximum control and productivity. The company may act alone or form a joint venture with an American partner. But foreign transplants, or "greenfield" investment, may involve high start-up costs, labor training, managerial transfers, and long time lags. Though acquisitions can circumvent these problems, the U.S. corporate culture may be dissimilar to that of the foreign parent, and the American subsidiary may require extensive restructuring to meet the objectives of the foreign parent. Statistical studies by Harvard's Richard Caves and Sanjeev Mehra indicate that acquisition is more likely if the parent firm runs extensive global operations with a diversified range of products.[23]

The mode of entry—whether new plants or acquisitions—has important implications for the American economy. State and local recruitment efforts, of course, target new plants, not acquisitions. New start-ups bolster employment opportunities, increase capital stock, and enhance the tax base of states and communities. But there appears to be some confusion about the relative size of new investment versus acquisitions investment. In a 1988 article published by the *New York Times*, Anthony M. Solomon, a former president of the Federal Reserve Bank of New York and an official in the Carter Administration, argued that foreign takeovers of existing companies "amount to a moderate proportion of total direct investments. They do not predominate. Only a handful of acquisitions have been unfriendly."[24]

Again, the facts tell a different story. Every year, takeovers dominate all new investment by foreign-based multinationals, according to Bureau of Economic Analysis surveys. From 1980 through 1987, for example, 96 percent of the jobs came through acquisitions of and mergers with existing U.S. operations. On the other hand, foreigners generated little employment through new establishments (only 4 percent).[25] We shall fully explore this phenomenon in chapter 5.

The point we want to stress here is that acquisitions, not new plant

TABLE 2.3

Acquisitions and Mergers in the United States, 1981–87

(Numbers of Acquisitions)

Year of Completion	U.S. Acquiring U.S.		Non-U.S. Acquiring U.S.		Both Types	
	Number	Percentage	Number	Percentage	Number	Percentage
1981	1,964	88.0	267	12.0	2,231	100.0
1982	1,960	89.8	222	10.2	2,182	100.0
1983	2,075	94.7	116	5.3	2,191	100.0
1984	2,729	93.6	186	6.4	2,915	100.0
1985	3,001	93.4	212	6.6	3,213	100.0
1986	3,799	91.4	358	8.6	4,157	100.0
1987	3,198	90.7	326	9.3	3,524	100.0
TOTAL	18,726	91.7	1,687	8.3	20,413	100.0

SOURCE: *Mergers & Acquisitions, 1988 Almanac and Index* 22 (6 [May/June 1988]): 45 (and previous issues).

investment, are the overwhelmingly favored mode of entry used by foreign multinationals. Indeed, foreigners exhibit the same penchant for takeovers that characterized domestic investors in the 1980s. Boosted by the Reagan administration's lenient antitrust posture, U.S. capitalism entered an unparalleled age of acquisition. One cynic noted that, "with the Reagan administration, antitrust restrictions became obsolete. Giant oil company mergers that would never have been allowed in the Carter years became boilerplate."[26] Records compiled by *Mergers & Acquisitions* show that there were over 20,000 mergers and acquisitions from 1981 through 1987 (see table 2.3). While foreigners accounted for only about 8 percent of the total number, they were responsible for more than 14 percent of the value of all U.S. corporate takeovers during that period[27] (see table 2.4). These numbers suggest that foreign acquisitions tend to be larger than average. Further, the average value of foreign takeovers has risen substantially, from about $20 million in 1976 to nearly $120 million a decade later.[28] Part of the reason foreign acquisitions tend to be larger than average is that foreigners pay phenomenal prices for U.S. assets.

Foreign investors, who rank among the biggest deal makers in the U.S. takeover game, are increasingly buying up U.S. companies through billion-dollar-plus transactions (see table 2.5). Most of these large purchases come from old-guard multinationals—Shell, Unilever, Nestlé, Bridgestone, and B.A.T Industries. These *patient* global corporations carefully study investment opportunities and are willing to pay a pre-

TABLE 2.4
Acquisitions and Mergers in the United States, 1981–87
(Value in Billions of Dollars)

Year of Completion	U.S. Acquiring U.S.		Non-U.S. Acquiring U.S.		Both Types	
	Value	Percentage	Value	Percentage	Value	Percentage
1981	56.1	88.0	16.3	22.5	72.4	100.0
1982	59.6	91.6	5.5	8.5	65.1	100.0
1983	48.4	95.7	2.2	4.3	50.6	100.0
1984	115.0	93.3	8.2	6.7	123.2	100.0
1985	124.3	86.9	18.8	13.1	143.1	100.0
1986	177.0	87.5	25.2	12.5	202.2	100.0
1987	119.8	74.1	41.9	25.9	161.7	100.0
TOTAL	700.2	85.6	118.1	14.4	818.3	100.0

SOURCE: *Mergers & Acquisitions, 1988 Almanac and Index* 22 (6 [May/June 1988]): 45 (and previous issues).
NOTE: Values are not disclosed for all investments given in table 2.3. Only transactions that disclose price are included in table 2.4. For further details, see *Mergers & Acquisitions* magazine.

mium for U.S. acquisitions—judging an asset by its long-run prospective return, not by its ability to turn over a quick profit.[29]

Unilever, the world's largest consumer products company, illustrates the interest in large U.S. acquisitions by established non-American multinationals. The Anglo-Dutch company dominates the global market for a wide range of products used daily by millions of consumers, including well-known brand names like Lipton's soup and tea and Lever Brothers' soaps and detergents. But until recently, the consumer products giant was considered a corporate dinosaur, a "relic of the age of empire,"[30] a stodgy image that would change as the company embarked on a direct takeover assault in the United States. Unilever raised a lot of eyebrows in 1978 when it bought National Starch and Chemical of New Jersey for $484 million. While foreign takeovers of that magnitude were rare, this transaction was measly compared with the company's $3.1 billion purchase of Chesebrough-Pond's in 1987.

When Unilever bought Chesebrough-Pond's, the foreign company "saved" the American company from an unsolicited bid by American Brands; it was a friendly suitor, a "white knight," to use the Wall Street jargon. But not all foreign takeovers are friendly acquisitions by old-guard multinationals—far from it. A new breed of foreign takeover artist emerged in the 1980s, responsible for enormous hostile acquisitions of U.S. companies. It's not, as some members of Congress suspect,

39

TABLE 2.5

The Largest Foreign Acquisitions 1979–88

Buyer	Acquisition	Date	Price (Billions)
British Petroleum (United Kingdom)	45% of Standard Oil	1987	$7.6
Campeau (Canada)	Federated Department Stores	1988	6.6
Grand Metropolitan (United Kingdom)	Pillsbury	1988	5.7
Royal Dutch/Shell (Netherlands)	30.5% of Shell Oil	1985	5.7
B.A.T (United Kingdom)	Farmers Group	1988	5.2
Royal Dutch/Shell (Netherlands)	Belridge Oil	1979	3.7
Campeau (Canada)	Allied Stores	1986	3.6
Unilever (Netherlands)	Cheseborough-Pond's	1987	3.1
News Corporation (Australia)	Triangle Publications	1988	3.0
Nestlé (Switzerland)	Carnation	1985	2.9
Hoechst (West Germany)	Celanese Corp.	1986	2.8
Maxwell (United Kingdom)	Macmillan	1988	2.6
Broken Hill Proprietary (Australia)	Utah International	1984	2.6
Seagram (Canada)	21% of E. I. du Pont de Nemours	1981	2.6
Bridgestone (Japan)	Firestone Tire and Rubber	1988	2.6
Seibu/Saison Group (Japan)	Intercontinental Hotel	1988	2.6
Kuwait Petroleum (Kuwait)	Santa Fe International	1981	2.5
Société Nationale Elf Acquitaine (France)	Texasgulf	1981	2.5
Sony (Japan)	CBS Records	1987	2.0
Hanson Trust (United Kingdom)	Kidde	1987	1.8
Beazer (United Kingdom)	Koppers	1988	1.7
Consolidated Gold Fields (United Kingdom)	Newmont Mining (increased stake to 49.7%)	1987	1.6
Montedison (Italy)	Increased equity in Himont	1987	1.5
Blue Arrow (United Kingdom)	Manpower	1987	1.3
Pechiney (France)	Triangle Industries	1988	1.3
Grand Metropolitan (United Kingdom)	Heublein	1987	1.1
Jefferson Smurfit (Ireland)	Container Corporation of America	1986	1.1
Nippon Mining (Japan)	Gould	1988	1.1
L'Air Liquide (France)	Big Three Industries	1987	1.0

that these upstarts are enemies of Uncle Sam, working out an insidious plot to seize national treasures and sensitive military technology. Rather, they are adversaries of the corporate status quo.

These new foreign acquisitors—the "impatient capitalists"—hunt America for companies they deem undervalued. In their raids on American companies, they have been known to wield the same weapons of "creative finance" used by American counterparts like T. Boone

Pickens, Saul P. Steinberg, and Carl C. Icahn: that is, they use a variety of debt instruments like *junk bonds* (high-risk, high-interest bonds and notes of low-grade quality) to raise the funds needed to complete their buyout. With junk financing, the buyer need not put up its own cash but, instead, often forms a partnership with a New York investment bank such as Drexel Burnham Lambert or Morgan Stanley. The foreign raider and the investment bank create a paper company (like JSC/MS Holdings, the limited partnership between Jefferson Smurfit and Morgan Stanley). As passive investor, the investment bank's role is to get commitments from hundreds of corporate and individual investors to buy junk bonds to finance the takeover. For its part, the raider presents its offer to stockholders and management of the targeted American company and begins a process of negotiation over price and terms. If the takeover is unfriendly, a fierce battle ensues in corporate board rooms and may drag through the courts for months. When a foreign raider successfully takes over the American company, it may quickly divest the subsidiary's assets. It sells off units and uses the proceeds to buy still other companies or to reduce the often-large debt incurred in making the acquisition in the first place. Even when a raider company fails to snare its target, it may profit handsomely through *greenmail*, stock repurchase deals reluctantly offered at premium prices by frightened managers.

One of the most active foreign raiders is Sir James Goldsmith. A restive, globe-trotting tycoon, Goldsmith seldom spends over a month in one place; his business deals are channeled through a maze of European, Latin American, and Far Eastern holding companies, mostly controlled by the mysterious-sounding Brunneria Foundation. He first entered the United States in 1973 by acquiring the languishing Grand Union supermarket chain for $62 million. Nine years later, he purchased Diamond International for over ten times what he paid for Grand Union. (He promptly sold off Diamond International's manufacturing units and kept its 1.7 million acres of timberland.) A deft greenmailer, he profited from the difference between what he paid for a block of stock and what he was paid for selling it back to a company's managers. These profits give him an ever-accumulating mass of funds to be used in the next raid.

In 1985, Goldsmith attended the infamous Predators' Ball—the Drexel High Yield Bond Conference. This gathering of financiers and impatient capitalists was sponsored in Beverly Hills, California, by the junk-bond impresario Michael Milken. Before Milken was indicted for insider trading in 1988, he presided over an extended merger and acqui-

sition empire that attracted many would-be raiders from around the country and across the globe. Shortly after the Predators' Ball, Milken's junk bonds leveraged Goldsmith's $1.1-billion hostile raid on Crown Zellerbach, a San Francisco-based paper and forest products company. (Again, Goldsmith dismantled the company, selling it off in pieces, keeping only the 1.9 million acres of timberland.)

In 1986, he entered Ohio, this time stalking much bigger game— Goodyear Tire and Rubber, the thirty-fifth largest company in America. This time the prey struck back: Goodyear mounted a massive campaign in Ohio and Washington against the $5 billion hostile bid. Goodyear supporters castigated Goldsmith for attempting to ruin a cherished midwestern "institution" about which he knew little. At hearings before the U.S. Congress, some of the company's partisans depicted Goldsmith as "a most serious threat to the future of Ohio."[31] In the end, Goodyear fought the offer through defensive restructuring and by accumulating a war chest to fight Goldsmith; in so doing, the company more than doubled its debt.* Meanwhile, Goldsmith, who had amassed 12 million shares of Goodyear stock, sold it back to the company in a greenmail bargain that netted him a $90-million profit.

No foreign takeover artists, however, are more doggedly pursuing acquisitions in America than Goldsmith's good friends from Yorkshire, Lord James Hanson and Sir Gordon White, who have transformed Hanson Trust into one of Europe's foremost holding companies.† In 1986, the company paid $930 million for SCM, which produces Smith-Corona typewriters, chemicals, and food products, after a fierce legal battle waged by the corporate management to ward off the invaders. Within a year, Hanson had discarded several units of SCM for more than the cost of the whole package; thus, the British acquired the remaining units for nothing and made a multimillion-dollar profit. That deal was topped the next year with an unsolicited $1.8-billion bid for Kidde, Inc., manufacturer of Jacuzzi spas, universal gym equipment, Farberware pots and pans, fire extinguishers, and other low-tech products. In all, Hanson's buying binge has given the company an American asset col-

* To work its way out of this financial squeeze, Goodyear sold its energy unit, Celeron, to Exxon for $650 million. Celeron was the centerpiece of Goodyear's strategy to diversify its operations and place less reliance on the highly cyclical auto markets. Thus, in order to ward off this hostile foreign takeover, Goodyear abandoned its long-term plan. The legislature of Ohio enacted antitakeover legislation to keep this from happening again.[32]

† A *holding company* is a corporation that owns a majority of the stock of another company or possesses sufficient amounts of the voting stock to exert effective control.

lection valued at over $10 billion, even after many units have been sold off.

Canadians also play the hostile takeover game. The top Canadian raiders are the Belzberg brothers and Robert Campeau. The Belzbergs (Samuel, William, and Hyman) transformed a furniture store business into a diversified, multibillion-dollar Canadian empire. In the 1980s, the Canadian kin joined Drexel Burnham Lambert and Michael Milken's extended family of corporate raiders and junk-bond investors. Along with Sir James Goldsmith, they attended the Predators' Ball[33] and, backed by Drexel, made millions of dollars greenmailing Ashland Oil and other U.S. companies. And when they actually took over a company, the Belzbergs proved to be as good at "asset stripping" as Hanson Trust. In 1985, they acquired Scovill, best known for Yale locks and Hamilton Beach mixers, in a $540-million deal that was the boldest attempt by the "Calgary pirates" to emerge from smaller lagoons of regionally based enterprise into the riskier waters of international capital. Within a short period, they sold off most of Scovill's units for $716 million, keeping only a zipper company.

The French-Canadian financier Robert Campeau has surfaced as his nation's most brazen global raider. Despite his blue-collar rather than blue-blood roots, Campeau transformed a real estate and construction company into a powerhouse of Canadian capital in the 1960s and 1970s. His ultimate ambition was to create an international empire. In one of the largest hostile acquisitions ever, Campeau seized Allied Stores, which owned Brooks Brothers, Ann Taylor, and a host of other department and specialty stores in 1986. Two years later came his record-setting $6.6-billion buyout of the nation's fifth largest retailer, Federated Department Stores, a deal that proved to be one of the most complicated takeover battles of the 1980s and the largest merger in U.S. history outside of the oil industry.[34] (See chapter 5 for more on Campeau's moves into U.S. retailing.)

Only a limited number of acquisitions have been hostile, but they have been among the most significant. In fact, foreign companies stood out in a September 1987 *Fortune* rating of takeover artists in the 1980s. The criteria for rating these "financial sharks" were credibility, financial clout, aggressiveness, and success in making money. Sharks who "nibbled and ran" got one "fin"; "drawing first blood" received two fins; three were awarded for "taking big bites"; and four for "swallowing companies." The list of the twelve biggest sharks included four foreigners. The Canadian Belzberg Brothers got one fin. Robert Holmes à

Court of Australia got two and a half. Britain's Sir James Goldsmith and Sir Gordon White took top honors with four fins, being matched by only Carl Icahn among the Americans. Given the scale of the takeover game in the United States, the fact that four of twelve of the top raiders were foreigners is surprising. Robert Campeau would surely get four fins if the ratings were tallied in 1988.

The Japanese, who are conspicuously absent from this school of sharks, remain the quintessential patient capitalists. When they buy into the United States, the Japanese prefer building from the ground up rather than raiding U.S. corporations. Of all announced new plant investments between 1979 and 1986, for example, the Japanese accounted for 24 percent, but were responsible for only 8 percent of all acquisitions and mergers. Of all major investor sources, only the Japanese announced more new plants than acquisitions during the period.[35] Moreover, although the Japanese appetite for takeovers is stronger than ever—rising from a few hundred million dollars per year in the early 1980s to several billion per year by mid-decade—most Japanese investors carefully chose their targets, with their sights always fixed on the long run. By and large, the Japanese view unfriendly takeovers with contempt. In principle, the Japanese corporation is run like a family, not a "collection of equipment and people linked by a company name"[36]—an attitude that surfaces in their acquisitions of large U.S. companies. For example, when Bridgestone fought off Italy's Pirelli for control of Firestone, its moves were in full agreement with the objectives of American management. Even in Fujitsu's controversial pursuit of Fairchild in 1986, the target company's management openly solicited the Japanese bid.

With a pile of surplus capital, a strong yen, and a depressed stock market in the United States, however, a new breed of Japanese predator may yet join the Canadians and British. Dainippon Ink and Chemicals' bid for Sun Chemical in 1987 was unwelcome, as was its acquisition of Reichhold Chemicals that same year. The most portentous sign of the rise of Japanese predator capitalism came in 1988, when Nomura Securities, the world's largest brokerage house, bought into a new investment firm started by the merger-and-acquisition masters Bruce Wasserstein and Joseph Perella. (Wasserstein-Perella handled Robert Campeau's multibillion-dollar purchase of Federated Department Stores, among other deals of the late 1980s). Chief among Nomura's goals in linking up with Wasserstein and Perella are to assist Japanese clients in acquiring U.S. companies and to channel trillions of yen into greater yielding American assets. Shortly after the deal, Nomura was reportedly sending employees to the United States to become thoroughly familiar with

merger and acquisition tactics.[37] But to date, Japanese capitalists have been among the most careful, even hesitant of all foreign acquisitors.

What Foreign Companies Buy

Foreigners are acquiring a bewildering array of American assets: skyscrapers, gambling casinos, gold mines, golf courses, vineyards, steel mills, chemical plants, supermarkets, banks, advertising agencies, manpower services, and much more. While the list seems endless, we can identify where foreign firms have bored the deepest into the U.S. economy by grouping U.S. affiliate assets into five broad categories: manufacturing, services and trade, finance and insurance, real estate, and natural resources.

MANUFACTURING

When it comes to buying American firms, manufacturing matters most to foreign investors.[38] Nearly half of the three million jobs affiliated with foreign companies are found in manufacturing industries. In contrast, all U.S. private firms have only about one in five jobs in manufacturing.*

Today, foreign ownership of U.S. manufacturing appears to be as large as, if not larger than, at any time in U.S. history.† In 1986, foreign firms controlled 7.8 percent of all U.S. manufacturing jobs—over twice the total share of U.S. employment accounted for by FDIUS (3.5 percent). The foreign share of total manufacturing sales is even higher (almost 10 percent) and higher still when one looks at the share of manufacturing assets (over 12 percent). Foreign control over U.S. manufacturing, however, is highly concentrated in a few key industries, with the greatest stake in chemicals; stone, clay, and glass; primary metals;

* See appendix A for a discussion of data sources. Note that the United Kingdom, Canada, Continental Europe, and Japan are again the major bases of manufacturing investment. Coincidentally, the source country distribution of manufacturing is an almost exact mirror of the distribution given for total FDIUS, the coefficient of correlation being a nearly perfect 0.997. Thus, the world map of FDIUS sources provides as good an indication of manufacturing sources as it does for total direct investment.

† Although precise comparisons are not possible, according to the best historical estimates foreign manufacturing peaked just before the First World War at about 6.2 percent of total U.S. assets. Two economic historians note that the early figures on manufacturing assets "are not purely for manufacturing and are not complete, so this is a minimum estimate."[39] The same could be said about current data.

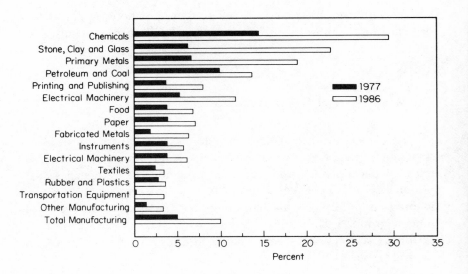

FIGURE 2.3

Foreign Companies as a Percentage of all U.S. Manufacturing Sales.

SOURCE: U.S. Department of Commerce. See Ned G. Howenstine, "U.S. Affiliates of Foreign Companies: Operations in 1986," *Survey of Current Business*, May 1988, table 4, p. 64.

printing and publishing; electronics; and food processing (see figures 2.3 and 2.4).

Chemicals. No other major U.S. industry has been "bought out" to the extent of chemicals. In 1986, foreign firms employed 37 percent of all U.S. chemical workers, owned 33 percent of the assets, and enjoyed 30 percent of U.S. sales. These figures include the Canadian Seagram company's 21-percent stake in Du Pont. Most significant, however, is the extent of European control over the industry. As is true in most industries, the British are the major investors. The British employ almost 90,000 U.S. chemical workers, over a fifth of whom work for Imperial Chemical Industries (ICI). The West Germans follow, with over 60,000 workers. Every leading German chemical company has set up operations in America.

Indeed, the resurgence of West German chemical manufacturing in the United States is one of the most engaging tales in the whole chronicle of alien ownership in America. Although the U.S. government confiscated Germany's chemical assets during the First World War and the colossal chemical cartel I. G. Farben was dismembered following the Second World War, I. G. Farben's successors—Hoechst, BASF, and Bayer—have emerged stronger than ever. These companies exemplify

46

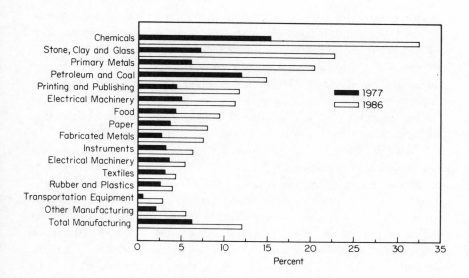

FIGURE 2.4

U.S. Affiliates as a Percentage of all U.S. Manufacturing Assets.

SOURCE: U.S. Department of Commerce. See Ned G. Howenstine, "U.S. Affiliates of Foreign Compa-
nies: Operations in 1986," *Survey of Current Business*, May 1988, table 4, p. 64.

the patient foreign enterprise we described earlier. Says Harvard Busi-
ness School professor Joseph Bower, "While U.S. companies have either
sold off or abandoned large pieces of the chemical business, German
companies have pursued systematic strategies that are long term and
global."[40] The German chemical firms have a good portion of their
investment in pharmaceuticals.* They are joined by Switzerland's Ciba-
Geigy, Sandoz, and Hoffman-LaRoche.[41]

Stone, Clay, and Glass. According to government statistics, the sec-
ond most significant area of foreign manufacturing investment—stone,
clay, and glass products—is well below the chemical industry. About 12
percent of the U.S. workforce in this industry was foreign-controlled
during 1986 (although foreigners held about 23 percent of the industry's
assets and 20 percent of all sales). Yet within this broad industry is

* Also in the vanguard of a European raid on American chemical businesses in 1986,
L'Air Liquide paid over a billion dollars for Big Three Industries, another chemical
concern. Akzo, a Dutch chemical MNC, lost out to Britain's ICI in the bidding
for Beatrice's chemical units in 1985. Undaunted, Akzo bought a plant from Monsanto
in 1986. All the Swiss firms have investments in the United States. Sandoz, for example,
runs large pharmaceutical subsidiaries out of New York and New Jersey; recent acqui-
sitions are strewn from Charlotte, North Carolina, to Minneapolis, Idaho Falls, and
Palo Alto. Other large investments have been made by Italy's Montedison and France's
Rhône-Poulenc.

cement production, more than half of which is controlled by foreigners.* The foreign foothold in U.S. cement primarily results from large acquisitions by France's Lafarge Coppée Group, which bought 58 percent of Lafarge Corporation (the second largest American cement maker) and Switzerland's Holderbank, which includes major stakes in Ideal Basic and Dundee Cement. The Japanese began to solidify a position in the industry when Mitsubishi Mining and Cement bought two California plants from Britain's Hanson Trust in early 1988.

Of all the foreign acquisitions in the construction material (or "aggregates") industry during the latter half of the 1980s, the most controversial was Beazer's $1.7 billion unfriendly takeover of Koppers, a diversified building materials supplier and chemical company headquartered in Pittsburgh. The British company seized Koppers in a highly leveraged deal made possible by the financial backing of Wall Street's Shearson Lehman Hutton. As was often the case in such raids, the deal hinged on immediately selling off some of Koppers' assets, some of which went to other British firms trying to penetrate the industry, others to U.S. firms.

Primary Metals: Foreigners are also establishing a significant position in America's foundry, the primary metals industry. The foreign share of the industry encompassed one-fifth of the U.S. workforce in 1986. This is one area dominated by Japanese investors, global leaders in primary metals. The Japanese employed 27,000 American workers in the industry during 1986, far more than any other foreign source.

Japanese investors are especially attracted to U.S. steel making. Auburn Steel, a producer of construction-related bars which began operation in the late 1970s, was the first Japanese-owned U.S. mill. Further investments followed in the 1980s, often through joint ventures with ailing U.S. steel companies. Japan's second largest steel maker, Nippon Kokan, allied with America's National Intergroup to run the seventh largest American producer, National Steel. There is no indication that the Japanese penetration of the U.S. steel industry will slow down any time soon. In 1988, National Intergroup planned to abandon steel production altogether by selling its remaining interest in National Steel to its Japanese partner. (Nippon Steel has also bought aluminum and titanium alloy facilities from Martin Marietta.) Nippon Steel, the largest steel company in the world, formed a joint venture with Inland Steel in 1987. Using advanced technology developed by Nippon Steel, a

* Foreigners have taken control of 51 percent of the U.S. cement industry, according to William Toal, an economist at the Portland Cement Association.[42] More recent reports put the foreign stake in the U.S. cement industry at 55 percent.[43]

new plant in Indiana is slated to open in 1990.[44]* By the end of 1988, there were eight Japanese-American joint ventures, with the Japanese generally supplying the steel technology. Many of these operations sold steel to Japanese auto plants in the United States.

Printing and Publishing: Foreign investment in printing and publishing, another area of heavy penetration that shows little sign of abating, reached nearly 12 percent of both U.S. assets and sales and 6 percent of employment in 1986. Most of the investment takes place through global media companies, whose activities span both manufacturing and service operations.

Because publishers and other media companies serve as gatekeepers of knowledge and can potentially steer American public opinion, increased external control over the nation's industry may encounter some resistance. So far, however, many media enterprises welcome foreign capital and, in fact, remain largely unchanged, both in style and content, under new foreign ownership. *Ms.* magazine, a leading organ of the American women's movement since the early 1970s, kept its editorial policy intact after it was sold in 1987 to a large Australian publisher. Following the sale, Gloria Steinem, one of the publication's co-founders, expressed nothing but praise for John Fairfax Ltd., *Ms.*'s suitor from "down under." "This is an opportunity for the magazine to grow," she said. "*Ms.* has been extraordinarily influential in this country over the last 15 years, but we've done it on very little money. This will be a very important and helpful change for the magazine."[45]

British and Canadian firms have traditionally held the largest position in U.S. printing and publishing. The British media baron Robert Maxwell now contends that he is America's second largest printer. Maxwell's British Publishing and Communications had become a major force in the global media industry, but by mid-1988, he had yet to snare a major U.S. publishing house. Harcourt Brace Jovanovich, a leading American publisher, defeated Maxwell's $1.7-billion takeover bid in 1987; but to maintain independence, the publishing house had to "recapitalize"— that is, it tripled its debt and sold off profitable magazine and school-supply subsidiaries. The next year Maxwell tendered an offer to buy another major publishing and information corporation, Macmillan, for $2.3 billion. At first, he was repelled by the U.S. company's management, who tried to restructure the company through a leveraged buyout with

* While we will return to foreign investment in steel in chapter 5, we note here that Nippon Steel held a 5 percent interest and Mitusi a 45-percent stake in Alumax, a major U.S. aluminum company; but they sold out the U.S. interests in 1986.

Kohlberg, Kravis, and Roberts.* Maxwell then sweetened his offer, and the battle for Macmillan dragged on into the fall of 1988.

Macmillan used every known defense in the hostile takeover game —a "golden parachute" plan for executives, a "poison pill" that would dilute the stock holdings of any acquirer, and more. It searched for a "white knight," but finally surrendered to Maxwell. Lest it appear that Maxwell is universally viewed as an unwelcome suitor in America, however, it should be noted that one company, Worlco, actually attempted to force itself into the hands of the British investor. Worlco, which provides data services to media companies, sued Maxwell Communications in 1988, not over the pursuit of a hostile acquisition, but rather over Maxwell's alleged *breaching* of an acquisition deal in which he no longer had any interest.

In publishing, West Germans and French investors are as aggressive as Maxwell. Indeed, two venerable German and French publishing houses are engaged in a fierce battle for supremacy in global media, and the rivalry has spread to the United States. Germany's 153-year-old Bertelsmann, now the world's largest publisher, is also the second largest in the United States thanks to its 1981 purchase of Bantam and its 1986 takeover of Doubleday. In 1986, Bertelsmann also bought RCA records. France's 162-year-old Hachette (which once employed Emile Zola) followed suit two years later by acquiring Grolier and Diamandis Communications, moves that thrust Hachette forth as the world's biggest publisher of encyclopedias and magazines. The French company's U.S. interests also include *Woman's Day, Elle,* and *Premiere* magazines, the latter jointly owned by Rupert Murdoch's Australian-based News Corporation.

For his part, Murdoch publishes over twenty magazines in the United States and owns the book publisher Harper & Row. He has also built one of the nation's largest media empires by acquiring Twentieth Century Fox Film Corporation and seven major television stations and by starting the Fox broadcasting network. Murdoch's biggest single acquisition came in 1988 with the $3-billion buyout of Triangle Publications, best known for publishing *TV Guide*.[46]

* In a leveraged buyout (LBO), a small band of investors, which typically includes a company's top executives, buys out most outstanding shares from public stockholders. To accomplish the acquisition, the investor group borrows (leverages) against the company's assets and then repays the debt with cash from the company or from the sale of its assets. Thus, in exchange for putting up 10 percent or less of the shares' purchase price, top management and a few outside investors become owners of the company. They succeed if they can quickly reduce the heavy debt; if they cannot, then budgets are slashed, payroll is cut, and, in some cases, bankruptcy ensues.

Electronics: The foreign share of electronics assets falls slightly below printing and publishing (see figure 2.4). But with over 220,000 jobs—or 10 percent of all U.S. electronics workers—non-American MNCs hire more U.S. workers than in any other major sector outside the chemical industry.

Most of the electronics investment stems from European companies. All the large European electronics multinationals—Britain's Plessey, Sweden's Electrolux, France's Thomson, Germany's Siemens, and the Netherlands' Philips—have major investments in the United States. Through its strong penetration of the consumer electronics market, Philips ranks as one of the most expansionist multinational challengers in this country. (Philips's U.S. operations include, among others, Magnavox, Norelco, Sylvania, and Philco.) Oddly, until 1987 the firm did not own 42 percent of its main U.S. subsidiary, North American Philips. Then, in a move designed to gain greater control over its U.S. operations and achieve more thorough worldwide integration of its operations, the parent company spent $610 million to get the shares it did not own in 1987.[47] Earlier that same year, France's Thomson entered the electronics war by acquiring General Electric's consumer electronics division. Meanwhile, Siemens USA's 25,000 employees produce a range of high-technology products, including telecommunications, fiber optics, medical systems, factory automation, and power generation. Electrolux employs about the same number of U.S. electronics workers as Siemens, largely as a result of its 1986 takeover of Cleveland-based White Consolidated Industries. By acquiring White Consolidated's lines (Frigidaire, Kelvinator, Westinghouse appliances, and Gibson), the Swedish company became the world's largest home-appliance maker.[48]

Far behind, Japan's electronics MNCs employed only 11,000 workers in 1986, but are continually expanding across the spectrum of the industry. Reflecting their leading position in international trade, Sony, Matsushita Electric, Sanyo, Mitsubishi Electric, Sharp, Toshiba, and Hitachi have color television plants in the United States; while Matsushita Electric, Sanyo, Sharp, and Toshiba assemble microwave ovens. At the high-tech end of the industry, all the major Japanese semiconductor producers—Fujitsu, Hitachi, NEC, and Toshiba—have manufacturing facilities in the United States. In addition, Fujitsu carries a 48-percent share of Amdahl, a mainframe computer maker; and Kyocera International manufactures technically advanced ceramic products for electronic components.

Food Processing: The next largest target of manufacturing FDIUS is food processing and kindred products (including alcoholic and non-

alcoholic beverages). While foreign investors' assets and sales are below the average penetration for manufacturing as a whole, foreign food manufacturers accounted for about 10 percent of all U.S. employment in the industry during 1986, above the 7.8 percent share of total manufacturing employment.

Food processing was one of the original areas of foreign involvement in U.S. manufacturing, in part because food is perishable and processing facilities are best located close to the final market. In the late 1880s, British acquisitions grew so large they provoked what one historian described as a "roar of protest among westerners."[49] We noted earlier that the British also held a tremendous interest in the alcoholic beverage industry until it was thwarted by Prohibition. Today, British firms still invest heavily in U.S. food processing and related industries. In 1986, British food processors employed 74,000 U.S. workers, 46 percent of all affiliate employment in that sector. Today's holdings include all-American staples like Arnold bread and Ball Park Franks (owned by Hanson Trust's Hygrade unit). And the British drive to penetrate the American food and drink industry grows larger every year.

One of the hottest areas is distilled spirits, dominated today by London-based Grand Metropolitan, the world's largest purveyor of wine and liquor. In 1987, Grand Metropolitan paid over a billion dollars for Heublein, which makes almost one hundred kinds of alcoholic beverages, including Smirnoff vodka, José Cuevo tequila, and Inglenook and Almadén wine. Grand Metropolitan's biggest move into the U.S. food industry came in 1988, when it used the proceeds from the sale of its Inter-Continental Hotel chain (to a Japanese investor) to swallow Pillsbury, an archetypical American-as-apple-pie company (besides Pillsbury flour, brands include Green Giant, Bumble Bee Seafood, and Burger King restaurants). The $5.7 billion unsolicited takeover bid was just completed at the time of this writing, but Grand Metropolitan's chief executive made his company's intentions transparent: "With Pillsbury, we plan to be not only one of the world's leading drinks companies in the 1990s, but also one of the world's greatest food companies and leading retailing companies."[50]

Grand Metropolitan faces stiff competition in America—from non-American companies. One of the nation's largest brewers is Australia's Bond, which bought Heileman (Schmidt, Iron City, Lone Star brands) in 1987. Another one of Grand Metropolitan's rivals in America is France's Pernod Ricard, whose U.S. subsidiary is best known for making Wild Turkey bourbon (and even Yoo-Hoo chocolate drink). And the largest of Grand Metropolitan's major competitors in the U.S. liquor

market is Seagram, Canada's large alcoholic beverage company which, as we have already seen, also has a major interest in Du Pont. Recently, Seagram has branched out into other food and beverages niches, as we shall discuss in the next chapter.

In another big takeover in the food industry, British Petroleum (BP) acquired Purina Mills, the animal feed producer, for $500 million dollars in 1986. But BP's deal was chicken feed compared with the $3-billion acquisition of Carnation Foods a year earlier by the world's largest food company, Switzerland's Nestlé.*

Once again, though the Japanese lag behind the Europeans and Canadians, they are moving quickly through takeovers and new plants. After years of listening to U.S. complaints about how they protect their own food industry from cheaper foreign imports, the Japanese took steps to liberalize the market in 1988. At the same time, Japanese multinationals have scoured America for food-industry acquisitions. In 1987, Naigai Chikusan bought 50 percent of Colonial Beef. The next year, Zennoh (a unit of Japan's National Federation of Agricultural Cooperative Associations) combined forces with C. Itoh to buy Consolidated Grain and Barge—a takeover that gave the Japanese control over thirty-three grain elevators and transport facilities in the Midwest. Other Japanese investors search the United States for new plant sites, following the lead of Kikkoman. Founded in 1661, Kikkoman has been called the world's oldest continuously operating company, and markets the only traditional Japanese product (soy sauce) that has a world market.[52] Since 1972, Kikkoman's soy sauce factory in Walworth, Wisconsin, has been one of the few Japanese food-processing plants on U.S. soil. It is no longer alone. Kagome, for example, established a tomato-processing plant in California; and Glico Dairy, a large Japanese milk company, built a grapefruit-processing plant in Florida. Japanese investment in the wine and beverage industry is also growing rapidly,[53] as are exports of food products from the United States to Japan.

Other Manufacturing Industries: While so far we have discussed the manufacturing sectors where foreign firms have their deepest penetration in U.S. production, many other manufacturing industries have witnessed considerable foreign involvement. France's Michelin, for exam-

* Nestlé is the largest food company only when measured against other multinationals' food product lines, not their total sales; 95 percent of Nestlé's sales are related to food. In addition to Carnation, the company owns the Cleveland-based Stouffer Corporation (the restaurant and frozen-food company), Beech-Nut (the baby-food and dietary-product concern), and Hills Brothers Coffee.[51]

ple, began investing in U.S. rubber and tire making during the 1970s and continued to add to its American production capacity during the 1980s. Despite Sir James Goldsmith's failed attempt to take over Goodyear, Michelin now faces intense competition from other foreign producers, including Continental of West Germany and Sumitomo Rubber of Japan. But the boldest move by a non-American company in the rubber and tire industry came when Japan's Bridgestone bought 75 percent of Firestone Rubber in 1988, one of the largest acquisitions by a Japanese company. As an executive of Goodyear, the last major United States–based tire maker, observed, "Everyone wants a piece of the U.S.A."[54]

This statement certainly applies to Japanese auto companies, which we take up in detail elsewhere in this book. Note, however, that government data on direct investment in the transportation industry understate the true extent of foreign ownership (see figures 2.3 and 2.4). The Bureau of Economic Analysis classifies under wholesale trade most of the Japanese auto industry's direct investment. If the published statistics are to be believed, then total foreign investment in transportation equipment, which includes major auto, truck, bus, and rail plants, amounted to no more than 3 percent of the U.S. industry's employment in 1986. No doubt we would find that the figure was much higher if we could only disentangle the government's statistics.*

We do know, however, that Japanese auto companies had no plants in the United States at the beginning of the 1980s—not a single car was produced on American soil; yet by the end of the decade, they had 8 major assembly plants and a network of over 200 auto-parts suppliers. In 1990, the "American division" of the Japanese auto industry, which includes joint ventures with U.S. producers, will produce about 1.5 million cars, trucks, and vans, or about 10 percent of U.S. production.[55] Among the joint ventures between American and Japanese auto makers (Toyota-General Motors, Mitsubishi-Chrysler, Mazda-Ford, and Nissan-Ford), all are managed by the Japanese, with the exception of the Nissan-Ford minivan venture announced in 1988.

* The Bureau of Economic Analysis classifies Japanese automobile investment under wholesale trade because the original Japanese investment in the auto industry came through wholesaling, not manufacturing. The government continues to consider wholesaling to be the major activity of the Japanese auto makers and lumps its manufacturing operations under this category. The BEA's understatement of Japanese employment affects the electronics sector as well: Matsushita Electric, for instance, employs about 8,000 U.S. workers, but the reported amount of employment by Japanese companies in electrical equipment was only about 11,000 in 1986. See appendix A for a further discussion of these problems.

SERVICES AND TRADE

Difficult as it is to measure the extent of foreign ownership in manufacturing, the problems multiply in nonmanufacturing industries (trade and services). Government statistics do not allow for an accurate assessment of foreign-owned assets or sales in nonmanufacturing sectors. Nevertheless, the New York investment bank Morgan Stanley recently calculated the foreign position in U.S. capital stock for both manufacturing and nonmanufacturing industries, and found that the total stock of America's fixed capital owned by non-American companies rose rapidly during the 1980s, reaching 6.1 percent by the end of 1987.[56] Further, Morgan Stanley determined that the manufacturing share of domestic capital outstripped nonmanufacturing. The foreign share hovered in the range of 2 percent to 3 percent until it shot up after 1980. Direct investment in manufacturing grew to 10 percent of capital stock in 1987. Yet the share of U.S. stock owned by foreigners in nonmanufacturing industries remained below 6 percent in 1987 (see figure 2.5).

Still, many service and trade businesses have become increasingly globalized. In turn, foreign direct investment in nonmanufacturing, as in manufacturing, swelled in the 1980s. European, Japanese, and Canadian firms now challenge U.S. firms in many sectors, ranging from janitorial services to wholesale trade.

British investors have led the recent charge into American services.

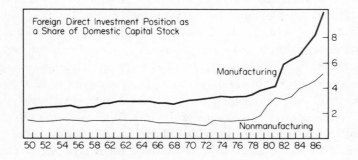

FIGURE 2.5
Foreign Ownership of American Capital.

NOTE: Capital stock data are current-cost net stocks for the private nonresidential sector. The direct investment position is defined in appendix A.
SOURCE: Stephen S. Roach, "Hooked on Foreign Investment," *Morgan Stanley Special Economic Study*, 13 April 1988, p. 5.

For instance, advertising was once a secure domain of U.S. business, but is no longer, thanks to several large takeovers on Madison Avenue by London-based multinationals. The reigning British advertising agency, Saatchi & Saatchi (S&S), is now the world's largest, owing to several large U.S. takeovers. The ascendancy of S&S in America is astounding, especially when you consider that the firm only started in 1970. It began to take off following a merger with Compton Communications, an American agency, in 1982. In the summer of 1986, S&S seized the Madison Avenue titan Ted Bates Worldwide for $450 million. The following year, Britain's WPP Group, headed by the tireless takeover artist Martin Sorrell, paid out $550 million to acquire America's fourth largest advertising agency—the JWT Group. JWT is the corporate parent of the venerable advertising firms, J. Walter Thompson and Lord Geller.

Hostile British raids by S&S, Sorrell, and others have stunned the U.S. advertising industry. Alarm first spread when S&S began its restructuring of Ted Bates, firing the chief executive officer and other top brass. In 1988, tension between British owners and Madison Avenue managers reached a crisis point. Following a bitter disagreement with Sorrell's global restructuring plan, Lord Geller's top executives stormed out and formed their own firm. Never before has the U.S. advertising industry been in so much chaos.

British companies have acquired a range of other prominent U.S. service businesses. Manpower, Inc., the largest U.S. temporary help agency, is now in the hands of Blue Arrow, following a successful battle waged by another British takeover artist, Anthony Berry. The $1.3 billion takeover pushed Blue Arrow to first place in global employment services. The Hawley Group, run by yet another British raider, Michael Aschcroft, bought out ADT, the leading American supplier of electronic security systems. These investors are joined by other European firms like ISS of Denmark, a global janitorial service concern which now employs 16,000 Americans.[57] Not to be outdone, Japanese service firms scout new prospects for direct investment as well. Already active are Japan's global construction contractors—Shimizu, Kajima, Takenaka, and Ohbayashi—many of which get the contracts to build Japan's new manufacturing plants in the United States. Kajima won the contract to build the Greater Los Angeles World Trade Center in Long Beach, California.

Direct investment in retail and wholesale trade remains, considerably larger than in most other services. According to the Bureau of Economic Analysis, about 580,000 U.S. citizens worked for foreign-owned retail trade subsidiaries in 1986; 10 percent of all U.S. employees in the sector were on foreign payrolls. And the foreign share is rising.

Indeed, U.S. retail companies have seen some of the biggest foreign takeovers in recent years. One major department store chain, Marshall Field, merged with Batus, the Louisville-based arm of Britain's B.A.T, after the New York raider Carl Icahn launched a hostile takeover. The largest retail investments came in 1986 when Canada's Campeau acquired Allied, and again in 1988 with Campeau's acquisition of Federated, two takeovers that alone amounted to more than $10 billion. Foreigners also favor American supermarket chains: investments include Grand Union, Great A&P, and BI-LO. The Belgian Delhaize company owns Food Giant and Big Apple, and holds a majority stake in Food Lion, America's fastest-growing supermarket chain in 1988.[58]

Approximately 300,000 U.S. citizens, about one out of every twenty in the industry, worked for foreign wholesalers in 1986. These wholesale subsidiaries are significant because they are linked to foreign trade. Not surprisingly, Japanese investment is unusually strong, accounting for one-third of wholesale affiliate employment, many times their share of total U.S. jobs.* Notably, the "neomercantilist" Japanese have used wholesale distribution affiliates to bolster their exports of cars, televisions, and other goods.

Not all Japan's wholesale subsidiaries are limited to exporting goods to the United States, however. Mitsubishi International is actually one of the largest firms servicing exports *from* America. Mitsubishi, along with C. Itoh and Mitsui, is a large global trading company known in Japan as *sogo shosha*. The *sogo shosha*, which have been leading Japanese trade expansion since Commodore Perry sailed into Tokyo Bay in 1853, are now the leading edge of trade expansion in the United States. Mitsubishi International accounts for $9 billion worth of annual trade to and from the United States.[59]

FINANCE AND INSURANCE

Foreign involvement in the strategically important financial system —the nerve center of any economy—is another source of alarm in the late 1980s. Foreigners have had a foothold in America's financial system since early in the nineteenth century, when the Bank of Montreal established an agency in New York. Other foreign banks followed, including Hongkong and Shanghai Banking Corporation (1875), Lloyds Bank International (1886), Barclays Bank International (1890), and Mitsubishi Bank (1920).[60] In one form or another, these banks still operate in the United States today.

* However, as we mentioned earlier, wholesale affiliate employment includes some manufacturing activity (see appendix A).

But, as with manufacturing, the recent concern about foreign investment in U.S. financial institutions stems from the substantial rise of non-American activity since the 1970s. Total U.S. assets of foreign banks increased from $32.3 billion in 1973 to $592.6 billion in 1987, when U.S. offices of foreign banks held 19 percent of total U.S. banking assets and they accounted for more than a quarter of all business loans (see figure 2.6).[61]* Most of the assets are controlled by the branches and agencies of foreign banks. Foreign agencies and branches engage in "wholesale" banking—servicing the U.S. operations of home country industries, financing trade with the home country, or setting up a foreign exchange operation in New York. Agencies differ from branches in that they are not allowed to accept deposits from U.S. citizens and they are exempt from many federal and state banking regulations. Acting as investment outlets for dollar balances accumulating abroad, they are primarily involved in trade financing and foreign exchange transactions. When a foreign bank wants to accept deposits from U.S. citizens and pursue a wider range of wholesale banking activity—lending to major corporations, for example—it would typically open a branch. Before the passage of the International Banking Act of 1978, both branches and agencies of foreign banks were exempt from federal regulations such as restrictions on interstate banking. The act put foreign and domestic banks on an equal footing, but operations established before 1978 were "grandfathered," and many rushed in before the act was passed.

A foreign bank wishing to offer a full range of banking services in the United States would acquire an existing bank as a subsidiary, although, to date, subsidiaries are not as significant as branches and agencies. But an increasing number of U.S. banks have been acquired by foreign concerns during the 1980s, usually with the approval, if not the encouragement, of the domestic concern. In 1980, Hongkong and Shanghai Banking Corporation courted Buffalo-based Marine Midland, the twelfth largest bank in the United States. When objections to the pending marriage were raised by New York State banking regulators, who feared that the foreigners would funnel funds abroad, Hongkong and Shanghai persuaded Marine Midland to change from a state-charted bank to a federally charted institution. In 1983, another veteran foreign

* About $230 billion of the foreign-controlled assets are booked in international banking facilities, which are not considered part of the U.S. domestic banking system. When these assets are subtracted, foreign investors were left in control of about 13 percent of U.S. banking assets in 1987.

Percent

FIGURE 2.6
Selected Assets and Liabilities of Foreign Banks Share of U.S.
SOURCE: U.S. Federal Reserve Bank.

banker in the United States, the Bank of Montreal, took over Chicago's Harris Bank (ranked thirty-sixth in the United States).

The British, as always, have been active investors in U.S. banking; large holdings are controlled by stalwarts of British finance like Midland Bank (which owned a majority interest in California's Crocker National until it sold out in 1986) and Barclays Bank. Britain's largest bank, National Westminster, has been among the most eager to acquire U.S. banks, beginning with National Bank of North America in 1979. National Westminster's takeover drive accelerated after it purchased First Jersey National Corporation in 1987.

The biggest buyouts of the 1980s, however, have been made by Japanese investors in California, where five of the ten largest banks are Japanese-owned. Mitsui Bank purchased the Los Angeles-based Manufacturers Bank (now Mitsui Manufacturers) and the Bank of Tokyo owns 77 percent of California First, a major U.S. institution with 4,000 employees. In the largest Japanese investment in a U.S. financial institution to date, California First acquired Union Bank from its British owners for $750 million in 1988. Still, the total assets of all the Japanese banks with representation in California amounted to only 62 percent of the assets held by the Bank of America. Says the Stanford finance professor James Van Horne, "By any measure—market share or total assets—it's not

appropriate to say they [the Japanese] dominate the industry in California."[62] However, even as Van Horne and others caution against over-reacting to the penetration of Japanese banks, one financier predicts that, "Most of us should expect to see Japan as the dominant influence in the financial markets for the rest of our working lives."[63]

Elsewhere in the financial sector, the Japanese swept through Wall Street during the 1980s, picking up interests in some of America's largest securities firms and brokerages. Nippon Life Insurance bought a 25-percent stake in the Shearson Lehman Brothers unit of American Express; Sumitomo Bank purchased 12.5 percent of Goldman, Sachs; Yasuda Mutual Life acquired 25 percent of Paine Webber; and the Industrial Bank of Japan owns Aubrey G. Lanston. And, as we have already noted, Nomura took an interest in Wasserstein and Perella, Wall Street's new investment banking house.

Many analysts will closely watch Nomura's moves on Wall Street. The company attained some notoriety in Daniel Burstein's *Yen! Japan's New Financial Empire and Its Threat to America*, a riveting, if somewhat sensationalist book on Japanese control over global finance. Recounting the "vision" of Setsuya Tabuchi, Nomura's founder, Burstein writes, "In the year 2000 Nomura's headquarters will not be in Tokyo but on a satellite orbiting the Earth, uplinking and downlinking information and electronic transactions instantaneously across the globalized axis of the London, New York, and Tokyo markets."[64] At present, the journalist describes Nomura as a global financial "supermarket," the "biggest and boldest of all Japanese financial houses . . . It is a huge retail brokerage house similar to Merrill Lynch in the United States. It is a global bond trading house like Salomon Brothers; a corporate underwriter and investment banking partner to industry like Goldman, Sachs."[65] Originally a brokerage on the Tokyo Stock Exchange, Nomura's interests have become thoroughly global: it is a primary dealer of U.S. Treasuries and its London office is the primary underwriter of new Eurobond issues. The market value of Nomura stock is greater than Royal Dutch/Shell, Ford, and Du Pont and many times greater than that of Merrill Lynch, a fact that has led many observers to quote a *Fortune* writer who said that Nomura "could swallow Merrill Lynch like a bit of predinner *sashimi*."[66] Masaaki Kurokawa, the chairman of Nomura Securities International (a New York subsidiary of the Japanese firm), argued that the company would mainly grow in the typical Japanese fashion: from within, not through takeovers.[67] Even so, the stake the firm now has in Wasserstein and Perella suggests that the world's financial powerhouse is no longer

so cautious and is poised to move more swiftly toward its goals for the year 2000.

For the moment, Zurich-based Crédit Suisse commands more power on Wall Street than Nomura or other Japanese companies. The Swiss firm's strength derives from a 44.5 percent stake in CS First Boston, the largest interest any foreign company has in a major New York securities house. CS First Boston emerged in 1988 out of negotiations between two affiliated financial institutions, First Boston and Crédit Suisse First Boston, and it is projected to become a new force in multinational investment banking.[68] Unlike the Japanese firms that have entered recently, Crédit Suisse is a commercial bank. Although America's Glass-Steagall Act prohibits commercial banks from entering the securities business, Crédit Suisse was allowed to invest in CS First Boston under the grandfather clause of the International Banking Act of 1978 (the Swiss company had an interest in First Boston before the law took effect).

The rising foreign presence in the U.S. financial sector shows up in the insurance as it does in the banking and brokerage business. According to the Bureau of Economic Analysis, of the $88 billion in insurance assets held by foreigners in 1986, the Canadians and Europeans held over four fifths. British investment dates back to 1804; today large British insurance companies continue to dominate the scene—Commercial Union, Prudential Corporation, and Royal Insurance. The biggest move into the U.S. insurance business came in 1988 after a bitter and protracted battle for Farmers Group by B.A.T, Britain's retail paper and financial service company. In that deal, B.A.T paid $5.2 billion for Farmers, the largest acquisition in California history and the fifth largest acquisition by a foreign company in America.

Large buyouts in the financial services and insurance industries may come as a surprise to many Americans who believe that although foreign manufacturing may have risen relative to the United States, in the service sector, especially in industries like finance and insurance, the United States is still the undisputed world leader. Clyde Prestowitz, a former advisor in the Reagan administration, wrote in a trenchant book on Japanese-American economic relations:

> U.S. financial institutions were deemed to be innovative, aggressive, and internationally minded. The idea was to unleash their full power and watch the money pile up without the bother and mess of having to manufacture

something. . . . The service-industry idyll was blasted in November 1986 when Nomura Securities announced that it had handled, entirely on its own, the placement of a major bond issue for General Electric Credit Corporation. Nomura was the first foreign company to do such a thing in the United States.[69]

In 1986, Japanese investment banks, led by Nomura, did nearly 10 percent of all trading on the New York Stock Exchange. As Japanese and other foreigners continue with this second-wave assault on "postindustrial America" (the first was on manufacturing), we should expect more surprises. Already many Americans appear alarmed by the trend: Smick-Medley found that 57 percent of the U.S. citizens it polled believed that foreign investment in American financial institutions was "bad" for the country.

REAL ESTATE

Many Americans also think foreign real estate purchases are "bad" for the country.* Indeed, purchases of American real estate symbolize the "buying of America" today, as they have in the past. Earlier we saw that U.S. agricultural land was the most bitterly disputed area of foreign ownership in the nineteenth century. While foreign farmland holdings have again been a focus of concern about alien ownership, foreigners own only about 1 percent of U.S. agricultural land.[71] The total foreign share of U.S. real estate is not much larger than its share of farmland.[72] Most striking is the foreign buying spree in prime office space of America's leading metropolitan centers. Figure 2.7 lists the cities with the greatest share of foreign-owned office space, according to a special study by Coldwell Banker in 1987. The study found that foreigners owned over 200 office towers and half of the office space in downtown Los Angeles. In selected areas, offshore investors have also been active in the residential market.[73] The Japanese have spent billions on prestigious Honolulu residential properties, accounting for 27 percent of the houses purchased in the exclusive Kahala area and 40 percent of the condominium apartments sold in Waikiki Beach during 1986.[74] Ironically, Japanese financiers have even purchased land near Pearl Harbor Naval Base, where they plan to construct a massive resort and residential

* When Smick-Medley asked U.S. citizens whether foreign investment in U.S. real estate is good or bad, 60 percent responded that it is bad.[70]

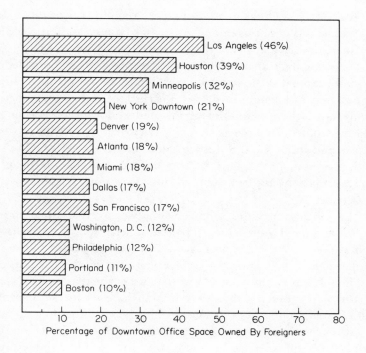

FIGURE 2.7
Foreign-owned Real Estate in Major U.S. Cities.

SOURCE: Coldwell Banker Boston, *Survey of International Investment* (Boston, Mass. Coldwell Banker Commercial Real Estate Services), July 1987.

development complex. To many foreigners, owning American property is "a symbol of having arrived."[75]

Canadian financiers and real estate developers are the biggest fish to bite. Overall, government figures indicate that the Canadians had $21 billion sunk in U.S. real estate assets in 1986, about the same amount as investors from all of Europe (including the United Kingdom) and seven times as much as those from Japan.[76] In fact, the largest real estate company in the world is Olympia & York, controlled by Toronto's Reichmann brothers who, in one buying spree during 1977, purchased eight Manhattan skyscrapers for $50 million. The value of those properties has shot up tenfold within a decade. In the 1980s Olympia & York has outhustled the real estate mogul Donald Trump to become New York City's largest owner of commercial property. Olympia & York also owns over a third of Campeau Corporation, which itself has far-reaching

U.S. real estate holdings in addition to its retailing operations. Hence, the Reichmanns count as one of America's largest landlords, although few Americans have heard of the reclusive Canadians.

Following the Canadians in total assets, the British controlled $10.3 billion in U.S. real estate in 1986 according to the conservative estimates of the Bureau of Economic Analysis. Real estate companies estimate that Britons have over a billion dollars invested in downtown Washington's exclusive Golden Triangle area alone. They own part of the Watergate complex and count the U.S. Justice Department as a tenant. One Washington real estate broker noted, "The British look to long-term appreciation, not tax benefits. In Britain, it's 100 years, not a five- or seven-year tax write-off."[77]

The Japanese manifest a similar long view of real estate appreciation in the United States. One Japanese official said, "We are patient. We have studied. We are prepared. Now we are ready."[78] They have willingly paid a premium for commercial and residential properties, considerably more than other investors. Part of the reason that Japanese investors pay so much is that there is a much better market here. Since Japanese real estate rarely changes hands, there is little domestic outlet for reinvesting the nation's enormous trade surpluses. Even if one could find available office space in Tokyo, the price would be steep, prime downtown land in Tokyo running as high as $151 per square *inch*, or $8,380 for a plot the size of this page.[79] Office space sells for $4,000 a square foot, over eleven times as high as in midtown Manhattan.[80] No wonder U.S. real estate looks cheap.

Although the Japanese trail the Canadians and British in real estate assets, they are, once again, catching up rapidly. Outlays in the mid-1980s soared, accounting for over half of all new foreign real estate investment. Japanese investors commanded about three-quarters of all foreign real estate outlays in 1987, according to official government figures, and reached as high as $12 billion according to some estimates.[81] Japanese real estate "shoguns" have seized some of the biggest properties in America, having paid more than $600 million each for skyscrapers like Los Angeles's Arco Plaza and New York's Exxon Building, or enough to buy whole downtowns of many medium-sized American cities. When the Tokyo-based Shuwa Corporation bought Arco Plaza, it even surprised the Reichmann brothers, who were far outbid for the office tower. In fact, the Kobayashi family, which owns Shuwa, may overtake the Reichmanns as America's premier foreign landlord if the Japanese investors keep up the buying frenzy of the late 1980s. Shuwa properties

are scattered in major metropolitan centers around the country; besides Los Angeles's Arco Plaza, they include the *U.S. News and World Report* building in Washington, D.C., and the ABC Tower in New York City.

By the late 1980s, Japanese investors had moved beyond their preoccupation with office towers in large coastal cities to urban growth centers like Atlanta, where Sumitomo Life paid $300 million for the IBM Tower in 1988. The pace of buying has been so rapid that no one knows the extent of Japanese-owned real estate, which now includes retail complexes and industrial warehouses, in addition to higher profile skyscrapers.[82] A study by Kenneth Leventhal & Company estimated that new Japanese investment in 1988 would run as high as $16 billion and total $35.2 billion in total U.S. real estate assets.[83] It has been estimated that the Japanese have sunk about $500 million in U.S. golf courses alone—a reflection of their long "fore-sight" in the U.S. real estate market.[84] According to Coldwell Banker, "The magnitude of this Japanese commitment represents more than 'just another wave.' On the contrary, the scope and scale of their commitment represents a 'sea change' in the United States market with major long-term implications."[85]

PETROLEUM, COAL, AND OTHER NATURAL RESOURCES

Natural resource extraction, primarily mining and crude oil extraction, is the final major target of FDIUS. U.S. affiliates had $12.2 billion invested in U.S. mining, controlled almost entirely by European, Canadian, and Australian companies, and $76.8 billion in petroleum, with over four-fifths of it controlled by European firms. A 1987 study by the U.S. Bureau of Mines estimated that foreign companies owned high proportions of U.S. mining capacity in several key minerals: 44 percent of gold, 30 percent of copper, 26 percent of zinc, 18 percent of lead, and 16 percent of silver.[86]

When considered together, all the activities of the foreign companies engaged in natural resource extraction and production accounted for 11 percent of the total assets held by non-bank foreign companies in 1986. Natural resources holdings are also obtained when a foreign company buys into U.S. manufacturing. For instance, Seagram's Du Pont investment gives the Canadian company an interest in Consolidation Coal, the second largest coal company in the United States. Another company controlled by Canada's Bronfman family, Brascan Ltd., owns 24 percent of Scott Paper, whose resource holdings include timberland and forest products subsidiaries in America.

The biggest player in the foreign-owned natural resource industry is Royal Dutch/Shell, the world's second largest oil company when ranked by sales. The Anglo-Dutch firm invested in the United States during the early part of this century, but has never been satisfied with its position. With billions in cash accumulated during the energy boom of the 1970s, Shell Oil, the Houston-based subsidiary, has astutely sought out U.S. acquisitions to strengthen its core strength in energy. It purchased Belridge Oil for $3.65 billion in 1979 and then returned the next year to buy a 50-percent stake in A. T. Massey Coal. In the United States, Shell's sales range well over $50 billion annually, and the company employs 34,000 workers.[87]

One of Shell's chief rivals in America is British Petroleum, whose 1987 move to acquire an additional 45 percent of Standard Oil of Ohio ranks as the largest foreign acquisition in U.S. history. The creation of John D. Rockefeller, Standard Oil is now wholly owned by BP. Earlier, British Petroleum paid almost $1 billion for Kennecott Corporation's coal deposits.

Apart from the foreign oil companies, the largest single foreign owner of U.S. natural resources is Anglo America Corporation, controlled by South Africa's Oppenheimer dynasty. A glance at Anglo's U.S. holdings suggests why government officials scratch their heads when they attempt to assess who owns what in the United States. It is difficult to measure the extent of Anglo America's holdings because the company has extremely complex linkages with several other global companies. Anglo owns 34 percent of another large South African mining company, De Beers, while De Beers owns 38 percent of Anglo. Meanwhile, Minorco takes care of international investing for both South African companies from Luxembourg (it moved its operations there from Bermuda in 1987). Among its investments, Minorco owns 29 percent of London-based Consolidated Gold Fields, which in turn owns a number of important mining companies in the United States, including 30.7 percent of Peabody Coal, the nation's largest producer, and a stake in Newmont Mining. In other words, several major U.S. coal companies are tied to the South African firm (as long as Minorco holds an interest in Consolidated Gold Fields). Another major player in U.S. coal mining is Australia's largest company, Broken Hill Proprietary, a steel, minerals, and energy producer; it paid General Electric $2.6 billion for San Francisco–based Utah International in 1984.

As for OPEC, while Kuwaiti and Saudi companies have invested heavily in the United States, the total OPEC asset position in U.S. petro-

leum resources, according to government records, remains only one tenth of the size of European investment. However, Congressman John Bryant contends, "There are numerous reports that OPEC nations are investing in the U.S. energy industry, although we don't know exactly who or in what."[88]

Conclusion

"Facts alone are wanted in life. Plant nothing else, and root out everything else. . . . Stick to the Facts, sir!" declares the schoolmaster Thomas Gradgrind, Dickens's caricature of nineteenth-century stoicism in *Hard Times*.[89] No doubt it would dismay Gradgrind to find that the spreading debate over foreign direct investment in the United States is based more on emotion than on hard data. The tide of inward direct investment has risen rapidly, but there is no consensus on whether we should swim with it or try to restrain it—in part because knowledge remains sketchy.

To be sure, there is much we still do not know about who the New Competitors are or in what they are investing. As Congressman Bryant and other observers contend, we need more and better information, a problem we will return to when we consider foreign investment policy in the last part of this book. Yet from many disparate sources of information we can piece together much of the puzzle about foreign direct investment in the United States. Five points are central to any contemporary discussion of U.S. inward investment.

- FDIUS primarily comes from the world's most advanced industrial nations, especially the United Kingdom, Continental Europe, Canada, and Japan —with only a fraction from OPEC. Contrary to the popular perception, the British still dominate, although no nation accounts for more than 1 percent of U.S. employment, the British included.
- It is not the size, but the rate of growth, of foreign direct investment in the U.S. that stands out. During the 1980s, Japanese investment outpaced all other sources; and if it keeps its stride, it could overtake the United Kingdom as the largest investor for the first time in U.S. history in the 1990s.
- FDIUS is fundamentally a takeover phenomenon, with little new plant construction. Although it is generally true that few foreign acquisitions during the 1980s have been "unfriendly," foreign capitalists were, as we have seen, anything but wallflowers at the "Predators' Ball."

There is considerable investment in services and trade, finance and insurance, real estate, and natural resources, but foreigners control more jobs in manufacturing than in any other sector. The greatest penetration is found in chemicals, consumer electronics, cement, banking, food processing, printing and publishing, and urban commercial real estate.

In this chapter we heeded Gradgrind's advice and stuck to the facts of foreign direct investment in the United States—but, as the old adage goes, the facts do not speak for themselves: they must be interpreted. That is the task of the next two chapters.

3

THE ROOTS OF FOREIGN
MULTINATIONAL POWER

A MYSTIQUE shrouds the multi-national corporation. More than any other form of business enterprise, its motives are suspect. Canadians questioned the objectives of United States-based corporations in their nation, but now the shoe is on the other foot. What drives Campeau to leave Canada and risk billions of dollars on U.S. clothing stores? The Japanese corporation appears even more alien and mysterious, whether because of xenophobia or just cultural differences. What is Honda's objective in deciding to move beyond exporting and to begin assembling cars and trucks in America?

Clearly, there are as many distinct motives for penetrating the United States as there are investors. Any generalization about foreign enterprise is not likely to fit all cases. Yet, in the early 1960s, Stephen Hymer, a Canadian doctoral student at Massachusetts Institute of Technology, pioneered a general theory of foreign direct investment—an approach, called "market imperfections" or "industrial organization" theory—that has emerged as the paradigm in the field.* His work, an

* Everyone who attempts to investigate the problem of direct investment owes a profound debt of gratitude to Hymer, one of the most influential thinkers in the new field of political economy that grew out of the intellectual turmoil in the 1960s. Hymer died at an early age in 1974, before many scholars fully appreciated his important contribution; but after some delay and controversy, his pathbreaking dissertation was published posthumously.[1]

important step in demystifying the multinational corporation, is crucial to understanding direct investment today. Before Hymer, no one clearly distinguished direct from portfolio investment. Through portfolio investment, financial arbitragers frenetically search the globe for the highest, risk-adjusted, short-run rate of return. Every morning, Japanese financiers scan their computer terminals for slight movements in bond prices. They buy and sell multimillion-dollar blocks of U.S. securities in the time it takes to read this paragraph. Through direct investment, on the other hand, multinational managers seek far more from their foreign assets: they want control over technology, production, and marketing. As the chief executive officer of American Hoechst asserted, the objective is "to invest now in order to secure long-term rather than short-term profits."[2]

The ability of foreigners to achieve their expansionist goals in America rests with their increased size and competitive power. MNCs obtain foreign control and favorable long-run returns through the strategic use of "ownership" advantages:[3] that is, each firm owns a unique bundle of advantages—including firm size, technical and managerial know-how, marketing expertise, favorable access to private and public capital—that shapes its global strategy. The British economist John Dunning developed the "ownership advantage" argument as part of his "eclectic" theory of direct investment.[4] While economists may disagree on almost everything else, they widely concur that the theoretical emphasis on ownership advantages was a major breakthrough in understanding global investment decisions.

In examining the rise of foreign direct investment in the United States we shall focus, in this chapter, through a microscopic lens on the cell form of international business—the multinational corporation; and, in the next chapter, on the macroeconomic or global environment of international investment.

The Nature of the Species

Twenty-five years ago, scarcely a book had been written on direct investment and the term *multinational corporation* was just beginning to enter the American vocabulary,[5] having been coined by David E. Lilienthal (chairman of the Development and Resources Corporation) in a speech at Carnegie Institute of Technology in 1960 and popularized in a *Business Week* article that appeared three years later.[6] Since then, books,

monographs, and articles on the subject have proliferated. However blasted by its critics or extolled by its proponents, everyone agrees that the MNC is a peculiar species of modern business enterprise, requiring a distinct analysis.

According to today's standard definition, the MNC is simply an integrated capitalist organization with headquarters in one nation and a marketing, resource, or production program that reaches across the boundaries of two or more nations. As Harvard's Raymond Vernon put it, the MNC is "a parent company that controls a large cluster of corporations of various nationalities. The corporations that make up each cluster appear to have access to a common pool of human and financial resources and seem responsive to elements of a common strategy."[7] Often, the range of international operations covers dozens of nations and hundreds of affiliates.

The "global reach" of U.S.-based MNCs like Ford, IBM, and ITT, which have operated on every continent for decades, is perhaps better known than that of non-American MNCs.[8] Yet few companies can now match the territorial sweep of Europe's enormous chemical concerns, to take but one example of the old-guard multinationals described in the last chapter. Britain's ICI, which derives three-quarters of its chemical sales outside the United Kingdom, has 180,000 workers spread worldwide. Germany's Hoechst rivals ICI with 180,000 workers in 144 countries. Not far behind are the next largest German chemical titans. BASF ties together an international network of affiliates with over 100,000 employees in 143 production companies, while Bayer employs 70,000 employees in hundreds of subsidiaries worldwide.

Unilever, another of the old-guard multinationals mentioned in chapter 2, is the "most multinational of all the multinational corporations," employing over 350,000 people spread across 78 nations and 500 affiliates.[9] Few MNCs can declare, as Unilever can, that they do business "in or with nearly every country in the world."[10] Nevertheless, all share the same global outlook that distinguishes the multinational enterprise from national or local companies. The drive toward globalization is sometimes an obsession, bordering on quixotic visions of grandeur. Sir James Goldsmith has sallied forth to create a global industrial empire that he vows will rival ubiquitous Unilever in a few years.

To be sure, the capitalist drive to "nestle everywhere, settle everywhere, establish connections everywhere"* is an old phenomenon, dating back to the East India Company, the Hudson's Bay Company, and

* The phrase is from Marx and Engels, among the first scholars to emphasize the internationalization of capitalist enterprise.[11]

other merchant concerns of the eighteenth century. But twentieth-century MNCs are far more complex than the early trading firms, spanning the globe with a myriad of marketing and production programs. MNCs set up distribution and marketing operations, in the process of *forward vertical integration*; or procure raw materials and other supplies through subsidiaries, or *backward vertical integration*. (Vertical mergers tend to strengthen existing firms as they make it difficult for new firms to enter an industry.) MNCs also expand *horizontally*, adding offshore facilities to broaden their capability to meet demand for given products lines. (Horizontal mergers in a given industry tend to concentrate economic power in the hands of a few dominant sellers, leading the industry away from perfect competition to the market structure known as *oligopoly*.) Other MNCs, today's global conglomerates, branch into diversified fields of services, trade, and manufacturing.

The New Competitors have employed all the mechanisms of modern multinational expansion, from the tight vertical and horizontal integration of many traditional MNCs to the loose organizational style of today's international conglomerates. Vertically integrated multinationals come from Japan, Europe, and even the Middle East. For example, Mitsubishi, Mitsui, C. Itoh, and other Japanese *sogo shosha* have evolved from strictly merchant concerns—trading steel, aluminum, and petrochemicals on low-profit margins around the globe—into tightly organized networks of resource extraction, production, and distribution. The European oil giants Royal Dutch/Shell and British Petroleum have also expanded through vertical integration, drilling for crude oil in one location, refining in another, and distributing the final product through retail outlets scattered across America. These European MNCs continue to add investments to their arsenal of energy-related assets in America. Until recently, however, OPEC-based MNCs confined their investments to resource extraction. OPEC's first significant move to integrate operations from the well head to the gas pump came in 1988 when Aramco, the Saudi Arabian national oil company, bought 50 percent of Texaco's distribution and marketing system. The investment endowed the Saudis with three oil refineries, 49 terminals, and over 10,000 Texaco service stations. West Germany's Bertelsmann media empire provides a further illustration of backward and forward vertical integration: the company has bought U.S. printing plants to publish its books and magazines (integrating backward) and purchased book clubs and other retail outlets to market the stock (integrating forward).

Many more foreign-owned manufacturing and service operations follow the horizontal route to expansion. Some MNCs build U.S. facili-

ties that produce goods similar to those manufactured at home and exported to the United States, as is the case with the recent spate of Japanese-American auto- and electronics-assembly plants. Foreign MNCs also move in via acquisitions of complementary companies, such as Nestlé's acquisition of Carnation, which bolstered its global position in the market for condensed milk and other food products, British advertising agency takeovers on Madison Avenue, and many Continental European chemical and pharmaceutical investments. (In chemicals, one researcher estimated that slightly over half of the investment is from horizontally integrated investors.)[12] Perhaps most surprising of all, foreign textile producers now expand in the United States through horizontal investment. French, West German, Canadian, Japanese, and even Pakistani and Indian textile producers, all with mills operating in the United States, are literally sticking to their knitting, augmenting existing capacity instead of seeking unrelated assets.[13] An executive with Amistal, a U.S.-Italian textile concern, contended, "Despite everything you hear, textiles has a future in this country. And we want to be a part of it."[14]

While horizontal and vertical integration tend to concentrate market power within a given industry, conglomerate investment entails diversification into new product lines. In some instances, acquisitions may be closely allied with existing competitive strengths. Unilever's buyout of Chesebrough-Pond's expanded its line of consumer products, giving it control over brand names like Ragú spaghetti sauces, Prince Matchabelli fragrances, Vaseline, Q-Tips, and Pond's cold cream. Other conglomerate MNCs bind together an ensemble of seemingly unrelated assets. Although the investments appear to have nothing in common, there is a risk-spreading logic to the conglomerate process. Some foreign acquisitions can be viewed as a carefully devised diversification strategy in which MNC managers seek to offset the risks of producing in a fluctuating world economy through selective acquisitions of foreign assets.[15] The best example is the old-guard British tobacco multinational B.A.T, whose diverse U.S. operations include, besides cigarette manufacturing (Kool, Viceroy, Raleigh, Belair, Barclay, and Richland), Appleton Paper, Hardee's (the fast-food chain), and People's Drug Store. When, in 1988, B.A.T acquired the Farmers Group, one of the nation's largest insurance companies, a spokesman for Americans for Nonsmokers' Rights marveled at the "horrifying mismatch of corporate interests."[16] After all, smoking curtails life, while the insurance industry profits from longevity. The real irony is that B.A.T's tobacco units (Brown & Williamson in the United States) sell about one-fifth of all cigarettes in the noncommunist world, while Farmers led the insurance industry in providing

nonsmokers' discounts. But B.A.T's acquisition makes sense when one recognizes that it carries the same risk-spreading logic that motivates most diversification moves. Even if consumer taste for cigarettes or hamburgers falls flat, people will still need insurance.* Moreover, B.A.T exemplifies the *devolution of management* policy that consciously avoids top-down multinational integration. From London, a headquarters staff of only 100 runs a global empire of over 300,000 employees,[18] and top management knows little about the day-to-day operations of its diverse affiliates around the world.

Foreign raiders have elevated to an art conglomerate building and the devolution of management strategy. Sir James Goldsmith wears many hats: publisher, tiremaker, casino owner, supermarket proprietor, lumberman, and restaurateur, among others. Hanson Trust also holds a wide range of manufacturing subsidiaries in America under one corporate umbrella, including building products, chemicals, hand tools, food services, fabrics, Endicott Johnson shoes, and Ball Park Franks. "They [Hanson Trust] are undoubtedly the most successful businessmen in Britain," proclaimed Sir James Goldsmith, "and the most successful British businessmen in America."[19] This is a remarkable accomplishment, especially in light of the fact that Sir Gordon White, who runs Hanson's U.S. operations, has reportedly not visited one of his American plants in more than a decade or ever checked in at his company's U.S. operational headquarters in New Jersey.[20]

The Disadvantages of Alien Status

The global reach of these MNCs is, however, so costly and uncertain as to be beyond the grasp of most firms. Stephen Bechtel, chairman of the San Francisco–based Bechtel Corporation, summarized the problems facing his sprawling engineering and construction company in the 1960s: "Generally speaking, international operations take several times more attention than domestic ones. The reason is simply logistical. It's also that every country presents its own set of problems—taxation, labor laws, current regulations, and so on. In these matters, management

* In this respect, foreign MNCs are akin to the classic American conglomerate, ITT, which grew to be one of the world's largest corporations by putting "its eggs in many widely disparate baskets under the theory that there will always be customers for Wonder Bread even if the market for Distant Early Warning Systems should dry up."[17]

must have the same thorough knowledge of each foreign country as it has of U.S. laws."[21]

Non-American MNCs faced similar obstacles on the road to global power in the 1970s and 1980s. Compared with domestic firms, foreign firms are presumably less familiar with the U.S. business climate, social and cultural peculiarities, consumer tastes, language, and so forth. Almost invariably, offshore production entails changing normal operating procedures. Most foreign companies operating in the United States, for example, must convert from the metric standard. Further, firms not accustomed to the vagaries of federal and state regulations, tax laws, and labor relations incur additional expenses. And the logistical problems of building a global corporate empire impose other costs: direct costs, as for communication and travel; and the opportunity costs implicit in time lost in slower and less accurate decision making.

In other words, multinational corporations considering direct investment face what Harvard economist Richard Caves called the "disadvantage of alien status."[22] For example, Japanese multinationals remain particularly cautious investors because, of all major industrialized countries, they face the most difficult cultural and language barriers.[23] Typically, the Japanese strike out overseas only after years of painstaking study. Yet even when they finally make their move to the United States, they still expose their "foreignness." Language problems inhibit interaction between Japanese and American managers, and the Japanese often misunderstand U.S. customs. In some instances, misunderstanding cultural differences may be more ludicrous than costly. At Hitachi's groundbreaking ceremony for a new auto parts subsidiary in Kentucky, the governor handed a state flag to visiting Japanese executives, only to watch in horror as they dragged it on the ground. Following their native custom, the Japanese meant to convey respect, not humiliation.[24] Speaking on behalf of Japan's Council for Better Investment in the U.S., Sony's Chris Wada said, "It is not easy to adjust to the customs and traditions of a different country particularly when you are faced with many difficult business challenges."[25]

Noncompliance with domestic labor and antitrust regulations is more costly than mere cultural blunders. Through failure to understand U.S. laws, many foreign companies end up paying fines. While in chapter 5 we will explore these problems in detail, for now we want to stress that ignorance of foreign laws and customs puts a special burden on multinational operations. Of course, recent advances in communications and transport make "foreignness" less of a disadvantage now than

in the past. Global communications networks have greatly facilitated the coordination of far-flung business empires and permitted a transition to globally dispersed corporate functions. For example, Honda executives in Tokyo can keep abreast of inventory in ten warehouses spread across the United States through a worldwide computer system. Many multinationals use satellites for video conferences to communicate directly with subsidiaries and dramatically reduce the information lag inherent in "going global." Clearly, the speed at which capital can be redeployed around the world increased because of the information revolution.[26] Technological changes since the 1960s, then, partially explain the growth of multinational investment.

Although the boundaries of time and space are minimized by modern communications and transport, technology does not completely eliminate the drawbacks of alien status. According to *Business Week*, building an international communication network is "fraught with technical and political problems."[27] In general, logistical and spatial disadvantages still make it difficult for foreign firms to compete with domestic firms. Overcoming these difficulties is an inherent cost of globalization. Since it is unlikely that a multinational could succeed if it faced the same competitive environment as its domestic rivals, foreign corporations must devise a strategic plan around such countervailing advantages as lower costs through economies of scale, marketing expertise, proprietary technology, and managerial skill. "Imperfect" competition is not just a feature of direct investment; it is a necessity. Only by operating in imperfect markets, where profit does not fall to a uniform rate, can the multinational firm obtain the necessary extra margin of profit it needs to survive abroad: a higher-than-average rate of return is necessary to offset the liabilities and risk attendant with overseas production.[28]

The Challenge of Foreign Multinationals

The imperfect character of multinational competition is often associated with the immense size of multinational corporations, and there is no denying that international direct investment is undertaken by a select group of giant firms. Although there are 10,000 MNCs worldwide, only 500 of them control 80 percent of the world's foreign-owned affiliates—figures that apply to all markets and goods: automotive, chemicals, electronics, and so on.[29]

Unparalleled in size, American multinationals captivated the world's attention in the late 1960s and early 1970s. Studies of American MNCs corroborated the key role that firm size plays in direct investment. An exhaustive survey of some 1,000 American manufacturing firms turned up one particularly arresting fact: manufacturing MNCs were 500 percent to 800 percent larger than manufacturers overall.[30] But as U.S. MNCs reached the pinnacle of global power in the 1960s, a counterchallenge emerged, particularly in Europe and Japan. To compete in the imperfect world of international competition, non-American corporations first had to match the size of U.S. MNCs.

The issue of European corporate size relative to American corporations did not arise in the first decade following the Second World War. European aggregate demand grew steadily, and there was ample room for expansion in local and neighboring markets. With the increasing infiltration of American capital, however, Europeans widely discussed the need for greater concentration and centralization of capital as a platform for recapturing domestic markets and capturing new foreign markets. Indeed, a major thrust of Servan-Schreiber's proposals for a European "counterattack" to the "American challenge" was the "creation of large industrial units which are able both in size and management to compete with the American giants."[31] Many Europeans agreed that a fragmented cultural, political, and economic structure within the European community made it difficult for a nationally based industry to compete with American MNCs.

The European counterchallenge was aided by the signing of the Treaty of Rome and the formation of the Common Market in 1957, creating in essence a free trade zone protected by a common tariff. Yet complaints about the American multinational menace grew ever more vociferous. In the mid-1960s, a Commission of the Common Market was formed to conduct a thorough examination of the unsettling difference between the size of European and American business enterprises. In the mid-1960s, corporate growth gathered momentum in Europe through a series of mergers, including chemicals and steel. European-based MNCs grew faster in the 1960s compared with those based in the United States.[32]

In the mid-1980s, the forging of trans-European corporate alliances intensified. The European Community pledged to dismantle most of the remaining intra-European trade barriers by 1992 and finally integrate a market of 320 million consumers spread across twelve nations, using twelve currencies, and speaking nine languages. Many European corpo-

rate executives now believe that the only way to compete in the world will be through a unified Europe in 1992.

Even MNCs based in Switzerland, a nation that is not a member of the European Community, recognize the importance of adjusting to a barrier-free Europe by forming cross-border alliances and growing through takeovers, friendly or unfriendly. Europe's biggest hostile acquisition came in 1988 when Nestlé bought Rowntree, a leading British confectioner, for the equivalent of $4.3 billion in U.S. currency. Like other Swiss MNCs, Nestlé must venture beyond the Alps: it needs the European market, and the world, for expansion; in fact, the company receives only a fraction of its total sales from Switzerland.[33] Europeans clearly hope that the 1992 integration will effectively change the whole character of multinational competition. The European Community eliminated tariff barriers among its member states in the 1960s, yet some 300 non-tariff barriers remained, including different technical specifications for products, custom posts, and restrictions on financial services. A result of centuries of divergent national development, these non-tariff barriers led to tremendous losses of economies of scale for firms operating in Europe. By creating a "Europe without borders" and a large internal market like that of the United States, economists project an increased growth in gross domestic product by 5 percent for the European Community and the creation of as many as 2 million jobs.[34] In general, European unification became a code word for the corporate mergers that swept across the Continent during the mid-1980s.* "Tomorrow, Europe, Inc." is the slogan of one French bank.[36] Barbel Jacob, deputy head of the U.S. Delegation of the Commission of the European Communities, put it best when she stated that with all the fanfare over 1992, the world moved from "Euro-pessimism" to "Euro-phoria."[37]

Consider next the somewhat different rise of Japan, Inc. Encouraging industrial and financial consolidation had been an explicit goal in Japan from the Meiji Restoration in 1868 to the Second World War. The

* The best-known merger attempt in the 1980s was the Italian deal maker Carlo De Benedetti's bitter battle for Société Générale de Belgique, a Belgian holding company that is equivalent to about a fifth the size of that nation's economy. Other examples include a merging of truck operations between DAF (Netherlands) and Leyland (Britain); the sale of Thorn's (Britain) appliance division to Electrolux (Sweden); and the joint purchase of French switchmakers by Ericsson (Sweden) and Matra (France), who hope to be major players in the burgeoning telecommunications industry. Also in 1987, not only did Britain's GEC electronics concern merge its medical electronics division with the Netherlands' giant Philips, but it also bought into Berkel, another Dutch firm. Feeling the pressure of the Japanese in the global microchip markets, SGS (Italy) and Thomson (France) combined their semiconductor operations, a move that propelled them to the number-12 position in the world market.[35]

belief that bigger is better lay behind the rise of the so-called *zaibatsu* (literally the "money clique" or plutocracy), the large enterprises that, favored by the Japanese government, formed the backbone of modern Japanese industry by 1920. Through mergers and conglomerate building, the *zaibatsu* dominated basic industry and foreign trade.[38] Even before the Second World War, they invested in the United States (roughly on par with U.S. investment in Japan). Much of the early investment was by Mitsui and Mitsubishi, the diversified holding companies that maintain a major presence today.

When they set out to restructure the postwar Japanese economy, the American occupation forces, under the direction of General Douglas MacArthur, dismantled the *zaibatsu*. Mitsubishi, a leading weapons supplier, was broken up. Japan Iron and Steel, a huge monopoly created by the Japanese government during the military buildup of the 1930s, was split into four private firms.

Cultivating corporate size was never an *explicit* element of Japan's industrial and trade policy, as was the case in Europe. Since the 1950s, Japan's Ministry of International Trade and Investment (MITI) has ostensibly discouraged domination of the domestic industry by a few competitors. Despite American-led trust busting and MITI's avowed promotion of small-scale enterprise, however, the hierarchical industrial system dating back to the Meiji Restoration remains intact. The *sogo shosha* and *keiretsu* (business groups) have taken the place of the *zaibatsu*. Today the Mitsubishi Group encompasses some twenty-eight semi-autonomous companies, including Mitsubishi Heavy Industries, Mitsubishi Electric, and Mitsubishi Motors. A central bank binds the corporate "family" together and supplies it with capital. In setting the pace of economic activity, the *keiretsu* are joined by an élite corps of industrial titans like Toyota and Sony with high profits, plenty of loan capital, and at least tacit support by MITI. In 1970, Yawata Steel and Fuji, two of the steel producers created by the U.S. occupation forces, merged into Nippon Steel, which is today the largest steel producer in the world. Such large Japanese firms are what most people think of as Japan, Inc., but they are followed by a group of foot soldiers, chiefly subcontractors and suppliers, who march in lockstep with Japanese multinationals.

Inevitably, foreign-based MNCs met the challenge of the American Goliaths. By 1987, thirty of *Fortune*'s fifty largest industrial corporations worldwide were from countries other than the United States, compared with just six in 1959.[39] In many industries, the deck of multinationals was "reshuffled" between the late 1950s and the late 1980s.[40] U.S.-based multinationals still hold respectable leads in several world markets, such

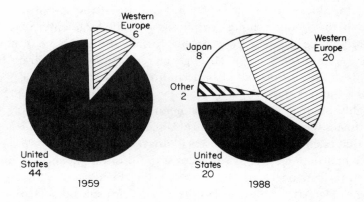

FIGURE 3.1
Home Countries of the 50 Largest MNCs.
SOURCE: "The Fortune 500," *Fortune*, August 1959, 1 August 1988.

as aerospace; but foreign-based multinationals are world leaders in a range of key industries and, in fact, excel in the very sectors identified in chapter 2 as important targets of foreign investors in the United States: chemicals and pharmaceuticals, electronics, metals manufacturing and products, automobiles, and banking.

Critical Mass and Direct Investment

As giant non-American corporations coalesced, direct investment in the United States became an increasingly viable option. Before engaging in foreign investment, a firm must often obtain a certain *critical mass*, a threshold size that propels it beyond the national economy to global production. As described earlier, this critical mass was obtained internally through corporate expansion as postwar economies grew and externally through mergers and acquisitions.

To illustrate the connection between critical mass and FDI, suppose two foreign firms have U.S. sales of $100 million dollars—a level of sales not justifying either the expense or the risk of setting up new facilities in America, and requiring a larger capital expenditure than either firm is willing to commit individually. It is safer to continue serving the U.S. market from the home base, where large and efficient plants already exist. If the two firms were to merge, however, the combined sales of

$200 million might justify horizontal expansion—setting up an offshore facility.[41]

Moreover, in many of the industries penetrated by foreign producers, small-scale operations are not feasible, for modern production is not efficiently divisible into small units. To succeed, MNCs must match their competitors' economies of scale. In particular, a large-scale plant is necessary in the batch, mass-production methods used by industries like auto and steel, to name two important targets of inward investment.[42] The same is true of continuous flow processes, such as those used in chemical production. For example, there are well-known economies of scale in ethylene production, a basic chemical that accounts for the greatest output in the petrochemical industry. An ethylene plant that produces 100 million tons per year is far less efficient than one with an annual volume many times greater. One author notes that once ethylene production of 200 million pounds per year "was deemed adequate," but now optimum size requires a billion pounds.[43] In general, the evidence shows that foreign multinationals tend to invest in large-scale plants, and their U.S. affiliate operations tend to be larger than indigenous firms.*

Industries that require economies of large-scale production tend to be dominated by a few large sellers. As we mentioned in chapter 2, large European trusts invested heavily in concentrated industries during the initial growth phase of modern big business before the First World War, Siemens, Michelin, and Lever Brothers competing head to head with General Electric, Goodyear, and Procter & Gamble, respectively. Oligopolistic competition among domestic and foreign producers—where a few large producers vie for a sizable portion of the market—was disrupted by the war years. Yet with the rise of the New Competitors, we find a return to the old rivalry among global giants in the United States. Recent studies confirm that FDIUS still tends to occur mainly in oligopolistic industries.†

Given their alien status, why would foreign firms risk large amounts of capital to compete in America's oligopolistic industries? Clearly, the objective is to share the high profits that industrial concentration breeds. The more industry-wide sales are dominated by a core of large firms, the higher the profit margin tends to be; and surveys have shown

* In one study, only 14 percent of all foreign multiestablishment firms reporting to the Census Bureau had less than fifty employees. About 34 percent of these foreign firms had more than five hundred employees; while only 6 percent of all multiestablishment firms in the United States had more than five hundred employees.[44]

† Statistical confirmation of the hypothesis[45] was rejected when scale and multiplant variables were tested on inward foreign direct investment data before 1974.[46]

that profit potential in the large U.S. market is the main motivation for inward investment in the United States.[47]

As we stressed earlier, most non-American corporations enter this high-stakes contest through acquisitions, many through multimillion- and billion-dollar transactions—exemplified by Unilever's purchase of Chesebrough-Pond's, Hoechst's buyout of Celanese, and Nestlé's purchase of Carnation. Corporate size provides firms with the financial clout necessary for large takeovers. Sony Corporation's deep pockets gave it the means to purchase CBS Records for $2 billion. The size of B.A.T, Great Britain's third largest corporation, emboldened the firm's $5.2-billion bid for Los Angeles-based Farmers Group in 1988. Germany's chemical giants have the financial muscle to buy any chemical company in the United States. A senior executive at a big U.S. chemical concern said: "When we ask ourselves who could afford to buy us if we wanted to be bought or even if we didn't, the answer is the Germans."[48]

Critical mass is only partly responsible, however, for the assertion of foreign multinational power in the United States. FDIUS requires substantial investments to achieve economies of scale and to facilitate takeovers; but firms also compete through marketing and managerial know-how, and proprietary technology. Indeed, it is through the strategic deployment of these "intangible" assets abroad that large domestic firms become even larger global MNCs.

Intangible Advantages and Direct Investment

Extending corporate power overseas is a decision MNCs must weigh against other options. For example, instead of growth through direct investment, a firm could license its intangible assets to firms already located in the foreign market. A firm possessing some technical lead—over which it holds a valuable patent—can always sell the rights to the highest bidder overseas: that is, in lieu of transferring know-how directly to a subsidiary, a foreign company sells specific ownership advantages to indigenous companies. After all, licensing can bring in profit without tying up capital in long-term commitments.

But MNCs have sound economic reasons for choosing corporate growth through direct investment instead of licensing. To explain this choice, modern theorists of industrial organization draw on the concept

of *internalization.** Some transactions (especially those that involve knowledge) are more efficiently and cheaply exploited internally, within a firm, rather than through the market. Ownership advantages explain how multinationals can compete overseas, and through internalization, why MNCs are driven to use direct investment as the most efficient means of profiting from the ownership advantages they possess.

Say, for example, a Swiss pharmaceutical company wants to profit from a beneficial drug developed at one of its labs. No doubt the firm would obtain patents for the drug, for knowledge and technology diffuse rapidly around the world, and rival firms would not want to "reinvent the wheel" if they could ride off an existing invention. On the other hand, the Swiss firm, which spent enormous sums of money on developing and testing the new product, uses the patent to keep the rival "free riders" from gaining on the backs of its private effort. Patents create property rights over knowledge and convert possible public benefits to private benefits; in other words, the firm ensures that the innovation becomes an ownership advantage. Now let us assume the firm wants to expand in the United States. It has several options, one of which is to license the drug technology to American firms. But licensing the drug's chemical technology in the United States would involve what economists call transaction costs and risk. Transaction costs are incurred in defining obligations and enforcing contracts, while risks are involved in accepting contracts. Moreover, the licensing option may involve long time lags before the profit from the ownership advantage may be realized. In addition, licensing boosts the competitiveness of potential rivals as it diffuses the firm's special know-how. Host countries like Japan sometimes limit multinationals to licensing agreements and prohibit or constrain direct investment in many industries. The conquest of the U.S. television market by Japanese producers drives home the point about the "stupidity" of licensing.[50] Following the Second World War, American producers enjoyed a strong technological lead over all foreign companies. The Japanese effectively closed their market to both direct investment and imports from the United States, allowing only licensing of the monochrome technology, which is just what RCA and General Electric did in 1950. With a protected market, lower wage costs, and aggressive pricing, Japanese producers turned around and captured a significant share of the U.S. black-and-white market by the early 1970s. The

* The internalization concept was originally put forth by Ronald Coase in his research on multiplant firm expansion and was later developed by the economists Kenneth Arrow and Harry Johnson.[49]

same pattern was repeated with color televisions, where again U.S. producers had an early lead and again licensed technology to Japan beginning in the early 1960s. The inevitable conquest of the American color television market by Japanese and other foreign producers, of course, only partially results from licensing. The point here is that licensing brings in short-term profits and could be seen as an alternative to direct investment.

But if MNCs are given a choice between licensing and direct investment, as they are in America, they often prefer to "appropriate" the full returns from special knowledge through the latter; that is, through internal, intrafirm transfer of knowledge (from parent to subsidiary).[51] Internalization is the process by which firms exploit "intangible" advantages and develop into integrated global organizations, offsetting the inherent cost of doing business abroad.

A range of intangible advantages—from superior technology to brand name appeal—is well documented in studies of U.S. multinationals. A major Harvard University study in the 1960s found that American MNCs were not only larger, but more advertising- and research-intensive than other firms in the United States.[52] Others have found a strong relationship between the extent of product differentiation and the proportion of firms in an industry with foreign subsidiaries.[53] Most of the early research focused on manufacturing, but recently, international economists have emphasized the role of intangible advantages and direct investment in global banking and business service industries.[54]

Which major advantages are possessed by foreign firms in the United States is still being debated.[55] Although the answer is many-sided, until recently some analysts pointed to *state-support*, not private competitive advantages, as the primary means of offsetting the disadvantage of alien status. Government ownership enables a foreign subsidiary to sustain losses even in the face of persistently poor performance. Unlike U.S.-based multinationals, a number of non-American MNCs are owned partly or wholly by foreign governments. Canadian government-supported multinationals with U.S. investments include the Canadian Development Corporation, a conglomerate with reported assets of over $5 billion; and MacMillan Bloedel, a pulp and paper concern with only a small degree of state ownership. European state enterprises with direct investments in the United States have included Ente Nazionale Idrocarbuti (ENI), Elf Acquitaine, British Petroleum, Renault, Pechiney, and Volkswagen.

Government support of indigenous MNCs makes it difficult for domestic producers to compete on a "level playing field," even when

they are the home team. A debate over foreign investment by state enterprise in the United States spread in the early 1980s, peppered with complaints of "neocolonialism" and "creeping expropriation." One author warned that we are entering the Age of State Enterprise," the beginning of what could become an open season on the purchase of American resources and industrial firms."[56] These fears, as we will show in chapter 9, influenced Reagan administration policies toward direct investment, but the "season" never really opened as so many anticipated. After investigating the matter, the U.S. Commerce Department concluded that foreign firms with government shareholders, while highly visible, constituted a modest amount of all direct investment transactions—about 2.5 percent of the total transactions recorded from 1974 through 1981.[57] State-controlled enterprises still have investments in the United States; but many, including Volkswagen and Renault, have sold off their investments in America, and others, like British Petroleum, have been privatized.

Of course, state ownership is not the only means by which governments confer significant advantages on indigenous firms. Governments foster advantages in scale and technology, for instance, by restricting commodity and capital imports in favored industries. Northern Telecom, Canada's titan of telecommunications, gained substantially from the tariff placed on imports in the Canadian telecommunications industry. Ottawa also treats banking as a vital and strategic national industry, protecting it from foreign competition. In fact, most foreign governments, except the United States, allow a few huge national banks to coalesce and thereby achieve scale economies.[58] Thus foreign banks obtain size and other advantages over U.S. concerns, which have been atomized into some 15,000 separate banks and restricted from combining across state lines. Japanese government policies stimulate the global financial empires in numerous, if often subtle ways. Japanese commercial banks, for instance, pay low government-controlled interest rates to domestic savers; at the same time, the government allows the banks to charge high fixed commissions. These measures swell the banks' profits for overseas ventures. Likewise, European and Japanese governments stimulated industrial growth by restricting commodity and capital inflows in key sectors of the home economy.

But we must give most of the credit to private foreign capital's competitive forte. European, Canadian, and Japanese corporations have clearly devised strategies to capitalize on ownership advantages without direct government involvement.

Some foreign multinationals have expertise in *natural resource-*

related industries.[59] Canada's Alcan, Australia's Broken Hill, and South Africa's Anglo American, for example, are global leaders in natural resources extraction and production, obviously tied to their respective country's plentiful stocks. European multinationals possess natural resource advantages as well, although not because of any special resource endowment in the home nation. Royal Dutch/Shell is among today's most aggressive oil-refining and marketing concerns in the world; its secret is a combination of financial muscle and knowledge. Part of the parent's $9 billion in cash reserves is plowed into endeavors that maintain the leading status its American-based subsidiary, Shell Oil, has achieved in America. Shell is widely acknowledged as the most successful developer of new oil reserves in the United States.

Most MNCs ultimately depend on sheer know-how, a most intangible advantage, to outmaneuver competitors and to succeed internationally. Often foreign companies have used aggressive *marketing skill* to gain a foothold in the U.S. market. In a mature oligopoly, the kind of market structure in which many multinationals find themselves in the United States, competition means not ruthless price cutting, but a struggle over market share in which image and advertising dominate corporate strategy. Foreign companies recognize that to compete in the United States means a company must establish its image, and many have excelled. Just as IBM and Coca-Cola have done abroad, the New Competitors emphasize building corporate identities in the United States. One survey found that foreign-based businesses rate the cultivation of a global image a high priority in 80 percent of the companies; yet among executives in U.S.-based companies, only one-third reported that corporate identity issues rank as a high priority.[60] Japanese companies are the most concerned about fostering international identities for their products. Through advertising campaigns emphasizing quality and image, many foreign companies differentiate their products from those of domestic concerns. Clearly, in the decision to penetrate U.S. production, Japanese electronics and auto companies rely on strong brand-name recognition and a growing reputation for high quality.[61] On the European side, Unilever spends hundreds of millions of dollars annually on U.S. advertising to boost the image of its American-made consumer products. But one of the more savvy approaches to U.S. mass marketing has come from Sweden's IKEA, a huge furniture retailer with an international reputation for "marketing pizazz." To lure upscale customers to its trendy Pennsylvania showroom in 1985, the firm launched a $2-million advertising blitz, including billboards, radio and TV commer-

cials, newspaper advertising, and a 130-page catalogue mailed to middle- and upper-income households. IKEA keeps shoppers content once inside the store by providing a day-care center and a restaurant serving Swedish meatballs. Competitors admit that the Swedish firm's marketing strategy is twenty years ahead of domestic furniture retailers.[62] Not surprisingly, IKEA has rapidly expanded its operations on the East Coast.

In manufacturing industries, where most FDIUS takes place, non-American firms have improved product lines and industrial technology through *research and development* in addition to purely market-oriented strategies. Like the development of large-scale capital overseas, the enhanced technological capability of foreign firms was evident at the beginning of the recent boom in FDIUS. As early as 1974, a major study of five hundred innovations confirmed the increasing technological capabilities of foreign firms relative to U.S. firms.[63*] The study conclusively showed an increase in the innovative capabilities of European and Japanese firms and a steady weakening in the American position. "This slippage," concluded the author, ". . . does not reflect a diminished global market assessment by American innovators so much as it is symptomatic of the growing foreign technical competence."[65]

One measure of this burgeoning technical capability is the startling fact that foreigners doubled their share of U.S. patents between the mid-1960s and the mid-1980s. The U.S. patent system gives a legal monopoly to an inventor or an inventor's company, a chance to avoid the free-rider problem and to obtain a market advantage. Of the roughly 90,000 patents awarded in the United States during 1986, non-Americans collected 46 percent, nearly as many as U.S. residents. Japanese inventors won more U.S. patents than other nonresidents, followed by the West Germans, the French, the British, and the Canadians. Moreover, the most recent evidence prepared for the National Science Foundation by Computer Horizons clearly contradicts Japan's stereotype as a "nation of imitators."[66] The study looked at "quality" innovations and found that, as early as 1976, high-quality U.S. patents awarded

* Sherman Gee reports that, in 1953, U.S. firms were responsible for approximately 80 percent of the new innovations; by 1973, the share was down to 60 percent. During this time, Japan, Germany, and the United Kingdom registered increases. Japan had virtually no new innovations in the early 1950s; by the early 1970s, this nation could claim about 10 percent. Moreover, just prior to the recent wave of FDIUS, there is evidence that foreign companies were gaining on the United States in international patent rights: in 1965, 35 percent of all international patents originated in the United States; by 1974, the U.S. share declined to 29 percent.[64]

to Japanese inventors surpassed all other non-American inventors.* Note that these patents are taken out primarily by companies, not by individuals (95 percent of all Japanese-invented patents are owned by companies, compared with about 75 percent of all U.S.-invented patents). Equally important, high-quality Japanese innovations tend to show up in "hot areas" and in widely used products like semiconductors, computers, photocopiers, pharmaceuticals, photography, televisions, stereos, video cassette recorders, and automotive technology.

Compared with U.S. rivals, foreign firms can also claim greater proficiency in turning innovations into marketable products. By quickly moving products from the design stage to the market, non-American MNCs have ascended as competitors in the global market. Perhaps the best illustration is Michelin. The French company, which first introduced radial tires, and eventually rose to be Europe's largest tire maker, came to the United States in the early 1970s seeking to exploit its technological and marketing lead in radials. Since its U.S. rivals—Goodyear, Goodrich, and Firestone—were at first reluctant to introduce radial tires, holding on to the older bias-ply technology, Michelin was able to capitalize on its ownership advantage, build up market share, and firmly establish itself with a strong manufacturing presence in South Carolina and Alabama. Foreign technological leads in chemicals and pharmaceuticals have motivated direct investment as well. Large Continental firms have always been among the world's innovators in these industries; they were among the first to produce basic and specialty chemicals, dyestuffs, pharmaceuticals, and synthetic fibers in the United States.[68] In electronics, the Japanese introduced solid-state technology earlier than American firms.

Food processing, another industry with a substantial foreign presence, is generally considered to be a technologically mature industry, in which competition takes place less through the possession of proprietary technology than through marketing and managerial expertise and intangible advantages like brand-name recognition. Even so, technological innovation by foreign multinationals forms part of the corporate strategy. In 1988, Nestlé announced that its Carnation unit would launch a new division to introduce a "revolutionary" milk-based infant formula for allergic children (existing formulas are not milk-based). Other technological advances have been in the lower-profile intermediate goods

* The method used by scientists to measure the quality of patents assumes that the quality of a patent can be gauged from how often other inventors cite it—a technique based on "networks of citations" which attempts to isolate original ideas. According to an index based on the procedure, Japanese inventors rank first in the quality of patents.[67]

industries. In the nineteenth century, Germany's Bosch pioneered the magneto for automobile ignition systems, the hand-cranked starter, and later the fuel-injected engine. It was an early entrant into U.S. automobile parts production, opening a plant in 1906, but its property was confiscated during the First World War along with that of other German producers.[69] Following the war, Bosch regained its position as the world's technological leader in electronic components and other auto parts, and its sales took off during the American boom of the 1920s. Since the U.S. government again confiscated its property during the Second World War, Bosch had to rebuild its global presence once more; yet it never lost its technological edge in the industry. Today Bosch, the world's largest automotive components company, runs two large manufacturing plants in South Carolina and a product-development facility in Michigan. Bosch's plant in Charleston, South Carolina, produces a broad range of gasoline and diesel fuel injection products. Following a series of recent technological breakthroughs, the company decided in 1987 to invest $170 million more in the United States, most of it earmarked for the production of anti-locking braking systems.

Over the past few decades, many European and Japanese corporations have also excelled through *innovations in production* as well as in product development.[70] Through U.S. affiliates, foreign firms have introduced into American production a range of labor and production practices, including better quality control, specific design and production skills, and close assembler-supplier relations. These are critical elements in the effective smaller-batch industrial processes, increasingly important in contemporary manufacturing. Competitive production techniques and labor practices are specific advantages perhaps most characteristic of Japanese corporations. The Japanese are widely noted for "quality circles," the widespread use of robotics, the *kanban*—or "just-in-time" (JIT)—method of inventory control, "total quality control," and other procedures that have improved, rationalized, and sped up factory production. These production advantages dramatically lower costs.

The just-in-time inventory system, combined with the drive for total quality control, is the greatest triumph of all Japanese production innovations. What is most amazing about JIT is its simplicity, according to Richard Schonberger, a leading authority on Japanese manufacturing strategies. Just-in-time means to produce with minimum inventory; produce finished goods "just in time" to be sold and have parts delivered "just in time" to be assembled. JIT enables firms to reduce inventory and production lead times and cut labor costs. A main objective of JIT is

to produce in small batches, or lots. The major benefit of producing in small batches is that it dramatically cuts machine set-up times and enhances quality control. On the latter advantage, Schonberger explains:

> Say that a worker makes one piece and hands it to a second worker whose job is to join another piece to it; but the second worker can't make them fit, because the first worker made a defective part. The second worker wants to meet his quota and doesn't like being stopped, so he lets the first worker know about it right away. The first worker's reactions are predictable: he tries not to foul up again—and tries to root out the problem that caused the defective part.
>
> The typical Western way, by contrast, is to make parts in large lots. A whole forklift-truck load—two weeks' worth, maybe. The second worker might find 10 percent to be defective but he doesn't care. He just tosses a defective part into a scrap or rework bin and grabs another. There are enough good ones to keep him busy, so why complain about defectives?
>
> So you see, the Japanese cut the wasted hours and wasted materials by not allowing large lots of defectives to be produced. The main force that drives Japanese quality and productivity is just-in-time inventory control.[71]

It is largely through the JIT process that the Japanese have ascended as the global masters of high-volume, repetitively produced goods—in consumer electronics, automobiles, and many others.[72] Often just-in-time (the Japanese use the English expression) is used interchangeably with *kanban* (Japanese for "card," or visible record), an inventory control and replacement system that carries a narrower meaning than JIT. (The visible record activates an order for more parts—a card to signal the delivery or production of more parts.)

"Among the simplifiers," says Schonberger, "Toyota is the standard-bearer."[73] Toyota has achieved remarkable efficiency in automobile assembly by producing in small-lot sizes, reducing average set-up time for 800-presses from one hour to twelve minutes. In some cases, Toyota has actually reduced the set-up time for these huge machine tools to less than a minute; a large-batch American competitor takes six hours to perform a similar task.[74] A modified just-in-time system is used at the joint Toyota–General Motors assembly facility at Fremont, California. The plant is also incorporating Japanese-style quality circles and job-rotation methods to revitalize a plant that was formerly plagued by low productivity and worker absenteeism. Even before Toyota, Kawasaki Heavy Industries introduced a complete JIT/*kanban* system at a plant in Lincoln, Nebraska, where it now produces motorcycles, snowmobiles, and other recreational vehicles. After getting off to a rocky start, Kawa-

saki's Japanese managers successfully implemented the JIT system. Consequently, says Schonberger, the plant witnessed dramatic productivity gains, and "the American personnel in the plant shed more of their American bad habits. Managers and staff became less inclined to go off on tangents, promote pet projects, further their own interests, and feather their own nests. Each just-in-time improvement thrust people's fortunes closer together, thus shutting out divisive behaviors that the Americans may have brought with them when they hired."[75] To some unions, however, JIT often means little more than old-fashioned speed-up—fewer workers producing more output at a faster pace. Therefore, we might expect that Kawasaki and other Japanese firms would want to avoid confrontations with American unions over the introduction of these new production techniques—an issue we shall explore in chapters 5 and 7.

The Challenge Facing Foreign Multinationals

If global production represents the last frontier of corporate growth—at least until the commercial colonization of outer space—then success in America is the ultimate test of multinational power for European, Canadian, and Pacific Rim companies. In this chapter we have seen that, despite the many obstacles to offshore expansion, foreign competitors seek to extend their reach into the United States through the strategic use of size, marketing and production expertise, and technological know-how. This key insight about multinational behavior, which dates to Stephen Hymer's early work, essentially explains how firms vie overseas for market share. The competitive-advantage idea best explains the horizontal moves of patient MNCs, where direct investment broadens the multinational's capacity to serve a given market.

However, as we have indicated throughout this chapter, an MNC's decision to invest abroad is rarely made in isolation. Multinational strategies are highly interrelated. Horizontal direct investment is akin to a multidimensional game of chess among a select group of contenders, who act and react to what their rivals are doing; and the moves of large-scale corporations are highly visible. This is quite unlike the "pure" competition game of economics textbooks, where investment decisions are made by many small firms struggling independently of one another.

According to some analysts, the non-American challenge is a kind

of defensive reaction on the part of foreign companies. Some firms, especially those based in Europe and Canada, retaliate for earlier moves by American MNCs in their home market or in their international sphere of influence.[76]* Say the domestic market position of a European firm has been undercut by American competitors, who have maintained high prices in concentrated markets at home to support cutthroat forays overseas. By investing abroad, the foreign company counters with a "return of threat," stalemating the U.S. strategy. Some old historical tales back up the "revenge" hypotheses. The best known is Royal Dutch/Shell's initial foray into the West Coast market in 1912, bringing Indonesian oil to counter Standard Oil's thrust into Shell's market territory in the Far East. Of course, then, as now, foreign MNCs remain highly vulnerable to competition from powerful domestic multinationals when they enter the United States; thus, we suspect they still must possess some unique competitive advantages.

Another characteristic game of international oligopoly, especially common to Japanese direct investment in the United States, is "follow the leader": first, one MNC takes the bold step to enter American production; if the firm builds market share and profits through direct investment, rivals follow. Because we expect such interdependence of corporate actions to occur where the market is controlled by a few firms, it is not surprising to find such gaming strategies in the Japanese automobile industry, one of the nation's many concentrated sectors. Honda led the charge, opening the first Japanese auto factory in Marysville, Ohio, in 1982; it quickly became the fourth largest U.S. auto producer. Shortly thereafter, Nissan built a plant in Smyrna, Tennessee. Other Japanese MNCs, either alone, or through joint ventures with U.S. auto firms, soon followed: Mazda, Mitsubishi, Toyota, and Subaru-Isuzu. Another good example is Japan's semiconductor industry (semiconductors, or chips, are used as microprocessors in computers and other electronic products). Japan's Ministry of International Trade and Industry actively promoted the oligopolistic structure of the Japanese semiconductor industry by inhibiting new firm entry; by 1978, the top four chipmakers commanded 63 percent of the Japanese market, with NEC holding the largest share (about 18 percent). In turn, the Japanese semiconductor industry exhibited the same imitative behavior found in automotive direct investment. NEC led the parade of chipmakers into U.S. production in 1978, followed by Hitachi and Fujitsu a year later,

* In a test of the "exchange of threats" hypothesis in the 1970s, Edward B. Flowers found that European and Canadian investment in the United States reacted to moves by American multinationals after a three-year lag.[77]

Toshiba in 1980, and Mitsubishi in 1983.[78] The point is that one decision to invest can lead to a chain reaction, with profound consequences for the host country.

MNCs are not invincible, however, nor are their strategies always on the mark. As John Maynard Keynes once said, long-term capitalist investment is a fundamentally uncertain endeavor: "The outstanding fact is the extreme precariousness of the basis of knowledge on which our estimates of prospective yields have to be made. Our knowledge of the factors which will govern the yield of an investment some years hence is usually very slight and often negligible."[79] While this long-term uncertainty affects all investment decisions, it aptly applies to direct investment strategies. There is nothing in the oligopolistic or "market imperfections" theory that says that long-term profit flowing from U.S. affiliates is preordained. Competitive advantages may compensate for alien status and motivate direct investment strategies, but they do not guarantee success.

Once the seeds of multinational expansion are planted overseas, a rigorous test of survival begins. As the Scottish poet Robert Burns said of mice and men, the best-laid schemes of multinationals often go awry. Foreign firms break new ground, but often in unfamiliar terrain. Despite the size and intangible advantages of multinationals, FDIUS remains a risky strategy. Many foreign ventures fall flat, as the experience of many veteran multinationals can attest.[80] For large and stable multinationals, a few casualties are not fatal and do not spell the end of involvement in American production.

One recent failure came in 1978 when Germany's Thyssen, Europe's largest steel maker, acquired the Budd Company. The $275 million takeover was an unmitigated disaster for Thyssen.[81] Under German control, Budd won sizable bids to produce railway cars for urban mass-transit systems—contracts on which the company consistently took a beating. The U.S. affiliate caused the whole German multinational to report annual losses in the early 1980s and to miss its first dividend payment in twenty-five years. The Budd disaster nearly cost Thyssen's chief executive his job; still the executive held on and sent a new German manager to America to save Budd.

Conglomerate takeovers are even riskier than the horizontal moves of foreign automakers, steel producers, and other manufacturers. As we saw in the last chapter, foreign raiders are willing to enter into highly leveraged deals. They can claim little in the way of competitive advantages—technical or marketing skill. The raiders' strategy is remarkably unadorned: first, they find a company that has, say, drifted from the

main line of production through diversification and become laden with middle managers; next, they buy the company at below breakup value, cast off some of the pieces, and then streamline the remaining core businesses. Foreign takeover artists may have a special faculty—even better than domestic capitalists—for spotting undervalued corporations, but the only clear "intangible" advantage is financial acumen. The risk in the strategy comes in the takeover's financing method. Drexel Burnham Lambert's Michael Milken pioneered junk-bond financing and offered it to both domestic and foreign clients as perhaps the most innovative tool for takeovers in the 1980s. But the British have plied a few new tricks of the takeover trade as well—notably the "rights offering," in which shareholders are given the right to buy new shares at a set price. A bank, or bank consortium, guarantees the purchase of all the shares not sold. Whether through junk bonds or the rights offering, the result has been to give acquisitors tempting financial power—a kind of Pandora's box that has made mergers and acquisitions far riskier than in the past. Earlier in this chapter, we pointed out that Sir Gordon White and other new acquisitors seem unconcerned, even arrogantly so, about the daily operations of their diverse units spread around the nation and the globe. The great risk foreign (and domestic) raiders face is a recession, which would sharply reduce sales and thus the ability to pay off the immense debt.

Of course, not all raiders and conglomerate-builders remain absentee owners, detached from managing their U.S. holdings. Many are willing to plunge head on into modern oligopolistic competition. For example, it was widely assumed that Du Pont really did not fall under foreign control when Canada's Edgar and Charles Bronfman bought a 21-percent stake in America's largest chemical company. Yet after they invested in Du Pont, the Bronfmans actively advised the second largest chemical corporation in the world. The Bronfmans believe they are more than just good investors; they proclaim themselves to be "the greatest marketing people in the world."[82] The Canadians are certainly good at marketing alcoholic beverages. The Bronfman-owned Seagram Company commands brand-name loyalty in the U.S. with spirits like Chivas Regal, VO, and Seven Crown and quickly moved to second place in the crowded U.S. wine-cooler market. Whereas Seagram clearly did not extend its line of distilled spirits with the Du Pont investment, some insiders maintained that the Bronfmans—"new Du Ponts"—brought financial expertise and new blood to an "inbred" giant. Others at the company complained, "Selling booze and wine isn't the same thing as running a world-wide chemical company."[83]

Even so, Seagram illustrates the new assertiveness that characterizes many of the New Competitors. To succeed in America, they are willing to use all the weapons of modern corporate warfare—expensive advertising campaigns, new product development, even lawsuits against rivals. In another bold move during 1988, the Canadians entered the highly competitive U.S. juice market, paying over a billion dollars to acquire Tropicana. One writer wryly noted, "Orange juice distribution bears no resemblance to anything Seagram currently does. Apart from the synergy of screwdrivers, it's a totally foreign business."[84] Undaunted, the Canadian company thrust forward into a fierce rivalry with huge American MNCs—Procter & Gamble (which markets Citrus Hill) and Coca-Cola (which markets Minute Maid). Minute Maid launched an aggressive counterattack with a new line of ready-to-serve juice and a big promotional campaign. Seagram's Tropicana struck back by suing Coca-Cola's Foods division for deceptive advertising, claiming that depiction of Minute Maid Premium Choice as "straight from the orange" was patently false (the product is pasteurized). Meanwhile, Tropicana moved into a new line of nonrefrigerated fruit juices, putting pressure on current market leaders like Ocean Spray. The director of operations at Ocean Spray said, "Tropicana is a formidable rival, but we have the lion's share of the business and will act to protect it."[85]

The successes and failures of foreign investment strategies, both by the traditional MNCs and the takeover artists, is a topic we will return to in chapter 5. For now it is sufficient to point out that many managers of foreign-based MNCs have shed any inferiority complex about American investment, asserting that they will lose money initially in order to establish a position in the United States. The reasons for America's appeal lie in the international macroeconomic environment of the 1970s and 1980s, which we will explore in the next chapter.

4

THE APPEAL OF AMERICA

MULTINATIONALS play out their investment strategies within a changing international environment —an imperfectly competitive environment that they help shape by virtue of their size and power. Having shown how foreign MNCs have expanded their global economic power, let us turn to *why* foreign firms invest in America. What lures them to the United States, even as U.S. companies invest abroad? Why do they invest instead of export? To answer these questions, we shift our focus from the microeconomics of the multinational enterprise to the macroeconomic and global domain in which international location decisions take place.

The attraction of foreign capital to the United States stems from long-run and short-run factors. Taking a long view, foreign companies, if they have the competitive edge, want a slice of America's large and growing market pie. Some foreigners see capturing a share of the U.S. market as a life-and-death struggle. "If we neglect the American market," said the president of Fujitsu America, "we cannot survive." A small market base overseas compels many nationally based firms to seek international outlets for their production through either international trade or direct investment. The United States economy provides a unique opportunity, not only because it has the world's richest and most diverse market, but because its demand for the world's goods and services exceeds domestic production. Under certain conditions, as we explain later, it makes more sense to exploit this gap between demand

and production through direct investment rather than exports. Besides market potential, other long-run attractions include America's openness to overseas capital, its labor relations climate, and its wellsprings of technology and innovation.

As a more immediate stimulus to direct investment in the United States, we will stress federal fiscal and trade policies. These policies set in motion a sequence of macroeconomic events, largely unanticipated, that eventually led to a downward plunge in the dollar's exchange rate in 1985. The price of America's assets in terms of yen, pounds, and marks fell along with the dollar and escalated the pace of foreign investment, giving rise to what we call the foreign *debt-for-equity swap*. When the dollar tumbled in the mid-1980s, many foreign companies perceived that the time was ripe to acquire a greater stake in the all-important American market.

With this chapter, then, we return to a major theme of this book: the federal government unwittingly contributed to America's dependence on foreign capital through ill-conceived policy. But before we look at the details behind the dollar's decline and the debt-for-equity swap, let us examine how the strong American market and other factors entice inward flows of direct investment at any price. Above all, it is important to understand the role that U.S. demand plays in international trade and investment.

The Global Factory and the Global Shopping Center

Modern macroeconomics appears to be a tug of war between those who stress the role of supply and production and those who emphasize demand and market growth. Everyone knows that supply supplanted demand as the prime mover in a new economics that enjoyed widespread influence in the Reagan administration. Contemporary supply-side economists typically trace their intellectual lineage to the writings of the eighteenth-century Scottish political economist Adam Smith. "In *The Wealth of Nations* Smith argued that real riches came from the power of production and supply," wrote George Gilder in a book that was to become the bible of Reaganomics. "But during the two centuries since Smith won this initial triumph for supply side economics, the demand side has all too often triumphed."[2]

Actually, Smith said nothing about modern supply-side economics's

main tenet—how low tax rates provide incentives for risk taking and investment; but he did open *The Wealth of Nations* (1776) with a supply-side argument that explains a lot about the nature of today's international production. To Smith, the secret of the Industrial Revolution lay in the huge productivity advances that resulted from the division of labor—the separation of the production process into discrete tasks. He illustrated his point with the now-immortal Scottish pin factory. Smith figured that in an eighteenth-century factory employing ten people, each laborer could produce about 4,800 pins on a given day. He assumed that this was possible if the firm separated the manufacturing process into some eighteen different operations—drawing the wire, straightening it, cutting, and so on. On the other hand, if these same ten people "wrought all separately and independently," they could scarcely make 20 pins and possibly not one. "In every other art and manufacture," Smith professed, "the effects of the division of labour are similar to what they are in this very trifling one."[3]

No doubt even Smith would marvel at how the division of labor has extended from the shop floors of Glasgow to the world stage. Now that multinationals have created the Global Factory,[4] scholars have emphasized the production side of the global economy, although in a way quite different than the kind of argument used by today's supply-side economists. Some economists refer to the Global Factory notion as a new *international division of labor* (IDOL).[5] In the old, "colonial" IDOL, advanced nations produced and exported manufactures, while less-developed ones extracted and exported raw materials. In the new IDOL, manufacturing processes and functions are spatially separated and diffused worldwide. MNCs ship routinized operations to less-developed nations, while administrative and control functions remain in mature industrialized countries.*

International wage differentials drive the new IDOL toward less-developed nations. Seeking cheap labor for assembly-type operations, MNCs have scattered plants across the Pacific Rim, the U.S.-Mexican border, Spain, and elsewhere. With workers paid only a fraction of what they receive in the developed world, less-developed countries would seem to be the logical choice for routine assembly operations in electronics, textiles, apparel, and many other industries. For example, wages in the Far Eastern apparel industry range from $0.18 per hour in In-

* Stephen Hymer was the first to recognize how the MNCs' geographical disengagement of control from production was leading to a dualistic spatial division of labor on a global scale.[6]

donesia to $1.89 in Hong Kong; U.S. apparel workers, by contrast, make $7.41 on average.* In chapter 6, we will explore the new IDOL in depth.

For now, suffice it to say that a cheap-labor direct investment strategy is limited.† Foreign investment in less-developed countries, though growing rapidly, is still small compared with direct investment in the developed nations. The difficulty with looking at only the production (cost) side of the global economy is that we cannot resolve an underlying paradox of international investment: foreign-based MNCs establish branches in the United States even as American multinationals invest overseas. This irony was not lost on Akio Morita, Sony's chief executive: "One of my American friends recently said to me, 'Akio, I bought an American TV rather than a Japanese TV because we have a terrible trade deficit. I found out later that the American set was made in Taiwan, and the Sony set that I wouldn't buy was made in the United States.' "[9] Even Asian electronics producers that clearly benefit from labor-cost advantages at home, like South Korea's Lucky Gold Star and Samsung, have joined Sony by constructing new television-assembly plants in the United States.‡ All recent color receiver plants facilities built in the United States result from inward direct investment. Now Sony exports TV picture tubes from California while Sanyo ships luxury television sets from Arkansas. And in 1987, France's Thomson became the largest U.S. television manufacturer when it acquired the consumer products unit of General Electric, the company sparked by Thomas Edison's inventions a century before.[10] Zenith, meanwhile, is the only major U.S.-based multinational still making TVs in America.

Hence, the Global Factory notion is important, but represents a one-sided and somewhat inadequate explanation of modern international location dynamics. International competition entails more than placing plants around the world so as to increase productivity and lower costs effectively. Rather, the problem is where to sell products and increase market share. As Adam Smith noted in *The Wealth of Nations*, "the power of exchanging" and the "extent of the market" put a limit on productivity gains associated with the division of labor.[11] The firm's ability to engage in specialized production and to sell sophisticated

* The apparel industry wage figures are in U.S. dollars and measure compensation per hour in 1986.[7]

† This point is found in Erica Schoenberger's critique of the "one-dimensional" labor-cost bias of the new international spatial division of labor literature.[8]

‡ According to Bureau of Economic Analysis data, there is a close symmetry between outward and inward investment in the radio and television industry: in 1985, USDIA amounted to $2.3 million, compared with $2.2 million for FDIUS.

products depends on a well-developed market system. Often, Smith observed, the first industrial improvements appeared on a sea coast because ports provided access to the world market.

Today's multinational corporations break all national and spatial barriers in their way in their quest for sources of demand. MNCs look at the world as their market, as the Global Shopping Center complementing the production-oriented Global Factory.[12] Capitalism sometimes poses the conundrum of *too much* productive capacity relative to effective demand by consumers, businesses, and governments. This raises one of the most vexing problems in the capitalist system, the one most often associated with the analysis of John Maynard Keynes: purchasing power must expand in approximate balance with increasing productive potential. Beginning in the early 1970s, for example, there has been a substantial increase in real industrial output worldwide. Relative overproduction in steel, semiconductors, chemicals, heavy equipment, and many other industries has dogged the world economy.[13] Since, overseas, many nations built more capacity than necessary to serve the internal market, the limits to global expansion are not on the supply but on the demand side. MNCs need an expanding world market, both for consumer and producer goods.

Multinationals, American and non-American alike, recognized that market potential in less-developed countries was scant in comparison with developed nations. Long before crushing external debts stifled purchasing power, the Third World was a thin market for many commodities, especially for products that appealed to middle- and upper-class tastes and catered to special market segments. Advanced nations are often the only outlets for the sophisticated commodities produced and sold by many MNCs. Accordingly, much of today's FDI flows not between the developed and underdeveloped world, but within the advanced sector of the capitalist world system.

The Allure of the American Market

Inevitably, the spotlight focused on America. Foreign investment in the United States is entirely understandable from a demand-side perspective. The élite hub of the Global Shopping Center, the U.S. market is like no other in both volume and variety. It is the world's leading source of demand for most goods and services, a land of high discretionary income, of warehouse food stores and computer fairs, of outlet

malls and designer boutiques. Essentially, the strong U.S. market is the macroeconomic complement to the competitive advantages of non-American firms discussed in the last chapter. Even the licensing of American television and other technology only gave Japanese producers the ability to compete with America; they needed more than technology —they needed the U.S. consumer. Surveys and studies of foreign investors uniformly confirm that the immense size and diversity of the market is the primary reason that non-American corporations invest in America.[14]*

Conceivably, the foreign attraction to the lucrative U.S. market might have soured had the stagnation of the 1970s persisted. From 1974 through 1980, demand growth (adjusted for inflation) slowed to a crawl and actually fell below other developed nations (see table 4.1). But that's only half the story. At any level of demand, a nation's ability to consume rests ultimately upon its ability to produce—or to allow other nations to produce for it. Any time a nation's productivity (output per man-hour) lags behind demand growth, it is vulnerable to foreign competition. In fact, U.S. productivity growth flattened in the late 1970s and fell considerably below most other developed countries.† But even as the U.S. slid into recession in the early 1980s, the chief executive of Siemens maintained, "Despite short-term difficulties there is much to be said for the fundamental strength of the American economy."[18] From a foreign perspective, this "fundamental strength" was a failure of domestic production to match demand.

The Reagan supply-side tax cuts of 1981 promised to restore America's productive might, not aggregate spending. But the primary effect was to widen the gap between demand and domestic production. From 1980 through 1986, U.S. demand growth outstripped other developed nations, reversing the situation in the latter half of the 1970s (see table 4.1). Conversely, as spending boomed, the domestic saving rate plunged. U.S. consumer saving as a percentage of personal income fell from 7.1 to 3.8 between 1980 and 1987 (in comparison with the thrifty Japanese whose saving rate stood at 17 percent a year).[19] Along with the federal government, households and businesses kept spending but went deeper and deeper into debt during the 1980s. Household installment credit set

* A survey of German chemical companies reported that the main motives for direct investment in the United States were the size, growth, and stability of the U.S. market as well as the maintenance of markets already gained through exports.[15] Recent statistical analyses further support the role of market size.[16]

† Admittedly productivity is hard to measure, especially across international boundaries.[17]

TABLE 4.1

Demand Growth in Developed Countries, 1974–86

(Percentage Change)

Country	1974–80	1980–86	1974–86
USA	0.31	2.78	1.54
France	2.45	0.86	1.66
Germany	3.56	0.50	2.02
Netherlands	2.88	−0.64	1.10
United Kingdom	0.71	2.50	1.60
Canada	1.79	0.82	1.30
Japan	1.34	1.79	1.57

SOURCE: International Monetary Fund *International Financial Statistics*, various issues.

NOTE: Growth rates represent average annual compounded rates of change for real aggregate demand (nominal demand deflated by the consumer price index). Demand comprises all private and public spending (consumption, investment, and government expenditure) and includes imports.

a new record at 16.5 percent of total personal income in 1986. More than one-half of corporate earnings paid off debt service in the mid-1980s, compared with about a third in the 1970s.[20] Meanwhile, with consumers, businesses, and the federal government deeply in hock, there was little money left to invest in new plant and equipment. Less investment, in turn, meant lower productivity growth. U.S. productivity remained sluggish through 1987.[21] Indeed, the United States was the only major developed nation where real output grew more slowly than demand.[22]

The failure of domestic production to match spending gave an opportunity to increase market share to foreign competitors, many of whom were dissatisfied with their U.S. position. In electronics, for instance, while the United States commands 30 percent to 40 percent of global demand, Siemens, Europe's largest electronics company, still derives only 10 percent of its sales in the United States.[23] The chemical industry represents another likely target for foreign producers since chemical firms are dependent both on large volume and on outlets for highly differentiated products. Until recently, many non-American MNCs had only a small percentage of their assets in the United States, although the United States accounts for about 30 percent of global chemical demand.[24] But foreign chemical companies are moving in rapidly by investing in basic chemicals, where only a few global companies can stay in business, and in specialty chemicals, where foreign MNCs aim to get a big share of smaller-niche markets. After Rhône-Poulenc paid

over half a billion dollars for Union Carbide's agricultural chemical business in 1986, the president of the French chemical giant stated, "You walk away from the U.S. market at your peril."[25]*

Why do non-American corporations choose investment over trade to exploit the American market? Foreign firms *could* export to the United States, but sometimes it is more profitable to serve the market from the inside rather than from offshore. Non-American MNCs find that a physical presence in the United States makes good sense for several reasons. First, they can save money on the transportation of goods from a factory at home to the distant market: companies pay lower freight charges and avoid custom duties when they move production stateside. Foreign investment can also drastically reduce turnover time on product orders. While it is clearly difficult to serve a consumer market from a distant site, reduced turnover time is important as well in meeting demand for factory goods. Furthermore, a local presence increases the firm's responsiveness to shifting consumer patterns and changes in tastes. Management consultants often point out that it is difficult to maintain a secure position in many markets unless a company establishes a local presence; otherwise, the company may lose the market's "feel."[27] Finally, market proximity allows for better adaptation to meet local requirements during the product-development stage and for better post-sales support. A German chemical executive explained, "U.S. customers are used to consistent supply: an overseas supplier will not be accepted in the long run, as his dependability is low."[28] When Minolta opened a facility to manufacture toner for copying machines, the president of the company made it clear that the move would "assure our customers a continuous supply of toner for their Minolta machines."[29]†

Acquisitions are the quickest means of establishing a presence in the vast U.S. market since production and distribution channels are already installed. Takeovers also provide foreign firms with an immediate American identity. Hoechst's Celanese, Nestlé's Carnation, or ICI's Glidden are readily accepted as American-made products. But the director in charge of ICI's American operations stated, "There is a danger of being seduced by size [of the U.S. market]. You have to be selec-

* "Walking away" from the market opportunities appears to be what American multinationals have done: the 1985 value of FDIUS in chemicals was $19.5 billion, almost exactly equal to the $19.8 billion U.S. chemical firms had invested abroad.[26] However, as we mentioned in chapter 2, one could quibble with the real meaning of these figures since they are imperfectly measured at historical cost.

† The value of the dollar, as we discuss later in this chapter, also played a role in Minolta's investment decision.

tive."[30] We know that many foreign companies have chosen to penetrate the U.S. market through selective takeovers, dovetailing the parent company's assets with "horizontally integrated" U.S. acquisitions. After buying Sunkist and Canada Dry from RJR Nabisco, Dominick Cadbury, the chief executive officer of Cadbury Schweppes, explained, "It's very difficult to start from scratch in any market and acquisitions are a very normal and practical way of establishing a foothold in the market. . . . We weren't satisfied with the small share of the U.S. market we had with Schweppes . . . and we felt the way to get a larger share was to acquire complementary brands that we understood and that were marketed in the same way as we had been marketing Schweppes."[31] Yet as we discussed in the last chapter, not all foreign MNCs are so cautious. By branching into new and unrelated endeavors, impatient capitalists risk being "seduced" (or "juiced" as may be the case with the Bronfman's purchase of Tropicana) by the U.S. market.

Although foreigners generally avoid new U.S. start-ups, when they do build assembly facilities they usually have wholesale subsidiaries already in place to market their exports. The rationale for shifting to FDI from exports becomes even clearer when we look at plant-location decisions across a product's "life cycle."* Economists typically delineate three stages in a firm's product cycle. During the *infancy* phase, the product is designed and tested in the marketplace. Firms tend to cluster their activities in the home country and sell to local consumers. Though they may begin to export, they keep production close to the original research-and-development and marketing centers. In the second, or *growth* phase, the firm becomes an active competitor in overseas markets. Here we find the chesslike strategic behavior normally associated with imperfect competition: action and reaction, move and countermove. Firms may establish production facilities in other developed countries to gain market share, in response to similar moves by their competitors or because of import barriers. In contrast with this market-driven strategy, during the third, or *maturity*, phase, production becomes standardized and requires cheap, unskilled labor. Production tends to filter into the less-developed world where production costs can be minimized, just as the new IDOL suggests. Thus, location decisions change over time, and nations hold different attractions to firms depending on the product life-cycle stage.

* The international-product cycle theory emerged to explain U.S. direct investment abroad in the 1960s with the work of Harvard's Raymond Vernon.[32]

While scholars sometimes criticize the life-cycle model for only explaining the overseas investment of American-based multinationals, the approach has some relevance to FDIUS. Most production by foreign investors in the United States is at an intermediate stage between growth and maturity, when marketing considerations matter most. Japanese investment, for example, resembles earlier shifts from trade to investment by American multinationals in Europe. (Japanese firms may have products at an earlier stage of the life-cycle than American firms in the same industry.)

A classic case is Sony, one of the first Japanese electronics companies to build a new facility inside the United States. During the 1960s, Sony targeted the U.S. consumer market and built up market share through exports. American consumers, who once spurned cheap, unsophisticated Japanese products, loved Sony's gadgets, and the company steadily gained brand-name appeal. The company became synonymous with quality electronics. It achieved one of its initial conquests with the Trinitron TV. With this product, Sony recognized that it possessed competitive advantages over American producers, including superior craftsmanship and technical innovation in component design. When Sony first began assembling televisions in the United States in 1970, the company was already so well known that it did not have to advertise for employees.[33] Today Sony's U.S. employment exceeds 7,000 people, over one-seventh of its global workforce. In explaining why his company manufactures in America, Sony's chief executive officer, Akio Morita, gave the definitive response of a firm in the growth phase of its life cycle, emphasizing markets and downplaying cost considerations. "Our policy is to make products where the market is. In 1970, we decided to build a factory to produce television sets in San Diego. At the time, it took 360 yen to buy a dollar, so operating costs in the United States were much higher than in Japan."[34]

Sony calls its strategy *global localization*. Almost two decades after their original U.S. investment, Sony representative Chris Wada stressed that the global localization strategy—to design, engineer, and manufacture close to the final market—still guided the company: "Clusters of factories and servicing facilities will be located in each area, such as Europe, North and South America, South East Asia, and Japan. This might become some trend for others as well as it seems to serve the world market best."[35]

Throughout the 1970s, many overseas firms were less enthusiastic about global localization, the notion of "making products where the

market is." As long as the U.S. market was accessible to foreign-made goods, most kept production at home. Shoes, computers, machine tools, and steel represent just a few of the goods that saw great increases in imports in recent years. The trade deficit in automobiles grew by 1,000 percent between 1972 and 1987. In all, imports (excluding oil) accounted for 23 cents of every dollar earmarked for consumption in 1987, rising from 16 cents as recently as 1982.[36] But U.S. consumers are not entirely to blame for the "orgy of spending" on foreign goods. U.S. business has increasingly imported ingredients for various stages of domestic production. A 1987 survey by the National Association of Purchasing Management found that 88 percent of U.S. manufacturers relied on foreign parts and materials.[37]

Thus, foreigners found, and exploited, important gaps in America's markets left open or abandoned by domestic producers. As exports lagged behind imports, the United States ran a merchandise trade deficit in every year since 1975. The trend worsened as time went on, the 1987 merchandise trade deficit reaching $171 billion. During that year, the United States ran *quarterly* trade deficits that surpassed the *annual* deficit of 1981.[38] The deficit narrowed only slightly in 1988.

Japan and the newly industrialized nations of the Pacific Rim benefited the most from the import surge. But success on the trade front created its own nemesis: the rise of protectionist sentiment beginning in the late 1970s. The pendulum swung toward restrictive trade legislation, promoted by labor organizations, industry groups, and regions hard hit by imports and trade-related job loss. Many foreign-based MNCs were understandably sensitive to even the threat of protectionism, having obtained a strong foothold in the American economy. Import restrictions and a series of so-called orderly market agreements left foreign producers with little choice but to shift to direct investment if they wanted to maintain market share. In turn, direct investment was no longer a choice to weigh against exporting to the United States; it was essential if many foreign competitors wanted continual access to the market. Many opened a second front to penetrate the United States.

The influence of trade barriers on direct investment is an old phenomenon. A century ago, Washington protected young industries from foreign competition, and as a consequence stimulated an initial wave of direct investment. As William Lever, founder of Lever Brothers (now Unilever), observed at the turn of the century, "When . . . various restrictions hinder sales in a country, it's time to build there."[39] For Asian producers the time came in the early 1980s, with the U.S. trade restric-

tions, but this time tariffs were proposed not mainly to bolster infant industries but to help prop up America's flagging industries.

Japanese "greenfield" investment shows a particularly strong correlation with import restrictions. Mitsubishi Electric, Sharp, Toshiba, and Hitachi rushed to set up television factories following an import limitation agreement between Japan and the United States in 1977. Honda's decision to produce in the United States, and the subsequent "follow the leader" behavior of Japanese automakers described in the last chapter, began just after Japan assented to voluntary export restraints demanded by America. Administered by Japan's Ministry of International Trade and Industry, the agreement set quotas on Japanese auto exports to the United States. Japanese ball-bearing manufacturers and semiconductor producers have also constructed or acquired plants in direct response to trade restrictions.[40] Essentially, by setting up plants in the United States, foreigners believed they would blunt protectionist sentiment, surmount trade barriers, and augment their standing in the U.S. market.

The Advantages of America's Open Access

Long-run market potential, coupled with the threat of exclusion as import penetration rose, exerted a major pull on direct investment. But other factors played a supporting role. Specifically, the United States is decidedly dedicated to capitalist production. As one German investment analyst said, the nation is *"die Bastion des freien Unternehmertums"*—the bastion of free enterprise.[41] In any language, America translates into capitalist Mecca.

A FAVORABLE LABOR CLIMATE

The New Competitors are especially attracted by America's *labor climate*, in which they can exert more control over production than is often possible in their native country. European and Canadian businesses do not have to worry as they do at home about worker participation in managerial and manpower decisions or labor's influence over working conditions. As a general manager of a French subsidiary stated, "What the French investor loses in wage costs, he makes up in lower fringe costs and in greater managerial flexibility, including the freedom

to fire workers when he wishes."[42] Indeed, some investors (especially the Europeans) believe that even unionized American workers are relatively docile for an advanced capitalist nation. As European labor grew increasingly militant and demanded a greater role in firm decision making in the 1960s and 1970s, the less politically active, more malleable U.S. labor force became more attractive. Foreign executives consistently praise the "dedicated" and "conscientious" labor force in the North as well as the South.

The labor climate is part of a generally hospitable economic environment in the United States. Barring another war, it is virtually impossible to conceive of a scenario under which a nationalist campaign against alien ownership would succeed in restricting the repatriation of multinational profits, nationalize assets, or otherwise interfere with a corporation's activities in any fundamental way. Foreign capital is "safe." Deviations from this policy occurred only in late nineteenth-century campaigns against alien ownership and during war years with the confiscation of enemy property. Moreover, America has imposed few restrictions on direct investment, even during periods of rising sentiment against imports.

The "safe haven" and open-investment attitude afforded multinational capital in America is not a given in other developed nations. During the 1970s, before Margaret Thatcher's election, many British capitalists were particularly concerned about investing in Europe. Among others, Sir James Goldsmith and Britain's Hawley Group turned toward the United States because they feared spreading European democratic socialism,[43] which, until "privatization" became the vogue in the middle of the 1980s, could mean nationalization. Foreign multinationals also worried that socialist governments might institute exchange controls and/or restrict the repatriation of profits. Others faced limitations on foreign involvement in sensitive and strategic industries in countries like Canada and Japan. Not so in America.

EASY ACCESS TO TECHNOLOGY

Foreign firms are even free to tap into America's reservoir of technology and innovation. And acquiring technology is another important reason that foreigners invest in the United States. Although the U.S. technological lead has slipped over the past fifteen years, it is still the world's major seedbed of innovation, and foreigners have invested heavily in new technology-intensive companies. As product lines mature

and markets become saturated, firms must replace old lines and develop new ones.

Since the early 1970s, analysts have linked direct investment in the United States to "technology assimilation."[44] They have found that foreigners often strive for a controlling interest in American corporations as an effective means of obtaining future competitive advantages. Accordingly, economic nationalists complain that the United States is *too* eager to welcome foreign capital. To them, foreign investment brings technology theft. William Casey, the late CIA director, caused a major stir when he forewarned that foreign investment was a part of a foreign-run espionage operation to pilfer American trade secrets, a "Trojan Horse." Martin and Susan Tolchin echoed Casey's admonition, calling inward investment "deceptively friendly and fraught with danger."[45]*

But assimilating U.S. technology is rarely clandestine. To the contrary, foreign firms openly buy American assets to stay abreast of the latest trends in marketing, production, and technology. A case in point is Unilever's acquisition of Chesebrough-Pond's. Acquiring Chesebrough's brand names allowed Europe's largest manufacturer to get in a much stronger position in the innovative American consumer-products market. A Unilever executive stated, "The United States is a particularly innovative market. . . . Many things are developed here before they are developed elsewhere. . . . It just happens you are more likely to come up with the next generation of innovative products if you have a strong base in the United States."[46]

Foreigners also fund emergent technology start-ups to keep abreast of "cutting edge" developments in the United States. Of the $2.3 billion in venture capital funds in 1985, almost one-fourth came from abroad.[47] Many risky U.S. ventures could not, in fact, survive without foreign money, especially from the Japanese, who have been conspicuous investors in the venture-capital sweepstakes. The large *sogo shosha*, Mitsui and Mitsubishi, are major investors in venture-capital partnerships and in small venture-backed companies—as are lesser-known concerns trying to break into the ranks of the global corporate hierarchy. For example,

* The example the Tolchins use to corroborate William Casey's Trojan horse metaphor is a Soviet attempt to buy several small banks around California's Silicon Valley and South Lake Tahoe, California. Although the Soviets did succeed in temporarily acquiring an interest in several California banks, some of which had made loans to high-technology companies, the deals took place over a decade before Casey's announcement or the publication of the Tolchins' book. The whole incident appears to be isolated; and a more current example of a Red plot to steal U.S. technology would have been more persuasive.

Japan's Recruit Company, a scandal-plagued advertising, communications, and real estate concern, funded a U.S. start-up that plans to market a new teletext service. Kubota, a Japanese tractor company, invested in two up-and-coming high-technology firms located in California's Silicon Valley: MIPS, a microprocessor design house; and Ardent Computer, a superminicomputer firm. From these firms, Kubota learned how to make supercomputer engineering work stations, another product the Japanese may soon export to America. Elsewhere, the Kirin Brewery Company has sunk $3 million into Plant Genetics, hoping to plant the seeds of future product development; the California biotechnology company is attempting to develop new disease-resistant strains of agricultural products.[48]

Venture-capital funding is just one means of assimilating U.S. technology advances. Foreigners also create their own U.S. research and development labs. Recent figures show that foreign-affiliated companies account for over 10 percent of all U.S. spending for industrial research and development.[49] However, because foreigners often situate their R&D facilities close to American centers of innovation like the Silicon Valley and Boston's Route 128, critics view this as another attempt to pirate U.S. technology. Foreign R&D labs are seen as technological surveillance operations or as attempts to siphon off domestic firms' technical, engineering, and scientific talent in an attempt to absorb their proprietary knowledge. No doubt foreign firms hope to use the know-how gained through their U.S. R&D subsidiaries to bolster their competitive position both at home and in the United States.

It is impossible to characterize the motives of all foreign firms, but one could argue that foreign-funded research and development is positive: the New Competitors are committed to placing high-level operations in the United States and are not focused exclusively on boosting market share for products developed at home, in line with the product-cycle theory. Thus, some foreign companies are becoming technological pioneers in the United States, with a long-run vision often lacking in domestic corporations. Bayer USA, for example, proudly broadcast that it devoted $200 million to research programs in 1986. Siemens immodestly claims it is "inventing the future" in America with a major research center and twenty-three development labs scattered throughout the United States. In chapter 5, we will take a closer look at the positive contributions of foreign MNCs. Here we simply note that there is little evidence that foreigners are violating U.S. laws or "stealing" technology by using FDI. Even if they do assimilate U.S. technology, it is just another means of competing in "*die Bastion des freien Unternehmertums.*"

The Dollar's Decline and the Great Debt-for-Equity Swap

Most of America's attractions have not changed drastically over the past decade. The U.S. has long been the world's largest consumer. Its openness to investment and its opportunities for technology assimilation have not appeared suddenly. But the new wave of foreign capital sweeping America in the late 1980s is quite unlike previous periods of FDI growth. When the nation began running astronomical budget and current account deficits,* the United States became dependent on inward foreign capital flows. The deficit-driven and capital-starved economy of the 1980s required foreign funds, providing an unprecedented opening for foreigners to achieve their long-run goals.

Hence the United States can no longer set new international policies without considering the consequences on inward investment—the lesson learned by the sequence of policies that culminated in a weak dollar during the late 1980s. Vexed by a triple threat—the twin budget and trade deficits combined with the world's largest international debt —the United States followed a path that led inexorably to a substantial rise in foreign takeovers.[50] Figure 4.1 shows how these problems have grown over time.

America's policy morass originated with the well-known rise in federal budget deficits beginning in the early part of the decade, which, early on, pushed real interest rates higher (by which we simply mean nominal, or observed, rates adjusted for anticipated inflation) as federal borrowing competed with private sources in the capital markets. Domestic demand rose, but was not accompanied by an equivalent rise in domestic savings; into this vacuum rushed foreign capital. To help fund our budget deficits, the U.S. Federal Reserve Board maintained high real interest rates to attract foreign capital. Thus, in order to attract this money, the United States had to tolerate high interest rates, certainly higher than if we were not so dependent on foreigners to fund the federal debt. After all, portfolio investment can be withdrawn instantaneously if interest rates are higher elsewhere. As a result, U.S. interest rates rose above those in America's major trading partners (see figure 4.2). And what would have happened if foreign capital was not enticed by this disparity in international interest rates? In the absence of foreign

* The current account includes the balance of imports and exports (the merchandise, or trade, account) plus trade in insurance and banking, spending by tourists, profits earned overseas, interest, foreign aid, and individual gifts.

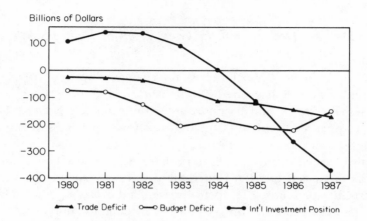

FIGURE 4.1

The Triple Threat: The Twin Deficits and the Growing International Debt.

SOURCE: Council of Economic Advisors, *Economic Report of the President* (Washington, D.C.: U.S. Government Printing Office, February 1988).

capital flows, the U.S. government and private domestic investors would compete for a more limited supply of savings and inevitably bid up the price of obtaining capital (interest rates). Steven Marris, an economist at the Institute for International Economics, estimated that real interest rates would have risen 3.5 to 5.5 percentage points higher without the foreign portfolio investment surge beginning in 1983.[51] Consequently, interest rates would have gone even higher, probably provoking a recession.

But this is only part of the story. After the economy recovered from the very deep recession of the early 1980s, a strong dollar helped push the U.S. trade imbalance to historic peaks. High interest rates in the United States helped strengthen the dollar as overseas portfolio investors perceived a growing disparity between the yield on U.S. bonds and the return found in other countries. To purchase U.S. securities, foreign investors needed dollars, and the demand for greenbacks rose on the foreign exchange market. Essentially, foreign portfolio investors lifted the dollar's purchasing power, making it cheaper to import and more expensive to export, thus reinforcing the long-run erosion in America's trade balance. Foreigners sold us more goods; we gave them IOUs. FDIUS, on the other hand, slowed considerably as the value of the dollar appreciated in the first half of the 1980s.

This situation was quite unlike the rise of trade imbalances of the 1970s, when America was still a net international creditor. Only a decade

FIGURE 4.2
Global Trends in Real Long-Term Interest Rates.

NOTE: Real long-term interest rates are 10-year government bond yields less an estimate of expected inflation; inflationary expectations are calculated as a weighted moving average of five years of consumer price index–based price changes with declining weights of 5, 4, 3, 2, and 1.
SOURCE: Stephen S. Roach, "Hooked on Foreign Investment," *Morgan Stanley Special Economic Study*, 13 April 1988, p. 8.

ago, the United States earned enough money through interest payments and profits on foreign operations to offset the merchandise trade deficit (the excess of imports over exports). But the deficits grew so large that they pushed the United States into its now dubious status as the world's largest international debtor in 1985 (see figure 4.3). Interest on that debt represents a net loss of wealth to the U.S. economy—and means that the United States needs to boost imports, reduce exports, and attract capital inflows to fund a growing balance-of-payments gap.

By the mid-1980s, the trade deficits appeared to be spinning out of control. Ultimately, the failure of export growth to balance import growth culminated in a great trade crisis,* and pressure built in Washington to restore balance on the international trade accounts. The vast and growing trade deficit and the reversal in international indebtedness became the rallying cries for campaigns to restore international competitiveness. Reaganomics preached laissez-faire, but something had to be done to bring America's appetite for foreign goods in line with its ability to vend its wares abroad.

* Note that it was the failure of exports to keep pace with general economic activity, not just import penetration, that was responsible for the trade deficit.[52]

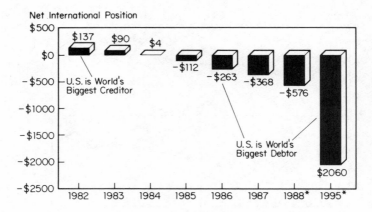

FIGURE 4.3

The United States Becomes a Debtor Nation.

SOURCE: *Economic Report of the President*, 1988; U.S. Department of Commerce, Bureau of Economic Analysis, projected by Congressional Research Service.

Further import restrictions provided one solution. At least in rhetoric, the Reagan administration resisted the protectionist pressure, but ended up executing restrictive policies on a case-by-case basis, thus avoiding a general tariff increase. This policy itself, as we have argued, shifted some foreigners into direct investment from trade.

Nevertheless, the trade deficit mounted, and so did the public anxiety. To resolve the crisis and temper further protectionist sentiment, the Reagan administration first insisted that foreign countries running huge trade surpluses "stimulate" their economies in order to attract U.S. exports. When it became apparent that the pleas fell on deaf ears, a set of closed-door international meetings took place among the leading industrial nations. While the United States had committed itself to free exchange rates, it began to look at a weak dollar as a general solution for the restoration of U.S. competitiveness. In fact, by 1985 the dollar had begun to fall. With the Plaza Accord exchange rate policy of September 1985,* the United States rallied foreign central banks (Japan, West Germany, France, Great Britain, Canada, and Italy) toward a *managed* dollar decline. The cheaper dollar was the last hope to improve the American trade balance by making our goods less expensive when sold abroad and

* At New York's Plaza Hotel in September 1985, the United States's strategy (in cooperation with other industrialized countries) was to cut sharply the dollar's value as a means of reducing global trade imbalances. That strategy was followed until February 1987, when the major industrialized countries sought an end to the dollar's decline and currency stabilization (the Louvre Accord).

to make foreign goods more expensive here. Consequently, the value of the dollar against the German mark, Japanese yen, and British pound fell precipitously over the next two years. The yen, for instance, plummeted from about 250 to near 120 to the dollar.

Note, however, that a soft-dollar policy is essentially a tacit policy of protectionism. As the Harvard economist Lawrence Summers put it, "A ten percent decline in the dollar exchange rate is equivalent to a ten percent tariff on all imported goods and a ten percent subsidy on all exported goods."[53] Many other analysts agree: the dollar's decline after 1985 meant an across-the-board tariff on all goods. Indeed, the falling exchange rate of the dollar was larger than any explicit tariff imposed in recent memory.[54]

But the problem remained: how to recycle the mass of dollars accumulated abroad alongside the negative balance of trade. Although the 1985 initiative was designed primarily to get foreigners to buy cheaper American goods and stimulate U.S. exports, many foreigners took the dollar surpluses and traded them for hard American assets—real estate, resources, and companies. Foreigners needed some place to park the mass of dollars accumulating abroad. When high real interest rates prevailed in the United States, the funds went primarily into portfolio investment, including U.S. Treasury securities (supporting the federal deficit), corporate bonds, and stocks. Foreign purchases of U.S. securities more than doubled in 1984 and again in 1985. But interest rate differentials began to narrow. Meanwhile, as the dollar tumbled, direct investment began to pick up dramatically in 1986, swelling by a record $34 billion. That year brought the first signs of a shift into hard assets from portfolio investment. The following year, private foreign investment in U.S. securities actually dropped significantly; while direct investment in real estate, companies, and other assets continued to reach new peaks (table 4.2).

The important link in the chain that led to the debt-for-equity swap, then, was the dollar devaluation that gave foreigners even more capital to spend. Unlike previous periods, when the dollar began its descent in 1985 it came as the United States went from being the world's largest creditor to the world's largest debtor.[55] The weak dollar gave foreign investors a historic opportunity to turn their debt, built up through years of trade surpluses, into an equity stake in America.

Then, on a fateful Friday in October 1987, the former U.S. secretary of the treasury, James Baker, spooked Wall Street by suggesting that the dollar would have to fall further. Black Monday followed Baker's statement, which accompanied government figures showing a continuing

TABLE 4.2

Asset Shifts of Foreign Investors (1980–87)

	Capital Inflows Into the U.S. (Billions of Dollars)				Ratio of Direct Investment to:	
		Private				
	Total (including public)	Total	Direct Investment	U.S. Securities	Private Capital Inflow	Foreign Purchases of U.S. Securities
1980	58.1	42.6	16.9	8.1	0.40	2.09
1981	83.0	78.1	25.2	9.8	0.32	2.57
1982	93.7	90.2	13.8	13.1	0.15	1.05
1983	84.9	79.0	11.9	16.9	0.15	0.70
1984	102.5	99.5	25.4	35.6	0.25	0.71
1985	129.9	131.0	19.0	71.4	0.15	0.27
1986	279.7	185.7	34.1	74.7	0.18	0.46
1987	195.4	166.5	42.0	34.6	0.25	1.21

SOURCE: Russell Scholl, "International Investment Position of the United States, 1987" *Survey of Current Business*, June 1988, p. 77; Stephen S. Roach, "Hooked on Foreign Investment," Morgan Stanley Special Economic Study, 13 April 1988, table 2, p. 7.

deterioration in the trade account. The stock-market crash intensified the foreign acquisitors' quest for undervalued assets. Throughout the mid-1980s, for example, Hanson Trust had $10 billion earmarked for takeover activity. "It's a time of increased opportunity," proclaimed a company director immediately following Black Monday.[56] Said a director of Britain's Saatchi & Saatchi, "With the dollar where it is, there are opportunities now in the U.S. that won't be there in two, five or ten years' time."[57]

As a result, the dollar policy has helped push foreign multinationals from trade into direct investment. The low dollar provided one additional bonus: it reduced U.S. production costs *vis-à-vis* other nations. The currency realignment after September 1985 adversely affected Japanese producers more than those of any other nation, since the yen appreciated far more rapidly than the currencies of other developed nations. The currencies of the newly industrialized countries of the Pacific Rim (Hong Kong, Taiwan, South Korea, and Singapore) actually depreciated against the dollar in 1986. Thus, nowhere did production costs, as measured by prevailing exchange rates, rise as they did in Japan. The Japanese response was immediate: direct investment outlays in 1986 jumped three and a half times over 1985, a leap that surpassed that of any other nation (see table 2.2). With the dollar rapidly depreciating against the yen, Japanese business executives often cited the exchange rate as a major reason for that nation's investment surge. For

example, months before the Firestone buyout, an executive from Japan's Bridgestone summarized the view of many Japanese businesses: "To be frank, in dollar terms, exports aren't profitable."[58] In other words, exchange rates seem to matter when it comes to shifting from exporting to direct investment.

The Challenge to America

More than any other recent event, the rush of foreign investment after the dollar's decline sparked the growing debate over the "selling of America." Combined with lower stock prices, the falling dollar stimulated the megatakeovers of U.S. corporations and real estate assets described in chapter 2. To many Americans the weak dollar represented a "fire sale" of the nation's assets, an alarming new side to the larger debate over U.S. global competitiveness, picking up where the debate over the nation's trade deficit left off.

Nevertheless, it is important to bear in mind that exchange rates primarily influence the timing of foreign acquisitions. Long-term investment decisions are based on more fundamental considerations, such as the need to better serve the U.S. market. Non-American corporations must compete, not only through size and know-how, but in cost, delivery, and support services, and that often means shifting from exports to direct investment. Sony's Akio Morita made it clear that the market, not currency rates, mattered most in his decision to enter the United States in 1970, when the dollar was strong relative to the yen. Because many veteran multinationals protect themselves by holding assets in many currencies, they are not always influenced by short-run exchange rate fluctuations. We should bear in mind that as foreign MNCs grew more competitive, the rich and diverse market drew them into U.S. production, before the dollar's decline in 1985.

Therefore, the "selling of America" is not linked to any one event, but results from even larger problems that have confronted this nation and its position in global competition. The first signs of competition appeared in the mounting U.S. trade deficits of the late 1970s and 1980s, not in FDI. The deficits arose out of macroeconomic policies run amok, which culminated in a historic turn from net international creditor to net debtor.

Our international debt situation makes things much more risky and potentially unsettling as we depend increasingly on foreign capital. The

problem reduces to simple arithmetic: a tremendous pool of dollar claims are built up somewhere in the world every time the United States runs a trade deficit; foreigners can hold those claims in portfolio assets like government securities, but if they want a long-term asset base and diversity, they choose direct investment. Sooner or later foreigners could demand higher returns or may withdraw their investments. Ultimately, they must have confidence in America's economic and political stability. Even if they do not divest, we also become poorer as a result of foreign debt. Already, the outflow of interest to the rest of the world has increased rapidly as portfolio investment has grown. We paid $24 billion in interest to foreigners on the federal debt during 1987, twice what we paid in 1980.[59] By the end of the 1990s, we will owe foreigners more than $1 trillion.[60] This means a loss in our standard of living. We will, as a result, have even less to spend and invest; foreigners will have more.

Thus we are dependent on foreigners not only because they are "invading," as some have said, but through our own policies. FDIUS is now closely tethered to U.S. macroeconomic and international trade policy, little though this situation was recognized only a few years ago. As long as the trade deficit exists, we must attract their investment: otherwise, interest rates could rise (because of a capital shortage), and the dollar would fall precipitously. We cannot block the investment, so we must reduce the twin deficits. At the same time, we must find ways of channeling investment into productive uses. In many ways, direct investment, when it means productive investment, is better than portfolio investment, since it can help restore U.S. economic clout and is not as prone to sudden shifts abroad. But simple "supply-side" tax-cut solutions will never work if they only stimulate spending and corporate takeover activity.

Following the failed policies of the Reagan era, America faces the momentous challenge of restoring its productivity and international competitiveness; how to meet this challenge is the subject of part IV.

PART II

The Domestic Consequences of Foreign Investment

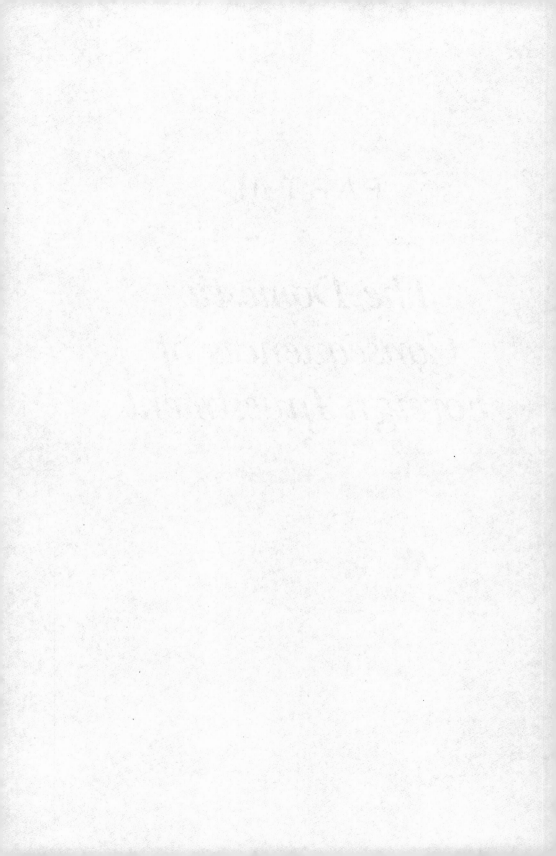

5

THE PROMISE
AND REALITY OF
THE NEW COMPETITORS

I N this part of the book, we examine the domestic consequences of foreign investment, both in this country and American investment abroad. First, we will examine what foreign investment in the United States promises, and then see how, and whether, that promise is fulfilled in terms of jobs and improved management and labor relations. Then we will turn to the other side of FDI—American direct investment abroad—and see what its effects are on our economy. And, finally, we will look in detail at how foreign investment affects particular regions and cities of the United States.

The Sun Also Rises?

During the 1970s and 1980s, the sun set on many American manufacturing firms. Widespread plant closures battered such mature industries as autos, steel, and textiles. This crisis in manufacturing has been analyzed by Barry Bluestone and Bennett Harrison in *The Deindustrialization of America*, in whose opening pages they lament the permanent

closing of fourteen steel mills and the layoffs of 13,000 workers by U.S. Steel in 1980.[1] To these observers, the steel industry symbolized *deindustrialization*—systematic disinvestment in the nation's productive capacity and loss of industrial jobs. They argued that if capitalism is a process of "creative destruction," as the eminent economic historian Joseph Schumpeter put it,[2] then deindustrialization is the destructive side. The trend resulted in part from investment abroad by American firms (see chapter 6), foreign competition, automation and labor-saving innovation, and the shift of employment to services. The deindustrialization debate sparked by Bluestone and Harrison revolved around manufacturing job loss. By any measure, the U.S. manufacturing workforce has been growing very slowly or declining since the late 1960s. After growing by 3 million jobs a decade between 1949 and 1979, manufacturing employment plummeted by 1.5 million jobs between 1980 and 1987. Further, Bluestone and Harrison documented the social costs of disinvestment. Plant closings caused a decline of workers' physical and mental health, lost wages, dwindling family wealth, underutilized infrastructure, and wasted productive potential. Deploring this "economic violence," Jesse Jackson put the issue in the forefront of his 1988 presidential campaign and won surprising support from voters.

But the sun also rises. By seeming to create rather than destroy jobs, foreign investment appears to reassert the positive side of Schumpeter's dialectic. By buying into this country, nondomestic companies counter the impression that the United States has lost its ability to attract and retain productive capital. If it is so hard to make a profit in the United States, then why do they flock here? Why—by investing in a wide array of industries—do foreigners seem so determined to succeed where many domestic companies have failed?

As we have seen, non-American multinational corporations hold a range of competitive advantages that could help revitalize U.S. industry. Not surprisingly, foreign firms have trumpeted their beneficial role in the economy. Germany's Siemens, for example, boasts of its 25,000 U.S. employees, its worker-training programs, and its R&D activities in multipage ads in *Business Week* and other business periodicals. Scores of articles provide free publicity glorifying the New Competitors' achievements. The U.S. Chamber of Commerce ran a cover story in *Nation's Business* under the banner "Corporate Immigrants Are Bringing Jobs, Money, and a New Way of Life."[3] No doubt there are sound reasons for such optimism about the prospects of foreign-led reindustrialization in America.

Although many New Competitors have created jobs and been cre-

ative and productive participants in our economy, it is easy to exaggerate the ways that they are "changing the face of our nation," as Martin and Susan Tolchin tell us in their generally unfavorable treatment of FDIUS.[4] Despite all that is written about the phenomenon, few analysts have carefully inspected the extent to which foreign firms have provided job opportunities and a "new way of life" for American workers. In fact, as we shall show, foreign companies do not create many, if any, new jobs for the U.S. economy; while some nondomestic firms have a poor track record, including plant closures, widespread divestitures, and sometimes-troubled labor relations.

Foreign Contributions to the U.S. Economy

Among important contributions foreigners have made to the economy, they paid out $87 billion in employee compensation in 1986. One Commerce Department analyst estimates that foreigners paid about 25 percent more per worker than U.S.-owned companies in 1982, although precise comparisons between American and foreign companies are difficult to make because of data restrictions.[5] Foreigners can pay well partly because they are concentrated in high-paying oligopolistic manufacturing industries. As we have seen in chapter 3, foreign multinationals are able to exploit a wide range of competitive advantages, by virtue of their size, marketing and technical proficiency, access to capital, better management, and strategic planning. They have brought new products and modern production techniques with them.

Foreigners have been active in many industries abandoned by American firms. Even steel, the symbol of America's atrophied smokestack industry, saw a foreign-led industrial renaissance, being, as we saw in chapter 2, a major target of foreign investment. In 1984, for example, Japan's Kawasaki Steel and Brazil's Companhia Vale do Rio Doce bought a plant from Kaiser Steel and renamed it California Steel. Although saved from closing, the company changed dramatically, from an integrated mill to one that made only rolled steel. Still, a California economic development official said, "You wouldn't have a steel industry in this state if it were not for foreign investment." The same could be said of many midwestern states, where Kawasaki steel has introduced the world's best steel-making technology at its Armco mills.[6] Elsewhere, Nippon Kokan Steel has been pumping new technology into its partner National Steel. The resurgence of the American foundry was capped

when Inland Steel and Japan's Nippon Steel announced I/N Tek in 1987. This joint venture created a state-of-the-art steel mill in New Carlisle, Indiana, prompting Indiana's lieutenant governor John Mutz to declare, "The very future of domestic steel depends on investment like this."[7] Mutz's message resonates throughout the country, as FDI raises hopes for new jobs, new technology, and new management expertise. After Hitachi announced a plant opening in Norman, Oklahoma, in 1985, the move "made headlines almost equal to the first man on the moon," says the former Oklahoma governor George Nigh who actively recruited the firm.[8] As we mentioned in the last chapter, some foreign firms have even become exporters and thereby may help reduce America's massive merchandise trade deficit.

The enthusiasm for foreign investment goes beyond direct employment expansion. FDIUS promises additional job opportunities through linkages with local suppliers. When foreigners invest in new plants, they create jobs not only directly, but *indirectly* as they buy inputs for their products from suppliers who employ more people. If those inputs are bought from American companies or foreign companies producing in this country, the impact of a new plant extends well beyond its own direct employment. More jobs are created in the company's supplier industries, meaning more income for American workers. Moreover, by providing direct income to U.S. residents, foreign firms boost retail and other businesses as the money is spent locally. When a new foreign plant opens, the injection of new money into the local economy touches off a cycle of spending and income *induced* by the original investment and subsequent job creation. For example, one study estimated that each $1.00 of direct increase in basic steel output generates $2.20 of total output as the steel industry creates demand in the mining, transportation and warehousing, business services, utilities, construction, and manufacturing industries. Every $1-billion increase in steel output creates over 52,000 jobs through the multiplier effect.[9] Thus, foreign steel firms can create many jobs with their investments. The more that inputs are bought locally, the greater the impact on the community. The more that inputs are imported from abroad (or from other parts of the country), the smaller the local impact. Therefore, the size of the "local content" of a foreign company's operations—how much it buys in the area—is critical in understanding the effects it will have on the economy.

Besides these quantitative effects on U.S. employment and income, foreign multinationals may revitalize American industry by introducing new technology, managerial skills, and labor practices. As we discussed

in chapter 3, Japanese firms have introduced the "just in time" (JIT) system (also known as *kanban*) which minimizes inventories and cuts costs. Many U.S. firms later adopted JIT. Thus, foreign firms have demonstrated that it is still possible to produce efficiently in the United States, even in smokestack industries once thought to be in irreversible decline. The objective of I/N Tek, for instance, is to slash the production time of cold-rolled steel from twelve days to less than an hour, and still produce the finest steel in the world.

Not only have there been investments by foreign MNCs, these firms have also become substantially involved in our political and cultural life to an extent far beyond job creation.[10] More *sushi* and *schnitzel* appear on restaurant menus, language classes abound, and local arts programs contain more opera and less bluegrass. Corporate leaders have also become heavily involved in philanthropy. One report in 1988 placed Japanese philanthropy at $140 million.[11] A Nissan executive ran Nashville's United Way drive in 1985. In Charlotte, North Carolina, foreigners, who comprise 7 percent of the population, are major supporters of an opera and symphony orchestra (which has a Dutch conductor). Canadian business firms endow academic chairs in Canadian studies, as other countries do for the study of their cultures. Japan's Mitsui and Mitsubishi have endowed sixteen chairs at U.S. universities; and Massachusetts Institute of Technology alone has created over a dozen academic chairs funded by Japanese multinationals.[12]

Some Japanese now live in semi-rural Middle American towns where they create demand for products and services. Several kinds of *tofu* and *samurai* movies can be found in small towns—developments that have taken some Americans by surprise. Many have sampled and adopted these exotic items. Workers with midwestern accents sometimes drop words like *wa* (meaning "harmony among people" in Japanese) in casual conversation.[13] The Japanese, like other newcomers, receive mixed receptions: some local people resent the influx; others welcome it. At any rate, Americans are being exposed to new social and cultural customs.

Hence the positive impact of direct investment spreads beyond the factory gates. Apart from their influence on community and political life, the New Competitors are showing domestic firms it is possible to compete from an American productive base. As they pump wages and salaries into the economy and bring in new management practices and technologies, they seem to be contributing to the economy. But that is only part of the picture.

The Uneven Record of Job Creation

One fallacy more than any other pervades the popular press: that foreigners have created millions of jobs in the United States. While it is true that almost three million Americans worked for foreign-owned companies in 1987, compared with only one million in 1974, it is definitely not true that foreigners generated two million *new* jobs.

JOBS FROM NEW PLANTS

To understand why foreigners have created fewer jobs than is commonly believed, we must look again at the way they enter the American economy. Without doubt, the start-ups of new plants add to the number of jobs. The Japanese have led all countries in greenfield investments, and the most often-cited example of job creation through new plants comes from the Japanese auto industry. Honda's Marysville, Ohio, factory, started in 1982, was the first Japanese auto transplant.* By the late-1980s, Honda employed over 5,000 workers and planned to add thousands more by the early 1990s in two more Ohio plants. Nissan employed 3,200 workers in Smyrna, Tennessee, by 1988 and was planning a joint venture with Ford to build trucks in Ohio; every major Japanese automaker played "follow the leader" by setting up its own assembly plants. Toyota, Mitsubishi, and Isuzu also built new facilities. These Japanese plants evoked an image of foreign start-ups sprouting jobs like wildflowers in spring.

But the reality is far different. A careful reading of available Bureau of Economic Analysis data dampens the excitement and fascination for foreign transplants. BEA figures show that new foreign-owned establishments created 90,000 jobs from 1980 through 1987, or an average of 11,000 jobs a year. The annual figures vary widely, however, as figure 5.1 shows. New establishments generated 14,072 jobs in 1981, but only 4,139 in 1984. The lower job gains in the mid-1980s were partly due to the strong dollar and the deep recession of 1982–83. By 1987, new-establishment jobs were rising: foreigners created just over 15,000 jobs that year.[14]† These small numbers—compared to the size of the U.S.

* Actually, the plant produced motorcycles beginning in the late 1970s; auto production began in 1982.

† These new-establishment jobs may include plant expansions, which we discuss separately in the text, and also are somewhat inflated because foreigners often report an anticipated job count that never actually reaches the tally provided to the Bureau of Economic Analysis.

economy—contradict the notion that foreigner start-ups are reindustrializing the country. Even if one assumes a very large multiplier effect, new foreign plants cannot be responsible for more than 30,000 to 40,000 jobs a year in an economy with more than 100 million workers. Greenfield investment is definitely not "creating [the] millions of jobs for Americans" that many writers on the subject claim.[15] Many states add more jobs each quarter than foreigners add nationwide in a year.

Although purchases from suppliers may generate additional jobs, these local linkages may be smaller for foreign than for domestic firms because foreigners often buy their inputs from their plants at home. One study estimated that the average Japanese automobile assembly plant in this country generated fewer than three supplier jobs for every assembly job, compared with a ratio of more than 4 to 1 for the average domestic automobile plant in the United States.[16] But there is some evidence that local supply linkages for foreigners are growing as foreigners build more supplier plants. By 1988, some 200 Japanese autoparts makers had followed on the heels of the Japanese MNCs; experts project that 300 parts makers will have set up operations by 1990.[17] Some American-owned companies in the mid-South and Midwest also benefited from the presence of Mazda and Toyota, especially since GM, Ford, and Chrysler are buying more of their parts offshore (see chapter 6). On the other hand, many of the New Competitors displaced American suppliers as they retained their ties to their traditional Japanese partners and successfully captured some of the business of our own Big

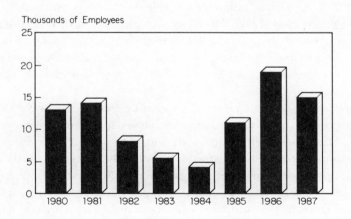

FIGURE 5.1
Employment from New Foreign Establishments, 1980 to 1987.
SOURCE: U.S. Department of Commerce, Bureau of Economic Analysis.

127

Three. In an era of overcapacity in this industry, there is likely to be a shakeout in the auto-supply industry. As an industry analyst put it, "There will be a bloodbath in the next recession as component companies are killed off."[8] Many of the dead will be U.S. suppliers, outgunned on their own battlefield by foreign companies. So the effect of foreign companies on supply operations is ambiguous: they buy local inputs and create additional jobs, but they also compete with and sometimes displace workers in domestic firms.

JOBS FROM PLANT EXPANSION

The source of most of direct job creation from foreign firms comes not from new plants but through expansions of existing facilities. In 1987, for example, Honda embarked on a $450-million expansion to boost its American engine-production capacity sixfold and to start producing transmissions, suspension assemblies, and brakes. According to the BEA, for large affiliates (with more than 500 employees), expansions of existing plants added nearly 300,000 employees from 1982 through 1986.* When we factor in smaller affiliates, we estimate the total jobs added to American payrolls through new plants and expansions is about 385,000. (In appendix B, we explain in detail this and the calculations that follow.) This sounds like a lot of jobs. It *appears* plausible that hundreds of thousands, perhaps even millions, of jobs were generated since the boom began in the 1970s. Through new plants and plant expansions, foreigners *directly* created about 75,000 jobs a year. A generous multiplier would perhaps triple that figure.

But, like American companies, foreigners close plants and lay off workers. The record shows that from 1982 through 1986, U.S. affiliates eliminated more than 442,000 jobs from their payrolls, about 88,000 a year. In fact, we find that foreigners *eliminated approximately 56,000 more jobs than they created*. Of course, the multiplier magnifies this job loss, to more than 100,000 jobs.

Since, as we said in chapter 3, foreign investment is always a risky and uncertain venture, our findings of job loss should not be a complete surprise. Many foreign enterprises are forced to scale back or drop out of U.S. competition. Despite expectations of high market penetration in America, optimistic plans often do not pan out. Even cautious Japanese companies, like Sumitomo Chemical Company and Tokyo Print Industries, have retreated or withdrawn. Japanese manufacturing companies have suffered continued losses, failing to meet with the kind of success

* The government provides figures for employment from expanded operations for large plants for only 1982 through 1986.

they anticipated in America. Some estimate that as many as four out of five Japanese factories are unprofitable.[19] Yet clearly many "patient" foreign multinationals are here for the long haul and are willing to hang in here until they make profits.

But just as there are expansions, there are also plant closures and layoffs. No case better illustrates this than Volkswagen, the first foreign company to assemble automobiles in the United States. In 1988, after a ten-year struggle to penetrate the U.S. market, Volkswagen abandoned the factory, leaving 2,500 employees jobless. Ironically, Volkswagen decided to shift much of its production to Brazil and to import VWs from there. A non-American MNC helped to deindustrialize the United States!

JOBS THROUGH ACQUISITIONS AND TAKEOVERS

Many economists argue that mergers and acquisitions are economically efficient because stockholders gain from higher stock-market prices, and management may become "leaner" as the pressure to show a good rate of return increases under the threat of a takeover. Others argue that many takeovers are speculative and do not create economic value. We side with the latter, but do not take up the debate here. What is interesting to us is that little of the discussion involves employment. We want instead to look at the potential effects on employment of foreign investment from mergers and acquisitions.

So far we have left aside the employment potential of acquisitions and mergers because it is difficult to measure accurately. Without better data than are currently available, it is often hard to tell precisely what happens when Nestlé buys Carnation or Seagram buys Tropicana. In some instances, foreign takeovers rescue the acquired corporations and save American jobs; other acquisitions restructure and liquidate U.S. companies, thus eliminating employment.

Consider first the positive side. If we ignore divestitures and liquidations for a minute, foreigners added 2.2 million jobs to their payrolls from 1980 to 1987 through U.S. acquisitions and mergers—over twenty-five times the amount of employment they created through new plants.[20]* Acquisitions may preserve jobs in failing American firms poised to shut down without infusions of capital. Many firms are performing poorly when acquired, their returns far below average on investment.[21] For all newly acquired U.S. businesses reporting to the U.S.

* These figures are inflated because many firms divested assets after the employment information was compiled by the BEA, as we will soon see in the case of the Campeau Corporation.

Department of Commerce, the average *rate of return* on sales (that is, net income divided by sales) is remarkably low, typically less than 2 percent a year and sometimes negative.[22] To survive, laggard firms often welcome both capital and the "intangible advantages" of non-American competitors. Once they acquire U.S. affiliates, foreign firms often reinvest their profits in their companies and try to build up their U.S. assets. Foreign takeovers during the 1970s helped turn around many affiliates, although one study—which showed that foreigners often bought weak firms and sometimes improved their performance—found "the gains tend to be modest."[23]

Many foreign takeovers *have* made a difference. Early in the 1980s, Britain's leading electronics firm, Plessey, set its sights on the thriving American telecommunications equipment market and acquired Stromberg-Carlson. Yet the 1982 takeover "drew more laughs than a Monty Python movie," for Stromberg-Carlson was a "stodgy little money-loser, suffering from a succession of owners, an unfocused strategy, and a boring product line."[24] Through superior management and technology, however, the British investors revitalized this once-listless firm. Now it appears that Plessey is getting the last laugh. By the mid-1980s, with the managerial and technical help it needed from its overseas parent, Stromberg-Carlson was turning a healthy profit and now commands a significant share of the telecommunications switching equipment business in the United States. In the service sector, lackluster food chains like Food Town found more people at their checkout lines when foreigners took over. These "patient" multinationals are here for the long run and believe that they have the competitive edge to prosper in the American market. They often create job opportunities through takeovers.

But U.S. jobs can also be *lost* through the process of acquisition and divestiture. The Canadian raider Robert Campeau provides an interesting example of the acquisitor-divestor in action. In 1986, his real estate firm, the Campeau Corporation, with $188 million in sales, bought the giant retail clothing chain Allied Stores. Here, a little fish swallowed a great big fish. Allied had sales of $4.5 billion that year.[25] The price tag was a hefty $3.6 billion; and the deal, according to *Business Week*, "advanced the art of the takeover."[26] Through this transaction, Robert Campeau got two things: first, he took control of some of this country's premier clothing stores, including the high-toned Brooks Brothers, Bonwit Teller, and Ann Taylor; second, he took on enormous debt, a direct result of this little fish's big meal. Campeau owed a staggering $2.1 billion by the end of 1988, with much more due later. In order to meet

these debt commitments, he sold off sixteen of twenty-four divisions within a few months: Bonwit Teller went to Australia's Hooker, Garfinckel's to Raleigh's, and Joske's to Dillard's—sales that raised about $750 million dollars by August 1987. Campeau kept only a few jewels, primarily Brooks Brothers and Ann Taylor.

But important for our story is the fact that 4,000 Allied Stores workers lost their jobs when the company was "restructured in order to pay off the debt."[27] The Allied story also shows how easy it is to misread the data on foreign investment. In tabulating the Allied deal, the Commerce Department reported that the number of Americans working for foreign companies went up by the number of those employed by Campeau's Allied *after* the divestiture—to the casual reader, thousands of people were added to foreign payrolls. But, as things turned out, there was net job loss as a result of the acquisition. More people had jobs *controlled* by Canada's Campeau, but fewer Allied people *had* jobs.

The Campeau story did not end with his capture and dispersal of Allied's assets. Early in 1988, he launched his biggest takeover bid by offering $6.6 billion for Federated Department Stores, the country's second largest retailer. To pull off this acquisition, he sold off Brooks Brothers (to England's Marks & Spencer) and Ann Taylor, the two remaining jewels of the Allied acquisition, and, even before completing the deal, arranged to divest $4.4 billion of Federated's assets. Figure 5.2 shows how Campeau's little fish ate two big fish.[28] During the spring of 1988, Campeau was looking to lay off enough workers to save $160 million. Within a few months of the takeover of Federated, Campeau fired 6,500 workers: he slashed Bloomingdale's staff by nearly one third, cut 794 jobs at Abraham & Strauss, 250 at Rich's in Atlanta, 1,200 at Lazarus, 320 at Burdine's, and 600 (25 percent of all workers) at Goldsmith's, among others.[29] This was only the beginning of what industry experts believe will be wholesale layoffs.[30] "Given the enormous number of jobs that have been eliminated, the morale is not good anywhere," said a former Federated executive.[31]

Further, the takeovers often drain resources from productive uses —modernizing and expanding plants—to strictly financial ones that produce little, if any, economic value—that is, corporate raiders buy and quickly sell off their U.S. assets. Apart from divestitures by raiders, foreign sales frequently come about when a multinational unloads a controlling share of stock in its U.S. affiliate. Often the sell-off represents the end of an American dream, a failure to succeed in the world's most important market. Renault couldn't make a profit with American Motors, despite deep cost cutting and pumping over $640 million dol-

FIGURE 5.2
Campeau's Little Fish Eats Big, Big Fish . . .
Divests Lots of Little Fish

lars into American Motors from 1979 through 1986. Hence the French state-run automaker sold its 46.1-percent interest in AMC to Chrysler in 1987.

Equally dramatic, West Germany's Flick Group suddenly chose to divest its 26-percent interest in W. R. Grace in late 1985—a sell-out that shocked Grace. Founded in 1854, Grace symbolized America's traditionally powerful multinational. Following the Second World War, the founder's grandson, J. Peter Grace, led the company into the big leagues of the global chemical business. Then he embarked on an aimless diversification drive into auto parts, office supplies, brewing, motor homes, and other sundry businesses. The conglomerate empire started to crack, and the company's earnings dove in the early 1980s. Compounding the New York–based company's problems, Friedrich Karl Flick (a close friend of J. Peter Grace) ceded control of the Flick Group to the Deutsche Bank. The latter wanted nothing to do with the ailing American MNC and, by selling off its holdings of Grace, effectively removed over 100,000 employees from the U.S. affiliate roster (so many jobs, in fact, that the total U.S. affiliate job count in manufacturing declined in 1986). Of course, not all of these jobs were lost; they were reclassified as domestic employment, as Grace bought back its own shares from Flick to fend off a hostile suitor. But to buy the stock, Grace had to sell off its entire retail business and cut the New York headquarters staff by 50 percent.

To be sure, not all foreign divestitures represent a decision to

retreat from the U.S. market, nor do they have wholly negative consequences. For example, A&P, the supermarket chain, was in bad shape before another West German company, the Tengelmann Group, took over and started selectively selling the U.S. affiliates' assets. Tengelmann sold off 600 unprofitable grocery stores and plowed capital into the remaining 1,000 units, making A&P profitable again.[32] There are many such recoveries, and they may mean that jobs are saved in the long run. Although divestitures sometimes bring layoffs, corporate restructuring and consolidation can strengthen troubled and capital-starved U.S. firms.[33]

FOREIGN JOB CREATION: LESS THAN MEETS THE EYE

As foreign acquisitors both buy and sell American companies, how many jobs do they actually create? According to the Bureau of Economic Analysis, foreigners added 547,927 jobs to their payrolls between 1982 and 1986.* This employment results from more than just the balance between new plants and expansions, on one hand, and cutbacks, on the other; it also comes through acquisitions and divestitures (sales and liquidations) of companies. Since acquisitions are much larger than new plants and expansions, we have to take account of their effect on employment. While many of these jobs were new, many were only apparently so. Let us think of the process as a job employment pool into which jobs pour through two faucets at the top and flow out through two drains at the bottom, as in figure 5.3.†

The faucet at the upper left represents jobs created by new plants (45,151) and plant expansions (341,281), thus unambiguously pouring 386,432 new jobs into the U.S. economy. In addition, acquisitions from the right-hand faucet added 1,381,690 more. Some of these were jobs that would have been lost, owing to a plant's poor performance, had not foreigners bought the plant before it was shut down, and thus saved them. It is impossible to tell exactly how many of these jobs were saved and how many were simply transferred from one owner to another, but the latter are definitely more prevalent. At any rate, taken together, new

* We analyzed only 1982 to 1986 data because these are the only years for which the BEA breaks down the components of employment change: that is, from new plants, expansions, cutbacks, and sales and liquidations (for more details, see appendix B).

† The BEA data give consistent breakdowns of new plants and plant expansions, acquisitions, sales and liquidations, and cutbacks only for affiliates with 500 or more employees; it does not cover consistently the activities of smaller affiliates. In addition to the larger companies, which account for some 90 percent of all affiliate employment, the results presented here include our estimate of the breakdowns for the smaller affiliates (see appendix B).

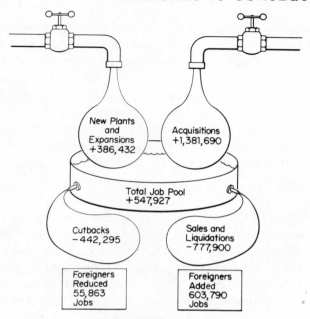

FIGURE 5.3
Do Foreigners Create New Jobs?
Source: U.S. Department of Commerce, Bureau of Economic Analysis.

plants, plant expansions, and plant acquisitions increased the *potential* foreign job pool by 1,768,122 workers between 1982 and 1986.

Now let's look at what happens at the bottom of the pool, as cutbacks and sales and liquidations of firms drain jobs. Cutbacks from existing plants drained off 442,295 jobs. As the multiplier worked to increase jobs through added purchases when foreigners created direct jobs, so the multiplier works to reduce (indirect) supplier jobs when cutbacks occur. Next, observe the bottom right side of figure 5.3. Although the BEA's reporting scheme lumps together sales and liquidations (we cannot separate the two categories), the largest component is sales.[34] Unquestionably, liquidation of a firm means job loss. But when a foreign firm sells some assets, the new domestic owner may save jobs and rebuild the company or eventually close it down. Thus, with a sale, as in the circumstances involving the "saving" of jobs through foreign acquisitions, it is impossible to tell whether there is job loss. All that the data allow us to say is that sales and liquidations of firms taken together resulted in 777,900 fewer jobs. So, when we finish pouring in new plants, expansions, and acquisitions and siphon off through the drain jobs from cutbacks and sales and liquidations, we have a total increase in the pool of 547,927 jobs. If foreign investment was only a matter of new plants

and expansions and cutbacks, there would have been a *net loss of jobs to the economy* of 55,863 jobs (386,432 jobs gained in new plants and expansions minus 442,295 lost in cutbacks).

In short, FDIUS is "creative destruction" in action, both spawning jobs and destroying them. The net result is job loss—that is, unless there is strong evidence for assuming that the vast majority of acquisitions saved jobs (that would have been lost had the acquired U.S. firm gone out of business). Even then, the net gain in foreign employment in the economy is strictly through takeover activity.

The period we examined (the only years for which data are available) included 1982, part of the deepest recession since the 1930s. Foreigners fired 140,000 workers that year. Of course, American firms also laid off workers—about 1.6 million—during the lean years of the early 1980s. To get a sense of what happened after the recession ended, we calculated the net jobs change for 1984 to 1986, when 5.1 million jobs were added nationwide. Of the foreigners' contribution to this job boom, there was a net increase of only 55,510 jobs (the employment gains from new plants and plant expansions minus cutbacks), an average of just under 17,500 per year. Once again, for the reasons discussed earlier, we leave out the net effects of acquisitions and mergers and sales and liquidations. In that case, foreigners contributed less than 1 percent of all U.S. job growth.

Anyway you look at the figures, even in a period of strong job gains, you end up wondering why so many people believe that foreign investment has created millions of jobs. Even in upswings, foreigners have added only a few drops to the large American job pool and are hardly "saviors" of American industry.

THE KINDS OF JOBS CREATED

Although few if any new jobs are created, the reindustrialization potential of FDIUS may come through technology transfer and high-quality jobs. Because of strict disclosure rules, the Commerce Department does not keep records on the kinds of jobs foreigners provide to American workers. There are no regularly collected data on how many scientists, managers, or janitors foreign companies hire. Therefore, it is hard to infer patterns of employment and compare them to domestic firms. We examined surveys and carried out our own and found that the evidence on employment is mixed: at times, foreign firms provide very good jobs; other times, they don't. Foreigners sometimes provide a lot of training for their American workers, but often simply look for cheap labor sites and invest little in their workforce.

One study of Japanese companies operating in the United States showed that they used similar technology and production techniques to those in their parent plants.[35] They stressed job training both in order to enhance the skills of their workers and to make them more flexible through job rotation. About twice the proportion of new workers in Japanese plants received training compared to their counterparts in American companies. Japanese companies invested more than four times the amount of training in new workers and twice as heavily in the training and retraining of existing workers as similar American companies. So the Japanese companies in this survey appear to be making important investments and thereby upgrading their workers' skills. This is a clear benefit to the U.S. economy.

However, another study of Japanese-American joint ventures showed that the jobs held by U.S. workers tend to be lower-level assembly positions rather than the better research and technical ones. Although a few Japanese have research laboratories in this country, these are rare: most such work is done in the home country. After all, foreigners come here for markets and to avoid protectionism. To many Japanese (as well as other foreign) investors, the United States is fundamentally an "assembly platform" where products are put together for sale in our market. They do not want to transfer the high value-added jobs and know-how to Americans but, not surprisingly, want to protect their productive capacity and keep their know-how from would-be competitors. Therefore, in the vast majority of cases, complex production and research and development take place in Japan, while the assembling and marketing of a product take place here. (Although foreigners do not carry out much research and development in their manufacturing firms or in manufacturing joint ventures, they sometimes participate in R&D joint ventures with American companies, as we noted in chapter 4.) According to this study, in joint ventures the Japanese companies and their workers gain valuable experience in new production techniques, while the Americans get mostly low-level jobs.[36]

This is not an invidious Japanese "plan": American companies enter into these agreements because they see greater short-term profits in doing so. In the Toyota-GM deal in Fremont, California (which we will discuss later in this chapter), the design and management is done by the Japanese, the assembly work by Americans.[37] Mazda, in partnership with Ford making Mazdas and Ford Probes in Flat Rock, Michigan, will not share information about its unique engine design. "We do not share that with other companies, including Ford," said the president of Mazda's American facility.[38] The major design work is done in Japan, the assem-

bly here—despite the fact that Ford owns 25 percent of Mazda. (Similarly, Ford will not share information with Mazda about its plans.)

Little of the American part of joint ventures ends up providing the experience necessary for the long-term competitiveness of these companies. Recent typical joint ventures had a U.S. firm selling a foreign-made product: Hewlett-Packard selling the Canon LBP-CX laser printer engine, Kodak vending a Matsushita video camera, and Bendix merchandising a small turning machine made by Murata. These joint ventures are not limited to Japanese deals: American firms are making similar arrangements with European companies.

Nor are low-level jobs just the result of joint ventures with the Japanese. In surveying foreign firms from all countries (as well as domestic companies for comparison's sake) in the automobile, the semiconductor, and the computer industries, we found that the proportion of U.S. workers engaged in research and development is significantly lower in foreign (3.1 percent of all workers) than in domestic companies (6.6 percent);[39] this was particularly true in the automobile industry, the differences being far less in semiconductors and computers. Research jobs aside, however, our survey revealed there were actually few differences in the occupational structures of foreign and domestic firms, once we took account of their industries. Thus, foreign and domestic auto firms hired similar people, as did foreign and domestic semiconductor firms. Since foreigners are here mostly to exploit the American market, this fact should not be a big surprise: intent on assembling products for the market, they hire a large number of assembly workers, just as their American counterparts do.

In order to avoid cultural problems, foreign firms are hiring more and more American managers to run their U.S. operations. Mercedes-Benz of North America filled fifteen of eighteen executive positions with Americans in recent years, and recruitment for American managers was up 60 percent in 1986. Hiring "locals" who know the market is "a matter of efficiency and easier communication," says an official of a French-owned company.[40]

So we emerge with a mixed picture of the quality of jobs provided by foreign companies. A large part of the problem is that data released by the government do not allow anyone to answer definitively questions about job quality or the occupational distribution of workers in foreign firms. As a result, we are left to surveys that are not always comparable or of high quality. As we have seen, these surveys yield different results. In some cases, there is little difference between foreign and U.S. compa-

nies; while in others, foreigners seem to provide inferior jobs; yet in others, foreigners provide good training and decent jobs.

Another piece of evidence comes from a 1988 study of Japanese auto and auto-supply firms done by the General Accounting Office (GAO).[41] The GAO found that workers for U.S. firms and foreign affiliates made about the same starting wage and that, eighteen months later, the figures were still rather close. For example, the Big Three firms paid a starting wage of $10.90 an hour; the range for foreign companies was fairly narrow, from a low of $10.48 (Toyota) to $11.41 (Diamond Star).* Eighteen months after beginning work, the average Big Three worker made $12.82. The foreign range was between $11.18 and $12.92—again, not much of a difference. Moreover, the GAO found that non-wage benefits (such as insurance, bonuses, and profit sharing) were similar between American and foreign auto firms.

Good information about jobs and wages is very important to have. After all, as we will see in chapter 8, states and localities bid feverishly for new foreign plants. But they really do not know what kinds of jobs they are getting in return for the incentives they proffer. Are they going to get many high-skilled and well-paying jobs, or are they going to get mostly routine, low-wage jobs? Local governments would behave differently if they knew the answers to these questions, and would offer different incentives packages depending on the mix of jobs. Often, as we will show in chapter 8, localities are wasting their money on their incentives. This need not be: it would not be difficult for the federal government to collect these data regularly—firms keep records on who they hire and how much they pay for tax and social security purposes; but these data have not been collected regularly, if at all. It would not be costly or intrusive for the BEA or some other agency to collect it without revealing data on specific companies. However, the foreign firms have fought hard to limit disclosure of more than the most basic information about their operations (as we will discuss further in chapters 9 and 10).

If foreign firms do not provide good jobs—and our evidence is far from complete due to the poor data available—the implications for the American economy are serious. Lacking complex manufacturing experience (research, development, engineering, and so on), our workers will not be able to innovate, do high-level tasks, and produce efficiently for world markets, and America will continue to decline in competitiveness —a point we will return to in the next chapter. If they do provide good

* Higher figures were reported for NUMMI ($11.95), which is a joint venture, and the now-defunct Volkswagen plant ($11.41).

jobs, then they are helping our economy and making this country a better place to live. However, the jury is out on this issue, awaiting needed information on what kinds of employee are hired by foreign companies and what kind of training they get.

Foreign Bosses, American Workers

When foreigners take control of an American company, they hire and fire American workers and bargain with them over pay and working conditions. We found that, as foreign multinationals differ greatly in their management styles and strategic objectives, they also differ greatly in their relations with labor. Some continue the practices of the American firms they acquired, often with the same managers. Others use new management and labor relations techniques. Some are fiercely anti-union; others, more accommodating. Overall, the labor relation practices of foreign companies mirror those of domestic companies. There is no *definitive* "foreign model."

Foreign MNCs have the advantages of multinationals operating everywhere—the option of shifting production from place to place. Of course, since foreign companies come to this country primarily to gain markets, they cannot use the "exit" option easily and move offshore. They must coexist with our workforce. They can, however, relocate production within the United States if labor relations problems occur. They have other advantages as well. For example, foreign MNCs, like large American firms, have considerable financial strength and can therefore weather strikes and boycotts organized by labor unions. Significantly, foreign companies face a union movement that has deteriorated substantially in power. Faced with increasing anti-union posture from American companies and a switch from manufacturing to services (where organizing is harder), unions have suffered substantial declines in membership. They are weaker organizations than they were twenty years ago, less able in general to bargain effectively with foreign or domestic companies. Unions are on the defensive in negotiations with all owners.[42] Where unions once insisted on cost-of-living wage increases and strict work rules, givebacks of previously won salary hikes became common in the mid-1980s. About one in eight manufacturing workers gave back previously won wages and benefits between 1981 and 1987 in the first year of their contracts.[43] To try to keep jobs, trade unions have become more flexible about job classifications and work rules. From the

foreigners' viewpoint, this means that their "management prerogatives" have increased: they have more control over the workplace. Despite these advantages, foreign MNCs still avoid union areas as much as possible, locating new plants in non-union areas such as the South (as we will see in chapter 7) and often battling organizing efforts in their plants.

Workers, on the other hand, do not have the option of moving to other countries as capital migrates; most workers have limited mobility to follow job opportunities even across the country. They are at a bargaining disadvantage, since the option to relocate work elsewhere in the United States remains in the hands of their foreign bosses. American workers also must bargain with local managers who are one step (or continent) removed from the power centers of these large corporations. Local management may not have full authority to negotiate independently. In addition, workers are less likely to know the future plans and real financial situation of their bosses than in a domestic company. Often, important financial records and investment plans are kept at corporate headquarters, a continent away, not with the local managers. This information is often crucial to employees in delicate negotiations.

But does "foreignness" influence the pattern of labor-management relations? We see a mixed bag of relations between American workers and foreign management.* A 1970s survey found that most foreign companies do not want to have their operations unionized, think that union shops are unfair, and believe unions reduce productivity.[44] Most American companies would probably answer the same way. It appears, though, that foreign companies' labor relations practices do not differ markedly from American companies. Our own firm survey shows no significant difference in the rate of unionization of foreign and domestic companies in the auto, the semiconductor, and the computer industries. Many foreigners try not to "seem different" from American firms but, like the American firms operating abroad we discuss in the next chapter, want to blend in and not be seen as foreign. Here, as elsewhere in the world, the labor relations practices of an MNC are determined by what the host country's environment will permit and, to a lesser degree, by the labor relations practices the MNC uses at home. If there is a strong labor movement and strong labor laws, MNCs will be less willing to fight unions than if labor is weak. Nevertheless, with labor weak in the United States and with minimal enforcement of labor laws during the Reagan era, many believed that they could avoid unions, and some foreigners

* Aside from the studies we cite, there is little research on labor relations between American and foreign companies.

have fought unionization fiercely here. The picture that emerges seems little different from that of large American companies in the 1980s: to avoid and fight unions when possible and to be accommodating only if necessary.

THE JAPANESE AUTO INDUSTRY

Several interesting cases point to both the differences and similarities between foreign and American companies regarding labor and industrial relations. Sometimes, the nationality of an owner is important, especially with new Japanese transplants. The "Japanese success story" is often attributed to a distinct managerial philosophy that emphasizes human relations: a sense of spirit and trust which managers try to instill in their employees; the idea that workers are a "team," and that product quality is paramount. A study of the performance of Japanese companies in the United States by two Columbia Business School researchers found that these firms perform better than their American counterparts by improving labor-management relations through job rotation and promoting a better sense of "family."[45] Other experts talk about the ability of the Japanese to integrate the hardware of the assembly line with the workers' abilities and talents—called "humanware."[46]

Over all, the conventional wisdom is that the success of Japanese corporations, in both Japan and this country, is based on a different management style than traditional American companies. This model says that the Japanese stress shared responsibility and authority (they are less "top down"), are more flexible and adaptable than their American counterparts, and think strategically, especially about global markets.[47] Although there are many elements of the truth in this model, the activities of Japanese companies in the United States are more complicated, and the "Japanese model" does not translate perfectly to the American workplace, as is clear from the experience of the Japanese auto industry here.

Success at NUMMI. In chapter 1, we mentioned the pathbreaking management changes at the Toyota-General Motors plant at Fremont, California, the New United Motor Manufacturing Company known as "NUMMI." At NUMMI, Toyota management (with GM's financial help) took over a shutdown GM plant, mothballed in part because of high worker absenteeism and general labor discontent. Toyota made few changes in the plant's layout and hired mostly laid-off UAW workers. Thus, Toyota had constraints, both in inheriting an old, "brownfield"

plant* and hiring workers with considerable experience under GM. Neither the plant nor the workers could be easily cast in the Toyota "mold." To make NUMMI a success, Toyota introduced new management techniques. First, it initiated *quality circles* in which workers do many different jobs and are responsible for high-quality products. It also reduced the amount of inventory and streamlined the production line through the *kanban* system, thus reducing costs and increasing productivity. The Toyota managers emphasized the notion of *kaizen*, or continuous improvement: enhanced efficiency and quality can be attained only with the cooperation and involvement of the workers. To achieve this aim, Toyota encouraged workers to say how their jobs could best be done, to learn the techniques necessary to master their jobs, and to teach others. As a result, the workers are both more involved in designing and carrying out their work and more productive. This work life is a far cry from the more regimented assembly line at GM.[48] The workers are happy, and so is the union. Owen Bieber, the United Auto Workers president, said, "NUMMI shows what workers can do if you give them some input into the design of their own work process."[49] NUMMI is profitable, and Toyota produced its first cars in the United States in a relatively riskless way: the cars produced at Fremont did not count as Toyota imports (against the company's import quota), and GM put up much of the joint venture's capital.

GM learned valuable lessons about building small cars from the Fremont experience. In Lansing, Michigan, GM now builds Buick Reattas in ways that would have surprised Henry Ford, the man most associated with the modern auto-production line. Instead of thousands of assemblers each repeating the same tasks, GM organized work into groups of five to eleven people, with considerable job rotation. Workers learn a great variety of skills and can teach each other. There is only one formal job classification—compared with hundreds under the traditional system; and even the plant manager works on the line once a month. GM cites the experience at NUMMI as the reason for attempting the changeover at Lansing; while Thomas A. Kochan, an MIT industrial relations professor, says, "NUMMI provided a lot of convincing data on quality, productivity, and comparisons with other plants in the United States. It gave everyone a concrete example."[50] Similar labor relations experiments—and they are still experiments, not structural changes— are going on at Ford and Chrysler. So Japanese-inspired management

* Older plants are known as "brownfield" facilities to distinguish them from new plants built in suburban or rural areas. The latter are known as "greenfield" plants.

techniques are felt throughout the auto industry (and in others as well). At NUMMI and Lansing, labor-management relations improved. At least in this limited way, the Japanese transferred some of their management techniques to domestic firms.

Discord at Nissan. Even though there has been considerable labor-management harmony at Toyota, Nissan provides a different, less rosy picture of a Japanese company's style. Nissan built its Smyrna, Tennessee plant in non-union territory and hired Marvin Runyon (an ex-Ford manager) to run the plant. The company blended Japanese technology with American-style management. The plant is large and roomy, and is highly mechanized. The management style, though, reflects Runyon's experience at Ford: it is hierarchical with few of the trappings of the Japanese model. Displaying the attitude of much of Japanese industry at the time the plant was built, Nissan was fiercely anti-union. There were advisors from the home office early in the process, but now the plant is primarily an American-run operation. There are trappings of the Japanese system—*kanban* and the like; but the labor-management cooperation Toyota achieved at NUMMI is missing. Speed-ups are common—many have resulted in injuries; and there have been law suits over sex discrimination. Although the company proclaimed an "open door" policy to encourage suggestions by employees, management considers many shop-floor employees who make suggestions "troublemakers,"[51] and harassed and fired some of them. Attempts by the UAW to organize the plant, strongly opposed by management, were unsuccessful.[52] The considerable dissatisfaction among workers appears to be more a result of the *American management team's policies* than of the Japanese management model.

Changing Labor Relations in the Japanese-American Auto Industry. Attitudes toward unions by Japanese car companies have changed over time. The early arrivals—Honda, Kawasaki, and Nissan especially—were very anti-union. Mazda, Mitsubishi, and Isuzu, who came later, were more willing to work with unions—partly because the attitude of the UAW became more accommodating. Mazda's choice of its Flat Rock, Michigan, site—in the heart of union territory (see chapter 7)—surprised many industry observers. Mazda also agreed not to fight unionization and signed an "understanding" that allowed organizing by the UAW. A contract with the UAW was signed in March 1988, a few months after the plant opened. But, in return, the company got a cheaper labor package and more flexible work rules than at Big Three plants. The union went out of its way to be cooperative. After all, with Big Three jobs going offshore (see chapter 6), there are few alternatives

for the hard-pressed union. Also, Mazda felt political pressure from Ford, which owns 25 percent of the Japanese car maker.[53] The auto union has been similarly friendly with Toyota in its Kentucky site, although there was conflict between the Japanese contractor and the construction unions over the building of the plant. In the construction of the factory, the Ohbayashi Construction Company wanted to use non-union workers and engaged in a protracted battle with sixteen building trade unions. Eventually, Ohbayashi agreed to hire union labor after a protracted struggle that included demonstrations at Toyota's U.S. headquarters.[54]

On the other hand, Japanese assemblers and suppliers often locate their plants in semi-rural or rural areas where unions are weak, and also in places where few blacks live. By locating in predominantly white towns, the companies can try to avoid charges of racial discrimination under Equal Employment Opportunity Commission guidelines, which often compare hiring patterns in a plant with the population in the area to see if minorities or women are facing discrimination. Honda is a case in point. By locating in Marysville and Anna, Ohio, where few blacks lived, it tried to avoid hiring them, according to a suit brought before the EEOC. Honda's workforce is 2.8 percent black, compared with a black population of 10.5 percent in the hiring area around its plants (American auto firms hire blacks at a rate of 17.2 percent of their workers). In 1988, Honda settled with the EEOC and gave $6 million in back pay to 370 minorities and women for discrimination.[55] (Honda also paid $461 million in a separate age-discrimination suit in 1987.) Other Japanese auto firms, especially suppliers, have followed the same location patterns and consistently hire fewer blacks than their American counterparts. In fairness, however, many American companies have also been moving away from big cities and union areas. The Japanese are certainly not alone in trying to avoid unions and, perhaps, minorities.

KAISER STEEL BECOMES CALIFORNIA STEEL

Another example of the uneven effects of the New Competitors is Kaiser Steel. In the early 1980s in Fontana, California, Kaiser Steel was in its death throes, a victim of competition from newer, more efficient plants in places like Japan and the newly industrializing countries. Without new capital for modernization, the Kaiser plant would have been closed for good in 1984. Instead, it was bought by Japan's Kawasaki Steel and Brazil's Companhia Vale do Rio Doce. The plant, renamed California Steel, was revived through a combination of infusions of

capital, technology, and managerial expertise from Kawasaki. But the renaming of the company was more than just cosmetic: the newly foreign-controlled firm became a very different company. Whereas the old Kaiser plant was a fully integrated facility, the new Japanese and Brazilian owners brought in cheap, unfinished slab steel from Brazil (the excess production of the Brazilian parent) and only rolled the steel in California to serve the local market, thus requiring less-skilled, lower-paid labor. Moreover, while there were 9,000 unionized employees working for Kaiser in the 1970s (the company was unionized in 1942), there were cutbacks because of international competition. In 1988, there were but 825 jobs at the California Steel rolling plant.[56] Kawasaki vehemently and successfully opposed unionization. California Steel is now part of the internationalized steel company, importing raw steel from Brazil and using Japanese technology to process steel for the California market. Although Kaiser was in a sense "saved," it became a very different company with different opportunities for workers: the fewer jobs required less-skilled work and paid lower wages.

SANYO AND SUMITOMO: CULTURAL DIFFERENCES

Other labor problems evolved over the clash of cultures between Japanese owners and their American workers, as occurred at Sanyo and Sumitomo Shoji. In Forrest City, Arkansas, a Sanyo TV and microwave oven plant was the scene of a bitter strike in 1985 (the second in six years) due in large part to this factor. Said a Japanese manager, "They come here for eight hours' work and eight hours' pay. As long as they get that, they don't care what happens to our production."[57] Based on its experience with Japanese workers, Sanyo misjudged the American work efforts: while, to many observers, "eight hours' work for eight hours' pay" is the goal of most American workers, Sanyo's Japanese employees may work longer hours and treat work as a bigger part of their lives than do their American employees.

When Sanyo bought the plant from Whirlpool in 1977, it put in $60 million of new capital and made other changes that resulted in short-term productivity and profit gains. But product design changes, a shift to assembly manufacturing, and speedups on the production line accounted for much of the improvement. No flexible manufacturing systems, *kanban* inventory approaches, or job rotation were put in place, even though the company wanted to introduce them. The local union leaders did not trust the new owners, thinking they were "brainwashing" them.[58] Over time, mistrust developed, as the cultural differences be-

tween managers and workers in a small, conservative town became ever more apparent; and the installation began to lose money. The company fired the union president in 1985 and, in subsequent contract negotiations, asked for givebacks and more work flexibility. A twenty-one-day strike ensued—replete with rock throwing, tire slashing, and thirty-nine arrests. The legacy of anger and misgivings continued long afterward. In 1987, the company lost $28 million (and $40 million over three years), it has ended its microwave-oven production, and only two of nine television lines still operate. "We don't know, to tell you the truth, if [Sanyo] will be here this fall," said the publisher of the local newspaper in the spring of 1988.[59] Some of Sanyo's production has already been moved to Mexico.

Although the Sanyo plant is not a business school example of the Japanese model of management, it gives an example of problems. Foreign managers must also overcome cultural and language barriers as well as deal with the day-to-day problems of running a factory. This case aptly demonstrates the "disadvantage of alien status" we discussed in chapter 3. There is conflict over goals and work rules, just as when American managers are running factories. The Sanyo story also illustrates the problems foreigners have when they take over existing plants: the workers are not as easily molded and may not be as trusting as those working in new plants.

Sumitomo Shoji of America, a subsidiary of one of the largest Japanese trading companies, had to deal with cultural dissonance in respect to the employment of women. At home, the company's management does not have to deal with assertive women in the workplace, as Japanese women are rarely allowed to advance beyond such low-level positions as clerk or assembler. When Sumitomo set up shop in the United States, it managed its workers as it did in Japan, following its policy of not promoting women above clerical positions. But more assertive American women sued the company in 1977 for sex discrimination. While the company argued that it was not subject to U.S. civil rights laws under a 1953 treaty between Japan and the United States, the U.S. Supreme Court ruled in 1982 that Sumitomo had to live by the same rules as American companies. Under terms of the final agreement (which was not signed until 1987), Sumitomo agreed to promote more women to management and to finance training programs in order to help women advance.[60] It has had, therefore, to learn to adjust to the cultural differences between the United States and Japan.

LABOR RELATIONS UNDER EUROPEAN AND
CANADIAN MANAGEMENT

Despite Japan's uneven record of labor relations in this country, Americans rate its companies above other nations'. When Smick-Medley asked a cross-section of the U.S. population about which nationalities treat their workers best, 43 percent said the Japanese, followed by the Germans (13 percent) and the British (12 percent).* At first glance, it is difficult to account for the relatively poor showing of British and German firms, as many British and German multinationals have favorable labor relations built on worker-management cooperation, both overseas and in the United States. The same is true of other European and Canadian firms. In fact, few Japanese multinationals can match the positive labor record of Philips, the huge Dutch electronics concern. Although spread across many nations, Philips universally treats its 344,000 global workforce with a kind of respect that sometimes borders on paternalism. The company holds regular meetings with their workers and with international trade unions to discuss job restructuring, production relocation, and other matters directly affecting its workers. Long before Japanese MNCs, Philips provided a model of the "family" approach to labor relations.[62]

Unfortunately, European and Canadian companies do not always transfer their good labor record to the United States. Since, as we noted in chapter 4, foreign multinationals are attracted to the United States partly because they see it as the bastion of free enterprise, involving a less organized, less politically active workforce, they perceive the American labor movement as weak and vulnerable, and thus do things quite differently here than at home. While, in the following accounts of European and Canadian experiences, we do not mean to stereotype all firms operating in the United States, they nonetheless address an untold story: violations of multinational labor guidelines, attempts to cut pension benefits, refusal to bargain in good faith, and more.

* In addition, only 2 percent of the respondents rated the Arabs as treating their workers best, and 30 percent said they did not know. In a separate poll of one hundred élite public officials, business leaders, and media figures, the results were close to those obtained from the 1,003 Americans surveyed in Smick-Medley's general poll: Smick-Medley reported that 40 percent of the "élite" group ranked the Japanese as the nationality that treated its workers best, followed by the Germans (23 percent), the British (11 percent), the Arabs (2 percent); 21 percent of the élite responded that they did not know.[61]

BASF's Blunders

BASF, one of Germany's Big Three chemical concerns, employs more than 20,000 Americans, but many are unhappy about the chemical giant's U.S. operations, as are some of the communities located near BASF's plants. For the company has a record of bad labor relations and environment disruption, especially at its plant in Geismar, Louisiana. Trouble started in the early 1970s with a long and bitter strike. The Oil, Chemical and Atomic Workers (OCAW) union mounted a "corporate campaign" against BASF, urging a boycott of the company's products and other sanctions against it.* The OCAW let its displeasure with the American management be known to the parent company. The German executives, who share the board of directors with German workers under "co-determination" rules, were aghast. Embarrassed BASF officials came to Louisiana, fired the local vice president for labor relations, and settled the strike on terms "very favorable to the union."[63]

But problems erupted again a decade later in one of the most bitter labor-management confrontations of the 1980s. When contract negotiations broke down in 1984, the company locked out some 370 union workers for more than three years. The company wanted to contract out some work to non-union shops and wanted to force the OCAW to give up previously won wages. The union charged the company with running an unsafe plant and with dumping toxic waste into the Mississippi River, referring to the river conditions as "Bhopal on the Bayou." The OCAW and the AFL-CIO mounted another corporate campaign based on the safety and lockout issues and urged boycotts of BASF products. The AFL-CIO put the company on its "Dishonor Roll," filed a complaint over the lockout with the Organization for Economic Cooperation and Development (OECD) under rules governing the employment and industrial relations of multinationals,† and demonstrated at the company's

* The term *corporate campaign* originated in the 1970s with union action against Farah and the J. P. Stevens Corporation by the Amalgamated Clothing & Textile Workers Union. Such a campaign usually involved legal charges of unfair labor practices, consumer boycotts of the company's products, and attempts to isolate the company from the rest of the business community. This tactic goes beyond strikes and other actions usually used by trade unions and attempts to embarrass a company and involve the courts and the public in the dispute. It has become widely used during the 1980s.

† The OECD guidelines, signed by the United States, West Germany, and other developed nations, states that multinationals should, "Respect the right of their employees to be represented by trade unions and other bona fide organizations of employees, and engage in constructive negotiations," and that they should, "Observe standards of employment and industrial relations not less favorable than those observed by comparable employers in the host country."[64]

148

headquarters in Germany and New Jersey. The company filed counter-charges and defended itself on the safety and pollution record, although it paid a fine for accidentally releasing 16,000 pounds of toxics into the river. In September 1987, the company offered to take back 240 of the 370 locked-out employees. The workers filed an unsuccessful action against the company before the National Labor Relations Board, which was very anti-labor during the Reagan administration. What worked for the union during the 1970s—a corporate campaign, an NLRB suit—did not work in the 1980s, when political attitudes toward unions in this country were considerably less positive.[65] As we said earlier, the attitude of a particular administration toward unions influences the behavior of foreign companies—as well as, of course, that of domestic companies.

The Struggle Between Foreign MNCs and American Miners

Of all the labor relations cases we explored, none was more disturbing than the bitter disputes that have recently pitted Canadian and European firms against the United Mine Workers of America (UMW). Just as for almost a century U.S. coal companies and the militant union have engaged in often-violent confrontation and habitual strikes and lockouts, so also have the foreign-owned coal industry and the union.

More than most other American unions, the UMW's power has declined over the past few decades. In 1987 it had around 230,000 members (more than half of whom were unemployed or retired), down by over 300,000 since the 1950s.[66] In the mid-1980s, many coal companies began to drop out of the Bituminous Coal Operators Association, created in the 1950s to negotiate industry-wide contracts with the powerful UMW. The coal operators then began to negotiate independent contracts with the union, making life more difficult for the UMW. Now the union had to deal with many separate negotiations rather than one. One of the companies was the nation's fifth largest coal producer, A. T. Massey, in which Royal Dutch/Shell holds a 50-percent stake. In 1984–85, the UMW struck Massey for its refusal to accept the 1984 industrywide agreement. The strike was marred by sporadic violence as Massey employed non-union labor and hired armed guards to keep the mines operating. The union responded with mass picketlines, civil disobedience, and intense political pressure. In the end, the union lost. According to two observers, "This battle changed the tenor of labor relations in the Appalachian coal fields."[67] We hesitate to implicate

Royal Dutch/Shell in any attempt to break the UMW; as only a partial owner, it does not fully control Massey's operations. Still, Shell's overall labor record in the U.S. coal mines reveals an anti-union bias. Besides Massey, all Shell's coal fields are non-union—this despite the company's very good relations with European unions.

Feuds between foreign companies and domestic labor are found elsewhere in the coal fields. Another stormy dispute involved the Canterbury Coal Company, owned by the Canadian Development Corporation (CDC). Contract negotiations with the UMW stalled in 1985, when the company attempted to impose a concessionary contract package that included attempts to cut pensioners' health care, even though the operations were profitable at the time. The union walked out and remained on strike for the next three years. The UMW launched a corporate campaign aimed at CDC: it picketed shareholder meetings and the CDC officials' homes in Toronto. In May 1987, the union followed the same tactic used by the AFL-CIO against BASF: it filed a complaint with the Organization of Economic Cooperation and Development, alleging that CDC violated the guidelines for multinational enterprises. The union charged that

> CDC adamantly refuses to participate in the collective bargaining process . . . even more disturbing has been the relationship between the multinational enterprise and the local Armstrong County, Pennsylvania police authorities, in which a substantial exchange of money has occurred to "compensate" local police for their security services on direct behalf of CDC and its local entities. This activity has formed the basis for a civil claim against the enterprise under the Racketeer Influenced and Corrupt Organization Act.[68]

The CDC (now owned by Canada's Polysar Corporation) has consistently maintained that the strike is a local issue and refused to negotiate at any level above its Canterbury subsidiary.

The UMW also filed a complaint with the OECD against Ente Nazionale Idrocarburi, Italy's state-owned energy company. In 1981, ENI formed a joint venture with Occidental Petroleum which wholly owned Enoxy Coal, with three mines in West Virginia and Kentucky. Although the UMW did not strike Enoxy Coal mines when its contract expired in 1987 without renegotiation, the union protested that the company was not bargaining in good faith. In its complaint, the union alleged that Enoxy Coal hired armed "mercenaries" (called the Asset Protection Team) to "harass and intimidate our members." During the Massey

strike, according to a local newspaper account, the Asset Protection Team "set up sniper nests, fortified bunkers and booby traps."[69] The UMW said it also confirmed that the Asset Protection Team guarded Enoxy's facilities with automatic handguns and rifles, machine guns, grenade launchers, and antipersonnel mines. A local newspaper reported that the facility was booby-trapped and that guards sat in "Viet Nam era bunkers."[70] The UMW brought its case to several international agencies and to the Italian embassy, hoping to show that ENI's U.S. operations violated established rules of multinational conduct. It appears that ENI's U.S. experience is sharply at variance with its good labor record in Italy.

Other Labor Problems

There have been other targets of union complaints. Germany's Heidelberger Zement, France's Lafarge Coppée, and Switzerland's Holderbank Financière, the multinationals chiefly responsible for buying up over half of the U.S. cement industry, refused to bargain and sign contracts.[71] Also, the United Food & Commercial Workers Union has charged that Belgian, British, and French supermarket chains were undercutting local pay rates. The AFL-CIO complained to the International Labor Organization over the actions of Carrefour, the French company. In its Philadelphia supermarket, the union charged, Carrefour "refuses even to talk to the union" despite the company's good labor relations at home. The AFL-CIO's representative charged that Carrefour was despoiling a supermarket atmosphere in which "labor and management have been working together well for decades."[72]

The American unions also brought charges against Sweden's Electrolux at the ILO for bad labor relations in its North American division. The AFL-CIO argued that Electrolux hired "one of the most notorious union-busting firms, which has on numerous occasions found to be in violation of U.S. labor laws."[73]

Foreign Investment and the Trade Deficit

Having examined the record of foreign companies on job creation and labor relations, we must agree that "nothing is an unmitigated good." Such were the words of former U.S. attorney general Elliot L.

Richardson in a *New York Times* letter entitled "Why Foreign Investment in U.S. Is Good for Us." Even so, he hastened to add that foreign investment employs three million Americans and introduces new manufacturing techniques and managerial methods—and in addition, noted that foreign investment "has contributed to United States export know-how."[74] Richardson is not, however, a disinterested observer: not only does he serve as the general counsel of the Association for Foreign Investment in America, but he also heads the Hitachi Foundation, the largest Japanese foundation in the United States. In 1988, Hitachi planned to export computer disk drives from the United States.

Anecdotes about how foreign companies export their U.S.-made products turn up frequently in the press. As we mentioned in chapter 4, Sony exports TV picture tubes, while Sanyo ships 37-inch television tubes from America. Japanese and other foreign companies trumpet their contributions to the reduction of the U.S. trade deficit. Honda, for example, launched a big publicity campaign about its first shipments of cars to Japan in 1988.[75] Siemens aired TV ads in which it claimed that 15 percent of its U.S. production was exported.

Although there are limited examples of exports by non-American MNCs, an inspection of aggregate data on foreigners' exports and imports reveals a very different picture. The New Competitors have increased, not decreased, our trade deficit. We mentioned earlier that many believe that foreigners import much of their inputs. In 1986, the U.S. had a merchandise trade deficit of $149 billion. That year, foreign affiliates imported $124 billion and exported only $51 billion, for a net deficit of $73 billion. Since much of the importing was through wholesalers who brought in goods from their overseas suppliers for sale in the United States, foreign wholesalers accounted for nearly $58 billion of that deficit. This reflects the ability of foreign companies to import successfully: it is more of a trade than an investment phenomenon. After all, American wholesalers are also importing goods from foreign sources. Yet, leaving aside wholesale operations, foreign firms imported $15.8 billion more than they exported—or nearly 11 percent of the entire merchandise trade balance, although we believe this to be an underestimate of foreigners' contribution to the trade deficit. This leaves out the Japanese wholesalers who own manufacturing plants and bring in auto parts for their American manufacturing operations. Honda's manufacturing operations are a subsidiary of its wholesaling company, and its manufacturing employees are counted as wholesaling workers. So our figures underestimate the extent of their imports. Most of the non-wholesaling deficit, $8.8 billion, was represented by the trade deficit of

manufacturers alone. For every dollar of exports by foreign-affiliated manufacturers, there were $1.65 in imports during 1986.

Our survey of firms sheds additional light on the issue of imports and local purchases. We asked foreign and domestic companies where they bought their three largest inputs (measured in dollar value). For the largest input, foreigners bought 40 percent of their inputs from overseas sources, compared with 36 percent for domestic companies. For the second and third largest inputs, the foreign companies bought 32.5 and 17.4 percent of their inputs offshore, respectively, compared to but 15.0 and 11.8 percent for domestic companies, respectively.* Once again, the propensity to import manufactured inputs is higher among foreign than domestic companies, but is far higher (relative to United States firms) in the auto and semiconductor industries. Thus, when we adjust for industry, the differences between foreign and domestic companies are not as great as the aggregate numbers seem to imply. Another important point comes out of the survey: foreigners buy relatively more of their high-technology inputs from foreign sources than do American companies. For non-high-technology inputs, the American firms tend to buy more domestically than foreigners.

Neither the government's data nor our survey data show that foreign companies are *the* cause of the U.S. trade deficit: this blame falls, quite obviously, on American firms that have not adequately competed in the world market. But the data show that the investments foreigners have made in this country come with a hidden cost: *part* of the responsibility for the increased trade deficit. This is the same trade deficit that has forced a lowering of the dollar which has, in turn, led to cheaper assets and more FDIUS.

Conclusion

Emboldened by their size and power and lured into the lucrative U.S. market, foreign MNCs have invested heavily—but with far different impact from the popular perception about the job potential of foreign companies. Although many more Americans work for foreigners than did a few years ago, these jobs were not new but mostly the result of mergers and acquisitions. When we looked at employment from new

* The differences between foreign and domestic firms were not statistically significant for the largest input, but were for the second and third at .05 significance levels.[76]

factories and expansions of existing ones and subtracted layoffs, we found that foreign companies reduced the number of workers they employed. Acquisitions, on the other hand, represent mainly the transfer of jobs from American to foreign bosses. Another important point is that some of the New Competitors are financing their invasion with a shaky mountain of debt. Many of the largest acquisitions—particularly those done by raiders like Robert Campeau—are highly fragile. "Once the economy weakens, as it sooner or later will, the high levels of corporate debt will exacerbate the downturn," said Mickey Levy, the chief economist of First Fidelity Bancorp. Levy added, "A company in trouble can simply cut or suspend dividend payments on stock but will go bankrupt if it can't service its debt."[77] The enormous debt that Campeau and other raiders have accumulated through highly leveraged buyouts is troubling—for Allied and Federated as well as for the economy as a whole. The financial community agrees. When Campeau tried to float junkbonds to finance the Federated debt, Wall Street balked at buying these speculative issues, forcing Campeau to increase the interest substantially to nearly 18 percent.

Moreover, despite some successful and innovative management-labor partnerships, there is a mixed record of labor-management relations. Even the Japanese, believed to be transforming the character of the American workplace, have encountered many difficulties and face problems similar to those of their U.S. counterparts. While the Japanese management style is most often mentioned in press accounts of foreign MNCs, it is not always followed, as the differences between NUMMI and Nissan illustrate. Multinationals from other countries show no distinct patterns either, largely because most affiliates are acquired and most of the management team remains in charge. Large foreign firms seem to act similarly to large American companies in an often uneasy relationship with labor. Yet when labor problems surface in the United States, foreign companies often counter that they did not realize what was going on in their U.S. affiliates—a problem to which we shall return in the conclusion to this book.

The same problems that afflict American corporations in the 1980s —uneven performance, unstable labor relations, hostile takeovers, restructuring due to mergers—are present in foreign companies. They are neither saviors nor the nemesis of American capitalism in the late twentieth century. We find that the most successful of these capitalists, the best of the patient capitalists, offer the potential for industrial rejuvenation in the United States. If foreigners can create jobs in the future,

that is fine. The tradeoff is that the U.S. economy becomes more subject to external control in key industrial sectors—a sign of external dependence.

But there is also another external influence on the U.S. economy —the American multinationals operating overseas, which we will discuss in the next chapter.

6

THE DOMESTIC EFFECTS

OF AMERICAN

INVESTMENT ABROAD

\mathbf{A}S foreign investment flows into the United States, so American investment goes abroad. Thus, while Nissan, Komatsu, and other Japanese firms located in Tennessee, Allis-Chalmers closed its Tennessee facilities and relocated them in Mexico. While Japanese computer companies invested in California and Massachusetts, and German chemical companies bought companies in South Carolina and Louisiana, American companies located offshore in the same industries. Foreign investment is a revolving door, with much cross-investment moving both outward and inward. These firms import components and products made in their offshore plants and compete with firms located in the United States, both for the American and other world markets. Therefore, subsidiaries of American firms have become another version of the foreign New Competitors by investing abroad. As the *Wall Street Journal* pointed out, companies expanding their offshore operations "*become* the foreign competition."[1]

Even though few, if any, jobs are actually created by foreign companies, state and local governments have poured vast amounts of money into enticing foreigners in the hope of increasing local jobs. They have done so largely because domestic job growth has not brought full em-

ployment to many parts of the country—despite the long upturn that began in 1983. They also worry about the quality of employment since many jobs created during the 1980s have commanded low wages.[2] But American firms have also invested heavily overseas, often closing domestic plants in the process. State and local governments are keenly aware of plant closings and the subsequent economic dislocation (hence, the heated controversy over the 1988 plant-closing notification bill, which we will discuss further in chapter 10). When American firms threaten to move their operations overseas, localities offer the same kinds of inducement to stay that they hold out to foreign firms to come to their towns. Thus, they compete fiercely for new jobs and to retain existing jobs—from both foreign and domestic sources—in an effort to maintain their employment and tax bases. In addition, labor unions and other workers submit to wage and working-condition givebacks to try to save their jobs.

In this chapter, we look at the domestic consequences of U.S. direct investment abroad (USDIA). These effects turn out to be strong—involving millions of workers—because outward investment has been and remains substantial, although its importance relative to other countries has declined somewhat. Recall that although there has been considerable investment by foreigners in this country, there has been even more investment by American multinationals overseas (see figure 2.1). Before the Second World War, the United Kingdom dominated the world's direct investment, with American MNCs a distant second. After the war, the United States forged ahead and became the world's leading capital exporter. By 1967, U.S. direct investment overseas was $57 billion, fully half of the global stock of international direct investment. Although USDIA continued to grow (with only minor cyclical downturns), its importance compared with the size of the economy peaked in the late 1960s or early 1970s.[3]* American overseas investment's share of world investment later declined to less than 40 percent, as other countries like Japan and the United Kingdom invested relatively more.

In the mid-1980s, when the dollar's value fell (see chapter 4), producing abroad became more expensive for American firms. Some companies expanded less quickly overseas, especially in countries like Japan where the dollar fell the most. Yet USDIA continued to grow substan-

* Although it is hard to measure precisely, two indicators show peaks: First, the percent of USDIA of all corporate assets reached its highest point in 1970—one and one half times what it was in 1950—but by 1985, it declined to its 1950 level. Second, the number of new affiliates established by major corporations peaked at 508 in 1968–69. Employment of U.S. firms abroad did not, however, peak until much later.

tially, and the employment of U.S. firms abroad remains large—6.3 million workers—more than twice the amount foreigners employ here.[4] By 1987, American firms had invested $309 billion overseas, a record $52 billion more than in 1986.*

A major shift occurred in the late 1970s, when, despite its size, the U.S. dominance as a capital exporter ended. Where, between 1975 and 1979, U.S. firms were responsible for 25 percent of the world's foreign direct investment, the investment picture changed abruptly in the early 1980s, as the United States became a net importer of nearly one-fifth of the world's foreign direct investment. Between 1980 and 1983, more investment flowed into the United States than into the rest of the OECD combined. There are several reasons for this change in the international investment picture, including the size and perceived positive growth prospects of the U.S. economy and the fear of protectionism. Furthermore, there was partial disinvestment by American MNCs, as payments to parents were made by their overseas subsidiaries; part of this disinvestment was to refinance U.S. operations undergoing corporate restructuring.[5]

It would be a mistake, however, to view those trends as evidence that outward investment is no longer important. It remains an economic force with considerable impact on the U.S. economy. The management *maven* Peter Drucker suggested that about one-fifth of all capital invested in U.S. manufacturing is in facilities outside of this country, as is a similar proportion of production.[6] With this large amount of USDIA comes the potential for fewer manufacturing jobs in this country. As a General Electric Motors' division executive put it, "There's a bunch of guys in Thailand, Korea and Brazil who get up every morning and try to figure out how to eat your lunch and take your market share, and you've got to deal with it."[7] GE set up motor plants in Mexico, Singapore, and South Korea and sharply reduced its U.S. employment. Many other U.S. companies did the same thing.

The Debate About Overseas Investment

Outward investment has been politically and economically controversial for three decades, much longer than inward investment. Some observers argue that "runaway shops" and "domestic disinvestment"

* Since much USDIA has been in place for many years and is reported at its original value, its $309-billion book value is biased downward compared with the amount that would be reported if current market value were used.

are a major cause of deindustrialization and economic insecurity. Many others, however, counter that foreign investment is critical to the United States's economic global might and is responsible for increased domestic employment opportunities.[8] Thus, a great controversy swirls around American multinationals: do they increase or reduce the number of domestic jobs when they invest abroad? Before considering this question, we will address the debate over job displacement.

FRAMING THE DEBATE

Imagine that General Motors has decided to build a car-assembly plant in Spain that will employ 3,000 Spaniards. Here is what GM and its major union, the United Auto Workers, might say in a debate over this new facility:

UNITED AUTO WORKERS: There you go again, exporting American jobs. You're taking employment from hard-working, experienced, union workers in cities like Flint and Milwaukee. Not only will they lose their jobs, but their cities' economic bases will deteriorate because of higher unemployment. You're cutting the number of jobs in this country, employing low-wage workers elsewhere, and deindustrializing America.

GENERAL MOTORS: Look. We need to compete more effectively in the European market. Otherwise, Toyota, Volkswagen, and Ford's European division will wipe us out. We can compete best by locating within the Common Market, employing local workers, and paying lower wages than you overstuffed and overpaid union guys get in the U.S.A. We *have* to go abroad or we'll lose out in international markets. Remember that we'll ship to that Spanish factory components your members make in Wisconsin and Indiana. We also employ thousands of executives in Detroit, and we hire lawyers and financial experts in New York to help us manage our operations around the world. As usual, the UAW is only looking out for itself and missing the larger picture. We are not *reducing* jobs in the American economy, we are *increasing* them.

UAW: Don't give us that baloney about increasing jobs. You're not only assembling cars abroad, but you are also outsourcing parts production too—we call it "international outsourcing." You're buying more and more of your components—shock absorbers, door handles, even your engines —from foreign suppliers. So you're destroying jobs in the auto-supply industry and hurting thousands of parts suppliers by moving their market three thousand miles away. Not only that, but some of your overseas suppliers are your own subsidiaries that used to operate at home. After all, GM is among the largest employers in the *maquiladoras* of northern Mexico. We struck you in 1986 because you wanted to shift your Delco Electronics work down there. Remember?

159

GM: Why are you so upset about a few jobs in Mexico? It's typical of you union people to want all of the jobs for yourselves. Why are you against your worker "brothers," as you call them, in Mexico and in other poor countries? We're providing jobs and economic development.

UAW: Economic development? You hire mostly teenage women for about fifty cents an hour; they work more than sixty hours a week with few benefits because they don't have a strong union to protect them. That's not "economic development." That's exploitation. Also, by taking jobs offshore and outsourcing components, you're using foreign investment as a club to beat us with at contract time. You keep saying, "Give us wage reductions and changes in work rules or we'll take our jobs offshore." Well, you've gotten concessions from us and you're going offshore anyway.

GM: You guys have had it too good for too long. The day has passed when GM or any other American car maker ruled the auto industry. You can't seem to understand that this is a tough, competitive world. We need to cut wages, cut transport costs—cut *all* costs—in order to compete. We can't keep paying your people more than $13 an hour. The UAW has been in the business of shielding its workers from international competition for long enough. The reality of the 1980s and 1990s is *internationalization* and you have to adjust and deal with it.

UAW: If the United States is such a tough place to make cars, then why are foreign firms investing here? The problem is with management, not workers. *You* are the ones who have failed to adjust.

Words like these have been spoken by labor and business leaders in many industries in the United States. This hard-fought and often bitter debate raises some of the important issues we have been talking about throughout this book: jobs, international competitiveness, deindustrialization, labor-management relations, and the health of our cities. Let's take a look at specific points in the debate.

"THE UNITED STATES IS ABANDONING ITS STATUS
AS AN INDUSTRIAL POWER"

To what extent—as our fictional UAW representative argues—does the overseas activity of MNCs reduce domestic employment?* Labor unions and their supporters contend that the increase in U.S. investment abroad has been, in essence, a move to "export jobs" to the detriment of American workers. Some scholars agree with organized labor. Lester Thurow, dean of MIT's Sloan School of Management,

* While USDIA also affects output and the distribution of income, the balance of payments, capital and technological advantages, and tax avoidance and evasion, it is its effect on employment that concerns us here.

argues that American MNCs have adopted an "offshore strategy" in which they construct large proportions of their facilities overseas: "In a very real sense, there are no private American firms. There are firms legally headquartered in America but they locate their research and development office or production facilities anywhere in the world. Per se they have no direct company interest in the success or failure of the U.S. economy." Thurow goes on to say that American MNCs have "only a direct interest in their own success and failure." It is often cheaper to "simply move production or engineering abroad than it is for it to make its American operations competitive. Yet foreign production is not a solution to American growth problems even if it is a solution to the competitive problems of American-based companies."[9] To Thurow, USDIA contributes to the decline of the American economy: as capital investment goes abroad, employment growth in the U.S. slows. Joining Thurow is none other than Akio Morita, the chief executive of the Sony Corporation:

> American companies have either shifted output to low-wage countries or come to buy parts and assembled products from Japan that can make quality products at low prices. The result is a hollowing of American industry. The U.S. is abandoning its status as an industrial power. . . . We [Japan] are taking away your manufacturers' business. They [U.S. companies] are giving it up. If they move factories and depend on the Far East, that means a hollowing of American industry.[10]

By "hollowing," Morita means that American firms are manufacturing less domestically and shifting their domestic operations to services. *Hollowing* is synonymous with *deindustrialization*. According to the Sony chief, there may be short-term profits to be had from going abroad, but they are at the long-term cost of loss of a company's production base and greater dependence on offshore operations. Morita believes this will ultimately undermine the productive capacity of American firms and the U.S. economy. Robert Lutz, former chairman of Ford's European operations, said, "You're seeing a substantial deindustrialization of the U.S., and I can't imagine any country maintaining its position in the world without an industrial base."[11] Lutz's view of deindustrialization goes beyond the offshore investment in low-wage, blue-collar industries that has been taking place since the 1970s. Nowadays, he says, things that are more difficult to replace are going abroad, including technology, management functions, design, and engineering. Thus, there is considerable concern that the decline of manufacturing competitiveness—

brought on in part by the export of U.S. manufacturing capital, the increasing dependence on outsourced components, and rising imports —could hurt our long-term international position. Moreover, international competitiveness in manufacturing matters, since so much of our fast-growing business service sector depends on manufacturing.[12] After all, much of the sales of service firms goes to manufacturers. Bankers, accountants, and computer specialists make substantial proportions of their living from manufacturers. If manufacturing declines, so will services. Faltering employment growth and higher unemployment will, according to this view, likely follow the decline in competitiveness.

If there is job loss because of USDIA, there are also increased costs for unemployment benefits, training, and welfare, declining public infrastructure, and a host of social problems related to unemployment, such as greater alcoholism and family violence.[13] Obviously, only a part of this deindustrialization is attributable to the foreign operations of U.S. firms. Yet there is cause for concern, particularly in manufacturing, that USDIA causes displacement that cannot be easily remedied. If we are losing not only low-skill manufacturing jobs, but engineering and other skilled work, these are structural problems that are not amenable to cyclical or short-term solutions. American multinationals contribute to our loss of competitiveness, if this argument is true. In addition, the jobs we lose to overseas investment add to our job loss from FDIUS.

"FOREIGN INVESTMENT PROMOTES AMERICAN INTERESTS"

Like our GM debater, most business leaders and academic economists claim that overseas investment is both necessary to maintain markets for American goods and central to the practice of free trade. C. Fred Bergsten, a Treasury assistant secretary under President Carter, summarizing the views of the international business community, adds that "foreign investment promotes American interests. World production is more efficient, American exports are increased, the quantity and quality of employment is augmented, and American access to raw materials at reasonable prices is improved. . . . United States policy should support existing investments and promote future investments."[14] MNCs argue that increases in exports to affiliates and increases in the demand for domestic services to establish and maintain them represent a *net gain* in domestic employment. Further, the MNCs say that job displacement would occur anyway: higher U.S. production costs would lead to shuttered factories even if offshore investment had not occurred. Moreover,

some argue, foreign investment is necessary to the health of the American economy and, indeed, the world economy; we must keep markets open and should encourage the free flow of capital. They say that those who argue that USDIA causes employment loss in the American economy are nothing but "closet" protectionists with narrow interests. The proponents of overseas investment say that any restrictions on foreign investment are as bad for America as tariffs, quotas, and other kinds of protectionism.

Traditionally, U.S. economic policy has been dedicated to the notion of free trade and investment. Ronald Reagan's *1987 Economic Report of the President* says that foreign investment "raises economic welfare around the world," and that the flow of capital among countries is "mutually beneficial."[15] (We will discuss this in greater detail in chapter 9.) So, according to this widely held view, U.S. employment growth will increase with the ability of MNCs to invest abroad. We will create more jobs—both at home and abroad—through USDIA. Thus, the debate rages on.

Corporate Strategies and U.S. Investment Abroad

To comprehend the domestic consequences of outward investment, it is important to understand the countries involved, their industrial composition, and the motives for shifting capital from America. In many respects, U.S. direct investment abroad looks like direct investment here. Most USDIA has been in petroleum and manufacturing, with manufacturing investment most heavily concentrated in chemicals, machinery, and transportation equipment (figure 6.1). But the growth rate of investment in finance, insurance, and banking has been higher than in manufacturing, with the share of these industries nearly quadrupling over the last thirty years. The service sectors (especially international finance and banking) grew in order to support the growth of manufacturing USDIA.[16] USDIA has gone mainly to other developed countries, especially in Europe and Canada—many of the sources of FDIUS. From 1950 to 1986, the share of USDIA in developed countries increased from 48 percent to 75 percent. In 1986, Canada (19 percent), the United Kingdom (14 percent), and the rest of Europe (34 percent) had the most USDIA.[17]

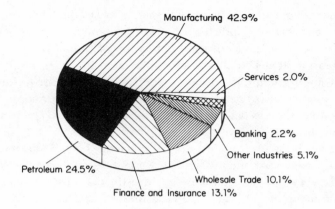

Manufacturing 42.9%

Services 2.0%

Banking 2.2%

Other Industries 5.1%

Wholesale Trade 10.1%

Finance and Insurance 13.1%

Petroleum 24.5%

FIGURE 6.1
Distribution of USDIA by Industry, 1986.

SOURCE: Obie G. Wichard, "U.S. Multinational Companies: Operations in 1986," *Survey of Current Business*, June 1987, pp. 85–98.

NOTE: Percent of USDIA position.

WHY AMERICAN FIRMS INVEST ABROAD

American firms have opened plants and offices abroad for many of the same reasons that foreigners invest here. And, as with FDIUS, the major reasons for USDIA have changed over the years. Historically, American firms went to other industrialized countries to capture growing *overseas markets* and to defend these markets from competition. Like the New Competitors here, Americans have been seeking out the Global Shopping Center. For a long time, American companies have exported a combination of technology, management, and capital in their foreign investment package.[18] In doing so, they used direct investment to supplement exports. Many executives feel that a "presence" in a foreign market gives them better access to it. Like Sony, American firms have a "global localization strategy" to create the image of a "local" company, facilitate closer business relationships, and deliver goods more quickly.[19] The greater use of just-in-time delivery systems, borrowed from the Japanese, increases the need to locate in foreign markets. In addition, U.S. firms sometimes tried to take advantage of *changes in the value of the dollar* compared with other currencies. During the early 1980s, for example, the high-valued dollar led to considerable overseas investment since it was cheaper to produce offshore. But when the dollar's value fell in 1985, direct investment was sometimes diverted to countries against

which the dollar did not decline or declined little.* But USDIA contin-
ued to grow substantially because of the market pull of Europe and
Japan, reaching a record level by 1987. Even though it became more
expensive to produce overseas, "we see no evidence of investment com-
ing back," said one Commerce Department official. Despite the rapid
fall of the dollar, net capital outflows more than doubled between 1985
and 1987.[21] Thus, since 1985, Apple pumped $15 million into its factory in
Ireland to upgrade it from assembly to a full manufacturing operation
for Macintosh and Apple II computers. Apple's senior European exec-
utive said, "On pure economic grounds, it might be less costly to export.
But cost does not decide the issue. We don't want to be an American
company selling products in Europe, but Apple Europe selling products
in Europe."[22]

Besides looking for markets, MNCs invested abroad in response to
real or threatened *tariff or nontariff barriers*. To sell products within the
Common Market, for example, it is advantageous for U.S. firms to
locate there because tariffs are otherwise higher for importers. Many
countries also impose import quotas. As the European Community con-
solidates its markets—breaking down hundreds of internal trade bar-
riers and creating one largely open, Continentwide market with 320
million people by 1992—there is even more reason for American firms to
be there. Companies not located inside the EC will face very high tariffs.
American firms could then operate on a pan-European basis in a unified
market that will be bigger than our own.[23] There are also a variety of
nontariff barriers, such as "local content" laws that require that some
proportion of a product sold in a foreign country be produced there.
For many years, countries have had laws making foreign investment a
prerequisite for doing business there. Although many of these are in
developing nations, many industrialized countries—including France,
Canada, Spain, and Australia—have them, too.[24] Other factors pulling
U.S. firms abroad include the need to be close to sources of supply, the
cost and availability of technology, and lower transport or capital costs.

Many American firms outsource in order to *diversify* their produc-
tion, sometimes using "co-production" arrangements to *supply inputs to
the parent firm at home* or to serve the U.S. market with products from
abroad. With co-production, the same product is made in several plants

* For example, between September 1985 and early 1988, the Korean *won* went up by 8
percent, the Singapore dollar by 10 percent, and the New Taiwan dollar by 42 percent
compared with the U.S. dollar. The Hong Kong dollar did not rise at all. The Japanese yen,
on the other hand, went up by 83 percent.[20]

in different countries simultaneously. If there is a strike or some other disruption of work at one of the plants, production is stepped up at others, thus ensuring that production remains smooth and less costly. In addition, MNCs use overseas investment as a *tool in labor relations*. The movement of production overseas—or even the threat of a move—is seen by labor as a strategy that MNCs use to beat back the demands of American workers who seek higher wages and better working conditions. At GE Motors, workers took a $1.20 wage cut in 1988. Said one veteran, "You either take it, or you don't have a job. It's just that simple."[25] Finally, the often-substantial *financial inducements* of host countries allow MNCs to reduce their costs; these subsidies include tax holidays, subsidized sites, free trade zones, and exemption from taxes on labor. A leading journal for business location, the *Site Selection Handbook*, made a comprehensive survey showing that nearly all countries have special incentives to attract foreign investment. Belgium, for instance, offers a five-year exemption from real estate taxes, labor-force tax exemptions, accelerated depreciation allowances, and several other incentives. Developing countries give incentives to help them entice labor-intensive industry, including long-term tax holidays, free trade zones, and free or subsidized site for factories.[26]

In chapter 4, we emphasized that inward foreign investment was driven by the size, growth, and sophistication of the U.S. market. U.S. outward investment to other developed nations also is central to globalized marketing strategies. Thus, the search for and maintenance of overseas markets has long been the major motive for offshore investment, and it remains so today. But the dynamics of the new international division of labor (IDOL) are crucial as well. U.S. multinationals have increasingly used international outsourcing to cut costs sharply, particularly labor costs. So, more recently, the *reduction of production costs* has become an increasingly important factor, especially when production is not "forced" into the EC by tariff barriers or local content laws. U.S. firms have done this by relocating a greater proportion of their production to developing countries or to low-wage developed countries—particularly for many assembly operations where low-cost Asian or Latin American laborers work in electronics, autos, and other sectors. In 1987, the average General Electric Motor worker in the United States made $16.16 an hour, while GE's Mexican workers made $1.23.[27]

Beginning in the 1970s, a significant shift in USDIA toward a small number of "newly industrialized countries" took place, particularly toward Argentina, Brazil, Hong Kong, Mexico, Singapore, South Korea, and Taiwan, although our Latin American investments declined later

because the debt those countries incurred stopped new investment. Between 1977 and 1982, American investments in these countries increased by 13.3 percent a year, compared with 8.2 percent in developed countries.[28] These investments were mostly in assembly manufacturing operations, usually producing for the U.S. and export markets elsewhere.[29] Low wages, coupled with modern plants, have made these sites very attractive to American companies for outsourcing components and products.

INTERNATIONAL OUTSOURCING OF COMPONENTS

International outsourcing of components and final products is an increasingly important corporate strategy related to the new IDOL. Through direct investment, joint ventures, and co-production agreements, firms import components into the United States for assembly into final goods—particularly for such products as personal computers where there are few, if any, "Made in America" PCs. Some may be "Designed in America" in research labs in California's Silicon Valley or along Massachusetts's Route 128. Others may be "Assembled in America" in Austin or Phoenix plants, often using outsourced components made in Taiwan or Japan. But few are fully "American"—taking the process from design to component making to assembly to distribution. More than 70 percent of the components in an IBM personal computer are made in Japan and Singapore.[30]

In nearly every industry, assembly plants are set up in foreign countries in order to take advantage of cheap labor and host government subsidies. A 1987 survey of 207 large manufacturers showed that the trend toward foreign outsourcing is increasing: 47 percent of these firms said that they expected to increase their proportion of offshore purchasing, despite the fall of the dollar.[31] Automobile plants, for instance, were established in Asia and Latin America, reducing production costs for GM, Ford, and others. Auto outsourcing grew rapidly: imported auto components increased from $8 billion to $28 billion between 1978 and 1987. GM brought in more than 1,000,000 engines from overseas in 1987, compared with just 60,000 in 1979. A study by the accounting firm Arthur Andersen and Co. predicted that 25 percent of auto parts for American cars will be foreign-made by 1995—up from 15 percent in 1985.[32]

Not only are components outsourced, so are entire cars. Ford, which builds cars in twenty-four countries, is planning to import minicars built in South Korea, and will supply Canada from a 70-percent-owned plant in Taiwan.[33] Chrysler imports cars made in Japan by its

partner Mitsubishi. GM brings in 430,000 cars made by Isuzu and Suzuki (both from Japan), Daewoo (South Korea), and from its own plants in Mexico. These are all from plants opened in 1984 or later.[34] After Chrysler phased out all domestic production of the K-car—the car that was largely responsible for the company's financial recovery during the 1980s—the company announced that it would make the cars in Toluca, Mexico.[35] (Chrysler, it should be recalled, used part of the 1980 bail-out from the federal government to build factories in Mexico.) In semiconductors, more than 80 percent of assembly takes place offshore, and imported components make up more than 25 percent of all semiconductor shipments. Motorola, a major semiconductor producer, is buying and building greater semiconductor capacity abroad, with plants in Japan, Taiwan, Hong Kong, Singapore, and Mexico.[36]

OUTSOURCING AND *MAQUILADORAS*

The 1,100 twin-plant *maquiladoras* along the Mexican border are prominent examples of modern outsourcing and the dynamics of the new IDOL. *Maquiladoras* are large assembly operations on the Mexican side of the border—in cities such as Juarez or Tijuana—and, when they exist, much smaller, usually distribution, facilities on the U.S. side from Brownsville, Texas, to San Ysidro, California. Under the *maquiladora* system, U.S.-made (or foreign-made) components are brought into Mexico duty free and assembled. When the finished goods are imported into the United States, the duty levied is only on the value added in Mexico. Since the value added is basically on the low Mexican wages, the duty is minimal. This lower tariff, combined with very low-wage labor, can dramatically reduce a company's costs and is a powerful incentive to locate facilities in Mexico. In 1987, there were about 350,000 workers on the Mexican side of the border, most assembling components and products for the American market. The automotive Big Three imported a total of 1.92 million engines in 1987, compared with 500,000 in 1983. Nearly all of this increase was from Mexican plants alone. Two Mexican government policies were responsible for much of this: a decree requiring export earnings to equal the value of imported parts and a domestic content rule that dictated that all cars sold in Mexico be equipped with Mexican-made engines. The sharp devaluation of the peso made production significantly cheaper in Mexico as well.[37]

The effects of the *maquiladoras* on the American economy have been hotly contested. Unions argue that outsourcing costs jobs in the United States, exploits Mexicans, and is used by companies as a tool in bargaining with their unions. A Zenith color television plant, built in

Juarez in 1986, resulted in the direct loss of 250 to 300 jobs in Evansville, Indiana. Trico Products, the world's largest maker of windshield wipers, moved nearly all its assembly operations to a *maquiladora* in Matamoros. In 1979, it employed 3,100 workers in Buffalo; now it has only its headquarters there.[38] Unions estimate that more than 250,000 jobs have been lost in recent years as firms have fled south in search of low wages and lax health and safety rules. Outsourcing to *maquiladoras* (or anywhere else for that matter) has become a point of contention for labor unions in contract talks. It was a major issue in the 1987 negotiations between the United Auto Workers and the auto companies. The union argued that the biggest threat to their jobs was the movement of work to foreign factories and to non-union domestic factories.

Business representatives reply that the *maquiladoras* help Mexico by providing more jobs and the American consumer by offering lower-cost goods. A 1987 International Trade Commission report said that the *maquiladoras* are beneficial to the U.S. economy because between 40 percent and 60 percent of the money earned in Mexico is spent in U.S. border towns.[39] In addition, firms argue that many of the jobs lost to American workers would have gone overseas anyway, probably to faraway Asia. The *maquiladoras*, they say, at least provide the possibility of jobs in distribution and trucking on the American side of the Mexican border. In addition, firms hold that their ability to outsource is a management prerogative, and a significant one at that.

In sum, American investment abroad went mainly to Europe and Japan to serve markets. But an increasing share has gone to a few developing countries in large part to create offshore "export platforms" to serve the American and other markets with low-wage labor. The use of outsourcing has increased in the past decade as U.S. companies use foreign labor to make components for assembly and products for sale in this country. Now let us look at the implications for the U.S. economy.

USDIA, American Competitiveness, and Deindustrialization

THE COMPETITIVENESS OF FIRMS

Like the strategies of the New Competitors in America, an offshore strategy usually "works" for American companies. That is, it is usually profitable for American multinationals to set up shop around the world; sometimes it is a necessity for their survival. Their competitiveness (as measured by productivity or world market share, for instance) depends

on a company's characteristics and strategies. A firm may succeed because of its skilled workforce, management team, a critical patent, or access to raw materials—factors that, except for the last, can be exploited wherever the firm sets up shop, as they are geographically mobile.[40] When firms go abroad they reduce their dependence on the U.S. market. Ford, for example, maintained its position in world auto markets by producing the "World Car" during the 1970s and 1980s. The same car (such as Ford's Escort) was made largely of foreign-made parts and assembled in foreign markets by foreign workers. More than one-fourth of Ford's record-breaking 1987 profits were from its overseas operations, a 43-percent increase from the previous year. Ford provides but one example of globalization strategies that American companies have adopted in lieu of producing at home and exporting. GM was not outdone: in 1987, it earned $1.9 billion dollars overseas, more than half its total profits.[41] In 1985, the 150 largest American corporations earned 34 percent of their pre-tax profits abroad. ITT earned two-thirds of its profits overseas, while IBM and Xerox earned close to half their profits outside the United States. In 1985, 30 percent of all after-tax corporate profits were earned from foreign sources, nearly triple the figure of twenty years earlier. These companies depend less and less on the American market—and they have less and less connection to the American economy itself.

In many low-wage sectors, such as textiles, clothing, and assembly portions of electronics, firms have followed profitable strategies by investing abroad. The three biggest Taiwanese exporters to the United States are subsidiaries (or closely tied subcontractors) of Sears, K-Mart, and J.C. Penney. Other major Taiwanese exporters are IBM, Hewlett-Packard, AT&T, and General Instruments. American firms invest in Taiwan to export everything from cheap shoes to consumer electronics with American brand names.[42] The large trade deficit with Taiwan (more than $15 billion in 1986) can be partly attributed to the activities of American companies operating there. Elsewhere in Asia, 52 percent of Singapore's 1986 exports to the United States are from American-owned factories.[43] The largest computer exporter from Japan is not Fujitsu or NEC or Toshiba: it is IBM. Forty percent of Japan's 1985 trade surplus with this country was due to U.S. companies producing or buying there and selling those products in the United States. Obviously, some of our chronic trade deficit results from the foreign operations of the American New Competitors.

Some business executives say that the difficulties of operating within the United States have made offshore location crucial. Motorola's

chief executive stated that offshore operations are "the only viable choice remaining [and] essential for our survival."[44] American multinationals have been able to keep pace with their international competitors by serving world markets, including the large American market itself, from abroad. Studies by Robert Lipsey and Irving Kravis of the National Bureau of Economic Research showed that, although the United States' share of world exports fell from 23 percent to 14 percent from the late 1950s to early 1980s, the export share of its multinationals operating abroad grew substantially. By the 1980s, a larger share of world markets were served by the overseas operations of American multinationals.[45] Robert Lipsey told *Business Week* that American multinationals were "able to compete on a firm-by-firm basis" overseas, but conceded that the resultant job losses and other macroeconomic effects in this country "may not be beneficial for the economy in the aggregate."[46] Therefore, as Lester Thurow also pointed out, while American companies were doing well in world markets, the country was not.

THE COMPETITIVENESS OF THE ECONOMY

Although U.S. firms' march abroad may help their international competitiveness, it is not so clear that USDIA helps the competitiveness of the U.S. economy. Robert Reich recounts the story of Charles E. Wilson, former GM president and President Eisenhower's Commerce Secretary, who told a Senate committee, "What was good for America was good for General Motors, and vice versa."[47] Back in the 1950s, this statement—despite the arrogance that underlies it—implied that American companies existed for their American stockholders and, by implication, workers. If the company succeeded, so would the United States. This is no longer the case. Thirty-five years later, the United States does not rule the world as "Engine Charlie" Wilson's GM did then. American firms now operate worldwide to a much greater degree. American managers, who have been notorious for taking the short view rather than the long, are now more likely to forego research and development and other activities that may pay off more handsomely for the company and the economy over time. And, of course, corporate raiders put pressure on companies to "restructure" and force managers to look even more nervously at the next quarter's earnings. Thus, what is good for stockholders is not necessarily good for the nation. To Reich, there is an increasing "divergence between the interests of the corporation and its shareholders and the interests of the nation."[48] The story is even more complicated, as Reich correctly tells us, by the buyouts by foreign companies: foreigners' purchase of U.S. assets increases the divergence of

national from corporate interests. What is good for GM or IBM is no longer necessarily good for the United States.

Therefore, we must carefully distinguish between the competitiveness of *a country* (that is, what happens inside its borders) and the competitiveness of *its companies.* The fact that many American firms are competing effectively when they operate from overseas locations, especially since their offshore facilities are often newer and more modern than some of their older domestic plants, does not say much about the competitiveness of the U.S. economy. A country's competitiveness depends on productivity, exchange rates, monetary and fiscal policy, production costs, and other factors. In recent years, many experts (including a presidential commission) have argued that there has been a sharp decline in the international competitiveness of American companies operating within the United States[49]—a decline that has contributed to a deterioration of our foreign trade balance, a decline in real wages and profits, loss of world market share, higher unemployment, and less stable economic growth.

Many argue that overseas investments have come at the expense of home-based subsidiaries. Donald E. Peterson, the chief executive of Ford, said that his company's investment share in this country "is drifting down" while foreign investment increases.[50] U.S. facilities, therefore, may often be less profitable because of the very competitive pressures that American overseas affiliates with newer plants put on them. Although this point is nearly impossible to prove, it is obvious that domestic firms are competing not only with each other and with foreign companies, but with the overseas affiliates of U.S. multinationals. Imports from our own affiliates—which reached $66 billion in 1986, up from $41 billion in 1977—increasingly compete with the products of domestic companies.[51]

It is important to recall, however, that national economic policy during the 1980s made overseas investment more advantageous and domestic investment less profitable. In particular, the high real interest rates that the Federal Reserve engineered during the early 1980s discouraged domestic investment because it was expensive to borrow. Simultaneously, the high dollar made exports expensive, further crippling American firms operating at home since it was hard to sell their products abroad. Of course, imports from overseas subsidiaries were cheaper because of the high dollar, encouraging more USDIA. Domestic investment was stagnant, especially in industries like steel where there was great worldwide overcapacity. Operating in this country was simply more expensive than in many other countries. Monetary policy helped

push domestic production offshore by raising interest rates and the dollar, making production in the United States less profitable.

Overseas investment and outsourcing can be troublesome to our economy's competitiveness for a variety of other reasons. Business people and scholars like Ford's Lutz and MIT's Thurow fear that it causes the erosion of our manufacturing base. After all, not only are U.S. manufacturers transferring low-wage jobs overseas, but an increasing proportion of high-technology activity is going there, too. Nearly every high-tech firm in this country makes substantial proportions of its inputs abroad. But the importance of USDIA is more than simply the outsourcing of production. Lionel Olmer, a Commerce Department undersecretary during the Reagan Administration, said that "many corporations have left the U.S., have given up on domestic manufacturing, have resorted to selling and licensing their technology [and] it is terribly important that we sustain a healthy domestic manufacturing base." Therefore, in "giving up" our domestic production, our firms are throwing in the towel and selling off much of the technology that has given us leadership in many industries. "The process occurring now is one of transferring production based on high technology, which is capital- and knowledge-intensive," frets Irving Feldman, chairman of Washington Capital Group.[52] In letting technology slip away, we may be selling off our greatest source of comparative advantage. RCA and Kodak are among the companies that have abandoned some production in favor of a strategy of importing and marketing, either from their own plants or from foreign contractors. Kodak, for example, sells Canon photocopiers, Matsushita video cameras, and TDK video tape under its own name.[53]

"Ripple" or "multiplier" effects magnify the impact of offshore investment, just as there are ripples from inward direct investment (see chapter 5). In the past, overseas plants bought most of their components from domestic sources, creating additional jobs at home in components and service industries. The purchases of components meant more income for the owners and workers of the supply companies, who, in turn, spent this income on plant expansion and consumer goods, further enriching contractors and retail stores. In the end, they generated considerably more income for the community. But, as we have shown, the trend is toward buying supplies abroad as well. An Ingersoll-Rand executive told *Industry Week* that one of his overseas affiliates bought half of its components domestically during the late 1970s; by 1985, this proportion was down to one-fifth.[54] This means that the linkages between offshore investment and the domestic economy are weakening: our affil-

iates abroad are buying a smaller proportion from domestic plants and, therefore, are not creating as many supply-related jobs as they did previously. The connections between U.S. firms and the economy are becoming more tenuous.

The severing of linkages showed up in the surge of business spending that occurred during the late-1980s. While American businesses were purchasing capital goods—machine tools, computers, engines, photocopying machines—so much was imported that the domestic economy did not benefit greatly. This boom kept the trade deficit high despite a low dollar. Boeing, the world's premier commercial aircraft manufacturer, imports 28 percent of its parts: tails from Canada, aluminum skin panels from Japan, Rolls-Royce engines from Britain; in 1980, only 2 percent to 3 percent of Boeing's inputs were internationally outsourced.[55] In computer-controlled machine tools, so important to manufacturing productivity, American firms like Cincinnati Milicron have ceded huge pieces of their markets to West German and Japanese firms—as happened with ceramic-making equipment and textile machinery as well. Domestic machine tool orders in 1988 were one-third the 1979 value as a result. These examples show why it has been so hard to reduce the trade deficit and regain market share. And, as the Brookings Institution economist Barry Bosworth said, "The United States had a real domination in capital goods, and the damage to it seems irreversible."[56]

Thus, the hollowing of America resurfaces, as we examine the strategies of American MNCs. The United States is relying less on domestic production to meet demand. Some companies have axed domestic production and are marketing foreign-made products instead. The United States is not only losing production in this way, it risks the loss of skilled labor and productive advantage by American firms. Not long ago, when Intel wanted to set up a chip plant in Arizona, it had to call in experts from its Malaysian facility; it seems that Intel did not think its American workers were up to the task.[57]

Overseas Investment and Employment

To recap our debate, it is crucial to understand the motives of multinationals for overseas investment. Over time, the MNCs have emphasized different reasons for their investments. Earlier, they went abroad mostly to maintain and defend markets in Europe and elsewhere. In terms of the debate, USDIA might save domestic jobs that would have

been lost if the markets were not maintained and defended. But more recently, much investment is *production driven*, as our discussion of international outsourcing showed. In this case, investment is a flight from the United States in search of low wages in Mexico or in the Pacific Rim, rather than a market-oriented phenomenon. In the production-oriented IDOL, jobs are likely to be eliminated, not created, by USDIA: that is, overseas investment is hurting workers and domestic business in the U.S. economy and contributing to economic insecurity. If defensive, market-preserving motives were behind today's investment, then USDIA might save domestic jobs. However, if American multinationals are not as motivated as they used to be by defensive strategies, but are increasingly concerned with production-related costs, they are, in effect, substituting cheaper foreign workers for American workers in more and more facilities. The behavior of American multinationals, like the British, Japanese, and others discussed in previous chapters, means less economic independence and more economic insecurity for Americans. In some respects, this brings us back to Servan-Schreiber's *le défi américain*—"the American challenge"—turned on its head: can we control our own destinies and maintain employment in the face of international direct investment—both FDIUS and USDIA?

DISPLACEMENT OF WORKERS

We estimated the effects of USDIA on domestic employment to try to resolve the controversy over displacement.[58] The repercussions of outward investment depend upon two considerations, what economists call the *displacement* and the *stimulus* effects. The displacement effect is job loss associated with overseas production that could occur in the United States. Such displacement includes employment lost when overseas affiliates sell goods in foreign markets that could be produced domestically and then exported, and also jobs lost when foreign affiliates import goods into the United States. On the other hand, the stimulus effect leads to increased domestic employment: that is, additional jobs created by the production of capital goods exported to affiliates; jobs resulting from the provision of services by the parent to its affiliates; home-office employment of multinationals; and new employment through services provided to the multinational and its affiliates by other domestic firms. The difference between the displacement and stimulus effects is USDIA's net impact on the economy. If the displacement effect is greater, then there is a net job loss; if the stimulus effect dominates, then there is a net job gain.

We estimated the employment effect of manufacturing USDIA for

175

1977 through 1986.[59] We used a variety of statistical techniques to calculate the values of the displacement and stimulus effects. In doing so, we drew upon the pathbreaking work of Robert Frank and Richard Freeman who previously analyzed the employment and distributional consequences of USDIA.[60] To calculate the impacts, we first estimated the "rate of substitutability" between foreign and domestic production: that is, we estimated how much foreign production done overseas could have been undertaken profitably at home. We combined these figures with the amount of USDIA to get an estimate of the displacement effect. Using an input-output table (which measures the relationship among industrial sectors), we then calculated the stimulus effect and the overall effects of USDIA on the economy. (Appendix C summarizes our procedures.) In addition, we examined its effect on workers by occupation, race, and gender to determine the *distributional consequences* of offshore investment. Finally, we looked at the cities and regions in which displacement took place. The results of our research are stark and troubling.

MANUFACTURING JOBS LOST

We found that USDIA cost American manufacturing workers more than 2.7 million jobs between 1977 and 1986 (see figures 6.2 and 6.3 and table C.1 in appendix C, pages 177 and 321, respectively)—a loss resulting from the displacement of 3.3 million jobs by foreign investment compared with only 588,000 jobs being stimulated (see table C.2 in appendix C, page 322, for the calculations of the stimulus and displacement effects for 1977 and 1982). Put in perspective, over the same time period there was a net loss of 868,000 manufacturing jobs in the economy.

Therefore, had there not been severe displacement from offshore investment, manufacturing employment would have increased by 1.8 million. Displacement increased from 292,000 in 1977 to a high of 397,000 in 1980; displacement then declined to 185,000 in 1983 and rose again to 211,000 in 1986. The decline in displacement after 1980 occurred largely because of the deep, worldwide recession and the sky-high dollar which reduced the growth of USDIA and, with it, the potential for displacement. Significantly, displacement actually *increased* between 1984 and 1986 as USDIA expanded quickly. This is largely because so much of the investment was in labor-intensive industries. In such companies, a small amount of investment produces relatively large amounts of domestic job loss. These figures are in the same range as two other studies of displacement: adjusted for the size of the economy and the amount of USDIA, our results are less than the study by Robert Frank and Richard

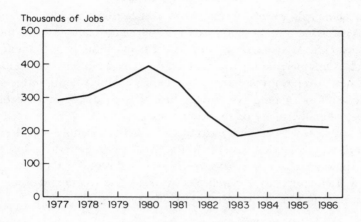

FIGURE 6.2
*Manufacturing Jobs Lost Each Year Due to USDIA
Between 1977 and 1986.*

Freeman, while Barry Bluestone and Bennett Harrison calculated a range of 450,000 to 650,000 jobs lost per year during the 1970s.[61]

INDUSTRIES MOST AFFECTED

By far the greatest number of jobs lost were in the nonelectrical machinery industry (663,489 from 1977 to 1986). Primary and fabricated metals, food, and chemicals were the next most heavily hit (see table C.1 in appendix C). The large number of jobs lost in nonelectrical machin-

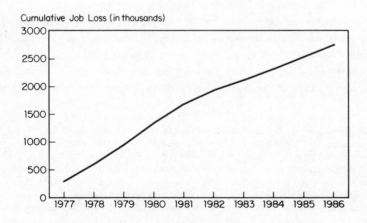

FIGURE 6.3
Total Manufacturing Jobs Lost Due to USDIA Between 1977 and 1986.

ery and chemicals were due mainly to constantly high levels of new overseas investment in these industries: 22 percent of all new investment abroad by U.S. MNCs was in nonelectrical machinery; 13 percent in chemicals. Only petroleum and coal products had a higher percentage of total new foreign investment (23 percent); but petroleum induced a much lower loss of employment because it is relatively more capital intensive.* Finally, many of the industries most negatively affected by domestic job loss were also hit hard by USDIA. For example, steel lost 41 percent of its production workers in the decade ending in 1985. USDIA was not the only reason that jobs were lost: the glut in world production in steel was a major reason as well. Yet overseas investment and domestic disinvestment in steel were certainly critical factors.

BLUE-COLLAR AND WHITE-COLLAR WORKERS

It is difficult to say with precision exactly which jobs were "exported," which workers displaced, by offshore investment. Since no records are kept on such phenomena, we looked both at the occupational characteristics of the industries that lost jobs due to USDIA, and at the race and gender characteristics of those workers in those industries, and compared these figures with the U.S. manufacturing labor force as a whole to calculate the probability of displacement for different workers. In effect, we looked at types of employees, and the industries in which they were employed, to see whether they were likely to be displaced.

We found that blue-collar workers were hardest hit by offshore investment. Of the nearly 212,000 jobs lost to overseas investment in 1985, 82 percent were likely to be in blue-collar categories, given the high concentration of blue-collar workers in the industries that suffered displacement. At the same time, only 59 percent of all manufacturing workers were blue collar. Thus, blue-collar workers were more than 39 percent more likely to be displaced than their proportion in the labor

* We also adjusted the amount of displacement by the amount of investment by industry. As expected, the relatively more labor-intensive industries (such as textiles and apparel, wood and furniture) lost the most jobs per million dollars of investment, while those that were relatively more capital intensive (such as petroleum and coal, transport equipment) experienced the least number of jobs displaced per million dollars of investment. Compared with total industry employment, the greatest displacement was in nonelectrical machinery and chemicals. Using a measure of displacement per 1,000 jobs, we found that the industries most affected were petroleum and coal, chemicals, and nonelectrical machinery (see tables C.2 and C.3 in appendix C, pages 322 and 323).

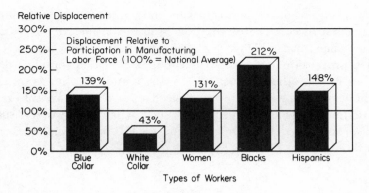

FIGURE 6.4
Who Was Displaced? Displacement by Occupation, Race, and Gender.

force predicts (see figure 6.4).* Looking at this phenomenon from the standpoint of white-collar workers—executives, professionals, technicians, salespeople, and administrative personnel—we found that the chance of displacement due to USDIA (18 percent) was much lower than the amount expected from their proportion in the labor force (41 percent).

DISPLACEMENT BY GENDER, ETHNICITY, AND RACE

We then estimated displacement by gender, ethnicity, and race, again to see which workers were likely to face displacement compared with their representation in the labor force. Three groups had higher chances of displacement than their proportion in the labor force predicted. First, women made up 32 percent of the 1985 manufacturing labor force but constituted 42 percent of those displaced by USDIA. Thus, women were 31 percent more likely to be displaced than average (figure 6.4). Second, black workers, who made up 21 percent of the displaced, were only 9.9 percent of the total manufacturing workforce and so stood more than twice the chance of displacement than is expected from their concentration in manufacturing. Finally, Hispanics

* If 82 percent of the displacement is suffered by blue-collar workers who make up 59 percent of manufacturing workers, dividing 82 by 59 yields 1.39; this arithmetic shows that blue-collar workers are 39 percent more likely to be displaced than their presence in the labor force predicts. If one discounts the notion underlying official data that clerical jobs are white collar—usually taken to mean "managerial"—and puts clerical workers into the blue-collar category (since they share the largely repetitive nature of work), the propensity for displacement to be concentrated in low-skill jobs is even greater.

made up 9 percent of displaced workers and 6.1 percent of the manufacturing labor force.* Therefore, these groups, considered "disadvantaged" by many, had a higher probability of displacement by USDIA than their proportion in the labor force, but black workers fared significantly worse than others. Thus, USDIA was reinforcing trends in domestic industry in which these groups, particularly blacks, have suffered structural unemployment in manufacturing.[62] While these workers suffered disproportionately, white collar and non-Hispanic white workers did not fare as badly.

Implications of USDIA for the National Economy

The impact of manufacturing USDIA on the national economy is troubling in many ways. The process of the impact of USDIA is the same as we saw with FDIUS in the last chapter: besides the direct loss of 2.7 million jobs, there were very important *indirect* job losses as well. For every manufacturing job lost through USDIA, there is a negative ripple effect throughout the economy, as there is a positive effect associated with FDIUS. First, there is a reduction of production and employment associated with what economists call *interindustry* relations. For example, if our Spanish GM plant displaces domestic auto employment, then production and employment in the domestic auto industry and the industries that sell their products to GM—spark plugs, windshield wipers, and electronic parts makers—also fall. Then, the loss of demand for auto inputs leads to decreased production and employment in such industries as steel, plastics, and financial services.

Moreover, when the direct and the indirect jobs are lost, consumer and business spending declines, leading to a further loss of jobs and production. For instance, out-of-work auto, steel, plastics, and service workers have less money to spend on groceries and medical care; therefore, the incomes and spending of workers and businesses in these industries also decline. These are known as the *induced* effects connected to job loss in manufacturing. When we add the direct, indirect, and

* In talking about the greater chances of displacement here, we are not referring to discrimination against these groups of workers. Although many studies have pointed to discrimination against them, our calculations assume that their chances of unemployment are due to their concentration in industries most affected by USDIA. Whatever discrimination exists is taken into account by their rate and duration of unemployment.

induced effects of job loss associated with USDIA, we get the total impact on the economy.*

To calculate these effects, we used a large-scale computer simulation model that took account of both interindustry and induced effects. The model allowed us to see the linkages between foreign activity and the domestic economy.† These linkages greatly magnify employment loss. Applying the effects of the 2.7 million manufacturing jobs lost due to USDIA, we found that overseas investment cost the economy a total of about 3.4 million jobs (figure 6.5).‡ This means that for every 100 manufacturing workers displaced by USDIA, another 26 were displaced elsewhere in the economy.** These figures provide a distressing view of the ramifications of USDIA. While domestic employment grew by 15 million jobs between 1977 and 1986, the loss of jobs offshore because of USDIA meant that domestic employment would have been 3.4 million more. Obviously, unemployment would have been considerably lower.

* While we calculated the indirect effect on manufacturing in reaching the 2.7 million job figure, the indirect effect on services and the induced effects of layoffs in all industries remain to be calculated here.

† We used a microsimulation model called "MRPIS" in a related study of the American economy and the role of international competitiveness in America's future. The MRPIS model consists of four large submodels: a *household* simulator that estimates how households spend income; a *labor market* model that shows the distribution of workers among industries and occupations; a *product market* model that determines the demands for goods and services; and an *industrial sector* model, a large multiregional input-output (124 industries and 51 regions). The simulations were made on the effects of a decline of manufacturing due to less international competitiveness. In the simulation, we found that for every 100 jobs lost in manufacturing, an additional 98 were lost in services and other sectors. Much of the service job loss was due to the induced effects. We could not simulate our USDIA findings directly through MRPIS because of incompatibilities between our broad industry detail and the much finer industry detail in MRPIS. However, we are confident that the more general simulation on which we based our conclusions yields results similar to those that we would have calculated had we been able to simulate directly.[63]

‡ A 1987 study found a quantified relationship between manufacturing and non-manufacturing.[64] If one assumes this relationship, then the results reported here should hold. Some technical adjustments were necessary. There is a potential for double counting here, since, in calculating displacement in manufacturing, we took account of the interindustry effects *within manufacturing*. To avoid overestimating the amount of displacement, we applied the ratio drawn from MRPIS only to direct manufacturing displacement.

** The reader should understand that the calculations we made of the impacts of manufacturing displacement on the service sector are relatively conservative. Moreover, even if we assume that the ratio of 100 manufacturing jobs lost to 98 in services (calculated by MRPIS) was cut in half to 100 to 49, the total jobs lost in the economy would still be more than 3 million.

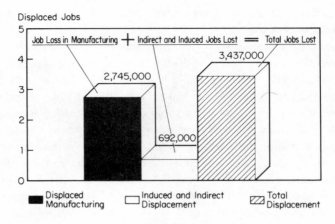

FIGURE 6.5

Jobs Displaced in Manufacturing Are Only Part of Total Displacement in the Economy.

CITIES AND REGIONS

USDIA also has important consequences for cities and regions. How hard has the North been hurt by the offshore sitings of auto plants and the importation of components? How have the movement of textiles and apparel companies to East Asia affected the Southeast? Have overseas supply operations stimulated jobs in cities and regions?

Newspaper stories tell of the havoc wrought on cities when manufacturers close their domestic operations and move them offshore. Elizabeth, New Jersey, a gritty manufacturing city across the Hudson River from New York, lost much employment when Singer closed a large factory there in 1982. The 109-year-old plant, which once employed 10,000 people, was, as one forty-four-year veteran of the plant observed, "a way of life." The plant closed because Singer switched to a "more cost effective strategy of foreign competition."[65] The company had begun moving its operations overseas twenty-five years prior to the closing of the Elizabeth operation. The shutdown was inevitable, given Singer's global strategy. Ultimately, Singer spun off all of its sewing machine and other operations and became a defense contractor.

The outsourcing of components can also cause job loss in cities. Ford contracted with Ogihara of Japan for Lincoln Continental dies and stampings, leading to a big loss of jobs for workers in Philadelphia's

182

Budd Company, the previous contractor, and wiping out one-fourth of the plant's sales and half of its employment.[66] The impact of this job loss on Philadelphia, a city that has lost much of its manufacturing base, was significant. Plant closings in cities housing old industries are common and not surprising. After all, these are old plants and therefore uncompetitive. Other recent examples include Manufacturing Belt cities such as Elmira, New York, where Westinghouse closed a large TV tube plant; and Battle Creek, Michigan, where Clark Material System Technology shut down its plant.[67]

There is widespread displacement from offshore investment: it is not limited to old, industrial cities or mature industries. It is troubling indeed to learn of the 1983 closing of sizable Atari computer operations in San Jose, in the heart of Silicon Valley. Atari—one of the symbols of America's high-technology future—moved its video-game and home-computer operations to Hong Kong and Taiwan: San Jose lost 600 jobs.[68] Similarly, Tandon Corporation moved much of its computer production to Singapore from Chatsworth, California.[69] And GTE stopped making business telephones in Huntsville, Alabama, and outsourced them to Mexican plants, idling 1,000 workers.[70]

When jobs are lost, a city and its people are hurt, as the effects ripple through the town. Tax revenues go down because there are fewer paying firms, and public expenditures go up. There are fewer contracts for suppliers of the closed factory; wages fall, meaning less spending and lower sales tax collections. Thus, taxes go up for other taxpayers, homeowners and businesses alike. In trying to attract new firms to replace the lost one, the city is at a disadvantage because of these higher taxes, which also make it difficult for the remaining firms to do business. Moreover, there are higher social service costs because of greater unemployment. The costs of providing other services also rises with unemployment. All these factors make the city less attractive for business and workers alike. And, as we indicated earlier, there are serious social effects on the people who have lost jobs: loss of wages and family wealth, family violence and suicide associated with loss of self-esteem, and a variety of other problems.[71]

To be sure, the urban and regional effects of USDIA are not all bleak. Jobs are also created by American foreign investment. In particular, it is easy to trace part of the growth of New York's and Los Angeles's service sectors to the support of overseas operations of U.S. multinationals. In 1977, New York City was home to thirty-six banks set up under the Edge Act (the international finance subsidiaries of out-of-state

banks) to finance foreign business—much of it from American firms overseas; while Los Angeles had twelve, and Chicago nine.[72]* A large number of Edge Act banks were established in many other cities, such as San Francisco, Miami, Houston, Boston, and Philadelphia. By 1986, Miami had forty-eight foreign banks and twenty-seven Edge Act banks.[73] Certainly, the employment created in these banks is a result of international direct investment and trade. Similarly, employment is created in a variety of other service sectors, such as shipping and wholesaling. More evidence of domestic job creation can be seen in the domestic production needed to supply foreign operations: in 1985, $58-billion worth of goods and services were exported to affiliates of American multinationals.[74] That level of exports in cities throughout the country generates considerable employment.

STATES AND METROPOLITAN AREAS

Which states and regions did the best (or worst) in the face of national job loss from international investment?[75] The answer depends in large part on the extent of a state's exposure to international trade and investment and the competitiveness of the state's firms in international markets. The more competitive they are, the more likely it is that they will maintain jobs that depend substantially on international trade and investment. Economists have found it very difficult to calculate the regional effects of USDIA since there are no regional data for the employment associated with it. Moreover, the conceptual and measurement questions regarding the stimulus and displacement effects are more complex at the regional than at the national level.

Nevertheless, we developed a technique to estimate the impacts of USDIA on states and regions.[76] We found that between 1977 and 1986 the Southeast and the Great Lakes suffered the greatest number of jobs lost, accounting for about 46 percent of all displacement. The mideastern states added 17 percent (figure 6.6).† There are no great surprises here.

* An Edge Bank is a nationally chartered organization set up to engage in international banking and investment under the Edge Act of 1919: such banks can make loans, take deposits, and provide a variety of banking services; all must be directly related to foreign or international transactions.

† Different industries dominated displacement in each region. In the Great Lakes, for example, nonelectrical machinery, primary and fabricated metals, transport equipment, and chemicals lost the most. In the Southeast, chemicals, food, feed, and tobacco, nonelectrical machinery, and textiles and apparel were hardest hit. Nonelectrical machinery, primary and fabricated metals, chemicals, and paper products and printing had the greatest number of jobs lost in the Mideast.

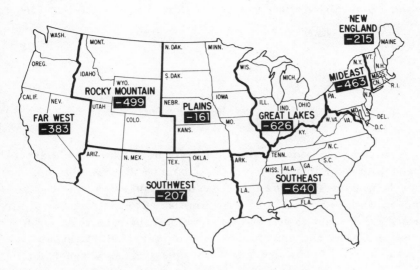

FIGURE 6.6
Manufacturing Displacement Due to USDIA by Region, 1977–1986.
NOTE: Figures represent thousands of jobs lost.

After all, these regions were the largest manufacturing areas and the largest regions in the country.

We also estimated the net manufacturing job loss in 246 Standard Metropolitan Areas (SMSAs) for 1977 (using a similar method to the one we used for states).* The leading employment losers were Los Angeles (5,195 jobs), Chicago (4,904), and Detroit (3,683). Other cities in the top ten were Philadelphia, Boston, San Jose, Seattle-Everett, Houston, Dallas–Fort Worth, and New York. The top twenty-five metropolitan areas lost a total of 47,275 jobs to displacement in 1977: seventeen of the twenty-five were in the Great Lakes, Far West, and Mideast regions and accounted for 76 percent of the displacement in the top twenty-five SMSAs; they represented 42 percent of the displacement in all SMSAs (see table C.4 in appendix C, p. 323). These results are consistent with our findings for the states. Although the top twenty-five SMSAs were generally among the larger SMSAs in the country, size and displacement were not strictly correlated: for example, while smaller cities such as San Jose and Seattle appear high on the list, many larger cities were far

* We made these calculations only for 1977 because data for export-related employment by city were not available for the years following 1977.

lower down. Miami, for example, was forty-seventh; and San Diego, thirty-sixth.

Conclusion

Foreign investment by American companies, which has been substantial for more than three decades, continues to grow. Our multinationals have invested more than $300 billion and employ more than 6 million workers abroad. American firms take production offshore for many of the same reasons that foreigners locate here; in particular, they want to capture and defend markets. However, unlike foreign MNCs operating here, American overseas investment has also been driven by the search for low-wage sites, a trend that has accelerated in the last fifteen years. The decision to invest abroad is taken in order to increase a company's worldwide profits: it is a logical, strategic, and sometimes necessary decision to ensure a corporation's survival. However, as we have shown, USDIA can have serious and indeed deleterious effects on the domestic economy. In addition to a large net displacement—2.7 million—between 1977 and 1986 in the vital manufacturing sector, nearly another 700,000 jobs were lost indirectly in the services and other industries. Making matters worse, the industries in which many jobs were lost (such as nonelectrical machinery, primary and fabricated metals, food, and chemicals) have been among those that have declined domestically. Therefore, the loss of manufacturing jobs due to USDIA *reinforced* domestic trends in manufacturing. Furthermore, the number of jobs lost supplement those cut by FDIUS. And, finally, those who most need jobs—blue-collar workers, women, and minorities—are those most likely to be displaced by overseas investment.

Our findings have important implications for public policy across the nation. The manufacturing job loss from USDIA greatly intensifies the small losses from FDIUS and from domestic manufacturing. The country simply cannot rely on FDIUS to help us regain employment in manufacturing. In addition, as Europe heads toward the important date of 1992, there is even more reason for American firms to invest there in order to avoid trade barriers. It would not be surprising, therefore, to see another turn of the revolving door of foreign direct investment—as American companies rush to locate in Europe, increasing USDIA. This

will mean more displacement and more serious problems of job creation in this country. We must find policies that will further domestic economic growth and thus make it more profitable for American companies to produce here. We will talk more about these policies in chapters 9 and 10. For states and cities, there are some relative (although not absolute) gainers and losers from USDIA, as there are from FDIUS (as the next chapter shows). As we shall see in chapter 8, they find themselves frantically seeking out new investment opportunities from foreign capitalists and trying to keep their factories from relocating abroad.

7

FOREIGN MULTINATIONALS AND
AMERICAN COMMUNITIES

A SATIRICAL comic strip published by *Nihon Keizai Shimbun*, the leading Japanese business journal, depicts a deeply troubled President Reagan staring out of an Oval Office window. "With the fall of the dollar," he complains, "Japanese industry seems to be invading our country." An advisor quickly answers, "But Mr. President, it's all according to our plan! It will increase jobs and reduce the unemployment rate." Another advisor reminds Reagan, "When the dollar was high, industries became hollowed out as enterprises went multinational. Everywhere ghost towns appeared." In the final frame, the President winks. "Ghost towns . . . ?" says the former host of *Death Valley Days*, "Like in a Western movie!"

From Ghost Town to Boom Town

As the dollar soared in the early 1980s, the Japanese viewed America's industrial "ghost towns" as both comedy and tragedy—more often the latter. Japanese business journals and government reports soberly discussed the loss of manufacturing jobs and its consequences for American communities. Besides the high dollar, they pointed to structural

problems: a weakening of American management, worker-management conflict, slow adaptation to new production technology, and capital flight to offshore production sites.[2] While the Japanese blamed America for creating its own woes, they also knew that U.S. politicians pointed an accusatory finger at the enormous bilateral trade surplus Japan ran up against the United States. Congressional calls for retaliatory trade legislation correlated directly with the spread of factory closings and layoffs. Thus, America's "ghost towns" haunted the Japanese—and other nations running huge trade surpluses with the United States.

Such was the curse of Clairton, Pennsylvania, where, until the early 1980s, U.S. Steel (now USX) was the major employer. But, after losing market share to the Japanese and other foreign competitors, the company sharply curtailed domestic steel production. Its decision to slash operations in Clairton led to a 50-percent reduction in local tax payments and austere cuts in public services as the city laid off the entire police force and fire department. A community leader grieved that public officials had "closed the city."[3]

The rising tide of Reaganomics promised to lift all boats, but whole communities sank even as the nation experienced the longest peacetime expansion of the postwar period. And the urban crises of the Reagan era were not confined to Frost Belt cities like Clairton. When McMinnville, Tennessee's leading textile mills shut down during the mid-1980s, for example, the jobless rate reached over 17 percent. As the city tumbled into depression, some residents blamed their misfortune on themselves; others, on the high value of the dollar and unrelenting import penetration.[4]

In the last chapter, we discussed how the outward investment contributed to domestic job loss, or as the Japanese put it, how "industries became hollow as enterprises went multinational." Now, as if according to the "plan" of Reagan's aides in the comic strip, some communities find jobs returning via foreign direct investment. Even a few of America's new industrial ghost towns are benefiting—like Chattanooga, Tennessee. Sixty miles southeast of McMinnville, this once-thriving factory city lost 10,000 blue-collar jobs between 1975 and 1985 as Swift's Meat Packing, Du Pont, Minnesota Mining & Manufacturing, and other large plants closed or operated with a drastically reduced workforce. In 1985, Chattanooga received a boost from Komatsu, Japan's huge farm and construction equipment company, which bought a mothballed crane-manufacturing plant and hired 250 workers. Toshiba revived a Westinghouse Electric plant in Elmira, New York, which we noted in the last

189

chapter was shut down as the company believed it could no longer compete.

A few hundred new manufacturing jobs hardly compensate for thousands lost in cities like Chattanooga and Elmira, battered by import competition and outward investment. But the Japanese hope that their growing commitment to produce on American soil will douse the flames of economic nationalism spreading in the United States. Investments by Komatsu, Nissan, Bridgestone, and others have already quelled protectionist sentiment among Tennessee's congressmen. Around the country, politicians are muting their criticism of Japanese trade practices, fearing they will jeopardize their claim in the direct investment sweepstakes. Michigan's governor James J. Blanchard candidly admitted, "We've told [the Japanese] that a strategy of investment in the Midwest could produce less trade pressure in Congress."[5]

Judging from the enthusiastic pronouncements of U.S. mayors and governors, foreign capital promises industrial salvation. There is reason to be upbeat. Although foreigners have created few jobs so far, new manufacturing plants sometimes provide the kind of skilled and semi-skilled employment lost through disinvestment by American companies. Moreover, the average wages of foreign-owned firms can surpass the average wages of U.S.-owned firms and are, according to some estimates, higher than average in every state in the U.S. mainland.[6] A plausible reason for this phenomenon is that MNCs operate in less competitive, "oligopolistic" sectors, where wages tend to run above average. At any rate, when a foreign company announces a major new plant, applications flood state employment offices. After Toyota's decision to locate in Georgetown, Kentucky, 90,000 people from 120 counties filed for 3,000 jobs. (The large number of applicants for the Toyota plant was matched by other Japanese investments: for example, Mazda hired 3,500 workers from a pool of 96,500 applicants for its Flat Rock, Michigan, plant.)

That is not to say that communities welcome all foreign multinational investment. Hostile acquisitions, in particular, risk provoking local opposition. In 1988, residents of Lawrenceburg, Tennessee, rallied against Electrolux, Sweden's huge electronics multinational, after the company tendered an unfriendly bid for Murray Ohio Manufacturing, a local bicycle and lawnmower manufacturer. When Electrolux tried to "invade," Lawrenceburg citizens met them with spirited protests, in sharp contrast with the zealous reception given Komatsu's new plant by citizens of Chattanooga. People in the small Tennessee town held placards that said "*nej*" (Swedish for "no") to Electrolux. Encouraged by

Murray's management, they opposed having a major factory change from local family ownership to external control by the world's largest appliance maker.[7] The Electrolux-Murray situation reflects general apprehension that communities have about losing control to outsiders.

Fear and resentment of outsiders may surface—albeit never as an organized protest—even when foreign companies announce a greenfield investment, rather than a corporate takeover. But many states and communities have seen ravages of deindustrialization; they far more often cheer the New Competitors as a source of economic growth and revitalization.

To be sure, foreign capital *can* spur industrial renewal in *preferred* areas. Often, once one foreign company settles in an area, others follow. Significant clusters of foreign capital include:

- A diversified foreign manufacturing corridor spawned by European investors in the Southern Piedmont area of South Carolina.
- A new "Auto Alley" stretching from Michigan to Tennessee paved by Japanese automotive companies.
- A foreign-owned petrochemical complex concentrated along the Gulf Coast of Texas and Louisiana.
- A semiconductor and computer-based "Silicon Forest" sprouting up in the Pacific Northwest.

As these examples suggest, the impact of the direct investment boom is being felt in pockets across the country. In this chapter, we analyze why some areas are favored by overseas investors, to see what attributes—markets, labor characteristics, taxes, and other factors—attract foreign capital to regions and localities.

Searching for Sites: Strangers in a Strange Land

Finding an advantageous site is the first important step toward establishing a foothold in the U.S. market. A favorable location can give foreign firms an edge over competitors and help compensate for the drawbacks of alien production discussed in chapter 3. Even when a foreign company takes over an existing company—Electrolux takes over Murray—it must consider the location of the assets. The new owner may keep some of the plants and offices and sell off others. Of course, a thorough location search is most important in establishing new plants.

When starting from scratch, however, foreign capitalists face an extremely complicated location decision in the United States. After all, foreign companies can locate in any of hundreds of places. The United States is many times the size of the home country, except for Canada. And even Canada has only three metropolitan areas with a population over one million (Toronto, Montreal, and Vancouver), whereas the United States has thirty-eight.[8] Moreover, American regions are culturally, economically, and politically diverse: they are as complex as most nations. Labor force characteristics, distribution networks, taxes, laws, and many other factors vary widely from state to state and locality to locality.

Typically, foreign companies delegate more personnel to site selection than do U.S. companies, and often spend a long time scrutinizing the American economic landscape before making their move. Japanese and German companies are known to take as long as five years. This lengthy search reflects both the characteristic patience of traditional MNCs and the disadvantage of alien status—a general unfamiliarity with American economic geography. Indeed, many are strangers in a strange land. To advise them on their many options, foreign companies sometimes hire sophisticated location consultants like the Fantus Corporation. A Fantus executive described Japanese site selection:

> The Japanese tend to be comprehensive and thorough in their investigation of U.S. locations. They have an insatiable appetite for facts and will gather every bit of data that can be possibly obtained on any factor that even remotely seems to have a bearing on the location decision. Naturally, they have less knowledge of operating conditions in the United States to begin with, so they cannot accurately judge which factors are truly significant and which are not. Rather than take the risk of overlooking some piece of information that might be vital, they engage in comprehensive fact gathering.[9]

Given the complexities of site selection in the United States, many foreign multinationals tackle the location decision in two steps: first, they choose what they consider to be the most desirable region; next, they survey the most competitive local sites within the region. For instance, when Japan's Matsushita planned a car-audio facility in the mid-1980s, company officials first narrowed their search to the South. In the second stage, the firm chose its site from ten candidate cities extending from North Carolina to Texas. The Hilti Corporation, a

machine-tool manufacturer based in Liechtenstein, conducted a similar probe; its locational checklist for its North American corporate head-quarters encompassed ten Southern cities.

During the second stage, company officials visit and compare prospective sites. They meet with public administrators, chambers of commerce representatives, tax assessors, and real estate brokers. Local industry boosters supply the prospective investor with lists of vacant industrial buildings, space in office parks, and computerized data on labor availability.[10] In the end, Matsushita selected a site in suburban Atlanta; Hilti chose Tulsa, Oklahoma.[11]

Ironically, some foreign firms have become so exacting about choosing U.S. sites that native companies actually follow them. In 1985, after General Motors announced the location of its innovative Saturn plant in Spring Hill, Tennessee, the largest single domestic investment in U.S. history, the governor of Tennessee took out a full-page advertisement in the *Wall Street Journal* to boast of his state's virtues as a manufacturing site. Yet his statement said more about GM's Japanese rivals: "We are grateful for their [G.M.'s] decision, but no one here is much surprised. Nissan made the same kind of decision in 1980 when, after six years of study, it decided to put the largest overseas Japanese investment in Smyrna, Tennessee."[12]

Regional and Urban Patterns of Foreign Investment

Let's now take a closer look at the regional and urban patterns of foreign jobs. Figure 7.1a shows how the three million foreign-controlled jobs in 1986 were distributed across the American mainland. The percentage of total state jobs that are foreign affiliated is given to rank the most "internationalized" states. Compared with the 3.5-percent U.S. average, states with greater percentages of their employment base in foreign hands stretch along the East Coast from Maine to Georgia. But no state has yet seen foreign companies command more than 10 percent of the workforce—if, that is, we discount Delaware's 13 percent, which largely results from the Bronfman brothers' 21-percent interest in the Wilmington-based Du Pont Corporation. One surprise is South Carolina, not usually believed to be an internationalized state. But, after Delaware, South Carolina has a larger share (5.9 percent) of its workers on a foreign payroll than any other state.

FIGURE 7.1

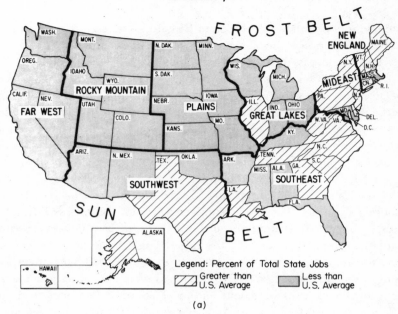

(a)

Foreign Firm Shares of Total State Employment (U.S. Average Equals 3.5 percent)

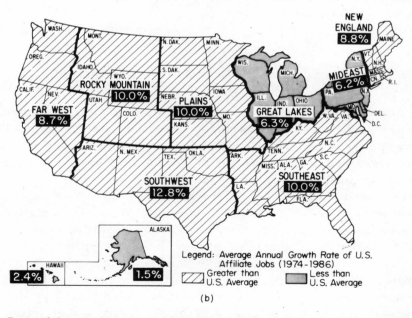

(b)

Regional Growth of Foreign Firm Employment (U.S. Average Equals 8.2 percent)

SOURCE: U.S. Department of Commerce, Bureau of Economic Analysis.

As they have become more familiar with U.S. production over the past fifteen years, foreign multinationals have fanned out across the continent. Figure 7.1b shows that from 1974 to 1986, the regions with above-average job growth include: the Southwest, the Southeast, the Rocky Mountains, the Plains, and the Far West. As the map also depicts, employment in the Mideast and Great Lakes grew slower than the rest of the nation. Of the three Frost Belt regions (the Mideast, Great Lakes, and New England), in fact, only New England enjoyed higher growth than the U.S. average.

In general, European companies are drifting across the nation from early outposts on the Eastern seaboard. Even some individual firms scatter their operations from coast to coast. Siemens USA, for instance, claims it is "a nationwide organization with a local presence": a vast network of 350 establishments, including 47 manufacturing assembly facilities. The Canadians, on the other hand, are moving into the interior from clusters in Maine and other border states. Meanwhile, the Japanese are moving eastward from California. Like European MNCs, several Japanese giants also have a "national presence." One of these is Mitsubishi Electric, an arm of the colossal company discussed in chapter 3. Mitsubishi Electric's investments include a television-assembly plant in California, a semiconductor facility in North Carolina, a television and cellular mobile phone plant in Georgia, and an automobile parts plant in Ohio.

When we examine manufacturing jobs, a pattern of more significant foreign control in U.S. regions emerges. Foreign manufacturers accounted for less than 8 percent of total U.S. manufacturing employment in 1986, yet eight states had over 10 percent of their manufacturing employment base in foreign hands, with the strongest regional clusters found in the Southwest, the Southeast, and the Mideast (see table 7.2). Massive investments by foreign-affiliated chemical companies explain the strong showing of many states, notably Delaware, West Virginia, Texas, New Jersey, and Louisiana. Recall that foreign control over chemicals is larger than in any other industry, but that most of the chemical investment results from acquisitions, not new plants.

To see where foreign companies located their new plants and plant expansions, we tabulated all investments recorded by the U.S. International Trade Administration. When foreign companies in the United States build new manufacturing plants or expand existing ones, they clearly favor the South. Of course, large states like New York and California receive many of these "employment-creating" investments. But after adjusting for the size of regions—the number of new plants and

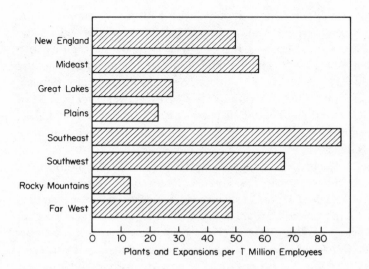

FIGURE 7.2
New Plants and Expansions by Region (1979–1986).
SOURCE: U.S. Department of Commerce, International Trade Administration.

expansions per million employees—we found an indisputable Southern bias from 1979 through 1986 (see figure 7.2). According to these adjusted figures, seven southeastern states ranked in the top ten. Significantly, only the Southeast received a larger number of new plants than acquisitions for foreign manufacturers (see appendix D, table D.1, pp. 326–27).

At the same time, "employment-creating" manufacturing plants are centralized in urban areas, which attracted nearly four-fifths of all new plants and expansions announced from 1979 through 1986 (see figure 7.3).* There are several reasons that urban, not rural, areas attract the lion's share of direct investment. First, they are attracted by markets, not only for sales to consumers but sales to other firms. Urban sites give them proximity to both. Cities also furnish professional services (accountants, lawyers, and the like) that foreign firms need, and have a large pool of skilled labor. Second, given foreigners' lack of knowledge about U.S. territory and the cautious nature of most multinationals, an urban orientation is not surprising: cities reduce risks because they afford non-American firms easier access to information. Third, size and oligopolistic power make it possible for foreign firms to afford the expensive metropolitan areas. Most foreign firms in America are not cutthroat competitors looking for cheap labor, as we pointed out

* American corporations also prefer metropolitan areas overseas.[13]

in chapter 3. Finally, metropolitan areas provide better travel and communications links between the home office and the U.S. site.

Regional Markets

Now let us examine why foreign firms prefer certain regions of the United States. Foreign manufacturers are attracted to the Sun Belt, especially to the Southeast and Southwest, in part because of something we stressed in chapter 4: a large, lucrative, and growing market. America's strong demand provides unsurpassed opportunities for industrial growth—a fact no one is more aware of than foreign competitors. A 1987 study by Japan's International Trade Institute underscored this point: "The most beneficial advantage is that the United States has an abundant and advanced market which is the precondition for the development of key advanced industries."[4]

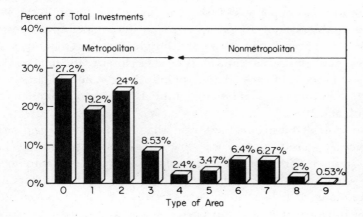

FIGURE 7.3
"Employment-Creating" Investments by Type of Area.

SOURCE: U.S. Department of Commerce, International Trade Administration; U.S. Department of Agriculture, Economic Research Service.

NOTE: Urban Code: 0 = Central counties of metropolitan areas of 1 million or more population; 1 = Fringe counties of metropolitan areas of 1 million or more population; 2 = Counties in metropolitan areas of 250,000–1 million population; 3 = Counties in metropolitan areas of less than 250,000; 4 = Non-metropolitan counties with urban population of 20,000 or more, adjacent to a metropolitan area; 5 = Non-metropolitan counties of 20,000 or more, non-adjacent to a metropolitan area; 6 = Non-metropolitan counties with urban population of less than 20,000, adjacent to a metropolitan area; 7 = Non-metropolitan counties with urban population of less than 20,000, non-adjacent to metropolitan area; 8 = Rural counties, adjacent to a metropolitan area; 9 = Rural counties, non-adjacent to a metropolitan area.

Actually, the United States is not a homogeneous market, but a collection of distinct regional markets with varying prospects for industrial development. Unlike most other developed nations, America has undergone monumental interregional shifts in migration and population. Of course, the Sun Belt's demand has grown most rapidly. As one economist recently put it, the United States still has a "frontier" economy, a "city-building dynamic in the South and West that generates abundant profit opportunities to capitalists."[15]

As cities developed in the South and West, they steadily augmented their share of manufacturing output. Still, they relied on Northern producers for a wide range of goods. The causes of this uneven distribution of manufacturing production date back to the turn of the century. In the late nineteenth and early twentieth centuries, production concentrated in large Northern plants, in part because of the scale advantages of mass production. It was more efficient to supply national markets from single locations than through a network of local branch plants.[16]* Moreover, some industries used a *basing-point* transport price system that decisively favored mass production in the Frost Belt. The most notorious example was Pittsburgh-plus pricing found in the steel industry. In this system, all price quotes were determined by the cost of delivering steel over rail lines from Pittsburgh—a system that offset any cost advantages of firms with production sites closer to the final market. In steel and other industries, basing-point pricing benefited large-scale production in the North and inhibited the dispersion of production to the South and West.[17]

The Frost Belt also benefited from what economists call *agglomeration economies*—a reduction in costs that firms enjoy by producing close to one another. Firms in the same industry—say, in the automobile sector—could draw from a shared pool of local input suppliers and concentrations of skilled labor. Firms across all industries benefited from the infrastructure and transportation systems that only developed industrial areas could provide.

As firms clustered in the North, it was difficult for alternative production sites to develop even as population grew in other regions. Thus, the North became highly industrialized, while "peripheral" regions experienced little manufacturing activity relative to demand. Local manu-

* Rail transport favored production in large plants: since railroads charged high terminal charges but low line haul rates, the transport rate per ton of output did not substantially increase with distance; by concentrating production at a single location, a firm could spread the high terminal costs of rail yards over many units, thereby reducing its average costs.

facturing supply has lagged behind demand growth in the Sun Belt. But the superprofits that Northern producers long enjoyed from their control over the U.S. market led to complacency. Northern oligopolies responded sluggishly to changing regional demand in the nation's periphery and often charged higher prices than foreign producers.[18]

Faced with constricted and saturated markets at home, foreign multinationals inevitably saw the gap between regional demand and supply in the United States, coupled with excessive prices by domestic firms, as a golden opportunity to extend global market share. The following passage from a report of the Japanese International Trade Institute reflects this perception of U.S. regional conditions—linking import penetration in the United States to imbalanced regional demand and supply:

> The problem is that while demand grows more rapidly in the West and South, supplies especially from the North cannot respond effectively to the demand, producing a mismatch between demand and supply and leading to a substantial leak of demand abroad accompanying larger imports. This kind of mismatch has been growing since the 1970's and has resulted in a larger trade deficit recently.[19]

As the trade deficit grew, it became increasingly obvious that non-American MNCs could exploit the regional mismatch between demand and supply. Non-American MNCs took advantage of America's regional growth potential and its mismatch between demand and supply through international trade. But, as we discussed in chapter 4, there are many reasons that international firms move beyond export strategies of market penetration to direct investment abroad. Multinationals need to surmount protectionist barriers, keep abreast of local demand conditions, deliver products promptly, protect themselves against exchange rate fluctuations, and so forth. Sony's *global localization* (producing close to the market) strategy describes succinctly the rationale for moving from exports to direct investment. Thus, foreign MNCs have either substituted or complemented exports to the United States with stateside production.

Accordingly, the Japanese International Trade Institute proposed a regional "import substitution" strategy for both U.S. and foreign producers:

> The basic direction for the betterment of American industry is to realize a virtuous combination by mobilizing and integrating technological innova-

199

tions, American management, and the contribution of foreign capital while making full use of her dynamic and abundant market. The virtuous combination can be realized, in terms of regional structure, by shifting industrial sites from the Northeast and North Central to a more decentralized system by development of the West and South. . . . In forming this kind of virtuous combination, not only American business but also foreign firms can play a role.[20]

Regional economists refer to the supply response as the "filling-in" thesis of regional growth[21]—the twist here being that *foreigners*, as well as U.S. suppliers, are "filling in" demand with local production.

California Steel, the joint venture of Japan's Kawasaki Steel and Brazil's Companhia Vale do Rio Doce (CVRD) discussed in chapter 5, provides a good illustration of how foreign companies are attracted to underserved regional markets. After Kaiser Steel closed down in 1983, Fontana, California, could have become another smokestack ghost town. Yet West Coast factories relied on Kaiser, the only mill in California. After the Kaiser shut down, U.S. Steel, operating the only western steel plant in Provo, Utah, took advantage of its spatial monopoly and ran up the price of sheet steel from $300 to $380 a ton. A former customer of Kaiser in Phoenix, Arizona, complained, "I don't blame U.S. Steel for raising prices after Kaiser closed Fontana. But I'm competing against products from Taiwan, and just because U.S. Steel thinks it can get more for its products doesn't mean I can get more for mine. We desperately needed another mill on the West Coast."[22]

Another customer of Kaiser Steel, Michael Wilkinson, put together the international rescue operation. Although imported steel was cheaper, Wilkinson saw that the advantages of timely delivery by a local supplier were worth the difference. When Kaiser closed, Wilkinson decided to buy the factory. Although building a new steel facility in the United States would cost well over a billion dollars, the cost of the Fontana steel rolling factory was only $110 million. But to make the plant profitable, Wilkinson needed the help of integrated foreign steel makers; so he allied with Kawasaki Steel and CVRD, becoming his own supplier for his wheel and pipe factories in southern California. He later sold out his interest to the Japanese and Brazilian partners. For the foreign companies the deal helped solve the problem of global overproduction. In a joint venture with Italian and Brazilian capital, Kawasaki had just finished building a steel slab mill in Brazil in 1983 as the world market for semifinished steel became glutted. California Steel now receives most of its raw materials—the steel slabs—from the Brazilian

plant. Those slabs are made of iron ore supplied by CVRD, which explains the Brazilian company's interest in reviving the Fontana plant.

The California Steel story gives us a concrete instance of a more general pattern of foreign firm location which we uncovered in a study prepared for the U.S. Economic Development Administration. In an exhaustive statistical analysis of U.S. affiliate employment, we found that foreign manufacturing jobs grew fastest in states where demand is strong, but where there is relatively less competition from local suppliers.* In an attempt to account fully for recent changes in foreign employment among states, we also examined many other factors that supposedly explain regional growth—including taxes, climate, and wages. But market pull dominated the other variables. (The other factors were either statistically insignificant or far less important determinants of job growth than regional market potential.)

The clustering of foreign firms in major urban areas attests to the local market orientation (see figure 7.3). Even when MNCs locate on the fringes of large metropolitan areas, transportation networks linking the site to major markets are often critical. Our research indicates that the probability that a community will attract a new plant is strongly influenced by both the percentage of the population residing in urban areas and transportation accessibility, especially interstate highway linkages.[24] But, as we shall see, markets are not the only influence on site selection by foreign firms in the United States. Each American region has special inducements to the New Competitors.

* According to our statistical analysis, a state's market potential (measured by the ratio of personal income to manufacturing employment) strongly influenced recent foreign firm employment growth. State personal income measured regional demand, while manufacturing employment represented supply, or the existing concentration of manufacturing. The ratio of the two variables captures the extent to which regions contain underdeveloped and exploitable manufacturing potential. In our statistical tests, we adjusted a state's personal income and manufacturing employment according to its geographical position in relation to all other states:

(1) $PIP_i = {}^{50}\sum_{j=1} PI_j/d_{ij}{}^2$

(2) $EMPP_i = {}^{50}\sum_{j=1} EMP_j/d_{ij}{}^2$,

where PI_j and EMP_j are, respectively, personal income and manufacturing employment in state j; and d_{ij} is a state's population centroid—that is, the distance from center of population in state i to state j. The distance from a state to itself (d_{ii}) was measured by one-half the average radius of the state. The market variable tested in our regression analysis of foreign employment growth was the ratio of the two *gravity* measures: personal income potential (*PIP*) and manufacturing employment potential (*EMPP*). This variable had a strongly positive and statistically significant influence on the growth of foreign employment among states.[23]

The Southern Strategy

Although the South is the least developed region of America in terms of per-capita income, infant mortality, average life expectancy, and many other indicators of economic and social well-being, it leads the nation according to most measures of foreign direct investment. Much of the recent employment growth in the South has come in services, but the region has long led the nation in manufacturing employment by overseas-affiliated companies. The foreign affinity for the South dates back to the last century, when British investors built a blast furnace in Tennessee and attempted to create a whole new town in the state—aptly named South Pittsburgh. Today, southeastern states have about 740,000 people working for foreign companies and hold over a quarter of all foreign manufacturing jobs (see tables 7.1 and 7.2). An economist at the Southern Center for International Studies, misinterpreting Bureau of Economic Analysis data that combine foreign acquisitions and new plants, concluded erroneously that hundreds of thousands of jobs have been created in the Southeast since the 1970s.[25] As we know, the BEA figures exaggerate the employment impact in the region. But no one doubts that new plants open each year, generating thousands of jobs.

Many prized manufacturing investments—in rubber, steel, and transport equipment—are concentrated in the region. In the rubber industry, for example, the French tire company Michelin established its North American beachhead in South Carolina, away from the domestic rubber industry clustered around Akron, Ohio. Other investments—like Japan's YKK zipper plant in Georgia or Hoechst's petrochemical investments in Louisiana—add to the region's traditional industry mix.

Nowhere is the Southern concentration of foreign start-ups more evident today than in South Carolina, especially in the state's Piedmont area. Like kudzu, the fast-growing vine first introduced into the United States by the Japanese in the nineteenth century, foreign-owned plants have so proliferated on the eastern slopes of the Blue Ridge Mountains that they now appear indigenous to the area. Scores of German, Swiss, French, and other European manufacturers have dramatically transformed the economic landscape. Interstate 85 between Greenville and Spartanburg, South Carolina, is known as the "Autobahn." Spartanburg has been called Euroville, "perhaps the most international city in the entire United States."[26] (While new reports claim that Spartanburg has more foreign capital per capita than any other U.S. metropolitan

area,[27] reliable data on foreign capital in urban areas are not available to confirm this often-cited statistic.) Spartanburg-Greenville has most of the attributes that foreign investors look for when they select a local site—the second stage in the location decision process. It is a growing urban area, South Carolina's largest, with almost 600,000 people. Equally important, it has good highway linkages to growing Southeastern markets. Interstate 85 directly connects Greenville-Spartanburg to Atlanta and Washington, D.C., and provides a indirect links to thriving markets along the Eastern seaboard. Interstate 26 connects the metropolitan area to the port of Charleston.

Another reason for the Piedmont's success is that local industry boosters sent trade missions overseas to woo foreigners long before most other areas. The Spartanburg Chamber of Commerce has aggressively pursued foreign direct investment for over twenty-five years. The story goes that one day in the early 1960s the executive vice president of the Chamber of Commerce, Richard Tukey, an immigrant from Brooklyn, sat back in his leather chair and wondered how he could help diversify the economic base of his adopted home. He seized upon the idea of foreign investment. Persuading the governor of the merits of his idea, Tukey and a group of South Carolinians embarked on a series of trips abroad.[28] Among other European firms, they persuaded Hoechst to locate in 1965. Today Hoechst Fibers, a textile subsidiary of the German chemical giant, employs over 3,000 workers in two Piedmont factories and runs the largest manufacturing plant in Spartanburg County.

Like Hoechst Fibers, many of the early foreign transplants to the Spartanburg-Greenville corridor were in the textile industry, the backbone of the area's industrial structure. But a second wave of diversified manufacturers followed in the late 1970s and 1980s. Said an executive of Euro-Drive, a West German conveyor-belt-drive manufacturer, "So many other German companies told us about their experiences here that we decided to follow them."[29]

In all, over sixty foreign manufacturers and service companies from twelve countries have settled in the area, accounting for over 7,000 jobs.[30] One of the ten largest employers in the state, the French tiremaker Michelin employs over 2,000 workers in the Greenville tire plant and another 1,200 in a rubber-compounding and fiber-processing facility in nearby Anderson County. Michelin also has a research corporation and its U.S. headquarters in the Piedmont. Not surprisingly, foreign companies are actively involved in community life. Michelin heavily funds arts programs, theaters, and symphonies and invests in the United

TABLE 7.1
Total Foreign Firm Employment: State and Regional Comparisons (1986)

	U.S. Affiliate Jobs	Share of Total U.S. Affiliate Jobs	Percent of Total State Jobs
New England			
Connecticut	50705	1.72%	3.58%
Maine	21731	0.74%	5.46%
Massachusetts	76727	2.60%	2.92%
New Hampshire	16785	0.57%	3.89%
Rhode Island	11243	0.38%	2.89%
Vermont	6957	0.24%	3.49%
Total	184148	6.25%	3.37%
Mideast			
Delaware	33896	1.15%	13.37%
District of Columbia	6793	0.23%	1.78%
Maryland	49762	1.69%	3.11%
New Jersey	161706	5.48%	5.45%
New York	284469	9.65%	4.33%
Pennsylvania	152439	5.17%	3.70%
Total	689065	23.37%	4.33%
Great Lakes			
Illinois	153197	5.20%	3.74%
Indiana	57033	1.93%	3.03%
Michigan	89639	3.04%	2.93%
Ohio	127072	4.31%	3.33%
Wisconsin	57469	1.95%	3.38%
Total	484410	16.43%	3.32%
Plains			
Iowa	18598	0.63%	2.15%
Kansas	16341	0.55%	2.04%
Minnesota	47982	1.63%	3.00%
Missouri	48250	1.64%	2.65%
Nebraska	6215	0.21%	1.19%
North Dakota	2361	0.08%	1.27%
South Dakota	1513	0.05%	0.80%
Total	141260	4.79%	2.36%
Southeast			
Alabama	35822	1.21%	3.01%
Arkansas	18324	0.62%	2.70%
Florida	107355	3.64%	2.69%
Georgia	109003	3.70%	4.83%
Kentucky	34714	1.18%	3.32%
Louisiana	49182	1.67%	4.02%
Mississippi	20391	0.69%	3.03%
North Carolina	119182	4.04%	5.08%
South Carolina	64643	2.19%	5.87%
Tennessee	78028	2.65%	4.75%

	U.S. Affiliate Jobs	Share of Total U.S. Affiliate Jobs	Percent of Total State Jobs
Virginia	76170	2.58%	3.68%
West Virginia	27116	0.92%	5.80%
Total	739930	25.09%	3.96%
Southwest			
Arizona	35733	1.21%	3.15%
New Mexico	10621	0.36%	2.65%
Oklahoma	26518	0.90%	3.03%
Texas	211254	7.16%	3.83%
Total	284126	9.64%	3.59%
Rocky Mountains			
Colorado	32545	1.10%	2.80%
Idaho	3072	0.10%	1.17%
Montana	3041	0.10%	1.45%
Utah	11630	0.39%	2.37%
Wyoming	2892	0.10%	1.98%
Total	53180	1.80%	2.34%
Far West			
California	284496	9.65%	2.92%
Nevada	8752	0.30%	2.11%
Oregon	17472	0.59%	2.02%
Washington	36558	1.24%	2.52%
Total	347278	11.78%	2.78%
Total Mainland U.S.	2923397	99.14%	3.51%
Alaska	6471	0.22%	4.10%
Hawaii	18851	0.64%	5.21%
Total U.S.	2948719	100.00%	3.52%

Source: U.S. Department of Commerce, Bureau of Economic Analysis

Way and the Urban League.[31] Michelin and Hoechst executives, along with other foreigners, are leading members of the Spartanburg Chamber of Commerce. They are aggressive lobbyists for more foreign-owned industry, continuing the tradition begun in the 1960s.

Of course, Spartanburg is no longer the only place in the region with a global outlook. A growing number of cities compete fervently to make the site selection cut—the list of ten or so cities deemed most desirable. All want to be like Spartanburg, one of the emerging international cities of the South. In Georgia, investment has spread from Atlanta, the service and distribution capital of the Southeast, to medium-sized industrial cities such as Macon. In Tennessee, or what the Japanese like to call "Tennessee-*ken*" because of their many investments there (*ken* being the Japanese word for "prefecture," the rough equivalent of

TABLE 7.2

Foreign Manufacturing Employment: State and Regional Comparisons (1986)

	U.S. Affiliate Manufacturing Jobs	Share of Manufacturing Affiliate Jobs	Percent of Total State Manufacturing Jobs
New England			
Connecticut	28594	2.06%	7.22%
Maine	8039	0.58%	7.69%
Massachusetts	29224	2.10%	4.71%
New Hampshire	7450	0.54%	6.28%
Rhode Island	9190	0.66%	7.65%
Vermont	2603	0.19%	5.26%
Total	85100	6.12%	6.04%
Mideast			
Delaware	29702	2.14%	42.76%
District of Columbia	858	0.06%	5.45%
Maryland	21422	1.54%	10.13%
New Jersey	84864	6.10%	12.24%
New York	94762	6.81%	7.50%
Pennsylvania	85457	6.14%	8.11%
Total	317065	22.79%	9.59%
Great Lakes			
Illinois	69708	5.01%	7.31%
Indiana	36987	2.66%	6.12%
Michigan	52955	3.81%	5.33%
Ohio	70769	5.09%	6.37%
Wisconsin	33423	2.40%	6.48%
Total	263842	18.97%	6.31%
Plains			
Iowa	10871	0.78%	5.36%
Kansas	7594	0.55%	4.30%
Minnesota	20147	1.45%	5.45%
Missouri	22923	1.65%	5.35%
Nebraska	3124	0.22%	3.53%
North Dakota	878	0.06%	5.69%
South Dakota	713	0.05%	2.52%
Total	66250	4.76%	5.05%
Southeast			
Alabama	20518	1.48%	5.68%
Arkansas	10206	0.73%	4.80%
Florida	36633	2.63%	7.06%
Georgia	53327	3.83%	9.32%
Kentucky	18903	1.36%	7.43%
Louisiana	16312	1.17%	9.84%
Mississippi	14112	1.01%	6.28%
North Carolina	62500	4.49%	7.48%
South Carolina	31801	2.29%	8.68%
Tennessee	48415	3.48%	9.86%

	U.S. Affiliate Manufacturing Jobs	Share of Manufacturing Affiliate Jobs	Percent of Total State Manufacturing Jobs
Virginia	34219	2.46%	8.01%
West Virginia	15779	1.13%	18.08%
Total	362725	26.08%	8.03%
Southwest			
Arizona	15699	1.13%	8.41%
New Mexico	2932	0.21%	7.77%
Oklahoma	10000	0.72%	6.21%
Texas	84777	6.09%	8.91%
Total	113408	8.15%	8.48%
Rocky Mountains			
Colorado	16783	1.21%	8.99%
Idaho	1869	0.13%	3.56%
Montana	1584	0.11%	7.41%
Utah	5218	0.38%	5.67%
Wyoming	1033	0.07%	13.09%
Total	26487	1.90%	7.35%
Far West			
California	127327	9.15%	6.15%
Nevada	3491	0.25%	15.57%
Oregon	7041	0.51%	3.53%
Washington	13389	0.96%	4.36%
Total	151248	10.87%	5.82%
Total Mainland U.S.	1386125	99.65%	7.29%
Alaska	2404	0.17%	18.80%
Hawaii	2442	0.18%	11.08%
Total U.S.	1390971	100.00%	7.30%

Source: U.S. Department of Commerce, Bureau of Economic Analysis

our "state"), investment has also spread throughout its urban areas. The rising sun in Tennessee has received considerable media attention. Mitsui, Sharp, and Toshiba and others have settled in Memphis; Bridgestone reopened a closed Firestone plant in LaVergne (near Nashville); Nissan placed its new plant in Smyrna (also outside Nashville); Matsushita located in Knoxville; and Komatsu in Chattanooga. Dozens of other Japanese companies blanket Tennessee, and about 8,000 citizens of the Volunteer State worked for Japanese multinationals at the end of 1986.[32] Both in total employment and in recent new plant announcements from all nationalities, North Carolina has done better than Tennessee (see appendix D, table D.1, pp. 326–27). The Charlotte/Mecklenburg metropolitan area holds the largest concentration of foreign firms in the state.

All these Southern cities possess the local attributes desired by foreign firms, notably market access. In one survey of German and Japanese MNCs in Charlotte, for example, the researchers detected an almost uniform interest "in capitalizing on the area's convenient and desirable location, which affords them relatively unrestricted access to large markets."[33] Tennessee economic development officials often point out that a Nashville site puts a company within 500 miles of three-quarters of the U.S. population. Another crucial determinant in local site selection is the availability of production labor, which these Southern industrial cities possess as well: for example, 38 percent of the Spartanburg labor force is engaged in manufacturing, with many trained for the textiles, chemicals, and related industries.[34]

As for labor costs, it is no secret that Southern wages are the lowest in the nation, falling about 12 percent below the national average for manufacturing production labor, and even lower in Deep South states like South Carolina, where average wages lie 20 percent below the rest of the nation.[35] No doubt the availability of cheap labor appeals to some investors—especially in industries like textiles and electronics with routinized, assembly-type manufacturing processes requiring cheap, semi-skilled and unskilled labor. "One of the major reasons we came here was the wage rates," says Paul Foerster, executive vice president of Hoechst Fibers and now vice president of the Spartanburg Chamber of Commerce. "People [in Spartanburg] are willing to do a day's work for a day's pay," he asserted.[36]*

If foreign investors want the cheapest labor, they can find no better place than the rural South, the area of the nation closest in wages to a Third World nation. A few foreign electronics plants, in fact, are found in some of the South's backward nonmetropolitan counties—counter to the general rule that foreign plants gravitate toward metropolitan areas.† These rural electronics plants mainly assemble audio equipment,

* The "willing" workers include some 14,000 workers in Spartanburg displaced by the domestic textile industry over the past ten years; in all, South Carolina lost 50,000 jobs in textiles from 1972 to 1986, mostly in the Spartanburg-Greenville metropolitan region.

† Coincidentally, 430 new plant investments from 1979 to 1983 were evenly divided into 215 sites in the South and 215 elsewhere. Southern counties with low urbanization levels received 35 plants (16 percent), while counties outside the South received 19 plants (9 percent); counties in the middle urbanization group received 76 plants (35 percent) and 60 plants (28 percent) for the South and non-South, respectively. This leaves 48 percent in the highly urbanized South and 63 percent outside the South. Similarly, of the 292 new Japanese plants, 16 of 87 (18 percent) were found in rural (low-urbanized) southern counties, compared with 15 of 205 (7 percent) in rural counties outside the South. The South had 44 percent of its Japanese plants in the most urbanized counties, while other regions had 69 percent.[37]

televisions, and other household appliances, where there is a low-skill level required of employees.[38] But these investments in low-wage industries of the rural South could be temporary and easily shifted to Malaysia or Mexico, where wages are much lower.

To many foreign firms, saving money on wage costs is far less important than control of the labor force. Along with proximity to growing markets, numerous surveys show that an absence of unions and positive "worker attitudes" consistently rank at the top of foreign firms' state and regional preferences.[39]* Here again the South has a special advantage. Throughout the region, right-to work laws (prohibiting "closed" union shops) make worker organizing difficult, if not impossible. All Southern states have low unionization rates. In South Carolina, for example, only about one in every twenty workers carries a union card, fewer than in any other state.

Our analysis of foreign employment patterns among states showed that labor climate (a combination of low unionization rates, right-to-work laws, and low strike activity) strongly influenced the distribution of jobs in the 1970s.[42] However, as we shall see shortly, this locational advantage may be diminishing as American unions increasingly yield more control and operational flexibility at the point of production. If the alien fear of American unions subsides, the Southern cities will find it more difficult to compete with other areas, especially those with fast-growing markets and/or concentrations of skilled labor.

To be sure, other features than relatively strong markets and cheap, unorganized labor draw foreign capital below the Mason-Dixon line. Shell, BASF, Hoechst, and ICI heavily participated in the Southern petrochemical boom of the late 1970s and early 1980s.[43] In the location of petrochemical plants, a deciding factor is an abundant supply of natural gas, the primary feedstock in ethylene production, found primarily in Texas and Louisiana. Since ethylene can only travel over a short distance, plants using this major petrochemical product cluster along the Gulf Coast. In turn, Texas and Louisiana witnessed the most rapid FDIUS growth of all states at the time because the investments were primarily resource-oriented.

* Low unionization and "worker attitudes" are often cited in studies of foreign investors' location preferences for specific Southern states: for instance, a study of 350 manufacturing companies in Tennessee shows that "worker attitude" was cited by 82 percent as a prime reason for locating or expanding in the state.[40] Another study of foreign investment in Tennessee found that the presence of nonunionized labor and favorable labor-management relations ranked at the top of 22 survey items.[41]

East Meets West

Whereas the South has a history of global smokestack chasing, the West's attractions mostly sell themselves. The region is a natural magnet for industry because of its continual population growth, high per-capita income, resources, and favorable climate. Of course, during the early nineteenth century, the inmigration both of people and of capital to California meant *from* the United States *to* a foreign land (controlled by Mexico). State development officials like to quote Mexico's Governor Pico, who during the 1840s mourned that, "We find ourselves suddenly threatened by hordes of Yankee emigrants who have already begun to flock into our country, and whose progress we cannot arrest."[44]

Today California attracts more of the nation's inmigration of capital than any other state. Direct investment grows at a rate above the U.S. average, and California leads the nation in total number of workers on a foreign payroll (almost 300,000). Although the percentage of Californians working for foreign companies remains below the national average, the percentage working for foreign manufacturing companies is much higher than average (see tables 7.1 and 7.2). Still, we have already noted the rapid growth of foreign investment in the region, which has outpaced the national average since the mid-1970s.

Besides its strong demographic growth and growing markets, Western states hold special features that lure foreign capital, one of the region's distinct advantages being proximity to the Pacific Rim. Thus, while the Southeast remains the strongest base of European capital in the United States, the Far West is the primary hub of Japanese capital. California's favorable location and strong market lured most of the investment. Over 30 percent of all Japanese employment in 1986 was in California—by far the largest share of foreign jobs in any state from a single nation.[45]

Japanese investment in the Far West also represents a major exception to the Southern bias of foreign greenfield investments. Of 295 new manufacturing plants announced by Japanese companies from the early 1970s through 1985, 109 (37 percent) went to the Far West—much more than any other region. Again, California dominated the picture.[46]*

* Adjusting the number of plants for the amount of employment in a region, we found that California was still way ahead of the rest of the nation. The Southeast ran a distant second with 68 new plants (23 percent). The principal beneficiaries were Georgia, Tennessee, Arizona, and Texas. Of all the Manufacturing Belt states, only New Jersey hosted any substantial number of Japanese plant sites.[47]

Over 10 percent of all Japanese manufacturing plants through 1985 located in Los Angeles County. Los Angeles has been dubbed the twenty-fourth ward (Tokyo has twenty-three wards), perhaps more because of real estate purchases than new factory construction.

Much of this investment came to California despite Japanese MNCs' well-known antipathy toward the state's unitary tax law, under which MNCs are not only taxed on the profits made in the state. Instead, the unitary formula determines the corporate tax from the percentage of total (unitary) company sales, payroll, or property in a given state. In the 1980s, twelve states had a worldwide unitary tax on the books; and at least twenty nations filed official protests in the United States on behalf of multinational corporations, complaining that the taxes subject foreign firms to double taxation, require burdensome accounting procedures, and force MNCs to write detailed reports on their global operations.[48] State comptrollers, on the other hand, often championed the tax because it countered transfer pricing. By reporting paper losses in a state while channeling real profits to the books of foreign subsidiaries, MNCs avoid state profit taxes. The campaign against the unitary tax reached a showdown in Sacramento, where lobbyists for multinational corporations argued that California would lose investment dollars if the method of assessment was not repealed. Until it was modified in a controversial battle fought with the state legislature in 1986, California's unitary tax was one of the strongest in the nation.

The loss of multinational investment dollars to states with unitary taxes may not have been an idle threat raised by corporate lobbyists. Our research shows that once we took account of locational influences like markets and labor, then states with unitary tax laws had 1.5 percent slower foreign employment growth between 1974 and 1983.[49] Since 1983, every state except Alaska capitulated to pressure from multinationals (foreign and domestic) and repealed or severely restricted the tax. California experienced an intense lobbying effort, no doubt because of the size of foreign investment in the state. In 1986, the California legislature worked out a compromise bill that allowed corporations to select either worldwide unitary taxation or a "water's edge" unitary tax which would consider only company operations in America. If a multinational chooses the water's-edge option, then it is subject to a penalty of 0.03 percent of the value of the company's payroll. Many foreign companies protested the 0.03 penalty, but the unitary tax reform was generally considered a victory for foreign, especially Japanese, lobbying efforts. Chris Wada, a key figure in the anti-unitary tax effort and Sony's spokesman in the U.S., testified before a special session of the California

legislature in 1988 and made it clear that the Japanese business community was thankful for the 1986 unitary tax modification. He pointed to a survey conducted by Japan's Council for Better Investment in the United States which showed that thirty out of seventy-three Japanese companies planning to invest in the United States would do so in California. Wada stressed that "modification of the unitary tax from the worldwide basis to water's edge election . . . has greatly contributed to this large number of expected investments in California."[50]

Oregon bowed to the anti-unitary tax campaign before California, in part, to attract some of the Japanese investment from its southern neighbor. Oregon once had a reputation for spurning economic development from outside its borders, even from other states. But the recession of the early 1980s and the global slump in the state's wood products business dramatically altered that attitude. In May 1983, Salem, Oregon, lost out to Durham, North Carolina, in a hotly contested bid to attract a high-technology start-up. After making it to number 2 on Mitsubishi's selection list of some twenty-six possible sites, state economic development experts reflected on the "lessons for Oregon."[51] They concluded that ultimately Oregon lost the plant because market proximity was the key factor in the decision process, and Mitsubishi wanted to settle close to the East Coast market. The officials also concluded, "While the unitary tax was carefully evaluated by the Japanese, it does not appear to have been a critical factor in their decision to build in North Carolina rather than Salem."[52] The next year, however, the state apparently reached a different conclusion. This time state development experts concluded, "Oregon's application of combined worldwide reporting discourages investment in new plant and equipment in Oregon in several ways: it results in perceived double taxation of multinational companies, taxes money-losing start-up manufacturing operations, invades confidential business information, and imposes undue administrative burdens."[53] Oregon rescinded its unitary tax in 1984, and in the first three years after the repeal, over fifty Japanese companies invested in Oregon, employing 2,500 people.[54]

Much of the investment—primarily in high-technology assembly plants—has located in the Portland metropolitan region, the so-called Silicon Forest. Actually, the German-owned Wacker Siltronics arrived before the Japanese, building a semiconductor plant and creating 500 jobs in the Portland area during the 1970s. But the new Japanese plants now eclipse investment from other nations. Drawn by the low land costs and the availability of skilled labor, Nippon Electric, Fujitsu, Kyocera, Epson, and Sharp Electronics all eschewed the Japanese attraction to

California and set up shop in the Northwest. For example, Fujitsu America built a $30-million plant for high-capacity disk drives which now employs about 200 workers in Hillsboro, just west of Portland. Fujitsu's state-of-the art facility incorporates its well-known quality-control advantages. The Hillsboro plant is a clone of a facility located across the Pacific in Nagano, Japan. Civic boosters often stress the similarities between Hillsboro and Nagano—both cities are surrounded by mountains and an hour's drive from the Pacific Ocean. Cementing the ties between these sister cities, Fujitsu initiated an annual Cross-Cultural Day celebration in Hillsboro; its festivities feature traditional Japanese music and theater side by side with American culture.[55]

The Chilling and Thawing of the Frost Belt

Can Northern cities duplicate the success of Spartanburg, Hillsboro, and other new internationalized areas of the South and West? The question is critical because so many domestic manufacturers have deserted the nation's traditional industrial heartland.

Essentially, deindustrialization emerged more as a regional malady than as a national epidemic. While manufacturing employment fell by less than 1 percent nationwide from 1972 to 1986, the geography of loss was highly uneven. Most states outside the Frost Belt enjoyed continued growth—although West Virginia, Kentucky, and Louisiana, Iowa, Missouri, and Montana also witnessed declines.

Within the Frost Belt, a technology-driven and defense-related industrial expansion revitalized the economic structure of New England. The biggest percentage of increases in manufacturing employment were found in New Hampshire (30 percent) and Vermont (29 percent). Massachusetts, spurred on by the development of the Route 128 corridor around Boston, moved to the forefront of the high-technology industrial revolution in computers, office equipment, robotics, and biotechnology. The state's unemployment rate, which had been one of the nation's highest following the recession in the mid-1970s, was one of the lowest among all states a decade later. Building on its heritage of superior education and skilled craftsmanship, Massachusetts seemed to reverse the 1970s manufacturing dispersion trend from the Frost Belt to the Sun Belt. Despite all the talk about the Massachusetts Miracle, however, the state's manufacturing base expanded by only 1.5 percent from 1972 to 1986. Blue-collar jobs actually fell in Connecticut and Rhode Island.

Jane Sneddon Little, a Boston Federal Reserve economist who closely watches New England's economic trends, concluded that foreign investment helped stem the decline in the region's manufacturing job base—even in otherwise lagging sectors—and contributed to a smooth transformation in the region's industrial base.[56] Some foreign firms located in pockets of high unemployment. Maine, the poorest state in New England (about 15 percent of the state's residents live below the poverty line), is not far behind South Carolina in terms of the number of workers on the payroll of a foreign company. Clearly, the region's high level of direct investment results from its proximity to Canada. Canadian firms, for example, own a large chunk of the state's lumber and paper-products industry. Foreign-affiliated companies also favor New England's vaunted high-technology industries. But it was in the Great Lakes and Mideast regions, not New England, that manufacturing employment virtually collapsed. Nowhere was reindustrialization more pressing. Illinois suffered the biggest decline from 1972–1986, losing 28 percent of its manufacturing job base over the period, followed by Pennsylvania (27 percent), New York (22 percent), Ohio (18 percent), and New Jersey (16 percent).[57] For many Northern blue-collar workers, economic survival meant finding work in the service sector and accepting a drastic pay cut. One worker from Chicago's depressed South Side said, "We all saw the mills as very stable. You got overtime."[58] But when Great Lakes Carbon closed down, this worker shuffled from job to job, finally settling for a position as a mailroom clerk at a fraction of his former wages as a steel worker.

Of course, the migration of U.S. industry away from the Frost Belt did not begin in the 1970s. Textile firms began relocating from New England to the low-wage areas of the South in the late nineteenth century. And following the development of cheaper and more efficient transportation systems in the twentieth century, plants were continually less tethered to Northern production sites. Trucking lowered transportation costs, for example, and market-oriented regional branch plant networks have been substituted for highly concentrated production sites. Nevertheless, until the early 1970s, Northern manufacturing employment expanded, although its share of total U.S. employment declined because job growth was faster in the Sun Belt.

Then, beginning in the early 1970s, foreign competition squeezed the profits of domestic factories and foundries. The institutional and geographic framework of mass production dating to the early twentieth century was no longer stable. By producing in the unionized North, firms paid substantially higher wages than foreign competitors; and,

perhaps more important, they faced rigid work rules and job classifications. Job classifications designate the scope of work each employee performs. As the number of classifications increased in the mass-production system of American manufacturing, the scope of work for each employee fell as did labor's flexibility. The "flexible team" approach to production adopted by the Japanese caught the eye of managers around the country. Mature, old-line mass-production industries restructured production under international pressure.

Consequently, domestic manufacturers increasingly shifted capital into states with right-to-work laws and low unionization. Our analysis of domestic employment growth found that "business climate," or low unionization, was a significant determinant of employment growth among states between 1974 and 1983.[59] The chilling winds of deindustrialization swept across the Frost Belt, leaving communities with abandoned and underutilized factories. In response to the increasingly "footloose" character of U.S. industry, unions have moved to accommodate industrial restructuring, agreeing to combine various job classifications and remove other labor "rigidities."

Further, recognizing the importance of FDIUS as a potential source of new manufacturing jobs for its members, union officials joined with Northern governors to woo foreign multinationals into the industrial heartland. A major effort was made in 1985, when a team of labor leaders in the auto, steel, rubber, textile, and apparel industries traveled to Japan. They argued that American unions could work within the framework of Japanese-style union-management cooperation. It seemed like a desperate and perhaps futile endeavor.

Yet we have detected a possible *reversal* in the anti-union location bias of foreign firms discussed earlier. Beginning in the early 1980s, we found that foreign firm employment growth was *positively* associated with the rate of unionization in a state.* At the same time, unionized states experienced below-average employment growth from domestic firms. Apparently, foreign investors were less "paranoid" about locating in unionized regions than were domestic firms. New Jersey stands out among the unionized industrial states; in fact, for many years European

* Our test of employment change covered 1974 to 1983 and included jobs added through acquisitions as well as new plants. In a regression analysis with the number of new plants as the dependent variable, we found that unionized states repelled foreign capital. Nevertheless, since 1983 the Great Lakes area's U.S. affiliate employment has grown, and we suspect the effect of unionization would still be positive if we included acquisitions. A similar reversal occurred in Great Britain. With a rise of foreign acquisitions during the 1970s, overseas corporations favored core manufacturing regions following two decades of dispersion to peripheral regions.[60]

pharmaceutical companies have invested there. Today the Asian electronics companies like Toshiba, Samsung, Sharp, and Brother join European investors, and over 10 percent of the state's manufacturing workers are on a foreign payroll. But unlike the Southeast, most foreign investment in New Jersey and throughout the Mideast and Great Lakes regions comes through acquisitions and mergers, not new plants and expansions (see appendix D, table D.1).

That is not to say that all start-ups have avoided union strongholds. As we saw in chapter 5, Japanese auto transplants exhibit an evolving attitude about organized labor and the location of greenfield investment. The first arrivals were Honda and Nissan. Wanting to avoid unions but remain near suppliers and major Northern and Eastern markets, Nissan selected Tennessee, the right-to-work state closest to the Northern auto industry. Honda was also averse to organized labor, but the company chose Ohio, a strong union state. During the mid-1980s, Honda was busy adding two more facilities in Anna to complement its existing plant in Marysville even as General Motors was closing factories in Norwood, Hamilton, and Elyria, Ohio. Unlike the closed GM plants, however, Honda's new Marysville and Anna assembly factories are located in non-unionized areas of the state.

The companies following Honda and Nissan have been more willing to settle in the center of union country and work with the United Auto Workers. Mazda made the first significant move. Although at first the company strongly considered locating in Greenville, South Carolina, the "Home of Mazda" wound up in Flat Rock, Michigan, about fifteen miles southwest of Detroit. Only a few years ago, one could have found no better example of a demoralized industrial town in "Rustbelt America." In 1981, Ford Motor Company closed its Flat Rock plant, the city's major business. Mazda built its new auto assembly plant on the site of the shuttered Ford factory. Ford owns a 25-percent stake in the Mazda Corporation, which partially explains the location choice. But there is no question about who is in charge: during the 1985 ground-breaking ceremony, one reporter observed, "The Governor of Michigan bowed before a Japanese altar, a local high school band struggled through the Japanese national anthem and a Shinto priest blessed the site."[61]

In a heavily unionized state that came to worship any force that brought employment, Flat Rock is often considered one of the most successful cases of foreign-led reindustrialization. Optimistic forecasts project the Mazda plant to induce upward of 10,000 supplier and service jobs by 1990.[62] Notably, Mazda workers endorsed the UAW as their bargaining representative. In their first contract agreement, the UAW

pledged to give the Japanese "operating flexibility" through a limited number of job classifications. Traditional U.S. assembly plants have over eighty different classifications; Mazda has just two (production and maintenance). In return, the Japanese promised to pay the going wage for the domesticauto industry and a benefit package comparable to that offered by America's Big Three companies.[63]

The lesson of Mazda is clear: a bastion of organized labor remains a viable site for production in the age of international capital. Finding the appropriate pool of skilled labor is crucial to many modern manufacturers, and Mazda is more demanding about the kind of workers it hires and trains than are most. Each applicant at Flat Rock goes through a rigorous screening process that includes testing workers' mental and physical aptitudes as well as interpersonal relations. Mazda looks for *kaizen*, or the potential for continual improvement, in its workers and, to find it, spends about $13,000 per employee. In a full-page banner carried by the *New York Times*, Mazda's president Kenichi Yamamoto explained, "Without the right people, our highly automated $550 million U.S. plant wouldn't be worth a dime."[64] Mazda officials were impressed by both the availability of skilled labor and the quality of the distribution system in the industrial heartland.[65]

Skilled labor and a developed infrastructure, coupled with the just-in-time inventory system that forces suppliers to cluster close to assembly plants, has helped shape the new Japanese Auto Alley (see figure 7.4). The map shows how clusters of machinery and material suppliers dot the areas around Nissan's plant in Tennessee, Toyota's plants in California and Kentucky, and Honda's plants in Ohio. But other Japanese auto-assembly plants—Mazda, Mitsubishi, and Isuzu—are now found throughout the unionized industrial areas of Michigan, Illinois, and Indiana. Parts suppliers are also scattered across the Northern states, although often in urban fringe and semirural areas away from unionized cities. One town that has benefited from this influx of suppliers is Battle Creek, Michigan, about 115 miles west of Detroit. Best known as Kellogg's headquarters, Battle Creek has long been a center of U.S. auto parts manufacturers. Recently it has attracted numerous Japanese suppliers, including Nippondenso, Hi-Lex, and Musashi.

Thus, recent investments in the automotive industry counter the tendency of foreign firms to locate where there is less industrial development and less competition from domestic producers. The Japanese are able to move into the highly competitive auto parts industry of the Great Lakes region because they are closely allied with assembly plants, which provide a stable sales base in the United States.

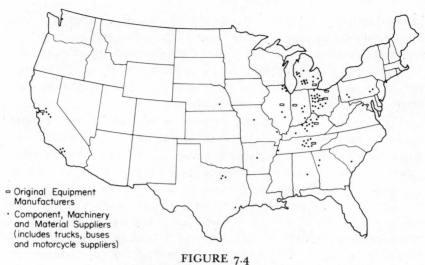

○ Original Equipment
 Manufacturers

· Component, Machinery
 and Material Suppliers
 (includes trucks, buses
 and motorcycle suppliers)

FIGURE 7.4

U.S. Distribution of Japanese Auto Plants.

SOURCE: Peter Arnesen, Robert Cole, and A. Rama Krishna, "Japanese Auto Parts Companies in the U.S. and Japan: Implications for U.S. Competitors" (Ann Arbor: University of Michigan, East Asia Studies Program, Working Paper no. 3, 1987).

The potential for foreign-sponsored reindustrialization extends beyond the Auto Alley and into some of the North's most depressed and forsaken industrial areas. In 1987, Kawasaki—the firm that introduced the just-in-time system to American manufacturing at its recreational vehicle plant in Lincoln, Nebraska, and then helped revive steel production in southern California—commenced yet another novel project in Yonkers, New York. The objective: to resuscitate an old Otis Elevator plant that shut down in 1982, and produce mass-transit rail cars. In a city that had seen its blue-collar job base continually erode for two decades, the company hired 500 skilled workers and brought in the latest industrial technology to produce the cars now used in the New York City subway. "The revitalization of that plant is the best thing that has ever happened to this city," said Yonkers's mayor, Angelo R. Martinelli.[66] The long-run success of the venture, the only mass-transit rail-car manufacturer left in the nation, is still questionable (New York City commuters routinely complain about the new subway cars' faulty design). Even so, Japanese investment counters the myth that manufacturing is moribund in older Northern towns.

Only a few miles south of the Yonkers plant stands America's infamous manifestation of urban and industrial decay—the South Bronx. It is there that politicians make routine pilgrimages to deliver hollow promises about industrial renewal. But it is also there that another

foreign firm is bucking the Frost Belt's deindustrialization trend. And in this case it is not a Japanese multinational; it is the Bonifica Company, an engineering subsidiary of Italy's Instituto per la Ricostruzione Industriale (Institute for Industrial Reconstruction, or IRI). Benito Mussolini started IRI in the Great Depression of the 1930s to help revitalize the national economy by bailing out failing companies; today the state-run conglomerate is Italy's largest enterprise, and its global workforce (over half a million) is second only to General Motors. Known for its projects in Italy's depressed south and in the Third World, IRI decided in 1985 to try its hand at turning around one of America's most chronically blighted urban areas. Its plan: to develop an industrial park and lure Italian manufacturers to produce there with financial incentives.[67] As always, its success remains to be seen. But Bonifica's president explains, "For us it's a matter of pride. We come to the South Bronx to introduce ourselves to the United States and show off the fruits of our experience. If we do well, we hope to get many jobs from other cities in the same position. If not, we go home."[68]

Everyone Is Not a Winner

From the South Bronx to southern California, the New Competitors have replaced plant closure with plant openings, and urban despair with confidence. They have revitalized the industrial base of such dissimilar American communities as Flat Rock, Michigan, Portland, Oregon, and Spartanburg, South Carolina. Yet most of these communities share certain characteristics: they are part of major metropolitan areas with a large pool of skilled labor and generally possess good interstate highway networks and other transportation systems. Rural areas without these attributes, especially good transport linkages, have generally not succeeded in getting foreign capital. At the same time, we have argued that foreign firms most prefer regions with untapped market potential, thus providing growing areas of the Sun Belt with the most new jobs and greenfield plants. In short, the benefits are not spread uniformly across the land, especially in respect to new plants and expansions.

Some observers argue that every region can be a winner, that foreign investment entails a positive-sum game for American communities.[69] Because the investment flows from outside the U.S. border, the line goes, no one loses because jobs are not shifted from one area of the country to another. As in any positive-sum game, FDIUS is supposedly "additive," not "distributive," that is, someone's gain is not someone else's loss.

There are two problems with the "everyone can be a winner" argument, which we discussed in chapter 5. Because the problems have a regional dimension, they are worth restating here. First, there is the question over whether foreign direct investment displaces existing production in the United States, thus creating economic opportunity in one area at the expense of another. The other problem is that foreign capital, just like domestic capital, is not always financed externally; some investment involves a disinvestment from one area and investment in another, closing down plants and shifting production and jobs to new sites.

The question of domestic displacement has been raised by domestic auto component producers, who complain that Nippondenso and other Japanese suppliers are fighting hard to take away their contracts with Detroit's Big Three. Remarking on this prospect, an official of the Automobile Parts and Accessories Association warned that foreign investment is "the greatest issue of our time. If you continue to allow an increase in capacity, clearly it's got to come out of someone else's hide, and clearly it's going to be the hides of the domestic industry."[70] Assessing the displacement of domestic jobs is necessary to determining whether there are net benefits to new foreign-owned investments. For the U.S. economy as a whole, such a determination is a monumental task. When analysts at the U.S. General Accounting Office (GAO) attempted to measure the net benefits of the 7 Japanese auto assemblers and over 100 parts suppliers, they concluded that the net job impact depended on what one assumes about the displacement ratio: the rate at which Japanese-American producers displace existing domestic automobile production instead of foreign-produced imported cars?[71] At one extreme, the GAO assumed a high displacement ratio of 100 percent (all the output of Japanese-affiliated automakers displaced U.S. automakers' production on a one-to-one basis) and found that America lost 45,000 jobs. At the other extreme, when they assumed no displacement of existing domestic auto capacity, the nation gains 112,000 jobs.

For cities and regions, "everyone wins" only if there is no displacement of existing production, an unlikely scenario. In other words, it is likely that some areas will lose out as Japanese firms outhustle the American competition and drive them out of business.

That there are going to be losers, of course, is nothing new in capitalism. For winning areas, the full benefits of any major assembly plant depend on the extent to which foreign-affiliated producers create strong linkages with local suppliers. "Winning" areas must also recognize that large-scale multinational capital can rapidly redeploy its in-

vestment to new sites within a nation. Profit, after all, comes before commitment to any community. Foreign multinationals may compound the problem of interregional capital mobility. Just like domestic firms, foreign-affiliated companies sometimes abandon plants in one community and open them elsewhere.

This is the saga of Mack Trucks. After Renault progressively bought into Mack—to 45 percent by 1983, with an option for 15 percent more —the company set new plans to assemble 10,000 trucks. But this meant relocation from Allentown, Pennsylvania to Winnsboro, South Carolina. When Mack closed its south-side Allentown plant in 1986, it ended a sixty-year history of truck manufacturing in the community. Allentown became a major casualty of "economic violence" in the 1980s.

The Mack announcement of relocation to Winnsboro should be the greatest thing that ever happened in this town in the Columbia, South Carolina, metropolitan area. The new truck factory is to be the world's most advanced truck-assembly plant. It has everything that experts say American manufacturers need to confront intense global competition: a "modular" production process, controlled and monitored continuously by computer; parts delivery on a just-in-time basis; outsourcing, the production of several major components by outside suppliers; and an automated materials-handling system. The plant drastically lowered production costs through labor reduction: 780 to 850 do the same work as 1,500 in Allentown.

Yet they worry in Winnsboro. Mack's regional restructuring brought fewer jobs than expected because many workers relocated from Allentown. Now people in South Carolina wonder what will happen if Renault decides to divest Mack, as it did when it sold AMC to Chrysler. Shifting ownership breeds insecurity. Moreover, there is always the possibility that Winnsboro might be the next Allentown. "Mack would have done well to go to South America—they're probably going to end up there anyway," said a Winnsboro merchant. Another merchant said the only good news about the Mack plant is that other industries will follow. But the Mack facility itself, he said, will be of little real benefit locally. "This plant won't last 10 years," he alleged, and continued, "They'll write it off. This is like the plant they had in California, except that one never even opened. . . . Besides, the U.S. truck market has already lost half of its business to imports. . . . We're not an industrial nation anymore—we're the consuming center of the world. . . . This nation, in terms of manufacturing, is history."[72]

Nevertheless, the influx of capital continues to grab the attention of regional policy makers, the modern agents of international develop-

ment. States and communities are doing all they can to entice foreign capital. Everywhere, in fact, the competition for FDIUS is heating up as they struggle to adapt to an ever-changing international economy. They are increasingly giving away the potential benefits of FDIUS with massive tax breaks and subsidies. Flat Rock, for example, enticed Mazda by shelving property taxes for fourteen years. Oregon bid away a Nippon Kokan plant from Washington with a $1-million water pipeline, partial property tax exemption for five years, cheap power, and a Japanese school for children.

John B. Curcio, Mack's chairman, uttered a somewhat surprising opinion on these industrial recruitment efforts. He criticized the state-to-state competition that won his company millions of dollars of incentives from South Carolina two years ago: "It doesn't do the United States any good to have regions vying against each other for jobs. We must create jobs for Americans, regardless of where they are."[73] Of course, in a world where there are winners and losers, incentives are like steroids in the Olympics: although they give communities a leg up in the competition for jobs, capital, and tax money, they are getting out of control. We explore incentives and industrial recruitment battles in the next chapter.

PART III

Policies Toward Foreign Investment

8

THE MAD SCRAMBLE

FOR THE CRUMBS

N OT LONG AGO, the mayor of Smyrna, Tennessee, gazing down from a bridge overlooking the shining new Nissan factory in his town, said he understood how Moses must have felt looking down from the mountain at the Promised Land.[1] Scores of other mayors, whose towns bid unsuccessfully for Nissan, would have enjoyed the view.

Governors and mayors from Oregon to Georgia ponder the fate of their communities as the economy becomes more internationalized, and localities learn to deal with imports that affect their factories and with international investment—both inward and outward—that moves capital in and out of their jurisdictions. Moreover, the responsibility for economic development now sits squarely on the shoulders of the states and, to a lesser extent, the cities, shifted there from the national level under the prodding of Ronald Reagan's "New Federalism." Under President Reagan, the federal government's role in all domestic policy has been reduced sharply. Many federal economic development programs, created during the 1960s and 1970s, have been eliminated or reduced significantly. States and cities have been left to fend for themselves in an already difficult economic environment. Governor Bill Clinton of Arkansas said that the internationalization of the economy has placed "thousands of stresses on the states."[2] States have tried

several new approaches—industrial policies, new firm incubators, programs to stimulate technology, and the like[3]—as we will discuss at chapter's end. Attracting foreign investment has become an important part of their economic development strategies.

The stakes in the economic development game are certainly high. With job loss hurting many American cities, with job declines even among the *Fortune* 500 firms (whose employment fell by 2.2 million between 1973 and 1988), and with many American firms locating offshore, the prospect of attracting spanking new foreign-owned plants and offices looms large and bright. Yet the chances of success are small: as we said in chapter 5, inward foreign investment does not produce many new jobs nationally. From 1980 to 1987, foreigners created only about 10,000 to 15,000 jobs each year nationwide in new (or greenfield) plants, the objects of so much competition among localities. Even so, public officials believe that their communities will be helped if they are able to attract new foreign facilities. The opportunities to increase the job base—despite the long odds—are dazzling to beleaguered officials used to shuttered shops, stilled assembly lines, and vacant industrial parks. Scrambling for the crumbs of economic development—the few jobs provided by large, foreign companies—they try, in effect, to "buy payroll."[4] It is not a totally new event for states and cities that have been chasing after branch plants of American companies for decades. (Actually, for centuries: in 1640, Massachusetts gave the first recorded industrial incentives to subsidize cloth producers.)

So local governments take the plunge and try their hardest to attract foreigners in a fierce competition that pits city against city, state against state. After all, foreign companies have many options. As we said in the last chapter, they hire location consultants to advise them on their many options. These consultants use sophisticated computerized data bases on cities' wages, utility costs, and market potential to tell a Toshiba or BASF executive what the dozen or so most promising sites are. Then company officials, arm in arm with their consultants, visit these sites and compare them. They announce or leak word of the sites they are seriously considering.

Then the mad scramble begins. Once a city finds out it is in the running, it puts together a bundle of incentives to lure the company— packages that usually combine the resources of several state and local agencies. As the potential locations assemble their offerings, a competition ensues. The company sits back and takes bids as the cities fall all over themselves to make the best offer. Obviously, the foreigners hold nearly all the cards.

Why are states and cities so eager to attract foreign plants? As with domestic branch plants, two benefits stand out: more jobs and more tax revenues. That is why the states alone spent more than $40 million in 1986 to attract FDI and to promote international trade[5]* even though, as we shall see, the strategies they use to attract the plants cut huge chunks out of the benefits they hope to gain. Still, Kentucky's governor, Martha Layne Collins, whose multimillion-dollar package attracted an $800-million Toyota plant, has argued that states and localities have no choice when it comes to offering incentives: "That day is over—the day of no incentives," she said. "If you don't have them, you're just out of the hunt."[6] But one of the governor's critics in the Kentucky legislature likened the incentive bidding wars to baseball, where team owners bid up the prices of free agent players, often to salaries that fail to reflect a player's actual importance to his team.[7] No doubt the New York Yankees' owner George Steinbrenner would feel right at home among the high-bidding mayors and governors.

In this chapter, we consider state and local policies used to attract foreign direct investment; then turn to several FDI stories—some successes, some failures—to see who won, who lost, and why; and, finally, examine strategies that could increase the benefits of FDI and local economic development. In chapter 9, we will examine the United States's often incoherent federal policies toward FDI owing to the government's preaching free trade but practicing protectionism; and, finally, in chapter 10, recommend measures for policies that the federal government should take to get the most out of FDI and to further economic prosperity.

The Promotion of Foreign Investment

How do states and cities attract foreign companies? What *should* they do? If news reports can be believed, states and localities that want greenfield investment will do almost anything to get it. Incentives worth more than $300 million have been used to woo (and win) a single automobile plant. Incentive packages in the range of $50 million to $70 million are typical for such investments. And the perks offered foreign investors are becoming more varied as well as more costly. Table 8.1

* It is impossible to break out spending on FDI and spending on export promotion since most staff expenditures are devoted to doing both at the same time.

shows the megadeals that auto companies got from various states for assembly plants. For comparison, we include the substantial package that GM got for its Saturn plant as well. Like most incentives packages, these were the result of negotiations between the localities and the companies.

Foreign investors rarely if ever base their investment decisions on incentives but, as we discussed in the last chapter, make—like their American counterparts—location decisions in two stages. First, they look for the region most appropriate for their business. Here they are most concerned with proximity to suppliers and markets, wages, and unionization. Once they find the right general area—say, the Southeast —they move to the second stage. They look for the best location within the region. Among the critical considerations here are, Is there good transportation access to markets? What is the city's prevailing wage? Are its workers highly skilled and productive? Does it have a high "quality of life"—a pleasant environment and first-rate cultural, educational, and recreational amenities? Good quality of life is especially critical for high-technology firms that want to attract talented engineers and scientists and care less about wages and other considerations.

These are very important location factors. Yet states and cities cannot influence them in the short run, if at all. As a major study of *Fortune* 500 companies showed, local economic development policies "simply cannot be relied on, by themselves, to attract new plants that would otherwise locate somewhere else."* A 1987 report to the National Governors Association said that "many manufacturers make the decision to locate a new facility without the benefit of state-provided incentives."[9] The location dynamics discussed in the last chapter completely overwhelm incentive programs. Incentives are, if anything, tie breakers in stage two of the location decision process. When two or more communities are equal in all other respects, an incentive package may be the deciding element.

Japanese firms, which make greenfield investments more frequently than other firms do, choose a site most commonly because it is near markets and can provide labor, a good quality of life, and high wages.[10] Local policies cannot affect these elements, especially in the short term. Another consideration, the absence of unions, is only influenced by state right-to-work laws which exist independent of foreign investment. The Japanese rate as less important typical incentives packages, such as tax

* Most studies of location factors find that incentives are not important,[8] although William Wheaton found that interstate differences in taxes do matter in industrial location decisions.

abatements, but place great weight on factors governments *can* influence in the long term: the availability of utilities, transportation facilities, and good educational systems.

Companies from other countries planning new facilities look for the same characteristics in cities as the Japanese do. In 1988, we surveyed foreign companies from many countries in the automobile, semiconductor, and computer industries to see what factors they found most important. Our survey showed that the cost of labor, good transportation, access to markets, and quality of life were the most important factors in choosing sites (see figure 8.1). The least important factors were tax incentives and government services. In our sample, more than half of the foreigners said they did not even get subsidies, making their decisions on economic factors alone. When subsidies were received, employee training and state financial programs (revenue bonds, for example) stood out as the most attractive to the New Competitors (figure 8.2).[11]

Despite this and other evidence to the contrary, officials paid to attract FDI insist they must have incentive packages to make sure their constituents are winners in the FDI jobs sweepstakes. It is sometimes difficult to argue with them, especially when they point to cases such as Nissan's decision to choose Tennessee over thirty-nine other states as the location for its first U.S. plant: Tennessee offered Nissan incentives worth more than $66 million dollars, or $20,000 a job (see table 8.1).[12]

Anecdotes about the power of incentives abound, but the effectiveness of these programs in general is questionable. Nevertheless, most states and many localities are committed to the use of incentives, despite questions about their effectiveness. Are they ever really necessary? Sometimes, yes. An area may be just about right for a foreign company, but a few shortcomings threaten the deal. For example, Japanese companies considering sites in the Southeast find the climate, the forested mountains, and the relative absence of unions nearly perfect. But often the low-wage workers who live there do not have the skills needed for sophisticated manufacturing tasks. To make sure the plants wind up in their communities, several Southeastern states have developed training programs like Georgia's Quick Start—programs that are acknowledged by FDI promoters and investors alike to be effective and useful. In another case, Toyota officials said they would not have seriously considered the hilly Georgetown, Kentucky, site where they built their first wholly owned U.S. plant if the state had not offered to regrade it.

But more often states and localities use incentives to draw attention to themselves or to make themselves look better than sites with similar

TABLE 8.1
Automotive Plant Incentive Packages

Company/Location	Completion Date	Company's Investment (millions)	Estimated Annual Production	Estimated Employment	Incentives	Total Incentives (millions)	Incentive Cost per Job
General Motors (Saturn), Springhill, Tenn.	1990	$3,500	200,000–250,000	3,000	Job training, road improvements, 40-year local tax abatement (GM makes payments in lieu of taxes).	$70+	$23,333
Toyota Motor Company, Scott County, Ky.	1988	$800	200,000	3,000	Land purchase assistance, site preparation, skills center, job training, highway improvements, educational programs for Japanese employees and families.	$325+[a]	$108,333
Diamond-Star (Mitsubishi/Chrysler), Bloomington/ Normal, Ill.	1988	$650[b]	180,000	2,900	Road, water, sewer installation and improvements; land purchase assistance; job training; property tax abatement, tax credits on investment, state sales tax, local utility tax; pollution control bonds, water and sewer fee savings.	$118.3+	$40,793
Isuzu/Fuji Motors, Lafayette, Ind.[c]	1988	$500	120,000	1,700	Road, highway, sewer improvements, land acquisition assistance, job training, $1-million cultural transition fund to aid Japanese workers and families.	$86+	$50,588

Company/Location	Completion Date	Company's Investment (millions)	Estimated Annual Production	Estimated Employment	Incentives	Total Incentives (millions)	Incentive Cost per Job
Mazda/Ford Motor, Flat Rock, Mich.	1987	$550[h]	240,000	3,500	Road, rail, sewer, site improvements; job training; special $500,000 loan; tax abatements; Mazda will make payments in lieu of taxes.	$52+	$14,857
Nissan Motor Co., Smyrna, Tenn.	1983	$850[h]	240,000	3,300[h]	Job training, road, sewer, water, rail improvements;[c] local property tax abatements; company makes payments in lieu of taxes.	$66+[d]	$20,000
Honda of America, Marysville, Ohio	1982	$870[h]	330,000	4,200[h]	Property tax abatement on buildings; previous $16.4-million grant to Honda for adjacent motorcycle factory.	$16.4+	$3,904
Volkswagen[f] AG, East Huntington, Penn.	1978	$236[h]	90,000	2,500	Low-interest loans; rail and highway improvements; job training;[g] local tax abatements; company makes payments in lieu of taxes.	$86+	$34,400

SOURCE: Except where noted, all information is based on Martin and Susan Tolchin, *Buying Into America* (New York: Times Books, 1988), pp. 313–14, which draws on other studies and press accounts. Where actual and projected figures were given, the actual figures are used.

[a] Roger Calautone et al., *The Estimated Impact of Toyota on the State's Economy* (Lexington, Ky.: College of Business and Economics, University of Kentucky, 1986), p. 1. This amount includes nearly $167 million in interest on bonds sold to finance the listed incentives.

[b] Brian Bremner and Barbara Marsh, "The False Promise of Diamond-Star: Touted Auto Corridor Sputters, Braking Expected Job Gains," *Crain's Chicago Business*, 13 April 1987.

[c] Susan Pastor, "2 Japanese Automakers to Build a $500 Million Plant in Indiana," *New York Times*, 3 December 1986, pp. 1, 36.

[d] John M. Kline, *State Government Influence in U.S. International Economic Policy* (Lexington, Mass.: Lexington Books, 1983), p. 67.

[e] Ibid., p. 67.

[f] Volkswagen closed this plant in July, 1988, so jobs and production figures are no longer valid.

[g] Kline, *State Government*, p. 65.

[h] Richard Florida, Martin Kenney, and Andrew Mair, "The Transplant Phenomenon: Japanese Auto Manufacturers in the United States," Working Paper 88-29, School of Urban and Public Affairs, Carnegie-Mellon University, May 1988.

natural attractions. The competition for foreign-owned auto-assembly plants has generally followed this pattern. Japanese investors in particular place great importance on "being wanted" by a locality. They see incentives as concrete demonstrations of how much a community wants a plant. Site-selection consultants are well aware of this, especially for Japanese companies, and make it clear to state and local investment recruiters.[13] So incentives sometimes become a sort of "love offering" to the potential investor.

Occasionally, however, incentive mania gets out of hand, and states and cities use hastily assembled packages of incentives to nab companies that are in the last stages of negotiation with other locations.* For example, Portland, Oregon, snatched Wacker Siltronic, a major German electronics manufacturer, out of the hands of Augusta, Georgia, with a huge incentive package, free city-purchased land, new road and rail connections to the site, waivers of procurement regulations, special arrangements on pollution control, government-financed worker training, and more.[15] Alabama officials admit they "stole" a $16-million Sony plant from Florida after Sony had already purchased its plant site. Alabama waived Sony's property taxes, use taxes on equipment, and sales taxes on the building materials used in constructing the plant. A local industrial development authority owns the plant site, and the building and tax-free industrial revenue bonds finance the property. Sony leases the facility.[16]

Table 8.1 shows how incentive programs get out of control when measured in another way: the amount of the incentive per job. Was a job in Georgetown, Kentucky, really worth the $108,333 that Kentucky paid for Toyota to move there? It is argued, correctly, that Japanese firms bring with them suppliers—members of their *keiretsu*, or "family"—creating more jobs. If the suppliers come without further subsidies (some of them do, some don't), then this incentives-per-job figure is inflated. But even if each plant brings with it two or three supplier jobs, the amount per job is still high compared to other uses of scarce government funds. In addition, if the foreign firms displace domestic firms, as they often do, the net figure per job will be higher than reported in table 8.1. This is because the number of jobs created on net (after workers

* In 1985, the state of Washington lured a $200-million semiconductor manufacturing joint venture, involving RCA and the Japanese Sharp Electronics Corporation, across the Columbia River from Oregon with a high-dollar last-minute incentives deal. Oregon was bitter, and so is Washington. In 1987, a decline in the semiconductor market killed the joint venture and Washington's hopes for new jobs. The dreams are gone, but the hard feelings remain.[14]

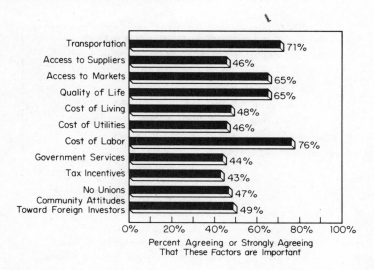

FIGURE 8.1
How Foreign Companies Rate Location Factors.

SOURCE: Norman J. Glickman, Amy Glasmeier, Geoffrey Bannister, and William Luker, Jr., *Foreign Investment and Industrial Linkages*, report to the Economic Development Administration of the U.S. Department of Commerce and the Aspen Institute for Humanistic Studies, 1989.

displaced from domestic firms are counted) will be less than if there is no displacement.

FREQUENT-FLYING GOVERNORS AND MAYORS

Widespread state FDI promotion is a relatively new phenomenon. In 1969, only ten states reported spending any state money to attract FDI. A decade later, forty-seven states had active promotion programs.[17] FDI programs differ from domestic smokestack chasing in one critical and costly sense: much of the work must be done overseas. Thus, investment missions have proliferated. In 1986, forty-eight states sent trade or investment missions to Europe, China, and Japan.[18] These missions usually are led by a mayor or governor and include government officials and staff as well as business people from the state or locality. Most big cities also use this technique. Boston, New Orleans, Minneapolis, Newark, and Washington, D.C., all sent their mayors in search of FDI in 1985. Mayors of smaller cities such as Peoria, Illinois, Austin, Texas, South Bend, Indiana, and Cedar Rapids, Iowa, also venture abroad and, like their big-city counterparts, occasionally succeed. Cedar

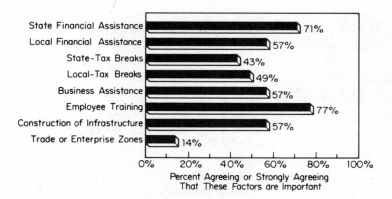

State Financial Assistance — 71%
Local Financial Assistance — 57%
State-Tax Breaks — 43%
Local-Tax Breaks — 49%
Business Assistance — 57%
Employee Training — 77%
Construction of Infrastructure — 57%
Trade or Enterprise Zones — 14%

Percent Agreeing or Strongly Agreeing
That These Factors are Important

FIGURE 8.2
How Foreign Companies Rate Government Programs.

SOURCE: Norman J. Glickman, Amy Glasmeier, Geoffrey Bannister, and William Luker Jr., *Foreign Investment and Industrial Linkages*, report to Economic Development Administration of the U.S. Department of Commerce and the Aspen Institute for Humanistic Studies, 1989.

Rapids won a West German tire chain factory as a result of an investment tour.[19] Illinois governor James Thompson led a delegation of state and local officials to the Peoples' Republic of China in 1985 and came home with the seeds of a $6-million joint venture to process soybeans that will employ seventy-five workers in Joliet.[20] But mayors and governors usually come home empty-handed—a big disappointment when the average daily cost for these expeditions is $1,000 per person per day.

Frequently these investment trips are aimed at following up on leads generated by a state or locality's foreign office. In 1987, thirty-five states had permanent offices in Japan alone. Nearly all states had offices in Europe. Such operations are expensive, the typical cost for two- to four-person offices being $200,000 to $400,000 per year in 1986.[21] With the decline in the dollar's value since 1985, the cost of maintaining foreign offices has increased dramatically. By 1988, a small office in Tokyo cost $1 million to run for a year. But state and local officials say the offices are worth the expense, being among the states' most effective tools in marketing themselves as good places to do business. North Carolina's West German office, for example, generates nearly half of the state's foreign investment leads.[22]

GOVERNMENT PROGRAMS TO ATTRACT FOREIGNERS

What does the "average" state or locality do to attract foreign investment? Does it hand out millions of dollars in loans and grants and tax credits? To be honest, no. The spectacular packages—for very large

investments—grab headlines, as they should; but most investments are more modest and draw commensurately modest incentives. The average FDI-promotion program roughly parallels domestic industrial-recruitment efforts. It is also in line with what towns pay in concessions to domestic firms threatening to move elsewhere.

In addition to their special efforts to reach foreign investors, most states and localities extend various types of direct incentives to lure both foreign and domestic firms.* Many of these incentives are standard and available to all companies, large and small. Others come through the process of negotiations in which the large companies exert their power (and promise of payroll) to get more than smaller companies. Because of the magnitude of certain foreign investments, particularly those of the Japanese automotive firms, it sometimes seems that foreign companies are given larger or different incentives than their domestic counter-parts. Most states deny this, and there is little hard evidence that this occurs. Both domestic and foreign investors are eligible in many states for the same tax breaks, grants, low-interest bond financing, loans and loan guarantees, employee training, site and access improvements, land grants, and special lease provisions. Typically, a state or city offers a combination of these benefits.

One exception is an incentive that became increasingly popular among communities seeking to attract Japanese companies in the late 1980s: the Japanese school. Variously designed to help Japanese workers and their families learn English and adjust to life in the United States or to help Japanese children retain their traditional values, the schools are not inexpensive. For example, Kentucky promised to spend $5 million over twenty years for schools for the Japanese employees of Toyota.

Tax breaks usually take the form of tax abatements or deferrals, tax exemptions, or tax credits. Sometimes these tax deals are on land, some-times on new investment or equipment purchases. Tax credits frequently are given for job training; for each worker trained, part of the local tax bill is forgiven. These concessions mean lost revenue for the governments involved, but make it cheaper for a company to do business. Theoretically, a company will prosper and contribute to the community through other means, such as sales taxes on purchases made by its employees. Michigan used large tax abatements to win Mazda's Flat Rock plant. Chattanooga used deferrals to lure the Japanese bulldozer manufacturer Komatsu.

* A few states have constitutional restrictions forbidding use of state money to aid any private business.

Grants, below-market rate loans, loan guarantees, and low-interest bond financing help the investor by providing money up front to build a plant or modernize it. By far the most popular of these is low-interest bond financing, usually in the form of tax free industrial revenue bonds (IRB) and industrial development bonds (IDB). Localities often use this form of financing to help the medium-size plants that are the vast majority of prospects for greenfield investment. But recent changes in the federal tax code restrict states' and localities' ability to issue tax-free industrial revenue or development bonds. They are now used less. However, several states have begun developing taxable IRB and IDB programs that may fill the gap.* In whatever form they give aid, the states and localities that give financial assistance can be exceedingly generous for large projects. Michigan lent Mazda $21 million to get the Flat Rock plant up and running. Ohio *gave* Honda $2.5 million outright as a grant for developing the site of its plant at Marysville. To persuade Volkswagen to locate its first American plant at New Stanton, Pennsylvania, various Pennsylvania state agencies extended more than $48 million in low-interest loans.

Since foreign firms often desire areas with high-skilled labor (see chapter 7), it is not surprising that, especially in low-skilled towns, by far the most popular and most effective form of incentive is *training and employment assistance*. This aid usually involves worker screening and training. It is frequently handled in tandem with the federal Job Training Partnership Act and is often at least partially federally funded. In 1980, 76 percent of the states reported providing some form of employment assistance, a number that has increased since then.[24] Virtually all the incentive packages that won major automobile plants included employee training. Toyota got a whopping $65 million in training benefits from Kentucky. Of the $66-million package that brought Nissan to Tennessee, $7 million went to employee training. For low-wage, low-skill states such as Georgia and South Carolina, free or low-cost employee training tailored to company needs is an essential selling point. Georgia's Quick Start program is one of the larger and better known state-financed programs that trains employees to meet the specific needs of companies locating in the state. An official of Denon Digital Industries, a Japanese firm that located a $40-million, 150-worker compact disc factory near Atlanta, said training was a tiebreaker for his firm: "One of

* Ironically, some of these new taxable bond issues are being underwritten by foreign banks. The Massachusetts Industrial Finance Agency (MIFA), one of the leaders in developing this new form of financing, has executed agreements with British and Dutch financial institutions, including the Netherlands Rabobank.[23]

the strongest incentives to come here was the offer by the state of Georgia to help us train our lead people."[25] Quick Start and similar programs often do part of the training program in the investor's home plants. Kentucky trained some of Toyota's new American workers in Japan.

Next to training, the most successful programs involve *infrastructure*. Improvements to transport access, such as highways, railroads, and other transportation links (such as airports), make it possible for a plant to operate profitably. These improvements are usually part of a long-term infrastructure strategy that will open an entire community to development rather than just attracting a plant. Commonly, more company-specific changes such as new highway exits make it possible for firms to locate in rural areas where land and labor are less expensive, so these, too, can be considered incentives.

Site improvements usually include grading the land where a plant will be built. A site may also require water, sewer, gas, and electrical utilities connections. Roads and rail spurs that connect a plant with the nearest highway or railroad may also be included, as may drainage and flood control improvements. Site preparation accounted for approximately $20 million of the $125 million the Kentucky legislature authorized for Toyota; the actual cost of getting the site ready for use ran closer to $45 million.

A grant of land allows a company to locate in an area without having to pay for the site itself, one of the most costly startup items. Lease arrangements accomplish the same goal; they also lessen a company's costs by freeing it of real property taxes and sometimes of other costs of ownership. Kentucky owns the 1,600-acre site of Toyota's plant, so the company does not have to pay real property taxes on the ground beneath its facility.

All states and localities that seek FDI provide *information* to prospective investors. As they have grown more experienced in dealing with foreign companies, they have become more sophisticated. Virtually every program now provides information in the form of brochures and videotapes in at least one foreign language, usually in two or three. Instead of general information about business climate and quality of life, program staffs have learned to provide the specific information investors want—on such topics as labor laws, environmental regulations, schools and colleges, comparative wage rates, fuel costs, transportation availability, and, of course, markets. Many of the information services now are computerized to provide information quickly.

Site-selection assistance is also important in attracting new plants.

Cities often set up "one-stop centers" to help identify sites (often in conjunction with industrial real estate developers) and to speed the development process. For example, a center might make information available on zoning and land-use regulations or help get a project through a city government's sometimes-cumbersome array of regulations. To foreigners facing a dizzying range of state and local rules, this can be a good sign that the town will make a good home.

DO INCENTIVES WASTE TAXPAYERS MONEY?

We surveyed all the states and seventy-eight cities to find out what location factors and incentives state development agencies (SDAs) and local development agencies (LDAs) felt were most important in attracting foreign companies (thirty-nine states returned usable surveys).[26] Our survey of the SDAs showed that state development officials thought that by far the most important location factors were convenient transportation and proximity to suppliers and markets. All respondents thought that transportation access was either "very important" (68 percent) or "important" (32 percent). Proximity to suppliers and markets was considered either "very important" or "important" by 95 percent of the SDAs. When asked about the role of government incentives, only 2.7 percent answered "very important," and 48.6 percent rated these programs as "important." Of the eight location factors, government incentives were seen as least important by the government officials who administered the programs. We also asked the SDAs what kinds of incentive they offered and how effective they thought the programs were. The major categories were bonds, tax exemptions and moratoria, special business assistance (such as site-selection assistance, employee recruiting and training), loans and loan guarantees, and special inducements (such as below-market-cost buildings, free land). When officials were asked which government incentives were used most, and which of these they considered most effective, three stood out: employee recruiting and training, site-selection help, and industrial revenue bonds. Local development agencies (city economic development departments, chambers of commerce, and so on) also regarded convenient transportation and access to suppliers and markets the most useful. Again, government incentives were rated as relatively unimportant. The most used incentives among cities were site-selection assistance, the provision of access roads, and employee recruitment and training.

How do the programs that cities and states offer compare with what firms most value? According to our firm survey, employee recruiting, training programs, access to markets, labor costs and productivity, and

quality of life are considered most important by foreigners. Our survey of SDAs and LDAs indicated that local development officers also saw that incentives as a whole were not very useful: that is, they realized that most of what they do for a living is not having much effect on the attraction of firms. Although they are aware that employee training and site selection are useful to foreigners, they continue to offer the wide range of tax abatements, enterprise zones, foreign trade zones, and the like that foreigners find least important and that appear to have little or no effect on location decisions, except perhaps as tiebreakers. Thus, these inducements probably waste taxpayers' money.

The Incentive Game

The incentive game is a gamble. States that win, win big. Nissan has already meant 3,300 jobs to Tennessee, not including those created by suppliers and related firms. Honda has brought more than 4,000 jobs to Ohio. But the incentive game is also dangerous, with the true odds of success rarely evaluated. Sometimes states and localities think they have hit the jackpot, only to see their winnings trickle away like so many quarters in a slot machine. Performance is uncertain, and foreigners find the U.S. market risky, as we know from chapters 3 and 4. When all but three states in the union were competing to land Volkswagen's first U.S. plant in the mid-1970s, projections for its benefits were every bit as optimistic as those for Toyota a decade later—but, as we shall see, the projections turned out to be wrong.

WINNING THE BATTLE AND LOSING THE WAR

The FDI bidding wars first escalated in 1976 when New Stanton, Pennsylvania, beat out sites in forty-seven other states and Puerto Rico for the first in a wave of foreign auto-assembly plants—a Volkswagen factory. By the time the German automaker made a decision, the war had been narrowed to a duel between Pennsylvania and neighboring Ohio, both of which sent their governors to Germany for last-minute appeals to the company. Pennsylvania assembled the best deal—about $34,000 per employee. Volkswagen purchased an abandoned Chrysler plant at New Stanton in Westmoreland County, about thirty-five miles southeast of Pittsburgh, for $236 million. Some $86 million, more than a quarter of the purchase price, came from state and local incentives.[27]

"There was no way Ohio could go out on a limb like that," an Ohio economic development official said. A representative of the Fantus Company put it more bluntly: "Ohio couldn't come up with the scratch," the site-selection consultant explained. "It was as simple as that."[28] "The scratch" included more than just a hand in meeting the cost of acquiring the site. Pennsylvania offered a wide range of incentives that the state, Westmoreland County, two townships, and some school districts paid.[29]

The key provision was a $40-million loan from the Pennsylvania Industrial Development Authority at the almost unheard-of interest rate of 1.75 percent for the first twenty years—with no payments on the principal until 1998. Volkswagen also got a $6-million loan at 8 percent from the state's school pension fund. In addition, the state issued bonds totaling $30 million to cover the cost of rail and highway connections to the rural site. The county, townships, and school districts offered to waive 95 percent of the property taxes Volkswagen would owe for the first two years, and 50 percent of those taxes for the next three years. The Pennsylvania Bureau of Employment Security recruited and screened the plant's more than 36,000 job applicants. Finally, the Pittsburgh Foreign Trade Zone designated the plant a subzone, greatly reducing the tariffs the company would have to pay on imported components.[30]

Volkswagen had high hopes for the plant, as did Pennsylvania. The company planned to make the New Stanton location the flagship of a chain of U.S. assembly plants, including one in Detroit. Pennsylvania expected more jobs, tax revenues, and linkages that would create still more jobs and tax revenues. State and local officials felt the subsidy was worth it, projecting 15,000 new jobs, including 5,000 at the plant itself, and more than $80 million in additional state revenues over five years.[31] When the plant began producing VW Rabbits in 1978, the outlook was rosy.

But, in capturing VW, Pennsylvania won a pyrrhic victory. Though incentives won the plant, they could not make VW turn a profit. In the early 1980s, facing the same onslaught of Japanese imports as American automakers, Volkswagen's U.S. sales dropped drastically. Despite model changes and extensive plant retooling, the company did not recover. The Detroit plant was canceled. By 1987, Volkswagen was producing only 60,000 cars a year at the plant designed to assemble 200,000. Only 2,500 workers manned the assembly line, half the number the plant's promoters had envisioned. Still, after the tax waivers ran out, the plant brought the local governments $1.25 million a year in property taxes,

and the annual payroll of $78 million supported some 2,000 additional jobs in a county where unemployment was more than 8 percent in the fall of 1987.[32]

But the company decided to cut its losses. At 11 A.M. on the Friday before Thanksgiving 1987, supervisors closed down the assembly lines. They gathered the employees in small groups and read them a brief statement announcing the plant would begin shutting down.[33] The production line stopped on 14 July 1988. Though distressed, workers were not surprised. "We just lost too much money for too long," said one. "Everybody knew we were in trouble. I'm just glad it lasted this long." Added a co-worker, "People could see things going downhill. But nobody wanted to believe it."[34]

Nor did the state. Even after the last vehicle rolled off the line, it would be ten years before Volkswagen would be obligated to begin paying back the $40 million lent it by the Pennsylvania Industrial Development Authority. Meanwhile, Pennsylvania's governor was frantically trying to interest Ford in the idle plant. And Volkswagen was issuing optimistic projections for U.S. sales of Volkswagen models built in West Germany, Mexico, and Brazil.[35]

Thus, the international mobility of capital—moving investments from country to country—was used by Volkswagen, as it has been by American and other multinationals. Left behind are communities, with lost jobs and lost subsidies.

THE COST OF WINNING

By the mid-1980s, Toyota was the only major Japanese automaker without a U.S. plant of its own. It had a joint venture plant with General Motors in Fremont, California, but no wholly owned U.S. automobile factory. Toyota followed Honda in the classic oligopolistic strategy discussed in chapter 3. By the "follow-the-leader" rules of the game played by MNCs, Toyota had to come to the United States to be close to its rival Honda, which was doing very well in the U.S. market, and felt that it *had* to make this move to stay competitive. While it was a necessary move to the company, states and cities saw it as an economic development plum. So when, in July 1985, the company announced plans to build its own assembly plant, the competition was frenzied. It was a whirlwind courtship, with many suitors vying to win what Toyota promised would be a December bride. Thirty states wooed the Japanese giant, offering packages that dwarfed those piled before Volkswagen less than a decade before. But on 11 December 1985, it was Kentucky's governor Martha Layne Collins who marched down the aisle to a press conference with

Toyota executives. "This is the most significant industrial development deal of the decade,"[36] she said of the $800-million plant and the $125-million incentive package she used to win it. "Together, Toyota and the people of Kentucky have a great future before us."[37]

For political reasons, Kentucky officials played down this large bundle of incentives, claiming that simple location factors had enabled their site to beat thirty rivals. The state's commerce secretary credited Scott County's "strategic location on major interstate routes, access to air transportation and an excellent workforce"[38] with persuading the Japanese. This may have been the case. But Tennessee, Ohio, Indiana, and Illinois offered similar features—so similar that they won auto factories of their own.

There was probably another reason Toyota picked Kentucky: politics. The Japanese automakers, under great threats of protectionism, have sought to deflect criticism of their huge trade surplus by investing in the United States. They have also sought to maximize their political power by locating their assembly plants in different states, since each has two U.S. senators and many congressmen. As Senator Jim Sasser of Tennessee (where Nissan and scores of other foreign plants are located) noted, foreign investment "can have an inhibiting impact on coming down strongly on trade legislation or trade matters,"[39] and indicated that foreign companies could be "punitive" with politicians who disagreed with them on trade issues. Other members of Congress voiced similar misgivings about the political fallout of FDIUS. Thus, it was unlikely that Toyota would locate in Ohio (where Honda is) or Tennessee (where Nissan is). It would be unwise for the other states with Japanese assembly plants—Illinois, Indiana, and Michigan—to bid for a facility announced in the future. It is nearly certain that, for strictly political reasons, additional capacity will go to states without existing plants. Similar informal arrangements rule the location of Japanese supplier plants: they try to spread out among congressional districts, thus maximizing their political power.

Yet with all these advantages going for it—access to suppliers and markets, relatively low wages, and the rest—Kentucky gave Toyota the largest incentive package in the history of FDI promotion. As we have pointed out, the state purchased the $35-million 1,600-acre plant site, saving the company years of property taxes, and graded the hilly site. It agreed to build an employee-training center and train American workers in Japanese production techniques in Japan when necessary, at a cost of $33 million. It also agreed to make some $60 million in improvements to sewers, highways, and roads leading to the site. In addition, the state

offered twenty years of Saturday classes for Japanese children and ten years of English-language classes for Japanese Toyota employees and their families, at an estimated cost of $5 million (see table 8.1).

State officials claimed that the incentives would cost Kentucky $125 million, and that is what the state legislature approved. But because most of the perks are paid for with economic development bonds, their cost to the state's taxpayers will ultimately be much higher. Interest on the bonds could run to nearly $167 million, according to a 1986 University of Kentucky study.[40] Besides neglecting to include bond interest in calculating the cost of the incentive package, officials assumed the state would get a helping hand from the federal government in training the new auto workers. If Washington decided not to extend that hand, the study said, training costs to the state could rise to $65 million. The total cost of the incentive package over twenty years might be as high as $325 million—a full $200 million more than the amount officially approved by state legislators.[41]

The special treatment for Toyota did not go down as smoothly as Kentucky bourbon. Governor Collins came under intense fire from political opponents for the incentive deal. Barely a month after Toyota announced its decision, a crowd rallied in Lexington, about twenty miles from the plant site, denouncing the incentive package. The company "played Martha Layne for a sucker," said the rally's organizer, as the crowd waved anti-Japanese bumper stickers. "They're taking our tax dollars to help cut their operating costs."[42] Some also questioned the constitutionality of the incentive package in a case that went to the Kentucky Supreme Court.[43] The court ruled that the package did not violate the state constitution's prohibition of giveaways to private businesses. But ill-feeling remained. The Kentucky AFL-CIO demanded the state legislature pass a measure requiring state officials to disclose the details of any economic incentive package before it is offered to a company. The bill, similar to ones passed by Illinois and Wisconsin,* was to be introduced in the 1988 legislature.

For its part, Toyota sought to lessen the adverse effects generated by the package and the labor dispute. Late in 1986, the company announced that it would pay for site improvements beyond the $20 million authorized by the legislature. Cost overruns were estimated at $24 million. "We worry about this because we want to have a good relationship with the community," a Toyota official said. "We started with a good atmosphere and the [controversy] hurts how people feel about

* Wisconsin's governor vetoed this bill, and the veto was not overridden.

Toyota."[44] The company remained confident of its welcome. "In three to five years, the question whether this was the right thing to do will never be asked again," the top American manager at the plant said. He was probably right. Late in 1987, the company announced a major expansion that would create hundreds of additional jobs. But the announcement was careful to make clear that no incentives were involved.

A Backlash in the Making

The bidding wars reached a new plateau in the battle for Toyota and probably their depths in the sad tale of Volkswagen. The lessons of the two situations are clear. In Pennsylvania, a company took what it could get and left local officials holding the bag—but local officials got so caught up in the frenzy to get a plant that they failed to protect themselves and their constituents by thoroughly analyzing the situation. In Toyota's case the lesson is that, once the competition begins, the foreign investors hold all the cards. Even though it had a near-perfect location, and could perfect that location with site work at a fraction of the cost of its incentive package, and had lobbied hard and cleverly with Toyota's headquarters in Japan, Kentucky had to compete with other states on the company's terms. So taxpayers will pay $325 million more in taxes than they had to over the next twenty years. And Toyota, one of the richest corporations in the world, will not have to pay its share.

Thus, cities and states often are not getting their money's worth. Ohio's Governor Richard Celeste admitted that despite his feverish (and sometimes successful) efforts to attract more foreign start-ups, "We have learned that smokestack and chip-chasing are hollow, self-defeating strategies that pit state against state and produce no real economic gain."[45] Governor Collins of Kentucky faced great criticism and a lawsuit over the Toyota deal. The mayor of Flat Rock, Michigan, lost re-election in part because of the Mazda deal which cost the taxpayers $2.5 million a year in lost revenues.[46] "It's a form of industrial blackmail," the mayor said. Added Doug Ross, Michigan's commerce director, "The brief period of unabashed bidding . . . is over just that quickly."[47]

Another shock has come to American parts manufacturers and other would-be suppliers of the automobile-assembly plants. Foreign companies typically import a large percentage of the parts they use, although that percentage may decrease as the number of suppliers

grows (see chapter 5). While this contributes to local development, it does not produce the level of secondary benefits many states and localities use in determining the size of incentives they are willing to offer. Domestic manufacturers who supported incentive packages with the idea they were ensuring a new market for their own products are faced with the New Competitor outhustling them for their old customers. Those vaunted multipliers do not work so well when the new companies are killing off long-established local ones. In many cases, public incentives are used to attract foreign firms that then beat out existing local firms. After Chattanooga attracted Komatsu, the Japanese heavy equipment giant gained an important foothold in the United States—a foothold it used to go one-on-one with its arch rival, Caterpillar. Senator Jim Sasser of Tennessee questioned the deal: "Why are we using taxpayers' money to help Komatsu beat Caterpillar's brains out?"[48] This statement has been echoed by auto suppliers and other domestic companies.

But even if inputs are not imported, they may be purchased outside the state (or locality) giving the incentive. Again, the tax and jobs benefits accruing to the state will be far less than anticipated when the package was put together. For example, when Bloomington-Normal, Illinois, attracted the 2,900-employee Diamond-Star auto plant, it put up $118 million in direct subsidies, a staggering $41,000 per employee (see table 8.1). Illinois officials expected Diamond-Star to buy many of its inputs locally and create 8,000 jobs altogether. They were wrong. First, Diamond-Star contracted for only half of the subcontracts it had earlier promised. Second, of the first thirty-nine subcontracts that Diamond-Star let, only six were to Illinois firms; the rest went throughout the Midwest and mid-South, as we described in chapter 7. "We're not coming very close to the 8,000 jobs," complained the state's leading economic development official. "I'm not sure where [the number 8,000] came from."[49] Although the state overestimated the impact of the Diamond-Star investment, it was stuck with the incentive package. Illinois officials and outside observers now expect that extra employment will be half of what they anticipated. One estimate put the job gain at only 1,500 additional jobs.[50] As a result, the expected returns from incentives fall far short of the mark, and other taxpayers' burdens are raised. An economic development spokesman for the U.S. Chamber of Commerce said, "More progressive business people are beginning to realize that there's no free lunch. If they get a special deal today, someone else will get a special deal several years from now and they'll have to pay for that."[51]

Another serious disappointment has been construction contracts.

When a major automobile factory is built, construction costs can amount to hundreds of millions of dollars—including excellent wages paid to the construction workers, subcontractors' fees, and construction supplies. But for at least two of the Japanese auto plants locating in the United States, the Japanese brought in their own construction companies. For the Diamond-Star plant, a joint venture of Chrysler and Mitsubishi, Kajima Corporation is the general contractor. Ohbayashi is the general contractor for the Kentucky Toyota plant. Although wages are paid to local construction workers, the profits go into the coffers of Ohbayashi and its brother and sister firms.

As a result of these and other issues, cities and states are beginning to look differently—and less sanguinely—at how foreign investors operate. Policy makers are also looking at the consequences of their actions which go beyond those new jobs. They wonder whether, by exempting from property taxes a plant that employs 3,000 people, they guarantee that those workers' children will get a second-rate education —because the rest of the community cannot afford good schools with a shrunken tax base. Or whether they are guaranteeing that those children will not have safe roads or drinking water or parks to play in. Are they inviting corporate irresponsibility? If the company does not pay its way in the community, are they encouraging it to behave as Volkswagen did? Some policy makers are wondering how fair it is for incentives to go to large firms at the expense of small firms and to new firms rather than existing ones. These questions are difficult to answer—much more difficult than figuring out how to structure an industrial revenue bond issue, or than announcing a new plant location creating a thousand jobs, or than looking down on a car plant and thinking about how Moses must have felt.

Looking Ahead, Keeping a Balance

To meet economic development objectives, state and local development agencies allocate limited financial resources among many competing projects and must therefore strive for the greatest possible returns from their budgets. When considering investing taxpayers' dollars in attracting FDI, economic development officials must decide what they and their communities want out of foreign investment, and then develop intelligent strategies to pursue that aim.

Any strategy should take into account the needs, strengths, and

values of the community. For example, a rural area with a low-skilled labor force and weak transportation linkages might be forced to pursue basic assembly plants, such as those in the electronics industry, that do not depend on heavy equipment suppliers requiring access to rail and interstate highway networks. An area with strong growth can afford to be more selective: for instance, a fast-growing area can pursue an economic diversification strategy or recruit only clean, nonpolluting industries.

Generally, economic development officials should channel scarce state funds into long-term public investments that both attract firms and simultaneously enhance the community at large. In providing incentives, certain programs, such as job training and investment in physical infrastructure, contribute to the overall development of cities and states. But, as we argued earlier, other incentives, especially tax abatements, are wasteful and rarely cost-effective. They offer little inducement to industries compared with other incentives like job training, and drain potential revenue needed for physical and human capital improvements.

Thus, to make decisions about the kinds of firms to pursue and the incentives to offer, it is important to have a framework to weigh the benefits to the community of new firms against the costs of attracting them. The decision-making process is complex: there are not only the direct costs of attracting firms (say, tax abatements), but indirect costs (such as increased congestion) as well. Similarly, there are direct and indirect benefits.

We propose that, before the mad scramble for jobs begins, a community draw up a balance sheet, such as that in table 8.2, in order to evaluate an incentive package and decide whether to pursue that plant in the first place.[52] Later, when the community knows it is being actively considered, it can use the balance sheet as a basis for deciding the kinds and level of incentives to offer.

The balance sheet in table 8.2 can show the direct benefits over five or ten years—often the expected life of a plant and the time in which localities should try to recapture rebated taxes and other incentives. First, let us look at the benefits in the left column of table 8.2. A key benefit is the number of jobs the firm provides and the wages it pays. The benefit of new jobs is clear: increased purchasing power for residents and a multiplier effect that reaches out to the whole city. Second, the new plant increases the tax base and revenues. Third, the new firm might teach more job skills, thus helping to upgrade the labor force. Finally, there is the possibility of industrial diversification, which is not quantifiable but could be important in reducing the cyclical fluctuations

247

TABLE 8.2

To Give or Not to Give: An Incentives Balance Sheet

Benefits	Costs
Direct	*Direct*
Jobs:	Providing New Public Services
Managerial: No × Average Salary	To Plant
Production: No × Average Salary	To Employees
Support: No × Average Salary	Subtotal:
Subtotal:	
Taxes:	Other
Tax Base Increases	
Tax Revenue Increases	
Subtotal:	
Greater Industrial Diversification	
Other	
Total:	Total:
Indirect	*Indirect*
Multiplier Effects	Pollution Generated by Plant
On Suppliers of New Plant	Competition with Local Firms
As a Result of Employees'	Labor Relations Problems
Consumption	Congestion
Subtotal:	Providing Services to New Residents
Increased Job Skills	Other than Plant Employees
Reduction in Social Welfare Costs to Community	Increased Living Costs
Intangibles:	Due to Population Growth
Increased Prestige	Other
Increased Cultural and Educational	
Opportunities	
More Cosmopolitan Atmosphere	
Other	
Total:	Total:

that towns go through. The more diverse a city's economy, the less severe its business cycles.

Next, a set of indirect benefits accrues because of the new plant. Foremost is the multiplier effect provided by the new firm. As we have said, there are two aspects of the multiplier: purchases from local suppliers and consumer spending. First, the firm buys some of its inputs locally, increasing the number of jobs in the supplying firms. In addition, the firm's employees spend their paychecks on food, clothing, and housing, thus enabling other companies in the city to expand their

employment rolls. Input-output analysis and other methods used to estimate multiplier effects are in the tool kits of economic development specialists. Another indirect benefit is the reduction in the cost of providing welfare, health care, and other forms of support to members of the community who are currently jobless. Like the multiplier, these savings are quantifiable. The community at large may also gain increased prestige, more cultural opportunities, and a more cosmopolitan atmosphere. These intangibles, though hard to quantify, certainly increase a community's quality of life.

On the cost side (the right column of table 8.2), there are the direct costs over time to the town of providing new public services for the plant and its employees: training, water and sewer service, fire and police protection, roads, rail and air access, and others. These costs depend critically on what the city has already invested in these items. If it has maintained its roads and other infrastructure, then the extra costs may not be great. Next, there are the indirect or external costs: for instance, plant emissions and effluents impose environmental costs. The dirtier the industry, the higher the costs, both in terms of people's health and cleanup. Increased congestion around a plant is a further cost. As jobs and population increase, the added population and traffic that accompany the greater economic activity bring costs of their own. The community may suffer forced changes in its way of life through rapid urbanization; increases in costs of housing, food, and other necessities; and social dislocations caused by a sudden shift in the economy. Then there are potential external costs brought on by foreign competition with local companies. Subsidies for new foreign-owned plants that compete directly with older domestic facilities may either shift jobs from one company to another or actually decrease employment.

In addition, communities must consider the possibility that a new plant will drive up wage rates throughout the city, increasing the cost of doing business for existing companies. They should also anticipate the effect of the plant on labor relations in the community. If the plant's owners are anti-union and the city is in a strongly unionized area, costly conflicts may occur—as has proven to be true even in such areas as Kentucky where the sector in which the plant belongs is not unionized, but there is a strong tradition of unionism in other industries.

While we cannot reduce these factors to specific numbers, they, too, affect the city's future. The city should have its economic development staff estimate the cost of services for new residents: city-owned utilities such as sewerage, trash collection, and water; streets and sidewalks; public transportation; and, of course, schools.

Using this framework, political, business, and community leaders can get a realistic sense of whether they want to pursue a particular plant. Once the economic development staff quantifies these costs and benefits (as much as is possible), it can compare the columns. If the costs outweigh the benefits over the long term, the community should not pursue the plant. If benefits outweigh costs, then the town must decide what, if any, incentives to offer. A price tag can be put on the package. Frequently the town negotiates packages with the company. The company may suggest its preferred set of incentives to all cities in the running. The local economic development staff can figure the cost of the ideal package to the community. For the variables that are quantifiable, computerized benefit-cost analysis can be employed to assess the net benefits of incentive packages and to rank competing projects.* Using the balance sheet, community leaders can decide whether they wish to make a counter offer and how much they are willing to spend to win the battle with other towns. In this way the balance sheet helps the state or city carry out its strategy.

The balance sheet is certainly not a prescription for solving escalating incentive competition. It would be best if states would get together and declare an end to the rampant bidding war. The Massachusetts legislature has proposed a moratorium on incentives, but only a state with such low unemployment can afford to push for one. Poorer states are unlikely to sign such a pact and will continue to do everything they can, within their budget constraints, to entice more investment. There is perhaps no way to stop it without federal intervention, unless the federal government taxes the incentives given by localities, to make incentives less valuable to firms and diminish the mad scramble a little.

In lieu of an interstate truce on incentives, the balance sheet provides a useful tool to help state and local policy makers see just how a given investment opportunity might affect their constituency. Used in this way, we believe that it can help them make better decisions and have a chance of opting out of futile incentive duels before they have spent too much time or money on developing elaborate packages. Fortunately, there are signs that states are moving in this direction: Illinois paved the way in 1987 with legislation requiring that its Department of Commerce and Community determine the impact of foreign investment on domestic business before any incentives are offered. Bills have been brought before other state legislatures, too.

* Cost-benefit analysis requires that development agencies calculate the flow of benefits, discounted to present value by an appropriate cost of capital, and any offsetting costs.

With the increasing backlash against incentives, there is also an important role for national associations like the National Governors Association or the National League of Cities, which could negotiate voluntary compacts to limit incentives. The problem of "cheaters" who continue to give incentives proscribed by the compacts could be addressed by federal legislation cutting aid to cities or states that do not play by the rules, or by taxing state and local subsidies. While such legislation would be difficult to draft and pass in our federalist system, in which states and cities enjoy wide powers, it would be worthwhile—as local officials are beginning to see—in limiting giveaways to the New Competitors.

As the Mad Scramble Continues

Increasingly governors and mayors are seeing that the effort may not be worth it. As the truth about the small numbers of jobs created by FDI becomes more evident, and as awareness of how much incentives cost the community grows, states and cities are realizing that foreign investment can be a "negative-sum game" in which there are many losers and only a few winners. By bidding against each other, they are all losing out in the end. Questioning the use of incentives to attract firms that compete directly with domestic companies, many have asked, Why subsidize your competitors?

Other problems are becoming obvious. First, the traditional incentives have little effect on the location decisions of foreign firms. The major reasons for the siting of a new facility are an area's proximity to suppliers and markets, its labor force, its quality of life, and its infrastructure. As states and cities see the importance of concentrating funds to improve education, infrastructure, and quality of life—parks, culture, and the like—they should likewise be careful to protect their environment—trading pollution and congestion for jobs will not do a town any good in the long run. Policy makers are realizing that these factors make an area economically strong whether or not they are trying to recruit a foreign firm or a *Fortune* 500 company. These factors help areas do things from the bottom up—"growing" new firms locally, a point to which we'll come back in a moment.

Second, as the Volkswagen case shows, there is a growing feeling that cities must figure out ways to put together what other countries use and call *performance requirements*. In return for incentives, officials

should insist that a certain number of jobs be created (including a share for the unemployed), a certain percentage of inputs be bought locally, and a variety of other actions be taken by a firm in the interest of the community. For instance, a high-tech firm could be asked to help put together a science curriculum for the high schools or junior college. This kind of *quid pro quo* sets a more equal relationship between community and company.

If the firm does not meet its performance requirements, then there can be *clawback provisions*: penalties to get back some of the incentives package. This could have been of great help to Pennsylvania in the Volkswagen case, for example. States and cities can avoid costly bidding mistakes by offering incentives on a contractual basis. Legally binding contracts are something all businesses expect of each other. They should not be surprised that state and local governments demand written guarantees of job creation, not promises, when public resources are used to aid private concerns. This is just sound business practice, the kind of trade-off underlying all business transactions. Firms like long-term agreements since it helps them make plans with less uncertainty. Foreigners, in particular, find contracts attractive since they then better know the ground rules in the state in which they are operating. When a state provides a carrot to lure foreign investors, then it has a right to carry a stick. Firms must keep their part of the bargain by satisfying performance requirements.[53] Specifically, governments should tie incentives to job creation and new investment in plant and equipment. In the case of tax concessions, states should only offer targeted refundable tax credits—tax benefits based on employment creation and plant and equipment investment. Moreover, they should continually monitor all subsidies, demanding repayment or reducing awards if job or investment targets are not met within a specified period.

European governments use this carrot-and-stick approach, administering incentive programs with clawback provisions. Most foreign countries provide both incentives and impose performance requirements on multinational corporations operating within their borders. Overseas, the most common requirements are various domestic content provisions: an MNC must produce a specified level of its sales locally. Other requirements include manpower performance (job creation and limits on foreign employees), minimum export levels, maximum import limits, encouragement of investment in priority industries and development areas, limitations on acquisitions of domestic firms, technology transfer agreements, and restrictions on remittances of profit. Among developed nations, Canada has had the most active foreign investment

policy for the simple reason that more of its economy is controlled by overseas MNCs than any other.[54] In this respect, it is way ahead of the United States.*

Another problem in an age of rapid capital mobility is that plants can be closed down quickly, their assets sold off, and workers fired. It is important, then, to protect the city or state's investment: that is, cities and states must *structure their incentives* so that they can be recaptured in a reasonable amount of time—say, five years.

Finally, it is important to have a *coherent strategy for economic development*. Very little long-term economic planning is done by states and cities. Rarely is there a game plan that targets funds to particular kinds of industries or areas. Few areas think through the consequences of nabbing a foreign (or domestic) branch plant. Too often cities have not done their homework and are out there bidding for firms that will not give them a serious look—except to use the incentives to jack up the perks demanded from some other town. There is a greater need to make sure that the firm meets the city's needs as well as the other way around. Cities must try to match up their other characteristics—education systems, utilities, and so on—with what will do the city *and* the company the most good in the long run. They should not waste on incentives money that could be better spent on investing in education, training, better roads, and airports.

Although much of the debate over U.S. "competitiveness" takes place in Washington, the real action is at the state and local levels. While talk of "industrial policy"—government policies to push certain industries—lacked broad political appeal nationally, industrial policies were being put together throughout the nation. States have been devising their own "industrial strategies," using their own funds for venture capital and for programs to stimulate technology, to encourage small home-grown business, and to improve skills. Increasingly, institutions such as Pennsylvania's Benjamin Franklin Partnership, which helps promote technology, and the Massachusetts Technology Development Corporation, which provides seed capital for start-up technology firms, have

* In two recent cases, cities have sued companies that have not lived up to incentives agreements: when Chicago gave Playskool a set of incentives, and the company promised to provide some jobs, Playskool closed without carrying out its end of the agreement; and Duluth, Minnesota took Triangle Industries to court on similar grounds. Although both involved American firms, the principle of seeking redress in the courts was established in both cases. Although these are not models for future clawbacks arrangements, since they ended up in the courts after the cities and companies disagreed, they give both localities and companies good reason to try to agree about performance requirements *before* the fact.

helped build local economies.[55] In the end, much of the growth of the economy must come from our own firms—particularly small ones—and from the skills of our own people. However foreign investment may add to the economy, it distracts the attention of state and local policy makers from the more important task of building up their own indigenous employment.

In the final analysis, states and cities can take on their own only limited action to attract foreign investment. The divide-and-conquer strategy of foreign multinationals means that the companies always have the advantage. In this respect, they have learned well from American companies—which have been getting large subsidies for a long time. The states and cities are left with little economic security despite their efforts. Although much must be done at the grass-roots level, a coherent national policy regarding foreign investment is urgently needed. Now, in chapters 9 and 10 respectively, we turn to the reasons behind the present U.S. policy and then to our prescription for change.

9

THE POLITICAL ECONOMY OF

FOREIGN INVESTMENT AND THE

LIMITS OF LAISSEZ-FAIRE

T HE SENSE that the New Competitors are at the core of U.S. economic problems has contributed to the rise of economic nationalism and to a great debate about America's place in the world economy. In a 1988 poll, 62 percent of Americans said that economic power is more important than military power (chosen by only 22 percent) in determining this country's influence in the world; 72 percent believe the trade deficit is a serious national security problem.[1] The meaning of this poll is clear: a majority of Americans see us losing control of the economy. These feelings are reflected in the political world. Both 1988 presidential nominees spoke to these fears in their stump speeches, Michael Dukakis declaring "a battle for the economic future of America," while George Bush warned that we need "to stay competitive in this increasingly competitive marketplace." Others chimed in. "Americans are increasingly sensitized . . . to losing control of our economic destiny," said Kevin Phillips, an influential Republican political analyst. Added the Democratic consultant Greg Schneiders, people are worried that "foreigners are beating us in world markets, foreigners are coming and taking away our jobs, that foreigners are buying up America."[2] Many believe that a greater and more active fed-

eral presence is needed. In addition, it should be clear by now that foreign direct investment is more than just an economic phenomenon. It is a political one too. In this chapter, we look at the economic and political climate surrounding FDIUS: how the federal government acts toward foreigners, how its policies are changing, and how foreign companies use their political clout. We show that America's long-standing laissez-faire (or liberal trade) ideals have given way to intervention as foreign investment has become a political issue. In practice, even the upholders of the liberal trade doctrine have become neo-interventionists—true believers in laissez-faire mugged by international economic reality. The government intervened with the deterioration of the trade balance and the explosion of inward investment. The country moved, often incoherently, from one set of policies to another—eventually toward what we call "ad hoc protectionism."

The Operation of Laissez-Faire

THE IDEAL OF FREE TRADE AND INVESTMENT

Laissez-faire has long enjoyed considerable support among economists and public officials. According to mainstream economic theory, the world economy is best served by a free market, in which companies can invest their money where it can be most profitable without government incentives or disincentives.[3] This principle is the basis for America's open-door investment policy, known as the "principle of national treatment." National treatment means that once non-American multinationals build new facilities or buy U.S. companies, they are considered the same as domestic investors. The government shows no favoritism; all firms are regarded as equals. The United States treats Toyota like GM, Robert Campeau like Boone Pickens. Foreign competitors enjoy all the rights of native firms. In addition, all federal and state laws apply to foreigners, including taxation and antitrust.

This basic philosophy has guided U.S. international investment policy since the 1791 *Report on Manufactures*, in which Alexander Hamilton wrote that foreign investment "ought to be considered as a most valuable auxiliary, conducting to put in motion a greater quantity of productive labor, and a greater portion of useful enterprise, than could exist without it."[4] Every U.S. President in recent memory has kept Hamilton's spirit alive by summoning foreigners to our shores. One clear statement

came from the Ford administration's Council on International Economic Policy:

> The basic thrust of U.S. international investment policy is to encourage the free flow of capital as a means of maximizing the operating efficiency of the world economy. In accordance with this general principle, we admit foreign investors freely; we give them equality of treatment with domestic investors once they are established here; and we offer no special incentives and impose few barriers. The few restrictions we have imposed are well known and generally accepted abroad. We have opposed any attempts to add to the list of existing restrictions as unjustified by economic analysis—a position we will continue to adhere to unless it becomes evident that a particular measure is necessary on ground of national security or to preserve our essential national interests.[5]

Similar pronouncements about how free international capital flows lead to the "most efficient allocation of economic resources" emanated from the Carter administration's economic policy makers.[6] By the early 1980s, it was hard to find an economist, a government official, or a business person who did not agree that the unfettered flow of international capital was good for America and all host economies.

The U.S. government has pledged to uphold the philosophy of free international trade and investment through many bilateral "Treaties of Friendship, Commerce, and Navigation," which state that foreign investors receive the same rights as Americans, except in national emergencies. The United States urges other nations to follow its lead; and, on paper, most do. The United States and the twenty-three other developed nations comprising the Organization of Economic Cooperation and Development signed the 1976 Declaration on International and Multinational Enterprises, strengthening the commitment to the free movement of international capital.[7] The document recommends that all member countries "improve the foreign investment climate, encourage the positive contribution which multinational enterprises can make to economic and social progress, and minimize and resolve difficulties which may arise from their various operations."[8] While the OECD declaration counsels nations to adhere to the principle of national treatment, it does not address the many regulations and restrictions that nations place on foreign investment. Nowhere does it explicitly call for a removal of barriers to free international capital flows.

In fact, free capital movement never exists in practice. Powerful multinationals, cartels like OPEC, and large, government-run corpora-

tions use their enormous economic clout to influence world investment and trade in ways that make free traders weep. Even more important, international markets contain a panoply of tariffs, quotas, local content regulations, and other non-tariff barriers that make liberal trade and investment look like an economist's blackboard fantasy. Nevertheless, the United States maintains the image and ideal of free market economics and investment, even though it has had its share of tariffs and quotas for more than two hundred years.

THE REALITY OF FREE TRADE AND INVESTMENT

In *Free to Choose*, a book of free-market wisdom widely read in Washington during the salad days of the Reagan administration, Milton and Rose Friedman proposed, "We are a great nation, the leader of the free world. . . . We should move *unilaterally* to free trade, not instantaneously, but over a period of, say, five years, at a pace announced in advance" (italics added).[9]

By the end of the Reagan era, however, dissenting voices were heard through the free market chorus. Clyde Prestowitz, a top Reagan administration trade negotiator, in bemoaning the loss of our economic leadership to Japan, argued, "At issue is not free trade or protectionism—we never had and never will have either one; but it is what combination of free and managed trade we will have."[10] Managed trade implies quotas, bilateral and multilateral trade and investment agreements, and a variety of other deviations from the liberal trade model. Addressing the problems associated with international capital, New York investment banker Felix Rohatyn argued that under "distorted market conditions," selective intervention may be needed to reassert competitiveness and economic independence.[11] Still, he conceded that "it is heretical to even suggest that some limitation on freedom of trade and investment might be considered."[12]

It might not seem so "heretical" if we look more carefully at the conditions economists need to prove that free-flowing international trade and capital maximizes everyone's welfare. The economists' justification for laissez-faire rests on one critical, if dubious, assumption: the existence of perfect competition. Forget Campeau and Toyota for a moment, and imagine that we live in a world containing thousands of firms with no significant market power and free entry and exit into any given industry. This is the textbook "perfect competition model" that underlies the liberal trade doctrine of "comparative advantage." Simply put, comparative advantage says that nations should do what they do best: specialize in those industries in which they are most efficient and

produce at least cost. If a nation is more efficient making semiconductors than textiles, or steel than autos, then it should produce semiconductors and steel and trade for other goods it needs (even if it can outperform other nations in textiles and autos). The policy prescription is clear: if you want to raise every nation's economic welfare, ensure economic growth, and create jobs, then remove all obstacles to free trade.* Above all, never protect flagging industries.

Perfectly competitive theories of portfolio capital investment reach the same conclusions, and need the same highly unrealistic assumptions. The argument here is that international arbitragers respond to the highest risk-adjusted rates of return at any time. Because rates of return are high where capital is scarce, portfolio capital flows to where it is most needed and can be most productive. From a host-country perspective, who would argue against a reallocation of global investment from the capital rich to the capital poor? Restrictions on capital flow hinder the ability of capital to reach its highest return, according to this view, and should not be allowed.

The justification for the unobstructed flow of direct investment across national borders extends the free-trade and portfolio capital postulates. Only the most efficient firms can survive the rigors of perfect competition. Restraining the flow of direct investment would potentially prop up inefficient domestic firms and rob nations of more efficient sources of capital investment. Theoretically, everyone benefits when multinational capital moves freely, unencumbered by governmental meddling. Therefore, all firms, regardless of national origin, *should* be given an equal opportunity to invest. In sum, if trade and investment are truly free, then everyone will be best off in this perfectly competitive world.

Of course, "perfect" competition resides only in a "perfect" world. All the arguments about the virtues of perfect competition remind us of Dr. Pangloss's blithe proclamation in Voltaire's *Candide*: "Tis demonstrated . . . that things cannot be otherwise; for, since everything is made for an end, everything is necessarily for the best end." To which Candide replies skeptically, "If this is the best of all possible worlds, what are the others?"[4]

One of the "others" is the twentieth-century world of imperfect competition, or oligopoly, which we discussed in chapter 3. In the real world, all firms are not equal. Foreign investors operate in markets with

* The seminal argument for the comparative advantage doctrine was set out in the early nineteenth century by the celebrated British classical economist David Ricardo and refined in the twentieth century by Eli Hecksher and Bertil Ohlin.[13]

concentrated economic power. Multinational corporations hold a spectrum of special advantages over their domestic competitors. The existence of market imperfections calls into question the whole notion that unfettered international capital flows are most efficient and confer more economic benefits on host nations than any other regime. Except under very limited assumptions, economic analysis cannot prove that laissez-faire, equal treatment, and strict neutrality ensure the best of all possible worlds.

Thus there are many reasons to be skeptical that every direct investment transaction makes a positive contribution to the economy. In particular, the power of large foreign capital may work against the public interest by fostering price discrimination, production restrictions, and by creating an uneven process of capital accumulation (favoring some industries and regions over others)—all phenomena associated with oligopoly. Under imperfectly competitive conditions, the industrial and market power of foreign MNCs may impede domestic capital formation and create inefficiencies, such as excess capacity. When this is so, there is a case for intervention, oversight, and monitoring (or screening) of investment to guarantee that investments confer benefits to the host country.*

A growing number of U.S. manufacturing and nonmanufacturing industries—including advertising, chemicals, cement, and gold mining —have rapidly come under the control of a few large foreign firms. In the chemicals industry, for example, there are some who suspect collusion and cartel behavior with Big Three German chemical giants, who have quickly moved up the U.S. corporate hierarchy to the top in sales. Each of Germany's chemical giants dominates specific product groups. As BASF's chairman, Hans Albers, says, competition exists among the German chemical giants, but "Of course we all speak the same language, so it isn't difficult to talk to each other."[16] It's hard to say what Germany's chemical giants discuss, but we are reminded of a passage from *The Wealth of Nations* by the father of laissez-faire, Adam Smith: "People of the same trade seldom meet together, even for merriment and diversion, but the conversation ends in a conspiracy against the public, or in some contrivance to raise prices."[17] Clyde Prestowitz discusses alleged collusion of bidding among the Japanese titans Hitachi, Toshiba, and Fuji Electric for hydrogenerator contracts in the United States. On one contract, one firm would bid very low and the others high; on the next, a second firm would bid low and the others high; and so on. Over a short

* One advocate of tighter control over foreign investment was Stephen Hymer, the founder of modern direct investment theory discussed in chapter 3.[15]

time span, bids differing by as much as 200 percent would be presented on the same equipment. The implication is that the Japanese companies were trying to drive the only remaining maker of these generators in this country out of the market by successfully "low-balling" their bids and winning contracts.[18] This is hardly the world of perfect competition that forms the basis for U.S. trade and investment policies.

MNCs may close markets through their size and power or merely substitute their own internal market for a missing external market for corporate know-how, as some economists now suggest.[19] Whether multinationals add to efficiency depends on the specific imperfection involved in each case.[20] On the one hand, the tendency toward increased concentration of global capital could lead to a reduction in economic efficiency. What analysts say about large-scale domestic capital applies to many global firms:

> that managers of giant corporations and conglomerates often create inefficiency through "over-managing" their subsidiaries, milking them of their profit, subjecting them to at best strenuous and sometimes impossible performance standards, interfering with local decisions about which the parent's managers are poorly informed, and quickly closing subsidiaries down when other more profitable opportunities appear.[21]

We recognize, on the other hand, that the assertion of multinational power may at times be an efficient means of spreading information and technology throughout the globe. The ability of large firms to keep competitors out of the market by using their vast economic power could be overemphasized. MNCs may provide an efficient means of "internalizing" special advantages and transferring technology. MNCs are sophisticated marketers and technically advanced corporations, offering new opportunities for industrial restructuring and rejuvenation. Sometimes cross-border mergers and joint ventures make sense, especially when firms collaborate in technology, human resources, market development, and so forth. But there are certainly strong reasons for questioning the assumptions of the free marketeers about international investment's efficiency.

NATIONAL RESTRICTIONS ON INVESTMENT

Many nations, indeed, have questioned the benefits of unrestricted foreign investment and most limit international capital in one form or another. Regrettably, no official international or national group has

ever compiled a comprehensive list of investment barriers,[22] which come under many guises, including mandatory levels of local ownership, performance requirements like local content and technology transfer mandates, export controls, and screening agencies. Many nations ban or restrain investment in mining, financial institutions, and other sectors considered strategically important or sensitive in respect to national security.

What is surprising is how many of our New Competitors' home bases have formal or informal screening agencies. Great Britain's Department of Trade and Industry has the authority to review foreign takeovers in "important" manufacturing concerns. Other European nations—West Germany and the Netherlands, for example—assume a relatively liberal posture on investment monitoring and control. On the other hand, Canada, Australia, Japan, and France all have formal screening mechanisms. Canada's screening dates to 1974, when the nation instituted the Foreign Investment Review Agency (FIRA) to evaluate whether an investment is of "significant benefit" to the country. Canada reviews large foreign acquisitions and regulates investments considered important to the nation's culture and identity—such as book publishing and film production and distribution.[23] FIRA examined the effects of foreign investment on Canadian employment, productivity, exports, technology, and other aspects of the domestic economy. Until recently it reviewed all inward investment, and MNCs had to have its approval before proceeding. FIRA rejected about 15 percent of all proposed investments. Although the conservative Mulroney administration scrapped the strict screening of all foreign investment in the mid-1980s, Canada still closely monitors FDI. Since 1985, an agency called Investment Canada has been charged with monitoring inward investment, screening all acquisitions over $5 million (Canadian dollars). Australia's review board is similar. In 1975, that nation established a Foreign Investment Review Board to prescreen applications for foreign investment in Australian businesses. The review process covers all investments over $10 million (Australian dollars), takeovers of more than $5 million, and those that involve at least 15-percent ownership. National law prohibits approval of investments found to be contrary to the national interest.

Japan, meanwhile, maintains some of the strictest controls and one of the more elaborate investment approval processes among developed nations. It restricts foreign ownership of energy companies to 50 percent and of "technologically innovative" companies to 25 percent. Under the Foreign Exchange and Foreign Trade Control Act of 1979, a proposed foreign investment must not "harm the national security,

disturb the public order, or hamper public safety" or "adversely and seriously affect Japanese companies in a similar line of business." In general, it must not "adversely affect the smooth operation of the national economy."[24] France, the nation that most worried about the American Challenge during the late 1960s, ranks with Japan as one of the most inhibiting hosts among all developed nations. The French government must approve all investments that involve more than 20-percent ownership in a domestic firm, and an intergovernmental committee examines all but the smallest investment proposals from foreign companies. The government has been known to use its authority, discouraging foreign takeovers. For example, the French blocked a Swedish company from acquiring an 80-percent stake in the Lafarge cement company in the early 1980s;[25] this company is now investing heavily in the U.S. cement industry, which, we know, is becoming dominated by foreign interests.

The United States government vows not to discriminate against foreign owners and vehemently opposes investment screening during the General Agreement on Tariffs and Trade (GATT) negotiations. But the United States, too, has many exceptions to national treatment and its open-door policies. Federal laws restrain or ban foreign involvement in a host of industries: coastal shipping, domestic aviation, hydroelectric power generation, leasing and mining of federal lands, banking, mass communications, nuclear energy, and areas considered vital to national security.[26]

Specifically, the United States requires that coastal trade (between points in the United States) be performed by vessels built in and documented under U.S. laws. In the aircraft industry, a foreign air carrier may not acquire an aeronautics business in the United States without the approval of the Justice Department. We ban foreigners from exploring for or extracting mineral deposits on federal lands unless they intend to become U.S. citizens or belong to corporations under the laws of a state. Federal laws also limit foreign ownership and operation of communications media. Radio and television station licenses, for instance, cannot be granted to foreign nationals: thus, the Australian media baron Rupert Murdoch became an American citizen in order to acquire a TV station. Federally chartered banks may have partial foreign ownership, but the majority of their boards must be U.S. citizens. Foreign-controlled corporations can generally, with some exceptions, compete for government contracts. The Department of Defense (DOD) regulates foreign businesses holding defense contracts and disallows contracts where classified information could hurt national security. While the

federal government imposes few limitations on land ownership by foreigners, state laws, many dating back to the anti-alien campaigns of the nineteenth century, limit farmland ownership. To varying degrees, thirty states place controls on agricultural land holdings.* Some states also impose special requirements on foreign-owned insurance operations. But, by and large, U.S. restrictions are limited compared with Canada, Australia, Japan, and other developed nations (not to mention Mexico, Saudi Arabia, Kuwait, and others).

The Retreat from Laissez-Faire

As the real changes in the international economy became apparent —especially our declining competitiveness—Congress and administrations from Ford to Reagan became more concerned about foreign takeovers. During the 1970s, the U.S. Congress, like Canada's Parliament, debated policies to review and restrict foreign investment. Incited by the "Arab threat," a blitz of bills—some seventy in all—were introduced into Congress between 1972 and 1976. Some of the proposed legislation threatened to overturn America's long-standing open-door policy. One bill sponsored by Senator Howard Metzenbaum of Ohio proposed screening laws similar to those in Canada and Australia; but, like other such bills, this one never made it through the Senate.

Free-trade advocates in the Ford administration and Congress scurried to head off moves toward restrictive legislation and to preserve America's neutrality position, lest restrictions on FDI cause foreigners to withhold or withdraw investments. President Ford signed a compromise bill that established the Committee on Foreign Investment in the United States (CFIUS), comprised of members from the departments of State, Treasury, Commerce, and Defense. Headed by Treasury, the interagency group still investigates the nature and scope of inward investment and recommends policy. But it has no formal screening or review requirements and ostensibly holds to the virtues of the open-door policy. The CFIUS mission, to the extent that it has a clear one, is to review foreign investments that might affect national security, and to ensure that other nations provide reciprocity—the same equality of national

* Federal land restrictions include a U.S. citizenship requirement for authorized grazing on public lands. As for state restrictions, one anti-alien restriction still on the books is a Kentucky law that grants the state the right to confiscate land if the alien owner fails to assume U.S. citizenship within eight years, although this law is rarely enforced. In Minnesota foreign ownership of farmland is outlawed altogether.[27]

treatment afforded by the United States. But it is up to the executive branch to use the committee as it sees fit.

The manner in which the American government has used its regulatory authority has evolved. Laissez-faire clearly was the conventional philosophy toward international investment when Reagan's "revolutionaries" descended on Washington in 1981 sporting Adam Smith neckties. But by the close of the Reagan era, the reality of international markets and the ballooning trade deficit broke through the President's ideology, compelling intervention in both the trade and investment. In the sphere of international trade, the administration put quotas on products not previously subject to restrictions and extended other quotas and tariffs. Senator Lloyd Bentsen, chairman of the Senate Finance Committee, said that import restrictions affected 15 percent of our imports in 1986, up from 9 percent in 1981. The administration, through its trade representative and other officials, increasingly challenged other countries' trade practices. During their first term, the government made only ten unfair trade complaints against the Europeans and Japanese; between 1985 and mid-1988, they made twenty-two, over such diverse products and services as airliners, aluminum, beef, oranges, computer chips, and construction. During the pasta war with the European Community, the United States placed a 40-percent tariff on imported pasta. So the practice of trade was far different from its rhetoric on the subject.[28]

The Reagan government also intervened frequently in the investment process, albeit without any clear direction. Under President Carter, the CFIUS reviewed only one transaction—a proposed investment by the Iranian government in a U.S. oil company. In contrast, once Reagan's "free market" proponents took charge, the CFIUS reviewed over twenty-five cases. But its international economic policy was in "laissez-faire drift," lacking direction and focus.

In the beginning, the Reagan administration objected to investments by companies owned by foreign governments. Not only was state ownership the only form of market "imperfection" that officials admitted, they treated it obsessively. In the early 1980s, Reagan's CFIUS focused exclusively on direct investment by firms with state control, although such investment comprised only an insignificant portion of total FDIUS.*

In October 1981, the administration's adherence to the open-door policy faced its first test—the controversial takeover of Santa Fe Petroleum by Kuwait Petroleum Company, a state-owned enterprise. While

* Although the Reagan administration was obsessed with foreign state enterprise in the U.S., a survey of business executives found that the main threat was foreign imports.[29]

the Kuwaitis and other Arab nations bought into U.S. energy companies during the 1970s, the $2.5-billion bid for Santa Fe set a new record. Apart from its government control and links to the OPEC cartel, Kuwait Petroleum's takeover raised concern about the transfer of military technology. C. F. Braun, a Santa Fe subsidiary, was a contractor for a U.S. government nuclear facility. In December 1981, a CFIUS investigation concluded that the Santa Fe acquisition should proceed, and the Energy Department negotiated a deal to keep C. F. Braun's technology out of Kuwaiti hands.

The deal was concluded, but the case did not come to rest. Representative John Dingell, the House Energy and Commerce Committee chairman, argued that the Reagan administration's review failed to consider the Mineral Lands Leasing Act of 1920. According to the act, if the United States allows mining or leasing of mineral rights on federal lands by a Kuwaiti firm, then the Kuwaiti (or any other) government must provide a "reciprocal" agreement for U.S. companies and not discriminate against U.S. citizens. James Watt, then secretary of the interior, was charged with investigating the matter. After deliberating for over a year, Watt concluded that Kuwait did not provide reciprocity; it discriminated against American firms and favored other nations. Watt announced that "we are committed to free trade that works in both directions, [so] we cannot condone a practice which shut[s] out Americans while allowing access to citizens and corporations of other nations."[30] The final decision fell to Watt's successor, William Clark, who reversed Watt's decision and allowed Kuwaiti Petroleum to keep Santa Fe's mining leases on federal lands. The confusion that shrouded the Santa Fe investigation from 1981 to 1985 exposed the disjointed and inconsistent governmental review process.[31] Were we for or against free investment? If not, under what conditions would controls be applied? The signals the administration sent out were mixed and confused.

The Kuwaiti Petroleum case presented just one of many challenges to the Reagan administration's avowed policy of neutrality toward foreign investment. When the "Arab threat" subsided, the administration continued to investigate other investments by state-controlled multinationals. One case arose when the French government holding company Elf Acquitaine proposed to buy a 63-percent interest in Texas Gulf, controlled at the time by a Canadian government holding company, the Canadian Development Corporation. The CFIUS requested that the French government postpone the purchase while CFIUS investigated the transaction. But President François Mitterand assured the CFIUS that the deal was purely commercial, and the transaction was approved.[32]

Thus, at one point in 1981, Texas Gulf was actually owned by two foreign state-controlled enterprises. In 1982, the French bought the whole concern from the Canadians, and the United States gave up its investigation. Once again, the on-again, off-again approach to FDI was apparent.

When the "Japanese threat" reared its head, the paranoia about investment by government-controlled enterprise subsided. The Reagan administration began investigating Japanese direct investment, sometimes claiming it to be a threat to national security. To be sure, the administration thwarted European takeovers of firms doing work for the military. For instance, the government discouraged Plessey Corporation, a major British defense contractor, from a 1987 acquisition of another Pentagon contractor, the Harris Corporation. But most cases involving national security involved Japanese enterprises. In 1983, for example, the Defense Department put pressure on the Kyocera Corporation, a high-tech ceramics and semiconductor company. Kyocera's Dexcel subsidiary sold military materials. The Defense Department requested that the company replace Japanese management with American citizens. Instead, Kyocera decided to sell Dexcel to a U.S. company. Also in 1983, Reagan's Defense Department thwarted a proposed takeover of Special Metals Corporation by Nippon Steel because of the American company's involvement in military production. Officials raised national security concerns in Minebea's proposed acquisition of New Hampshire Ball Bearings, one of the few companies that supplied specialized ball bearings to the Pentagon. In addition, Minebea already controlled 30 percent of the U.S. ball-bearing market, and there were fears by domestic producers that the acquisition would increase Minebea's dominance in this strategic market. But the deal went through, despite these anti-trust and national defense concerns. As the professors Sara Gordon and Francis Lees have observed, there are two serious problems with the Minebea decision: "It has its anti-competitive effects, and it gives a foreign-controlled company an even stronger position in an industrial sector that is highly sensitive from the point of view of national defense needs."[33] Once again, the message was unclear: under what conditions are foreigners barred from defense-related investments, and to what extent will antitrust laws be applied to non-American firms?

The Reagan administration often exaggerated the military threat from foreign investment as a cover for its piecemeal and confused foreign trade policy. This happened most baldly in the fall of 1986, when Fujitsu sought an 80-percent interest in Fairchild Semiconductor, the grandfather of America's semiconductor industry. Fujitsu already had an extended reach into U.S. high technology through a 48-percent inter-

est in Amdahl (which makes IBM-compatible mainframe computers), greenfield investments in Oregon's Silicon Forest, and elsewhere. As usual with Japanese companies, the proposed offer was not hostile; Fairchild openly solicited the acquisition. However, the Fairchild take-over supposedly threatened national security, because Fairchild supplied sophisticated microchips to the Pentagon. The federal ban against foreign investment in sensitive military areas was raised in high-level discussions at the U.S. Commerce Department and the National Security Council during 1987. Of course, the government knew that Fairchild was already foreign owned—by Schlumberger of France. The real issues were Japan's growing trade surplus with the United States, the increasing dominance of Japanese industry in chipmaking, and fears that an important segment of the domestic semiconductor industry would fall into Japanese hands. Although it was no longer a "cutting edge" producer, Fairchild supplied high-speed logic chips for supercomputers, an area where Japanese companies trailed the United States. Further, American officials criticized the Japanese for continuing to dump chips in the United States (selling at prices below cost), despite an agreement reached in July 1986 in which the Japanese pledged to end the practice. The exclusion of American supercomputers from the Japanese market was also a factor. But by 1987, the administration wanted to show it was getting tough in a critical area of trade and it decided to use Fairchild as a bargaining chip. The government worried about the increasing economic power of Japan and about American firms' inability to compete in this economically strategic market. The Commerce Department's "jaw-boning" on the Fujitsu bid became a bargaining ploy to force Japan to open its markets.

On 11 March 1987, Commerce Secretary Malcolm Baldrige announced that he and Defense Secretary Casper Weinberger had decided to oppose the Fairchild-Fujitsu deal. The commerce secretary said, "Everyone wants an open investment policy, but there have to be some exceptions for the national interest."[34] But another administration official pointed to the real nature of the administration's objections. "This is a test case. If Japan can come in and buy this company, it can come in and buy them all over the place. We don't want to see the semiconductor industry under Japanese control."[35] Many observers recognized Baldrige was actively intervening in trade policy: the government did not have the legal authority to block Fujitsu, but cautious Japanese MNCs would undoubtedly react to criticism issued by America's leading economic official.[36] Five days after Baldrige's statement, Fujitsu backed out. Instead, it built a new plant in Oregon's Silicon Forest.

The apparent distrust of foreign involvement in U.S. military production should be put in perspective. The U.S. military does not always oppose working with foreign firms. With Defense Department approval, Mitsubishi Heavy Industries, an offspring of the *zaibatsu* company that made the Zeros that attacked U.S. targets in the Second World War, is now redesigning and producing F-16 fighter jets based on the original General Dynamics plane. Although the planes are built in Japan, the Defense Department requires that U.S. firms receive 35 percent to 45 percent of the development and production work.

In addition, under Defense Secretary Frank Carlucci in 1988, the Department of Defense eased its traditional opposition to foreign-controlled firms gaining DOD contracts, despite its fear that key technology would fall into foreign hands. Again, the administration's policy changed course. This new attitude reflected the slippage of America's technical and industrial dominance: many of our own defense contractors were purchasing sophisticated components abroad anyway. As the foreign takeover binge continues, many defense contractors will be bought up, but without opposition of the DOD. For example, in 1987, British Aerospace bought 41 percent of Reflectone, a Tampa, Florida, maker of flight simulator and information systems; the company expects the Pentagon to approve an additional 10-percent stake. Plessey purchased Sippican, maker of ocean and scientific instruments.[37] Other foreign purchases can be expected.

Thus, although there has always been some degree of protectionism, selective and inconsistent government involvement in managing the global economy increased in the 1980s. And as the Reagan era came to a close, many politicians revolted against the liberal trade doctrine. What began early in the decade as an international trade debate soon turned into a battle over the selling of America. Some members of Congress believe that too many firms have been bought up by foreigners, and that it must take action. Organized opposition to free trade and investment was especially apparent in the drafting of the 1988 Omnibus Trade Bill and Competitiveness Act.

During the debate over and drafting of the bill, several members of Congress offered amendments to monitor or restrict foreign investment—partly as a result of the fear generated by Fujitsu-Fairchild, Goldsmith-Goodyear, and other deals. Representative John Bryant of Texas picked up the issue of foreign disclosure from the late New York Congressman Benjamin Rosenthal who had championed the cause in the early 1980s. "America has been selling off its family jewels to pay for a night on the town," asserted Bryant, "and we don't know enough

about the proud new owners."[38] He introduced an amendment calling for more reporting requirements on foreign investment. Under the Bryant provisions, if a foreign investor held an equity stake of 25 percent or more or sales of $20 million or more, it would have to supply the U.S. government with an audited financial statement on the U.S. enterprise —encompassing sales, assets, operating income, depreciation, changes in financial condition, executive compensation, related business transactions of the directors, and any major civil litigation during the year. If the investor had less than a 25-percent interest, less information would be required. Those foreigners with only a 5-percent stake in a U.S. enterprise would have to report the name, location, and industry of the enterprise, the size of the interest, and the price paid. Congressman Bryant said that current procedure does not allow for an "early warning system" to signal when foreigners are buying in areas sensitive to national security. He also argued that the present data-collection system inhibits research into the effects of FDIUS: that existing data are too highly aggregated because of disclosure rules (to protect the identity of individual companies) to be useful for analysts looking at the effects of foreign investment. Congressman Bryant, in describing his "very modest proposal," said that his amendment called for information that was not very different from other industrialized nations and consistent with our obligations under OECD guidelines.[39] Senator Tom Harkin, a Democrat from Iowa, introduced a similar amendment in the Senate version of the bill. (We return to the Bryant amendment and issues of disclosure in chapter 10.)

Bryant and Harkin's views on disclosure remain a minority opinion in Washington circles. As we have said, throughout most of U.S. history the investment door has been wide open, allowing both inward and outward investment to flow relatively unencumbered. So it is today. Opponents of Bryant and Harkin contended that the provisions would deter foreign investment at a time when the United States needs it; and that restrictions and disclosure would encourage restraints on U.S. multinational investment abroad. Most economists take the free flow of investment and trade as central to a healthy economy and argue strongly against restrictions. Anthony Solomon, former president of the Federal Reserve Bank of New York, said, "People who would have the Government protect business against foreign investors would also have the Government interfere in the global activities of American multinational corporations and controls on international trade. Their prescriptions would impose heavy burdens on business, consumers, and workers alike."[40] Solomon's views represent the economic and business main-

stream. Not surprisingly, U.S. multinationals also argued forcefully against restrictions because so much of their production is already overseas. Knowing that they are part of the "foreign" competition (see chapter 6) and also fearing retaliation by foreign countries or restrictions on their investments by the U.S. government, they continue to push for free, unhindered foreign investment.

Those opposed to the Bryant amendment misunderstood it, according to the sponsor. Bryant said that his bill only "asks major foreign investors to sign in after they have walked in through our open door. The U.S. would still have the most open foreign investment policy in the world—in stark contrast to the other nations, which impose all sorts of restrictions, preclearance requirements, and outright prohibitions on American investments."[41] Foreign firms invest in this country because of the opportunities for profit, not anonymity, Bryant argued.

Other amendments to the 1988 trade bill were offered by Congressman James Florio of New Jersey and Senator J. James Exon of Nebraska, giving the President the right to block takeovers that would jeopardize "national security, essential commerce and economic welfare." That support for restrictions crossed a wide range of the political spectrum —left to right, domestic business firms to labor unions—demonstrates how rampant was the anxiety about the New Competitors. Bryant's amendment was passed by the House but dropped when the bill went to the House-Senate conference committee after it became "veto bait" for the President. Reagan was so concerned about the Bryant amendment that he accepted the Exon amendment as a compromise, though he did not like it either.[42] Despite the lost battle over disclosure and registration—a subject to which we will return in the next chapter—the issue has not disappeared and will be raised again as FDIUS increases.

Foreign-Controlled Political Action Committees and Lobbyists

As the New Competitors' economic influence has grown, so too has their political influence. Such luminaries as former Vice President Walter Mondale and Elliot Richardson are now foreign lobbyists.They have been joined by scores of former presidential advisors and members of Congress, military officials, and others who work directly in the "governmental relations" office of foreign companies or for industry

groups.[43] There is nothing illegal about peddling corporate influence on Capitol Hill—some of the same people lobby on behalf of American-based companies; but as their representatives turned up all over Washington in the late 1980s, the political power of foreign companies became a *cause célèbre*.[44]

Not surprisingly, the primary opposition to disclosure rules proposed by Congressman Bryant were foreign companies and their American affiliates. Such actions worry some House members, senators, and even some members of the Federal Elections Commission (FEC), who sounded the alarm against foreign companies that use political action committees (PACs) and lobbyists to influence U.S. public policy. Those suspicious of foreign lobbyists cite such instances as a group of Japanese-owned lumber mills in Alaska that pressured the state's U.S. senators to delay reauthorization of the Clean Water Act and sought special treatment under the act; and Toshiba America, which rallied its workforce to lobby against sanctions the United States sought to levy against the Japanese parent firm for selling sensitive equipment to the Soviet Union.[45] Tennessee's Senator Jim Sasser cites a more personal example: Nissan's PAC, miffed at Sasser's support of a domestic content bill, threw a fundraiser for his Republican opponent.[46]

Foreign PACs' political power, while a legitimate and troubling issue, must be put in perspective. It is certainly not like the direct intervention in the affairs of other countries by American firms—such as International Telephone and Telegraph Corporation's role in the destabilization of the duly elected Allende government in Chile—or other shady forms of political interference in which American MNCs have been involved. Foreign investors try to shape U.S. policy to fit their interests within the established rules of American politics.

Further, of the more than four thousand PACs on record at the Federal Election Commission (FEC), less than one hundred were established or controlled by foreign-owned companies. True, these PACs gave more than $1 million to congressional candidates in 1985–86 and donated even larger amounts to state and local candidates. In states where it is allowed, companies contributed directly to campaigns. But all of this is legal, at least technically. While federal law prohibits foreign individuals and all corporations, foreign and domestic, from giving to federal campaigns, the FEC has ruled that foreign-controlled companies may establish political action committees so long as only U.S. citizens donate to the committees and make their decisions. Officially, all company-sponsored PACs are made up only of company employees. But

in reality almost all corporate PACs, foreign and domestic, are run by company management and toe the company line. PACs are allowed to give larger sums to each candidate than may an individual: $25,000 versus $1,000 per election.[47] The average contribution by foreign PACs in 1985–86 was only $796—less than an individual corporate officer could give.[48]

Besides relatively modest PAC budgets, generally averaging well under $100,000 per company, foreign investors seek to turn public opinion to their side through lavish contributions to local philanthropies, through engaging the services of highly paid Washington lawyers and lobbyists, and through advertising and public relations campaigns. When even this approach is not enough, some companies resort to the old "I'm-going-home-and-I'm-taking-my-ball-with-me" routine, threatening to pull out of any state that tries to force them to play by rules other than the ones they want. Finally, they may turn to the diplomatic approach, using their government officials to approach the U.S. government on their behalf. Foreign investors successfully employed these methods in the fight against the unitary tax, which we discussed in chapter 7.

In the late 1980s, the FEC requested clarification from Congress about whether the United States wishes to allow foreign investors to participate fully in the political life of the nation or whether it wishes to restrict that participation. Ironically, the answer to that request may be shaped by the efforts of the foreign MNCs themselves.[49] Since they are not regulated, they may use all of the tools at their disposal to try to influence members of Congress who write the legislation governing foreign MNCs.

Attempts by foreigners to turn policy to their advantage are not always successful, of course. After all, the Clean Water Act was reauthorized, Toshiba received some sanctions (although the company succeeded in watering them down), and Senator Sasser still represents his state. Still, as concern about FDIUS has risen, so have fears about the power foreign investors may wield in U.S. state houses and on Capitol Hill. Indeed, multinationals in general (not just foreigners) strongly influence government. Concentrated economic and political power—whether foreign or American—thwarts democracy and requires constant vigilance to keep it in check. A strict policy of laissez-faire, if it means blinding ourselves to the political realities of multinational corporate influence in politics, is indeed "lazy," but it is neither "fair" nor in the public interest.

273

Policy at the Crossroads: The Reagan Legacy

As George Bush enters and Ronald Reagan departs from the White House, the U.S. economy is at a crossroads. While our economy remains the most open to foreign investment of any industrialized country, our policies on foreign trade and investment have drifted from strong free-market rhetoric and programs to protectionist ones. Despite the strategic importance of trade and foreign investment, no consistent policies have been developed. If anything, there has been an inexorable movement to "ad-hoc protectionism"—a restriction here, a quota there, and so on. The Reagan administration entered office wanting to let the market decide economic events and to keep government involvement to a minimum. As we have seen, however, laissez-faire represents a flight to the fantasy of perfect competition, the international market being far more complicated and much less free than the Reagan advisors thought. Simultaneously, our international competitors have active trade and industrial policies in which they promote export industries and protect many industries at home—policies that have helped them compete and open the doors for FDIUS.

While the Reagan administration may have avoided an outright trade war, it brought on not only ad-hoc protectionism but, through its exchange-rate policy, what we call the debt-for-equity swap. *The Economist*, a former Reaganomics cheerleader, summed up the policy dilemma by the events leading to the falling dollar in a stinging polemic: "By making it necessary for the dollar to fall so far, President Reagan's economic policy has, in effect, put America up for sale. . . . as a result, countries can no longer pursue Alice-in-Wonderland macroeconomic policies for more than a few years without paying a high price. Mr. Reagan's biggest failure has been his unwillingness to accept the truth."[50] The "truth" being, of course, that debt-ridden America is vulnerable to external forces and control.

These problems cannot be fixed easily—and the Reagan legacy, as the investment banker Peter Petersen said, is "the morning after." The veteran journalist I. F. Stone called 1988 the "end of a profligate era."[51] These and other observers argue that we have spent too much money on wasteful mergers and takeovers, too little on productive investment and research and development. Although there has been some recovery of manufacturing productivity growth since the depths of the 1982–83 recession (as is usually the case during recoveries), we lag behind our

major competitors in Europe and in the Pacific in productivity growth in both manufacturing and services.[52] William Norris, retired chief executive of the Control Data Corporation, wrote, "Takeovers detract from competitiveness because of the adverse effects on innovation . . . by reducing the availability of funds for research and development."[53] A variety of blue-ribbon panels and scholars call for strong measures to reverse America's decline.

As we discussed in chapter 4, the foreign investment "problem" was in large part brought on by the Reagan administration's mismanagement of policy. We believe that the debate over restrictions and disclosure discussed in this chapter—though not trivial—is less important than figuring out how to reverse our industrial decline. There is no significant national security threat: Foreigners have not taken over strategic industries and cannot do so under existing laws. The important issue relating to foreigners is the future of the American economy—its performance and the policies that guide it. This means active policies, not a passive laissez-faire approach. It means strategic choices, not drift and indecision. From the White House and Congress down to city halls and neighborhoods, we must find new solutions to our problems in this more internationalized economy.

The real problem is that the United States is not competitive because it wastes its productive potential and is unable to handle its own economic problems. Americans need be concerned less about national security in the form of a foreign takeover, than about economic security in the face of international economic change. As capital becomes increasingly mobile, economic security is what really counts. We should aim for policies that provide it, as we will elaborate in the next chapter.

10

A PROGRAM FOR ECONOMIC

SECURITY IN THE AGE OF

INTERNATIONAL CAPITAL

THE GROWTH of both inward and outward investment was inevitable, given the economic, political, and technological forces at work during the past forty years. Direct investment has made nations more interdependent and allowed them less control of their own destinies. Though capital is mobile, workers, their families, and their communities are not. When GE Motors shifts production to Mexico or Malaysia, it leaves behind unemployed workers—some of whom, if Honda or Hoechst move in, can be re-employed. Is working for a foreign company worse than not working at all? To many employees, whether their boss is "alien" or American is irrelevant so long as they are employed.

The revolving door of international capital will keep spinning. At the moment, the door has swung wide open for inward investment, lubricated by a dollar policy that since 1985 has sharply driven down the price of American assets for overseas buyers. This was the inevitable result of running huge current account deficits. The question is not whether to welcome or restrict inward investment. We have no choice but to accept it. Blocking foreign investment (direct or portfolio) would be playing with economic dynamite, which carries the risk of detonating

a serious economic catastrophe by sharply running up interest rates. At the same time, the U.S. government has failed to respond decisively to the growing mobility of international capital and its economic consequences. As we face the 1990s, U.S. policies remain inert, ineffective, or inconsistent—a policy drift that leaves many Americans apprehensive about the future. It scares people to think that Japan has accumulated enough capital to buy a controlling interest in America's largest companies.[1] While we are far from becoming a colony of "Japan, Inc." or any other nation, we must start now to shape a long-run strategy for foreign investment—indeed, for a revitalization of the economy—before these fears spread and the doomsday scenario becomes reality.

One major roadblock is the manner in which policy makers consider FDI. Many proposals circulating around Washington are piecemeal rather than comprehensive. Consider the barrage of federal legislation during the one hundredth congressional session. In 1987 alone, separate bills contained provisions that called for the expanded registration of foreign owners, further prohibitions against foreign takeovers that threaten national security, a six-month moratorium on hostile foreign takeovers, and a ban on Communist ownership of U.S. banks.[2] Each problem was viewed in isolation, an issue in itself.* But not only are these issues interconnected, foreign investment must be viewed within the larger context of international trade, economic policy, and American competitiveness.

Moreover, economic nationalists, who tend to be most supportive of this kind of legislation, get the FDI problem backward. In the final analysis, the "buying of America" is really not an external problem, as many of them argue. Rather, America has serious internal problems— owing to short-term business planning, the lack of long-run investment commitments, slow economic and productivity growth, and mismanagement of economic policy. Our economy has not been flexible enough to adapt to major changes in the international arena. This inflexibility is stark compared with the spectacular adjustments the Japanese have made when the yen effectively doubled against the dollar after 1985.

As the problems posed by global capital are complex and multifaceted, so must the solutions be comprehensive. In our view, the United States must base a bold agenda for economic growth on two pillars: productive investment and job security. Achieving this new agenda, though difficult, will be one of the passionate political issues of the

* Stephen Roach, an economist at Morgan Stanley, is one of the few observers to note the "flaw" of treating foreign investment as a problem "in itself."[3]

coming decade. Policy makers must carefully decide which strategies will work in an intertwined and rapidly changing world economy. We must make both inward and outward FDI work for us—supplying jobs and incomes for the American people. Moreover, we must look at foreign investment policy as part of a broader set of programs to revive the economy so that the nation has nothing to fear from "outsiders," whether they are Fujitsu-America or IBM-Japan.

In this final chapter, we review the important policy issues raised throughout this book and offer recommendations for reassessing foreign investment and economic policy. We have seen that foreign multinationals are similar to American firms in their goals, strategies, and structure. Foreigners look for productive workers, abundant and growing markets, and modern technology; they are large oligopolists who are trying to maximize their worldwide profits by using the United States as one of many production and market sites. American-based MNCs are little different in all of these respects. Therefore, the policies that we recommend are aimed at making the American economy stronger—not only to appeal to foreign producers, but to our own—who continue to go abroad for markets and lower costs. Although we highlight issues involving foreign investment, most of what we discuss next is aimed at firms and workers, domestic and foreign. Our proposals fall into five major categories which will be discussed in greater detail later in this chapter.

Closing the Ignorance Gap: The building blocks of any policy are the information needed to formulate it. In order to formulate effective policy, the United States must gather all pertinent information about direct investment needed to measure the effects of foreign investment. Further, we should create a federal review board that analyzes the economic impact of major investments and reports both to other federal agencies and to state development organizations that are attempting to attract FDI.

Federal Programs to Restore International Competitiveness: At present, foreign firms are primarily attracted to America's market, not to its productive climate. The federal government must play a stronger role in creating a basis for long-term, capacity-building investment and better job opportunities. We believe that this can be done by primarily investing in education, training, research, and physical infrastructure, which will encourage the flow of foreign investment into productive uses over the long run. Equally important, these policies will make United States–based firms more productive and successful in world markets and create jobs here.

Bringing the Dual Deficits Under Control: More than anything else, the federal budget and international trade deficits have made the U.S. economy increasingly dependent on foreign capital. We need policies to reduce the federal deficit and still pay for new programs to restore competitiveness. In addition, the United States must move beyond exchange-rate manipulation to bring the foreign trade deficit under control.

Merger and Antitrust Policy: Foreigners have piled up financial assets, in part through the massive trade deficits we have run during the 1980s. These assets now help fuel an unprecedented merger and acquisition binge. In turn, foreign companies are gaining significant control over some U.S. markets. As a necessary complement to policies designed to restore real productive investment in plant and equipment, the federal government must enforce policies that both discourage uncompetitive practices and unproductive merger and acquisition activity.

"Exit Policy" and Plant Closing Legislation: Any program for economic growth must also involve a program for economic security. The tendency of firms, both foreign and domestic, to shift capital rapidly around the globe exacerbates job insecurity. Thus, America's open door for multinational entry must be balanced by a multinational "exit" policy when firms relocate abroad and displace workers here. Apart from federal and state job retraining programs, the best policy is a uniform national standard for plant closings and layoffs for large firms—including 120-day advance notification of plant closings, job severance pay, and adjustment assistance to workers and communities afflicted by job loss.

We shall elaborate on each of these categories, first by outlining the problem and then by presenting specific proposals.

Closing the Ignorance Gap

In this, the Age of Information, we have a dearth of information about the international economy.* Despite all the concern and confusion surrounding the "alien threat," the United States has not improved information gathering on international investment during the 1980s. The paucity of data precludes us from knowing the full extent of foreign ownership, precisely how many jobs these firms create, and other important consequences of FDI. Faced with budget cuts, agencies like the

* The economists' lack of information affects all areas of study, not just the international economy, as Nobel prize-winning economist Wassily Leontief often points out.[4]

Bureau of Economic Analysis (BEA) have been hamstrung in collecting more and better data on direct investment.

Federal data collection remains, as we have suggested, incomplete, inadequate, and disjointed. Information collection is scattered among sixteen government agencies, including the BEA, the International Trade Administration, the Treasury Department, the Department of Agriculture, and the Federal Reserve Board (see appendix A). While we squeezed as much as possible out of these data for this book, the available information severely impedes policy making and limits scholarly research. Some of these data are detailed, but unreliable; some of the published information is reliable, but too general to be of any practical use. Additional information is collected but not publicly available because of disclosure prohibitions about individual firms or other federal rules.

Information is power—and, in this instance, can tell us how foreigners are affecting our economy. To increase the amount of information available to decision makers at all levels of government, we must have two kinds of policy: more disclosure of information already obtained on foreign companies; and a monitoring and research agency to collect more data, to coordinate its dissemination, and to conduct thorough reviews of FDI when necessary.

INFORMATION ON THE EFFECTS OF FOREIGN INVESTMENT

To gauge the impact of FDIUS, we need more information on industrial concentration, on what inputs foreigners buy domestically and where they buy them, on the amount and types of labor they hire, and on layoffs. At the very least, Congress should direct the Bureau of Economic Analysis to release more comprehensive and detailed data from its annual surveys of inward and outward investment. Further, the agency should be directed to speed up the release of a select number of variables, especially those measuring new capital inflows. At present, when the data are released, they are often stale; many variables are first published one or two years after the fact. Yet global capital shifts much more rapidly today than in the past and we need keep abreast of the changes. Of course, this will mean that the government will have to commit more resources to data gathering.

In addition, the federal government should collect more information than it presently does. The Bryant bill, introduced in 1988, was a step in this direction. As we explained in the last chapter, the legislation aimed at getting more public disclosure on size of the interest and the market value of foreign acquisitions; additional operating and financial

information; specific information on the corporate parent; and the identity and nationality of executive officers and directors. However, its provisions contained no restrictions on direct investment; and it actually required far less information than what small publicly traded American companies disclose to the Securities and Exchange Commission.*

Nevertheless, the Bryant's legislation drew wails of protest from the Reagan administration and was denounced by organizations funded by multinationals. Immediately after the U.S. House of Representatives passed the Bryant bill (H.R. 5410) on 5 October 1988, the Association for Foreign Investment in America issued a press release calling it "discriminatory, burdensome, and a reversal of the U.S.' traditional support for freedom of investment." It would, the statement asserted, undermine the nation's efforts to reduce global investment barriers through bodies like the Organization for Economic Cooperation and Development (OECD).[5]

Yet the very document signed by Reagan administration and other members of the OECD upholding the "principle of national treatment" contains a clear call for disclosure of multinational operations. In the OECD "Declaration on International Investment and Multinational Enterprises," foreign-owned companies are asked to register with a host nation and supply far more information than the Bryant bill required.†

Needless to say, this information would be a gold mine for researchers and policy makers, allowing them to understand the movement of global capital and make more effective policy at the national and local levels. It is not necessary, however, to compel full public disclosure of detailed financial information about *individual* companies. On this point, our suggestions diverge from Bryant's proposals.‡ The additional information hidden in government computers can be carefully compiled

* U.S. Securities and Exchange Commission requires that any firm purchasing more than 5 percent of the stock in a publicly listed U.S. corporation disclose this acquisition and file forms that include sensitive operating information.

† The OECD guidelines state that multinational enterprises should publish, at least once a year, financial information and other relevant data on its operations, including: (1) the name and location of the parent company, its major affiliates, and percentage ownership in these affiliates; (2) sales by geographic area; (3) significant new capital investment by geographic area; (4) the average number of employees in each area; (5) research and development spending for the company; (6) policies on intragroup pricing; (7) a statement of sources and uses of funds for the enterprise; and (8) the accounting procedures used in compiling the information.[6]

‡ Efforts to report the names of foreign investors ignore that the government's statistical system is built on anonymity. Divulging investors' names would make it more difficult to collect data from all foreign investors. Those investors with something to hide, money launderers, and other offenders would not report anyway.[7]

to avoid giving confidential operating and financial information about individual companies. But it is ridiculous to argue—as opponents of greater disclosure do—that foreigners will stop investing because someone might find out, say, that all foreign-owned auto companies created 1,500 new jobs in Ohio during a given year.*

MONITORING AND ANALYZING FOREIGN INVESTMENT

Indeed, our proposals are mild compared with many of those voiced by leading members of the U.S. business community. The New York investment banker Felix Rohatyn has pushed for a review process, arguing, "No other major industrial power in the world, certainly not Japan, not even Great Britain, allows foreign control of strategic companies to be acquired without government approval."[9] Malcolm Forbes, the conservative editor of *Forbes*, went further, proposing the creation of a "Board of Knowledgeables" to approve all foreign purchases regardless of size.[10] These men are not mean-spirited regulators, but pillars of the business mainstream.

After taking this first step of getting more information under existing laws, we must consider revamping the federal approach to monitoring foreign investment. The United States needs a new agency for coordination and oversight, as our present institutions are simply not up to the task. The Committee on Foreign Investment in the United States, currently charged with reviewing foreign investment, is weak and ineffective, and rarely meets. Martin and Susan Tolchin correctly pointed out that this committee is a "paper tiger" and has never barred an investment in the United States.[11] The CFIUS should be scrapped and replaced with a federal review and information clearinghouse: let us call it "MIRADOR," for Multinational Investment Review Agency and Department of Research. The MIRADOR acronym suggests the agency's mission with its implication from Spanish architecture of a window, or balcony, designed to command an extensive outlook. The agency should be made a permanent part of the federal government (perhaps within the Commerce Department) and maintain close contacts with state and local development agencies in charge of recruiting foreign investment.

To critics of the "monstrous" federal bureaucracy, creating an-

* In a survey of foreign and domestic companies, we asked about their suppliers, markets, types of employment, and a variety of other things.[8] In carrying out the survey, we got the support of several foreign embassies and trade groups, domestic trade organizations, and state development agencies. From these groups and our respondents, we got cooperation that would surprise those who believe that foreign firms are secretive (or more secretive than American companies) and would withdraw investment because the government wanted basic information about their operations.

other federal agency would appear to be the wrong route to travel. But the Fujitsu-Fairchild case discussed in the last chapter drove home the point that the government needs a systematic review procedure managed by an independent agency within the executive branch. We saw how an ad hoc group of administration officials were clearly confused and divided over what constitutes national security and the national interest. One of the administration officials who participated in the CFIUS review of Fujitsu-Fairchild, Robert Dean (now a Senior Vice President of the Ball Corporation) argued that if a case similar to Fujitsu-Fairchild arises—and it no doubt will—so will the confusion.[12]

Thus the federal bureaucracy is not prepared to deal with international capital and the many sensitive issues it raises. Yet with the implementation of the Exon-Florio amendment to the 1988 omnibus trade bill, mentioned in the last chapter, the government now faces a possible flood of foreign investment reviews. Under the Exon-Florio procedure (which modifies the Defense Appropriations Act), the President or his representative can block certain foreign takeovers and mergers that may impede national security. The President has 30 days from the date of the request to initiate an investigation. Packaged as a national security measure, Exon-Florio was accepted by "laissez-faire" partisans within the Reagan administration, who believe, as do many proponents of free international capital flows, in Adam Smith's dictum that, "defence . . . is of much more importance than opulence."[13] Supposedly, Exon-Florio serves as a breakwall against security-threatening acquisitions, but it creates no agency, staffed with experts, to help answer the difficult questions raised. Where do you draw the line on what constitutes national defense? Tires, oil, steel, supercomputers? The trouble with Exon-Florio is that it gives a president blanket power without any specificity about what constitute U.S. security interests. As with the CFIUS, if a Fujitsu-Fairchild case came up again, and it will, the same difficulties and confusion will emerge.

Therefore we believe that Congress should consider a permanent review agency for foreign investment. The new agency's mission should be carefully defined and clearly not cast as a restrictive authority, something that would be counterproductive and dangerous for a nation dependent on foreign capital. It would be hypocritical for the United States to argue for free capital movements abroad and yet block the inward flow of capital. Let us restate emphatically that this nation should not revive the Know-Nothing nationalism and "America for the Americans" campaigns of the nineteenth century. Still, all nations reserve the right to screen takeovers when they threaten national interest or com-

petition. Notwithstanding Prime Minister Margaret Thatcher's commitment ot free capital flows, for example, her government ordered Kuwait to trim its stake in British Petroleum by more than half in 1988.

Specifically, MIRADOR's review objectives should extend beyond the narrow concerns of CFIUS and the Exon-Florio amendment about reciprocity and national security. MIRADOR should have a staff of experts who analyze all forms of multinational investment, both inward and outward. Its primary tasks would be to:

- Assemble information from the many agencies that collect data on FDI. MIRADOR should analyze and disseminate this information to other federal agencies and to states to help them to devise FDI-related development policies.
- Conduct economic impact analyses of all significant foreign investments, both to and from the United States. MIRADOR should publish detailed public reports on employment creation or destruction. It is important that detailed data be given to the Department of Defense in investigations of national security and the Justice Department and the Federal Trade Commission when they investigate antitrust cases. Data on individual companies would not be publicly divulged.
- Serve as a watchdog agency that ensures that foreign firms in the United States adhere to domestic and international labor laws and guidelines— working with the National Labor Relations Board, the Equal Employment Opportunity Commission, and other U.S. agencies. It should help enforce international agreements on multinationals signed by the United States, such as the guidelines of the Organization for Economic Cooperation and Development, including its labor guidelines.
- Provide foreign investors with information on U.S. antitrust statutes, labor laws, and other regulations, thereby helping foreign firms overcome the disadvantage of alien status.
- Report annually to Congress and the Executive Branch to help shape macroeconomic and international trade policy.
- Screen a limited number of large investments and those in strategic industries to gauge their impact on the economy. It should be given the power to recommend to the President the denial of investments that are clearly harmful or detrimental to the national interest.

The information gathering and investment monitoring we suggest will be neither expensive nor particularly intrusive to foreign companies. MIRADOR would indeed be useful to policy makers at all levels and could help shape the kinds of policies we propose in the rest of the chapter. We believe that a review mechanism, as Felix Rohatyn put it, "need not be viewed as a xenophobic manifestation . . . a highly selective

mechanism may become necessary. It will not cause the flight of capital any more than such procedures have caused capital flight from the U.K., Germany, or Japan."[4]*

Investing in America

Just as international investment in this country does not threaten us, it will not save us either. Many of our fundamental production problems have existed for a long time: sluggish productivity, a low savings rate, deterioration in the quality of education, decaying infrastructure, and often poor labor-management relations. All of these problems existed before foreign investment surged in the 1980s. They exist now. We need public investment policies both to make the United States attractive as a production site, not just as a shopping center, and to reverse the federal government's dangerous practice of walking away from making important public investments in training, retraining, and infrastructure.

The United States needs to restore its competitiveness by adopting active policies to spur industry, particularly those of strategic importance in world markets. We must find ways of not only getting more jobs, but better ones.

An active economic policy on international investment begins with the abandonment of the invisible hand as the guiding force. The federal government should not leave its international responsibilities solely to "free" market forces and to the states which are painfully subject to the vagaries of the international economy. It should be part of the federal government's role to create "competitive advantage"—to take measures to help our firms compete internationally—and provide a productive climate conducive to new long-term investment in high-skill, complex production. For instance, we have stressed that most investment comes through acquisitions, not in new plant and equipment. Yet even when foreigners construct new plants, they often build "screwdriver operations" that rely heavily on imported parts. The United States government must encourage them to expand their operations and to employ more of our workers in good, high-paying jobs. To do this, policies must be put in place to make the economy more conducive to efficient

* Mr. Rohatyn was, of course, referring specifically not to our MIRADOR but to a more general (unstated) mechanism.

production—for foreign and U.S.-owned companies. Next we suggest programs that the Congress and the Executive branch should follow to improve our international standing.

EDUCATION, TRAINING, AND RETRAINING

National competitiveness first requires investment in human capital, including retraining displaced workers, training the economically disadvantaged in basic skills, expanding vocational education, and language, math and science instruction. This means more funding for education at all levels and inducements to firms that conduct important on-the-job training. A system of training and retraining can be developed, with a partnership among the federal government, the states and localities, and business firms, that improves markedly on the Job Training Partnership Act. The program would be available for all firms, foreign and domestic. But when assistance is given to firms, they should meet domestic performance requirements: when a firm gets a government training grant, it must agree to provide a specified number of jobs or lose the incentives.

REBUILDING PHYSICAL INFRASTRUCTURE

We also must rebuild and repair the physical infrastructure of the nation, which has seriously deteriorated. In real terms, spending on infrastructure has declined substantially since the 1960s. Shoring up our decaying roads, bridges, sewers, and ports will help national economic efficiency and create thousands of construction jobs. A federal-state partnership (state programs with federal matching support) will help to make these policies work.*

RESEARCH AND DEVELOPMENT

No doubt, as we stressed in chapter 3, technology is the root of much international competitive advantage today. Here the United States is slipping. America needs a public-private program for research and development—a pool of funds to develop new technologies and new manufacturing production techniques—in order to form the bedrock for future growth.

This money could be used for a variety of purposes—such as joint government-private ventures, university research, and federal research labs. There is already a working model of such cooperation: Sematech, a

* The Cuomo Commission recommends that the federal government have a separate capital budget to account for public investments of this type.[15]

286

consortium of semiconductor manufacturers and the Department of Defense, has established a research facility in Austin, Texas. The purpose of Sematech is to improve our companies' ability to manufacture semiconductors and to compete more effectively with Japanese companies. The funding is split among the DOD, the firms, the State of Texas, and the City of Austin. It is a model that still must prove itself, but if it works it could be duplicated in other industries. Other examples exist in which government and private funds and talents are brought together in high-tech and traditional industries, some at the local, some at the federal level. In addition, more effort must be made to commercialize research, by turning ideas and prototypes into marketable products. Commercialization is primarily a private-sector function, but governments can help through appropriate policies.

INDUSTRIAL STRATEGIES

The United States has not comprehensively designed policies to retain and expand production that relies on skilled labor, complex manufacturing production, research and development, and the like. We can establish a set of targeted policies—to spur investment and production in important industries. The federal government could design public-private partnerships to aid technologically important industries (for example, ceramics and semiconductors) and bedrock sectors (steel and autos). The Japanese, to take but one example, have used industrial promotion to great profit in such sectors as automobiles, telecommunications, and semiconductors and owe a portion of their success to these policies. We do not argue that the Japanese model is directly transferable to the United States, nor should the nation attempt to do so. We need to find a uniquely "American" model, one that will work within our culture and institutions. Industrial strategies require cooperation among governments, firms, and labor. Any government aid must be conditioned on changes in management and labor relations. Firms and their workers must make necessary changes in their outlook: they must think strategically in order to enhance long-term competitiveness. Industrial policy has not enjoyed political favor during the Reagan era—to some it smacks of "centralized planning" or "government picking winners." However, some careful experiments in strategic areas are needed to test ways to bolster our international competitive strength. It has been working at the state and local levels—where innovative policies have succeeded—and can work at the federal level too.[16]

At the very least, the United States must reorient its federal budget priorities, which are an implicit "industrial policy" anyway, since the way

we tax and spend helps certain industries.* Investments in labor and infrastructure would attract firms seeking locations for complex production and high-value-added products. Success in creating competitiveness depends more and more on public investment in human and physical capital and in research and development.

PAYING FOR THESE INVESTMENTS

Inevitably, the question arises: How is the nation going to pay for these multibillion-dollar programs and still grapple with the huge federal deficits built up over the past eight years? It appears that the Reagan legacy has left the nation so insolvent that the federal government could not possibly fund our initiatives. However, compared to the military buildup and domestic expenditure cuts of the Reagan years, the program that we have outlined is relatively small—about $60 billion a year.[17] Given our $4 trillion economy, some tax increases and some spending cuts in other areas can raise enough money for these critical investments. In the next section, we show that we can pay for these investments and still reduce the budget deficit. But the federal government will have to make some hard choices, to reorient its priorities, and demonstrate much more resolve in dealing with the budget deficit in the next few years than it has in the recent past. We will also outline some ways to reduce the trade deficit.

Dealing with the Dual Deficits

In chapter 4, we showed that macroeconomic policies induced a debt-for-equity swap with foreigners. The monstrous federal budget deficits led to high interest rates. High interest rates begat a strong dollar, which in turn engendered a huge trade deficit. The dollar policy was supposed to get foreigners to buy American goods; after a long delay, exports began to increase in 1988, although the trade balance remained stubbornly high because we continued to import so many goods. In addition, many foreign companies opted to buy American assets—prime real estate and U.S. companies.

Clearly, we need to reassess the ways that our macroeconomic and

* Defense and agriculture benefit from industrial policies, although government actions in these areas have not been labeled as such. Targeted procurement and tax policies in these areas have proven beneficial to these sectors.

trade policy affect our international position. A lack of coordination of our FDI and trade policy plagues U.S. economic policy. Everyone now recognizes the need to reduce the twin deficits. Here, we lay out some proposals that will both reduce the deficit and help us improve our place in the world economy.

FISCAL AND MONETARY POLICY

It is essential to raise federal revenues and decrease expenditures without adversely affecting productivity and growth. Simultaneously, the United States must cut wasteful and counterproductive expenditures so that they do not hurt productivity or needy people. Our approach to reducing the budget deficit is simple: it should be fair and gradual. By fair, we believe that those who have benefited most from the Reagan-era tax cuts and expenditures and those at the upper end of the income scale should bear most of the burden of tax increases.[18] In addition, reducing the deficit should take place over a period of five or so years: trying to do it too quickly will surely throw the nation into a deep recession. We must first set some targets for tax increases and expenditure cuts that will lower the deficit. Studies by the Congressional Budget Office, the Joint Committee on Taxation, and others show several ways in which the federal government could increase personal and corporate taxes between 1989 and 1993.[19] Here are some of the details of a plan to increase taxes and cut expenditures in a fair and equitable way. Let's start with taxes.

On the revenue side, we first recommend raising personal and corporate tax rates at the upper ranges to levels above the 1986 Tax Reform Law, but below those before the beginning of the Reagan administration. There is little or no evidence that reducing tax rates increased savings and investment, as the Reaganites had argued. Savings have fallen to the lowest rate (about 4 percent in 1987) in decades, and investment has been relatively stagnant. Moreover, the evidence shows clearly that the after-tax incomes of the rich increased dramatically at the expense of those of the poor. According to the Congressional Budget Office (CBO), the poorest 10 percent of Americans paid effective tax rates 19 percent higher in 1988 than they did in 1977, while the effective tax rate on the richest 10 percent declined. During the same time, the share of income taxes paid by the top 1 percent fell by 25 percent.[20] Deficit reduction will involve economic pain, but it is necessary if the United States is to regain its economic buoyancy. America cannot continue to live on a national credit card.

Most experts agree that taxes must be raised if the budget deficit

is to be reduced. We could start by restoring the highest marginal tax rate on the top 1 percent of taxpayers—the richest 600,000 Americans—to 38.5 percent. The CBO and other analyses show that other taxes that fall mainly on upper-income groups: capping mortgage-interest deductions, closing loopholes, increasing luxury taxes, raising the minimum tax on the top 2 percent of taxpayers, and placing a special 5 percent budget-reduction surcharge on upper-income families would raise a total of about $141 billion by 1993. In addition, several tax increases for corporations could help reduce the deficit: restore the minimum tax on corporations to 25 percent, lower business meals and entertainment deductions, and levy a 5 percent budget-reduction surcharge. (Both personal income and corporate income surcharges should have strict "sunset" provisions: that is, they would be ended when the budget deficit was reduced by an amount determined by the President and the Congress.) In addition, in order to reduce speculative mergers and acquisitions, we favor an excise tax on the transfer of securities and a rule that disallows the interest expenses incurred in hostile takeovers to be tax deductible. According to CBO and our estimates, corporate taxes would go up by $189.6 billion between 1989 and 1993 if these changes were made. Total taxes go up by about $331 billion. These tax increases should be phased in slowly so as to reduce the dampening impact of this restrictive fiscal policy.

On the expenditure side, two kinds of expenditure cuts are possible. First, a freeze on military expenditures in nominal terms for 5 years would reduce projected spending by $164 billion. The Reagan administration already reduced Pentagon spending growth and this freeze would not, in our view, harm national security—especially if it were accompanied by an increase in a share of the defense burden by our allies. Historian Paul Kennedy's phrase, "imperial overstretch," captures the essence of the problem: we are overcommitted around the world relative to our resources.[21] In fact, our *economic* security could be increased by using some of the money now devoted to military R&D for commercial purposes. Public opinion, according to 1988 polls, showed most Americans favored either cutting or freezing Pentagon spending (in sharp contrast to 1980, when the public favored increased defense budgets).

For non-defense programs, the cost-of-living adjustments on Social Security and Medicare should be kept to increases in the Consumer Price Index or wages, whichever is lower (as many experts have suggested). Over the past decade, these entitlements have risen much faster

than wages and those who have benefited most from these increases—the majority of whom are not poor—could gain a little less over the near term without suffering great distress. These cuts could be balanced by increases in funds for the elderly poor who are eligible for means-tested programs, and thus make the elderly poor better off than they are now. According to the Congressional Budget Office, such a program would cut federal expenditures by $13 billion over five years.

Together, these two expenditure changes—one on the defense side and one on the nondefense side—would cut federal spending by $177 billion. And combined with the revenue-raising efforts, the budget would cut the federal deficit by $517 billion or $103 billion a year. Those who got the biggest tax cuts and spending over the past ten years, and who can afford it the most, would finance most of the deficit reductions.

The deficit reduction scheme that we have outlined should not adversely affect savings, investment, and economic efficiency—especially when part of the proceeds are plowed back into the economy through the social investments which we suggested earlier. Our program of research and development and other critical investments in human and physical capital would cost the federal government about $280 billion over five years. After taking these investments into account, our budget reduction scheme comes to about $237 billion, or $47 billion a year. This is about the right amount of budget reduction necessary to produce a soft landing—not raising taxes and cutting expenditures too quickly. More important, it shifts resources from consumption to socially and economically useful investment in a fair and equitable manner.

These fiscal changes must be accompanied by a monetary policy that produces lower interest rates. This will prove difficult, given our dependence on foreign capital. In addition, the Federal Reserve Bank's proclivity for keeping interest rates high in order to keep foreign portfolio investment flowing and to fight inflation (rather than have lower interest rates to promote investment with the risk of inflation) must be changed. The goals of faster growth and reduced unemployment should be adopted by the Fed. We should aim for real interest rates of no higher than 2 percent to 3 percent to allow our economy to produce at high levels of capacity and to keep our workers employed.[22] Although both the fiscal and monetary policies recommended here represent a break from the practices of the past decade, they are necessary in order to restore our competitive position.

291

TRADE POLICY

Sooner or later, the trade deficit must be balanced. This is a matter not of economics but of arithmetic. No country can carry a deficit perpetually. We are faced with the question not of *if* we are to solve the deficit, but of *when* and *how*. In 1987, foreigners lent us more than one-fifth of our investment funds—money we spent on housing, machine tools, and factory buildings.[23] Unless we reduce the trade deficit, foreign investors could—and probably *will*—stop lending us these large sums. When that happens, we would not be able to build those houses and factories or buy those machine tools. Then, interest rates would have to increase, which will trigger a major recession. We must export more and import less, and we must find the best ways to doing so. The longer we wait, the bigger the burden on the economy, the greater the eventual decline in our living standards.

The orthodox view has been to let the dollar fall considerably in order to allow American products to be competitive. The former Fed chairman Paul Volcker and economists went on record in favor of letting the dollar slide further from the roughly 130 yen to the dollar that existed in mid-1988. This is necessary, but will not solve our trade deficit by itself for three reasons. First, we will need international cooperation to bring this about. The fall of the dollar will require the further rise in the yen, deutschmark, and other currencies. In turn, this means that Japanese and German products will become more expensive and less competitive in world markets. It is unreasonable to expect these countries to shoot themselves in their economic feet by allowing too substantial a fall in the dollar.* Second, this is a limited strategy because some MNCs, notably those based in Japan, enjoy protected home markets. This gives them a high profit cushion which can compensate for the lower profit margins that result from a falling dollar. Third, the decline in the dollar means more inflation and lower living standards in the United States. It is actually a tariff in disguise since we will pay higher prices for our imported goods and suffer lower living conditions as a result. In addition, this type of policy brings additional, unintended consequences: there is more uncertainty about the American investment climate and possibly volatile shifts in international capital, as in the foreign takeover binge of 1987–88. A more reasonable course is a more stable exchange rate regime—"zones" in which the dollar can fluctuate

* In the long run, there could be a decoupling of trade from the dollar and more trade could take place in terms of yen or other currencies—a possibility that is unlikely but not out of the question.

have been suggested by Paul Volcker and others.[24] If these zones are established through international coordination, they could help stabilize both the dollar and investment. But they will not be easy to bring about.

Thus, driving down the dollar is inadequate. We also must have a more active trade policy. After all, other countries manage their trade by supporting key industries, while we have passive policies that only react to trade problems as they emerge. A more active and, we believe, more realistic approach is to use the most important piece of leverage we have—access to the American market—to negotiate multilateral and bilateral agreements to open up foreign markets to our goods in exchange for continued access to the U.S. market. These agreements should also include international labor standards so that workers around the world will not be subject to unfair labor practices that lower their wages and also undercut the wages of our workers who compete with them.[25]

An active trade policy means, in addition, an export-based strategy to sell more of our goods abroad. As America restores its productive might, other nations' markets must expand. This will take at least two things, besides a greater fall in the dollar.[26] First, Germany and Japan, for example, must stimulate their economies: in effect, they must shovel coal into the "engine of growth" of the world economy. Again, these countries must see reflation in their sovereign best interests.* Second, we need to resolve the Third World debt problem quickly. The austerity programs forced on developing countries by the International Monetary Fund, dominated by the United States, have clearly not worked. These policies have not only brought more hardship to the world's already poor people, but disrupted U.S. exports to these countries. These programs have boomeranged on the United States since it has lost markets because these countries could no longer buy its goods. In order to sell more—particularly capital goods—to those nations that were responsible for 40 percent of our exports in the late 1970s, we must develop, with other lending nations, a program of debt cancellation and restructuring. In a sense this has already begun, as many international banks are writing off the debt and recognize that more will be written off in the future. The French and Canadian governments also announced debt reduction programs in 1988. We should do the same. The drastic scaledown of debt would open up markets of less-developed countries in the

* During 1988, Japan was growing rapidly from domestic sources, while Germany had a far less buoyant domestic economy.

long run. Finally, we should increase our foreign aid to these countries. Both strategies will not be easy to accomplish and would take a long time, but we should push in these directions. In the end, the world economy must be made to grow faster by the greater opening of markets and by high-growth policies that make all of us better off.

Managing Mergers and Antitrust Enforcement

The United States must look at the global, not national, character of modern business to ensure that firms do not misuse market power and restrict competition. Global industrial consolidation—already seen in industries like chemicals, cement, and tire making—will require special attention. Our antitrust laws are strong relative to other nations, despite lax enforcement during the 1980s.* The task of upholding antitrust statutes falls with the U.S. Justice Department and the Federal Trade Commission. In some cases, foreign acquisitions are held up for weeks and even months as the Justice Department or the Federal Trade Commission investigates. Most of their concerns involve horizontal mergers —those between competitors in the same industry. The Federal Trade Commission, for example, approved Hoechst's Celanese takeover only after the German chemical company agreed to sell part of its capacity in polyester fibers. The Justice Department blocked Cadbury Schweppes from buying 30 percent of Dr. Pepper after the company acquired Sunkist and Canada Dry. But too often in the 1980s, the federal government has failed to investigate horizontal mergers. Lax antitrust enforcement was justified by "efficient-market theory," which says that if conduct is inefficient, the market will correct it: if a market fell under control of a few powerful firms, who then raised prices, new companies would be attracted to the market and would drive prices back down.

The special justification for active antitrust enforcement in foreign investment stems from the fact that international capital flows typically imply imperfect competition. Of course, imperfect global competition does not mean that the United States should oppose all cases as

* Few nations have the kind of prohibitions against trust building found in section 1 of the Sherman Act of 1890, which proclaims, "every contract, combination in the form of trust or otherwise, or conspiracy, in restraint of trade or commerce among the several states or with foreign nations, is hereby declared to be illegal." Clause 7 of the Clayton Act of 1914 bars takeovers "where the effect of such acquisitions may be to substantially lessen competition between the Corporation whose stock is so acquired and the Corporation making the acquisition, or to restrain such commerce in any section or community, or tend to create a monopoly in any line of commerce."

violations of antitrust a priori. Jefferson Smurfit or Sony may introduce new managerial techniques and technology, leading to greater efficiency; while German chemical acquisitions may only lead to greater industrial concentration which effectively inhibits domestic capital formation. Some foreign firms create jobs, build new state-of-the art plants, and supply fresh capital to subsidiaries; others take over domestic firms, consolidate global holdings, and displace substantial numbers of workers.

Hence, the MNC's strategic decision to assert its power through competitive advantages has both positive and negative implications for host economies like the United States. Multinational investment requires careful review on a case-by-case basis in order to maximize competition in U.S. markets. MIRADOR, the agency we propose for overseeing foreign direct investment transactions, should work closely with the Justice Department and the Federal Trade Commission in antitrust cases, since the nature of collusion and other forms of anticompetitive practice are difficult to detect across borders. Often foreign firms operate in a much different corporate culture at home. Said the chief executive officer of Reichhold Chemicals, after being taken over by Dainippon Ink and Chemicals, "In Japan they have 'harmony': a closed industry; you don't cut prices. I told them 'harmony' in the U.S. is six years in Leavenworth."[27] With Japanese companies, regulators should carefully monitor that peculiar form of vertical organization—the *keiretsu*, or family system, which is unlike U.S. business organizations. Through the *keiretsu*, the Japanese transfer strong industry ties to the United States and build a separate economic structure of assemblers and suppliers, avoiding ties with local industry. Evidence of this process is already present in the Japanese-American auto industry. The strong, but often hidden vertical linkages among Japanese companies can inhibit and destroy U.S. competitors.[28] In general, as U.S. business becomes cross-fertilized with business structures developed abroad, industrial regulation must respond to changing competitive practices.

Another special antitrust problem concerns joint ventures. For instance, the NUMMI joint venture between General Motors and Toyota bonds the two largest automakers in their respective home countries. And the alliance between these giants is not confined to the United States: Toyota and General Motors consolidated their global operations in Australia. Back in the United States, the Federal Trade Commission approved the NUMMI joint venture—but, as Robert Reich and Eric Mankin wonder, "would it have also approved a GM-Ford deal?"[29] The

point is that these companies are no more "domestic" than many foreign firms: their production facilities span the globe.

MIRADOR should provide information on the economic consequences of hostile foreign acquisitions as well. If corporate takeovers are as beneficial to the United States as proponents claim, we should want more known about what investment and employment changes are planned. At a minimum, shareholders, employees, communities, and other constituents have a right to know what is being contemplated.[30]

Like antitrust, the problem of hostile takeovers must be addressed case by case. Unfriendly mergers and acquisitions could be a healthy phenomenon that raises shareholders' profits and forces entrenched management to become more competitive and to streamline their business after years of being "fat and lazy." During the 1980s, this was the enthusiastic message coming out of the White House and the Justice Department. The President's Council of Economic Advisors argued that takeovers improve efficiency, transfer scarce resources to higher-valued uses, and stimulate corporate management. However, leading economic experts on mergers and acquisitions refuted such unbridled claims at Congressional hearings and elsewhere.[31] Some takeovers, they argued, are strategic business deals and many are well-managed; others are tactical and purely financial maneuvers, takeovers by firms with no managerial expertise who impair, rather than improve, economic efficiency.

Our analysis of the foreign record in chapter 5 suggests that hostile tender offers and large acquisitions may destroy jobs and leave companies saddled with debt. In particular, although many foreign raiders do not have a clear idea of what is going to happen after they win a takeover battle, they put pressure on U.S. managers to defend themselves and to keep stock prices up (to avoid takeovers), instead of making long-range decisions to enhance the quality of the business. Hostile takeovers, or even the threat of them, hamper U.S. global competitiveness because of the detrimental effects on debt and on innovation. The debt incurred in financing the takeover undermines research and development by diverting funds to unproductive purposes. Firms rush to take defensive actions and make short-term investments to maintain quarterly earnings growth and maximize stock prices, thus weakening their long-term competitive abilities. Corporations shelve investments that lead to better processes, higher quality, and lower costs.

There are no simple rules to follow, just vast complexities when it comes to mergers and acquisitions. Thus we need information and advice from an informed government agency like MIRADOR. The need for a separate agency becomes even more pressing with the passage of

the Exon-Florio amendment mentioned earlier. Indeed it was Sir James Goldsmith's struggle for control of Goodyear Tire and Rubber that first motivated the drafting of the bill eventually signed by President Reagan.[32] Before Senate hearings, Goldsmith demonstrated an arrogance that recalled the days of robber barons, who inspired the early antitrust legislation. "The hell with CFIUS," seemed to be his attitude, according to a congressional aide, and, indeed, the government's review procedure lacked any authority to deal with him until the passage of Exon-Florio.[33] Thus, although this important legislation was passed as a national security measure, it was inspired by the bitter takeover battles that pointed to serious gaps in federal securities and antitrust law.

Exon-Florio was used as a defensive merger and acquisition tactic soon after it became law. A company needs to show "credible evidence" that there is a threat to national security to invoke the procedure, but it is not hard to use Exon-Florio as a delaying tactic, which establishes a "cooling off" period during a hostile raid. The first important test of Exon-Florio came in October 1988, when Britain's Consolidated Gold Fields and U.S. Newmont Mining asked President Reagan to intervene to stop Minorco, controlled by South Africa's Oppenheimer family, from taking over the rest of the British company it did not already own. The request was made on grounds of national security. (Consolidated Gold Fields produces strategic materials, with defense applications.) But the British firm's main concern was a possible management shake-up and asset stripping. Indeed Minorco agreed to sell Newmont to placate U.S. concerns about its control over North American minerals. However unintended, the new law has the potential to become a global merger and acquisition court of appeal, housed in the executive branch, although no agency was established to handle the mounting cases. An agency like MIRADOR is needed to handle such cases and provide needed expertise.

The proliferation of state antitakeover laws adds to regulatory confusion. For states, the preservation of jobs is paramount. Many fear that raiders, both domestic and foreign, will reduce employment. For example, when Britain's Beazer acquired Pittsburgh-based Koppers, the heated issue was not so much ownership, but the implication for jobs and the location of its facilities. Though there has been pressure for a federal statute on contested takeovers like Beazer-Koppers, both Congress and the Reagan administration were reluctant to move in this area, citing the traditional role of the states in regulating corporations chartered within their borders. Thus, as domestic and foreign raiders threaten homegrown companies, more and more states have passed

statutes to restrict the tools takeover artists use to gain control. State (and local) governments fear that foreign MNCs will come in and strip assets and reduce jobs. Sir James Goldsmith's run on Goodyear and Robert Campeau's takeover of Federated Department stores (both in Ohio) and Alan Bond's acquisition of Heileman Brewing (Wisconsin) spurred legislation in those states. By June 1988, twenty-nine states had passed such measures.

Most states' statutes fall into one of two categories. In the first, if a shareholder acquires a certain percentage of the stock of a firm without the approval of management, the law imposes a waiting period during which that shareholder cannot take further action, such as acquiring more shares or voting in shareholder elections. In the second, known as a control-acquisition law, the law sets share and acquisition thresholds. If an acquisition would give a shareholder substantial control of the company against management's wishes, the acquisition would be subject to current shareholder approval with the voting rights of the newly acquired shares suspended until the acquisition is approved.[34]

There have been many court challenges to state antitakeover laws. In 1982, at least thirty-seven states had such statutes. But a 1982 U.S. Supreme Court ruling invalidated all those measures as placing an unconstitutional burden on interstate commerce. State lawmakers went back to the drawing board. In an effort to protect Arvin Industries from the Canadian Belzberg family, Indiana adopted a control-share acquisition law that was upheld by the U.S. Supreme Court in 1987. Indiana's success set off a new round of legislation, culminating in Delaware's passage of an antitakeover statute that would impose a three-year waiting period between a raider's offer to purchase a controlling interest in a company and the consummation of the merger. This law is significant because Delaware is the official corporate home to 179,000 companies, including about half of the *Fortune* 500—and the law covers all companies incorporated in the state. In 1988, the Delaware statute was challenged in the courts by Robert Campeau.

More and more states have been passing similar laws to protect their companies and workers from Campeau and raiders like him. It is naïve, however, under any circumstances to think that the states are capable of handling antitrust problems in a global economy. Stronger federal action is required.

It may seem that when the government acts on hostile takeovers, it really need not distinguish between foreign and domestic raiders; but the international character of mergers and acquisitions may warrant special consideration. One concern is the potential edge that foreign

interests have over domestic acquisitors. Unlike U.S. financiers, some foreign companies can write off what accountants call "goodwill" (the excess of the purchase price over the fair value of the actual assets of a company) against stockholders' equity without depressing earnings. The edge that these accounting methods yield may be difficult to discern, but the result, according to a study by the U.S. General Accounting Office, is clear: it often gives foreign firms (especially British and German companies) an ability to outbid U.S. acquisitors. Canadian firms have tax-deduction privileges in the treatment of goodwill.[35] An Australian-based company, moreover, could benefit from accounting rules that give the company a special advantage over U.S. competitors. Under Australian accounting principles, TV licenses, titles, and other "intangible" assets are not considered to have any finite life and thus do not have to be counted as goodwill and gradually written off against earnings.

Again, the folly of "national treatment" emerges: the United States strives to keep the door open to everyone on an equal footing, but not all firms compete equally. As the U.S. economy opens to cross-border mergers, the federal government fails to consider how accounting advantages distort the flow of international capital. In general, the government must recognize that monitoring global corporations entails many problems, many without precedent.

Plant-Closing Legislation and Exit Policy

Whether by the closing of a VW or a GM plant, American workers face continual job insecurity through the increased mobility of international capital. Even during the surge of inward investment, foreign firms in the United States cut thousands of jobs during the 1980s. Overseas investment by American firms displaced millions and will displace more with pre-1992 investment in Europe. When we look at the job loss caused by inward and outward investment, the impact of capital mobility becomes a critical issue that requires action.

Besides our open-door policy to attract FDI, we also need an "exit" policy for both U.S. and foreign MNCs. By this we mean plant-closing legislation, notification, consultation, and adjustment assistance to reduce the damage to communities and workers. That is, if capital is withdrawn, it should be with minimum damage to our workers and cities. In the absence of a plant-closing law, the median length of layoff

notice was only about one week, according to a U.S. General Accounting Office study.[36] Most of the major U.S. trading partners—Japan, Canada, and West Germany, and others—have strong laws, and there are few complaints about the effects of these laws on their competitiveness. There is little evidence that humane plant-closing legislation hurts productivity or increases absenteeism. The United States, too, needs strong legislation for foreign and domestic companies, even stronger than legislation Congress passed in 1988 which requires only two months' notice before workers are thrown out of their jobs. Firms should provide 120-days notice.

Such early warning about closures makes it easier to enroll workers in adjustment programs before they are laid off, to engage in job search, and ultimately to reduce the spell of unemployment. The evidence shows overwhelmingly that workers and the economy as a whole benefit from prior notification. It has been estimated that sixty days' prior notice means four fewer weeks of unemployment on average. Nationally, this could save as much as $400 million in unemployment compensation costs and adds $1.5 billion to the payroll.[37] We could save even more with a longer notification period.

Some enlightened employers, including companies affiliated with overseas investors, give American workers long advance notification of job closings and otherwise attempt to cushion the blow of cutbacks. Doubleday, owned by the West German publishing giant Bertelsmann, announced that it would close a book-printing plant in Smithsburg, Maryland, a full year before it shut the doors in April 1988. Some workers in Smithsburg were offered an opportunity to transfer to other facilities. Doubleday also hired an industrial psychologist to counsel the displaced workers and brought in a job-placement firm to advise workers about job hunting. The company went so far as to advertise to other employers that workers would be available, inviting them to contact the Doubleday personnel office. Many other companies provide some advance notification, but Bertelsmann's Doubleday policy could serve as a model for federal legislation.

As an additional step, the United States needs rapid-response aid for dislocated workers, including job training with income support during training; education and relocation assistance; and employment service assistance for job counseling, job search, and job placement. The federal government should set up a Dislocated Worker Unit in the U.S. Labor Department and require states to establish Dislocated Worker Units and tripartite labor-business-public review committees. Cities suffering from large-scale plant closings should be eligible for special ad-

justment assistance. The federal budget plan we outlined earlier for investments in human and physical capital includes labor-displacement adjustment assistance to communities and workers.

Often the United States inadvertently encourages job displacement by subsidizing offshore investment and allowing U.S. MNCs to move abroad more cheaply. We must close the loopholes in the Tax Code that allow firms that invest abroad to defer taxes on profits made there until the profits are repatriated. Closing these loopholes would amount to only a small part of lost revenue, but will send a signal to American corporations to encourage them to keep their production at home. This negative signal should be accompanied by a positive one to U.S. and foreign investors: a refundable tax-credit investment when firms create new jobs, particularly high-paying ones involved in complex production.[38] That is, we should give these tax credits after the investment has been made and the jobs added. Past policies of giving tax breaks to corporations in the hope that they will do things to help the economy— like depreciation allowances—have done little if anything but reduce a company's taxes. We could also give tax credits for activities that will help the American economy in the long run: training, research and development, the siting of complex production, and the like.[39]

We might also consider giving tax credits for domestic content of high-value-added products. These inducements would indeed be costly, but so have been the open-ended tax policies we have followed in the past. At least, these would be more directly tied to job creation in the U.S. economy. What is important is that these inducements would be available to both domestic and foreign companies, help keep American companies home, and maximize the contribution of foreign companies to the U.S. economy.

For Years—and Years—and Years

In 1988, Mitsubishi Electric took out a full-page advertisement in the *Wall Street Journal* to inform Americans that its products are:

Made in Japan . . . and California. And North Carolina. And Georgia. And Ohio. Just because a product says Mitsubishi on the front, doesn't mean it says made in Japan on the back. . . . Close to 3,000 Americans are employed at Mitsubishi facilities. We buy parts from local suppliers. And we do our best to strike a balance between exports and imports. So even though our

home base is in Japan, we intend to be a positive force in the American economy for years. And years. And years. And years.[40]

In at least one respect, Mitsubishi's statement represents the aspirations of many New Competitors in America: they intend to stay. However much they close plants they have opened, or divest U.S. companies they have acquired, foreign investment will be here for years and years—and years. This will be one of the most important issues in the America of the 1990s and is but part of a larger set of events that is fundamentally altering not only the U.S. economy but also the lives of its workers and its states, cities, and smallest communities.

With foreign-based multinationals increasing their position in America and American multinationals shipping products into the United States from offshore, it is no longer easy to say what is "foreign" and what is "American." The distinction between where a product is developed, produced, and assembled is blurred since the Global Factory can disperse these functions throughout the world. For the same reasons, the relationship between the corporation and the nation has significantly altered. Is Nestlé, which derives but 2 percent of its sales from Switzerland, really a Swiss corporation except in the location of its headquarters and the laws under which its by-laws are written? Similarly, as IBM and Ford outsource more of their components, what is their connection—and their commitment—to the American economy? By definition, multinationals span national boundaries and transcend nations and national interests. We have, therefore, to rethink the fundamental idea that a country and its corporations have consistent interests. Or, that foreign-based MNCs are necessarily "less American" than "American" MNCs.

Foreign firms have often been seen as our "enemy"—but let us extend the memorable line from the old comic strip *Pogo*—"We have met the enemy and they is us"—to both U.S. and foreign multinationals. Now is the time to begin to understand not only ourselves but them, as the lives of Americans and "aliens" become ever more closely intertwined.

APPENDIX A

Data Sources and Problems

This appendix describes the various data sources we have used to measure and analyze foreign direct investment. Such appendices typically interest scholars, while other readers find them tedious. In this case, however, the subject has become an urgent matter of public policy. As we have mentioned, the foreign investment information gap has become a controversial topic, with many observers suggesting that we really do not know who "they" are; that we only track about half of all foreign investment; and so forth. The Bryant bill, discussed in chapters 9 and 10, served as a rallying cry for those concerned about the data gap. In what follows, we discuss the data sources used in this study, as well as some of the problems and limitations we encountered in conducting our research.[1]

Bureau of Economic Analysis Data: How Wide Is the Gap?

Our study relied extensively on the latest information on U.S. affiliates of foreign corporations. There is no perfect data source, but, as we mentioned in chapter 2, the most complete and reliable information comes from the U.S. Department of Commerce, Bureau of Economic Analysis (BEA). According to Robert Ortner, the undersecretary for economic affairs, "BEA's data provide a wealth of information on foreign direct investment. . . . In terms of quantity, quality, variety, and timeliness of the aggregate statistics it produces, the BEA data system is unmatched by any other country in the world."[2]

The only reason we have these data—and, indeed, the only reason we can say much about the size and extent of direct investment today—

is by virtue of legislation passed over a decade ago: the International Investment Survey Act of 1976 and the Agricultural Foreign Investment Disclosure Act of 1978. The International Investment Survey Act of 1976 authorized the President to collect data and conduct comprehensive studies on direct and portfolio investment. In turn, the President gave the BEA the task of collecting direct investment information, including a wide range of information from every affiliate of a foreign-owned corporation operating in the United States. (The U.S. Treasury was given the task of collecting portfolio data.)

From the start, the BEA's job has been difficult and controversial. It would be fair to say that the agency does not track every direct investment; therefore the data *understate* the total amount of direct investment in the United States. At the same time, to assert unequivocally that we do not know who "they" are would seriously *overstate* the data gap. The BEA's list of affiliates covers over 30,000 names and addresses of firms, some active, some not. All individual company reports are confidential, however, and can be used only for analytical and statistical purposes; they cannot be used for taxation, investigation, or regulation.

There should be no doubt that the BEA data cover most direct investment transactions. First, *all* foreign investors in a U.S. business enterprise must report to the BEA when they control 10 percent or more of the voting interest (or the equivalent); this includes all ownership of real estate, except that for personal use. Only minimal information is required when the U.S. business enterprise acquired or established has total assets of $1 million or less and owns less than 200 acres of land (most direct investment comes through transactions much larger than $1 million). Following the directives of the 1976 law mentioned earlier, and the legal authority written in the International Investment and Trade in Services Act, an investor who fails to file with the BEA is subject to a fine of up to $10,000. Nevertheless, compliance and accurate reporting ultimately rest with the cooperation and goodwill of the companies involved.

Initially, foreign direct investors must report any new establishment or acquisition. To update and expand its coverage, the BEA sends a questionnaire to U.S. businesses newly acquired or established by foreign direct investors. A summary of these data is published every year, usually in the May issue of the *Survey of Current Business*.[3] These data were used in our analysis of employment change attributed to new plants, expansions, acquisitions, and liquidations in chapter 5. Unfortu-

nately, the published data do not break down new establishment employment into detailed industry groups.

The BEA keeps track of ongoing changes in U.S. affiliate activity through quarterly and annual sample surveys. Samples are expanded to estimate the total amount of investment. In addition, the International Investment and Trade in Services Act stipulates that a comprehensive survey of direct investment must be conducted once every five years. These "benchmark," or census, studies cover the direct investment "universe." Benchmark studies are available for 1974 and 1980, and the 1987 benchmark will be available in 1989. Meanwhile, annual survey results report any changes between the benchmark years, usually in the May issue of the *Survey of Current Business*.[4]

A large "statistical discrepancy" reported by the BEA is sometimes used to suggest that government records miss a substantial amount of direct investment. Yet, according to the staff of the U.S. Department of Commerce, this discrepancy consists mostly of portfolio, not direct, investment.[5]

Despite the relative completeness of the BEA data, it is still difficult to ascertain, for a variety of reasons, exactly who owns our resources. Part of the problem is that some global corporations change hands frequently; other companies furtively list island tax shelters as their headquarters. Thus, more than other forms of business enterprise, multinational corporations are difficult and complex organizations, with circuitous links between their U.S. affiliates and the corporate parents. MNCs often tie together scores of subsidiaries domiciled in different nations, all belonging to one corporate entity. Imagine trying to follow a genealogical chart in a world where bigamy is widely practiced, and you get some idea of the complexity involved determining the true base of a corporate parent.

To pinpoint the "ultimate beneficial owner" (UBO) of a U.S. affiliate, the BEA follows the ownership chain of direct investment back to the "person" (usually a business enterprise) that is not owned by more than 50 percent by another person. These UBOs are sometimes as elusive as UFOs. Consider the Fairchild Semiconductor case, mentioned in chapters 1 and 9. Most people believed that this founding father of the microchip industry was still U.S.-owned when the Japanese Fujitsu corporation's takeover ran into opposition for national security reasons. Yet the real owner of Fairchild was not American after all, but Schlumberger. An advanced oilfield services and electronics firm, Schlumberger lists the Netherlands Antilles as its home base. But Schlumberger

is not really based in the Caribbean; it is tightly controlled by a French family. Finding the "ultimate beneficial owner," however, is a general problem inherent in dealing with multinational enterprises; it is not a problem of the BEA data *per se*.

Mandatory "disclosure" rules pose a major limitation to the BEA data. This problem is not unique to foreign investment statistics (disclosure rules affect most other government economic data). The government suppresses publication when a few companies account for most of the data contained in an individual cell (the amount of chemical employment in Delaware, for instance). Clearly, these rules are designed to prevent the government from divulging confidential information about the individual operations of private foreign firms. Even when the data are presented in highly aggregated form, we find missing observations, or cells, in the government reports. Preventing disclosure is necessary, however, if we are to get accurate reports from the companies in the first place.

In addition to the largely unavoidable problems discussed so far, numerous other data problems were encountered during our study. One problem is that the definition of U.S. affiliate employment changed between the 1974 and 1980 benchmark studies. In the 1980 benchmark, employment was reported on a "full-time" basis; in the 1974 benchmark, employment was reported on a "full-time equivalent basis." This means that employment was higher for the 1980s, everything being equal, because part-time workers were counted like full-time workers, "but it is impossible to quantify the difference."[6] It also means that the 3 million jobs reported by the BEA do not represent full-time employment only.

Because of the precise way in which employment is defined for foreign-controlled operations in the United States, one must be careful when comparing these numbers with employment by domestic firms. To measure how much total U.S. employment can be attributed to the U.S. operations of foreign companies, affiliate employment must be compared with nonbank private, nonfarm wage and salary employment (full-time and part-time workers). A U.S. employment series comparable with the latest figures on U.S. affiliate employment reported by the BEA is found in the July 1987 *Survey of Current Business*, where we see that there were 84,012,000 workers in private nonbank American businesses.[7] Hence, to measure the amount of employment controlled by foreign companies in the United States, one first goes to the BEA's 1986 employment figures published in the 1988 *Survey of Current Business* article by Ned G. Howenstine.[8] There you find that affiliates employed 2,964,153 workers. This figure represents 3.5 percent of the 84,012,000

employees of all nonbank U.S. businesses in 1986. Any of the many other U.S. employment series published by the federal government would yield a different percentage and give a distorted picture of affiliate activity.

Another major problem with the BEA data is that beginning with the 1977 figures, the amount of detail requested of affiliates was reduced. After the initial benchmark study of 1974, it was decided (in line with the Paperwork Reduction Act) that foreign corporations should be required to supply information on a "fully consolidated basis" to ease the reporting burden on their American affiliates. Reporting on a consolidated basis means that the industry classification of an enterprise does not necessarily capture the extent of its activities. For example, if a manufacturing affiliate located in Ohio owned an office tower in New York City, the office tower is classified as manufacturing. This means that all data are classified under the enterprise's (the overall company's) main industry classification—even though individual establishments may not correspond to these classifications. Du Pont, for instance, is mainly a chemical company but produces many other products.

For this reason, we cannot measure with any accuracy the extent of foreign ownership in our nation's industries. Domestic business employment, on the other hand, is classified at the establishment (plant or office) level. This may seem like a trivial point, but the difference in the means of classification—whether by establishment or by enterprise—poses major problems, even for measuring the extent of foreign control in highly aggregated industries like manufacturing and wholesale. For example, Japanese automobile assembly plants are mostly classified as wholesale affiliates.

Special care must be taken in analyzing the regional data as well. To compare foreign-affiliated employment in states with domestic state employment, one needs a special series: private, nonbank wage and salary employment available from the Regional Economic Information System of the Bureau of Economic Analysis (these "ES 202" data are compiled by the BEA from state employment security information). Edwin Coleman has put together a good summary of BEA state and regional data from 1974 through 1983.[9]

One possible source of confusion that arises in chapters 2 and 7 concerns the amount of foreign control of manufacturing employment. In chapter 2, we have said that affiliate manufacturing equaled 7.8 percent of all U.S. manufacturing employment in 1986. In our state comparisons of chapter 7, the manufacturing job numbers differ slightly because we use a different base for U.S. private nonfarm employment (the

ES 202 data mentioned earlier). Part of the difference occurs because the petroleum and coal sector is left out of manufacturing (because of the "enterprise" versus "establishment" problem that afflicts these data, it is not clear whether petroleum and coal manufacturing should be included). Accordingly, the affiliate share of total U.S. manufacturing jobs drops to 7.5 percent.

An additional source of confusion arises over what variable, besides employment, best measures the extent of foreign direct investment. Country rankings of total foreign ownership, for instance, depend on what one chooses as the measure of foreign ownership. One measure of ownership is the foreign direct investment "position" we use in chapter 2 and elsewhere ($262 billion in 1987). The "foreign direct investment position" is the book value of foreign parents' equity in, and net outstanding loans to, their U.S. affiliates. Essentially, these data are collected for international balance-of-payments purposes; they show transactions between foreign parent companies and their U.S. affiliates. In terms of foreign direct investment position in 1987, the United Kingdom ranked first, the Netherlands second, Japan third, and Canada fourth.[10]

Other data used to measure the extent of direct investment, like total assets, cover the total financial structure and operations of U.S. affiliates. The total asset figure runs much larger than the "position" (it was $830 billion in 1986). In the report on U.S. affiliate operations in 1986 by Ned G. Howenstine, we find the United Kingdom ranked at the top of the list in total assets, followed by Canada, Japan, the Netherlands, and Germany.[11]

In either case, whether we look at assets or position, the amount is measured in terms of historical book value. As we have noted in chapter 2, because most inward investment is newer than outward investment, the amount of outward investment may be understated if it is compared directly with inward investment.

Other Data Sources

Given the problems and limitations of the BEA data, where can one turn? Additional public and private data on foreign direct investment are available from the International Trade Administration (ITA). The agency provides an overview of foreign investment trends, used in the history presented in chapter 2.[12]

The ITA has also compiled a special data base on individual transac-

tions that break out announced investments into new plants, plant expansions, acquisitions and mergers, joint ventures, and equity increases. The ITA assembled these data from newspaper and journal announcements of foreign firm transactions and from the files of federal regulatory agencies. We have carefully examined these data from 1979 through 1986, especially the new plants and expansions (what we call "employment-creating investments") and acquisitions and mergers. All the ITA's announcement data were placed on a computer tape. Hard copies of the data are available in a series of annual reports published by the ITA.[13]

The ITA claims their direct investment series is highly correlated with the BEA data.[14] Yet the ITA information is inconsistent in many places (including double counting) and really offers no more than a secondary compilation of public and private data. The ITA does not check to see whether the investment actually occurred or was the size mentioned in a given newpaper report. Clearly, these data are not as reliable as the BEA data, which are based on mandatory reports from all firms affiliated with foreign companies. The ITA data are best used as a source of information on the new plants announcements and acquisitions and mergers, since this level of detail is not available in the BEA data. In the ITA's *1983 Transactions* document cited earlier, a *new plant* is defined as "a new operating facility, established either in conjunction with an existing foreign-owned productive enterprise or as a completely new venture."[15] *Acquisition* is defined as a "transaction in which title to stock or assets of the U.S. target is secured by another person or enterprise"; and *merger* as a "transaction which results in the dissolution of the acquired business enterprise, into either another already existing or into a reorganized (but not always renamed) company."[16]

A similar breakdown of Japanese manufacturing investments was keyed into a computer from a data base put together by the Japan Economic Institute (JEI). Like the ITA data, the JEI compiled the data base by monitoring announced transactions in the business press. A major drawback of both the ITA and JEI data is that one is limited to tabulations of numbers of plants, rather than employment, capital stock, or other (better) measures of foreign activity.[17]

Other sources of FDI information include the U.S. Bureau of the Census, which published a valuable series on multiestablishment foreign firms taken from the Census' Company Organization Survey files. Annual issues of its *Selected Characteristics of Foreign-Owned U.S. Firms* are available from 1975 to 1982.[18] Independently, two scholars at the University of South Carolina have kept track of foreign investment transac-

tions; unlike most government data, they "name names" and the location of the investment.[19]

For data on the foreign banking presence, one turns to the Board of Governors of the U.S. Federal Reserve System. For the figures cited in chapter 2, we obtained unpublished tables directly from the Federal Reserve; however, a summary table of U.S. offices of foreign banks can be found in the annual statistical volume of the U.S. government.[20]

A most useful source of information in the fast-paced world of corporate takeovers is *Mergers & Acquisitions* magazine, a private annual report that tracks both domestic and foreign merger and acquisition activity.[21] The *Mergers & Acquisitions* data base consists of reported transactions that involve a U.S. company with a value of at least $1 million and include partial acquisitions of 5 percent or more (thus differing from the standard government 10-percent rule). The data base includes divestitures on a like basis. The *Mergers & Acquisitions* data base excludes real property sales.[22]

Finally, what about real estate data? Government real estate figures often diverge from private estimates, in part because the BEA numbers only include real estate for commercial purposes, not for personal use. The National Association of Realtors and Coldwell Banker Boston have provided alternative private estimates of foreign-owned real estate,[23] both of which were to be updated in 1988 but were unavailable at the time of this writing.

Some additional data not in the text from the sources cited earlier are provided in the tables that follow.

TABLE A.1
Inward Direct Investment Leading Investor Nations

Nation	Direct Investment Position (1987) Amount (billions)	Rank	Assets (1986) Amount (billions)	Rank	Sales (1986) Amount (billions)	Rank
Canada	$21.7	4	$129.5	2	$82.6	3
Germany	19.6	5	49.3	5	62.0	4
Japan	33.4	3	96.7	3	165.7	1
Netherlands	47.0	2	68.4	4	46.4	5
United Kingdom	75.0	1	133.8	1	113.5	2
Total U.S.	261.9		829.9		667.3	

SOURCE: U.S. Department of Commerce, Bureau of Economic Analysis.

TABLE A.2

Manufacturing Foreign Investment Transaction Announcements by Country, 1979–1986

Nation	Acquisitions and Mergers (A&M)			New Plants			Plant Expansions		
	Number	Share of Total A&M Announcements (%)	A&M as a Share of Each Nation's Total Investment (%)	Number	Share of Total New Plant Announcements (%)	New Plants as a Share of Each Nation's Total Investment (%)	Number	Share of Total Plant Expansion Announcements (%)	Plant Expansions as a Share of Each Nation's Total Investment (%)
Canada	200	15.9	55.7	60	9.5	16.7	46	17.2	12.8
Japan	102	8.1	23.0	153	24.2	34.5	61	22.9	13.7
Continental Europe	520	41.2	43.3	317	50.1	26.4	117	43.8	9.6
United Kingdom	345	27.4	64.4	73	11.5	13.6	39	14.6	7.3
Other	94	7.5	58.8	30	4.7	18.8	4	1.5	2.5
Total	1,261	100.0*	46.7†	633	100.0*	23.5†	267	100.0*	9.9†

SOURCE: U.S. Department of Commerce, International Trade Administration.

* Country shares may not add up to 100 percent due to rounding.

† U.S. average for the given column.

TABLE A.3

Foreign Employment-Creating and Employment-Acquiring
Investments Through 1986 by Industry

Industry	Employment-Creating Investments	Employment-Acquiring Investments
Agriculture, Forestry and Fishing	5	33
Mining	12	425
Construction	1	47
Food, Feed and Tobacco	51	169
Textiles and Apparel	28	64
Wood Products and Furniture	27	30
Paper Printing and Publishing	47	269
Chemical Products	221	258
Petroleum and Coal Products	20	33
Rubber, Plastics and Leather	49	71
Stone, Clay and Glass	37	109
Primary Metals	64	122
Fabricated Metals	48	100
Nonelectric Machinery	112	340
Electric and Electronic Equipment	141	321
Transportation Equipment	107	65
Measuring and Scientific Equipment	46	111
Miscellaneous Manufacturing	39	46
Transportation, Communication, and Public Utilities	33	209
Wholesale Trade	73	728
Retail Trade	14	405
Finance and Insurance	0	420
Services	31	572
Total	1206	4947

SOURCE: Department of Commerce, International Trade Administration.
NOTE: Employment-Creating Investments consist of new plants and plant expansions. Employment-Acquiring Investments consist of mergers and acquisitions, joint ventures, equity investments, and unclassified categories.

TABLE A.4

Japanese Employment-Creating and Employment-Acquiring Investments
in Manufacturing Through 1986 by Industry

Industry	Employment-Creating Investments	Employment-Acquiring Investments
Agriculture, Forestry and Fishing	10	4
Food, Feed and Tobacco	51	53
Textiles and Apparel	11	11
Wood Products and Furniture	6	4
Paper, Printing and Publishing	16	2
Chemical Products	24	48
Petroleum and Coal Products	0	3
Rubber, Plastic and Leather	32	12
Stone, Glass and Clay	8	10
Primary Metals	18	16
Fabricated Metals	27	11
Machinery Except Electrical	62	45
Electric and Electronic Equipment	80	35
Transportation Equipment	31	3
Measurement and Scientific Equipment	22	12
Miscellaneous Manufacturing	22	5
Total	420	274

SOURCE: Japan Economic Institute.
NOTE: Employment-Creating Investments consist of new plants. Employment-Acquiring Investments consist of mergers and acquisitions.

APPENDIX B

Estimates of Employment Change for U.S. Affiliates of Foreign Companies

In chapter 5, we provided employment estimates for new foreign plants, plant expansions, acquisitions, cutbacks, and sales and liquidations. We noted that the BEA data are sometimes hard to interpret. In this appendix, we explain how we arrived at our figures. We made a set of assumptions to divide BEA's aggregated data into useful categories.

For 1982 through 1986, the Bureau of Economic Analysis broke down annual employment of *large* affiliates (more than five hundred employees, which covers almost all foreign investment in the United States) into five sources of change in affiliate employment: *new investments*, *expansions* of existing operations, *sales or liquidations* of businesses, *cutbacks* in existing operations, and *combinations* of new investments and sales or liquidations of businesses.[1] These, the only data that allow us to examine the important issue of the size of new employment relative to cutbacks, are not always given in the most useful form for our purposes. After conversations with analysts at the BEA, we found it impossible to obtain the information in any other way, and so were forced to make some assumptions in order to arrive at reasonable estimates.

One of the "sources of change"—new investments—posed a problem because it combines employment from both new acquisitions and new establishments. It is important to separate these two components of employment change because employment from new establishments clearly creates new jobs, while employment from new acquisitions often transfers workers from a domestic company to a company affiliated with a foreign firm. We separated new investments into acquisitions and new establishments by using a second set of employment data published by the BEA.[2] These alternative data enabled us to compute an

annual ratio of employment in new establishments to total new employment (including jobs from newly acquired firms). For example, we found that new establishments created 19,046 jobs in 1986, while new acquisitions added 418,965 jobs. In other words, out of a total of 438,011 jobs added by U.S. affiliates in 1986, 4.4 percent came through new establishments, and 95.6 percent came through acquisitions. In other years, the percentages varied slightly. We calculated these percentages for each year from 1982 through 1986. Next, we used these numbers to allocate "new investments" into employment from acquisitions and from new plants: thus, for 1982 through 1986, we estimated that of the 1,020,974 jobs through new investments, 39,686 (or 3.9 percent over the period as a whole) came through new plants, while 981,288 (or 96.1 percent) came through acquired firms.

Another problem with the "sources of employment change" data provided by the BEA is the category that combines "new investments and sales or liquidations of businesses." The figures represent the change in employment of affiliates that both acquired *and* sold a business during a given year. Since they are not broken down separately, we made some assumptions about their relationship based on the ratio of acquisitions to sales and liquidations. Over the five years we examined, there was a net increase of 140,446 jobs in this category. To allocate this, we added to the acquisitions category and subtracted sales and liquidations to get a net increase of 140,446. To illustrate better the sources of employment change in figure 5.3, we adjusted upward both the jobs pouring in through acquisitions and those pouring out through sales and liquidations to include this category. Since the ratio of acquisitions to sales and liquidations was 1.66, we added 66 percent of the 140,446 to acquisitions. Therefore, to our estimate of 981,288 jobs coming through acquisitions (1982 to 1986) we added 233,188 jobs (140,446 times 1.66). To the 591,015 jobs lost through sales and liquidations (1982 to 1986), we added 92,742. The difference between the change in acquisitions and sales and liquidations equals the total "combinations of new investments and sales and liquidations of businesses" reported by the BEA. This calculation was mainly a matter of accounting and does not affect our estimate of job gain or loss.

By using the BEA "sources of employment change" data for *large* affiliates, we were able to account for a net change in employment of 481,616 jobs from 1982 through 1986. These large firms represent about 88 percent of the total job change (547,927) during the period. The remaining 12 percent (66,311 jobs) includes changes in the employment of large affiliates that the BEA could not allocate to new investment, ex-

pansions, or other categories, as well as all the changes in employment for affiliates with fewer than five hundred employees. We allocated this "unaccounted for" category based on the pattern of large affiliates. That is, we adjusted each of the five categories of employment change. We added 5,465 jobs to new plants, 41,302 to expansions, 167,214 to acquisitions, 53,527 to cutbacks, and 94,143 to sales and liquidations. (Adding new plants, expansions, and acquisitions, and then subtracting cutbacks and sales and liquidations yields a net employment change of 66,311—the "unaccounted for" portion of the BEA data.)

In the end, we arrived at the following estimates for different components of employment change for 1982 and 1986.

Acquisitions	1,381,690
New Plants	45,151
Expansions	341,281
Cutbacks	442,295
Sales and Liquidations	777,900

Adding acquisitions, plants, and expansions and subtracting cutbacks and sales and liquidations yield the total change in affiliate employment reported by the BEA for 1982 through 1986 (547,927 jobs)—the number shown in figure 5.3. Though estimates, they are very good approximations of each component of employment change. For example, our estimate of employment from new plants (45,151) is very close to the estimate provided by the BEA for 1982 to 1986 employment in new establishments (47,936).[3] Since the "new establishment" data include some expansions, it is surprising that the difference between our estimate and the BEA's is not greater. We are confident that we are not underestimating employment from new plants. Anyway you look at these numbers, you reach one startling conclusion: *employment from new plants and expansions is less than employment cutbacks* during the period.

APPENDIX C

Calculating Displacement

National Employment Impacts

A host of studies have attempted to quantify the domestic employment effects of U.S. direct investment abroad, many evaluating the magnitude of the displacement and stimulus effects. Estimates of the net effects vary from a loss of more than two million jobs to a gain of one million. These differences depend on the assumptions made about the ways that multinationals behave, statistical methods, and the time frame of the study. With this much disparity, new and more definitive research was needed to more precisely estimate the employment gains or losses due to USDIA. We began with a comprehensive study by Robert Frank and Richard Freeman, who estimated the employment effects of USDIA from 1966 to 1973.[1] They calculated empirical estimates of the rate of substitutability between foreign and domestic production, rather than assuming this rate as had been done by others.

We estimated the employment effects of USDIA for 1977 through 1986, building on Frank and Freeman's methodology. There are problems with the Frank and Freeman approach, although we believe that it is the best to date.[2] First, Frank and Freeman do not take into account the possible reactions of foreign firms to a ban on U.S. investment abroad. If foreign firms filled the gap left by U.S. affiliates, then there would be fewer U.S. exports. Moreover, there is no consideration of a partial ban or constraint on investment. Frank and Freeman assume the ban is an all-or-nothing proposition, although political reality might dictate a less-than-complete prohibition. In addition, these authors made their calculations of demand elasticities on the basis of accounting costs, while an opportunity-cost approach might have been more appropriate. Moreover, the estimates that they calculate are very sensitive

to the value of the substitution ratio. Also, since costs have grown over time, the assumption of constant short-run marginal costs underestimate total costs and overestimate the substitution ratio.[3] While these criticisms have merit, particularly on a theoretical level, most would be difficult to incorporate into an empirical model. Finally, we feel that the Frank-Freeman methodology does not accurately reflect market conditions in nonmanufacturing sectors since it depends so heavily on comparative costs. We have, therefore, concentrated on manufacturing and omitted services. Using the MRPIS model, we estimated the associated service job change separately. Combining estimates of the substitution ratio s with an estimate of the employment generated by expenditures on property, plant, and equipment (PPE) by majority-owned foreign affiliates, we calculated the number of jobs displaced and stimulated by USDIA.

We measured the displacement effect using equation (1).

(1) $[EDIS] = [L][I - A]^{-1}[q][s][PPE]$

where: $EDIS$ = n × 1 vector of jobs displaced due to USDIA by industry; L = n × n diagonal matrix of labor-output ratios by industry; $[I - A]^{-1}$ = n × n Leontief inverse matrix of the U.S. economy; q = n × n diagonal matrix of output-capital ratios by industry; s = n × n diagonal matrix of substitution ratios; and PPE = n × 1 vector of expenditures on property, plant, and equipment.

We multiplied the production resulting from foreign affiliates' PPE expenditures ($[I - A]^{-1}[q][PPE]$) by s to derive the production that would have resulted in the United States had investment been undertaken domestically instead of abroad.

Using a 23 × 23 input-output table, we were able to capture both the direct and indirect effects.[4] These output figures were then converted to employment by multiplying by the labor-output ratio L to calculate $EDIS$.

We defined the stimulus effect on employment as:

(2) $[ESTI] = [L]\{[I - A]^{-1}[X] - [X]\}[q][PPE]$

where: $ESTI$ = n × 1 vector of jobs gained due to export stimulus of PPE; and X = n × n diagonal matrix of elements that show the proportion of affiliate's inputs obtained from U.S. suppliers.

Calculating Displacement

This is calculated under the crucial assumption that the technology of U.S. firms abroad is the same as that of domestic firms. Hence, the production of U.S. firms abroad is:

$$[I - A]^{-1}[q][PPE]$$

and the input requirements for this level of production are:

$$\{[I - A]^{-1} - I\}[q][PPE].$$

Weighting this expression by the diagonal matrix [X] yields the input requirements exported from the United States. Premultiplying by the diagonal matrix of labor-output rations [L] yields employment.

The substitution ratio, s, is:

$$s = \{[TVLC_F + TVNLC_F]/[TVLC_H + TVNLC_H][(1 + t)]\}^e$$

where: $TVLC_F$ = total variable labor cost in foreign affiliates; $TVNLC_F$ = total variable nonlabor cost in foreign affiliates; $TVLC_H$ = total variable labor cost in domestic affiliates; $TVNLC_H$ = total variable nonlabor cost in domestic affiliates; e = elasticity of demand; and t = cost of transporting products from domestic sites to foreign markets.

The net change in employment in equation (3) is the difference between equations (2) and (1):

(3) [NEFE] = [EDIS] − [ESTI]

where: $NEFE$ = n × 1 vector of net job change.

We made these calculations using the 1977 input-output table (assuming no change in industry structure) and 1977–86 figures (deflated to 1977 values) for U.S. direct investment abroad. Since data used to calculate s and X were not available for 1978–81 and 1983–86, we used the 1977 and 1982 estimates and only changed the level of USDIA by industry.

DISPLACEMENT BY OCCUPATION, GENDER, AND RACE

We made estimates of the occupational breakdown and gender and race characteristics of jobs lost by weighting the percentage participation of each occupational, race, or gender group by probability of unemployment compared with the probability of unemployment of the

labor force as a whole. This weighted proportion was then applied, by industry, to the figures for work years lost. For example, for women:

(4) $DW_i = W_i(uW_i/u_i)D_i$

> where DW_i = women displaced due to USDIA in industry i; W_i = proportion of women in the workforce in industry i; uW_i = unemployment rate for women in industry i; u_i = unemployment rate for the total labor force in industry i; and D_i = work years lost due to USDIA in industry i.

One final note about methodology. The calculations of job displacement in this chapter were carried out by a different methodology than used to calculate job change in chapter 5. The reason for the different methodology is straightforward: since none of the data used in chapter 5 are available for USDIA, we had to develop alternative methods. For example, the Commerce Department does not measure the displacement and stimulus effects, and we had to do that. The technique we used was appropriate to take account of what could have been produced in the United States which was produced abroad and what was produced in this country as a result of overseas production. The use of an input-output table properly added the indirect to the direct effects. No such input-output calculation was possible for FDIUS because the inward investment data are so highly aggregated. Although the techniques differ, the results are based on very conservative assumptions and time-honored economic techniques.

TABLE C.1

Employment Effects of U.S. Direct Investment Abroad, 1977 and 1982

	Export Displacement	Export Stimulus	Total Jobs Lost	Displacement per 1,000 Domestic Employees	Export Displacement	Export Stimulus	Total Jobs Lost	Jobs Lost per 1,000 Domestic Employees
Food, Feed, and Tobacco	31436	922	30514	17.3	27050	1058	25992	15.4
Textile Products and Apparel	12762	3058	9704	4.1	12875	4879	7996	4.2
Wood Products and Furniture	11169	1530	9638	8.0	7194	1896	5298	5.3
Paper, Printing and Publishing	29141	3554	25587	13.7	22167	4529	17638	9.2
Chemicals and Allied Products	35300	3110	32190	32.8	34624	4236	30388	34.1
Petroleum and Coal Products	9905	252	9653	14.3	7584	167	7417	13.3
Rubber, Plastics, and Leather	12454	1979	10474	46.1	19010	4420	14590	77.6
Stone, Clay, and Glass Products	6439	1474	4965	1.6	8575	1763	6813	2.9
Primary and Fabricated Metals	51726	14733	36993	14.8	49582	20340	29242	16.8
Nonelectrical Machinery	78717	5843	72874	11.7	61926	7242	54684	50.7
Electrical Equipment and Supplies	21979	5035	16945	6.4	24618	6898	17720	7.9
Transport Equipment and Ordnance	20482	3623	16859	8.8	25137	6323	18814	9.6
Other Manufacturing	16729	1112	15617	14.6	13272	1322	11950	11.0
TOTAL MANUFACTURING	338840	46225	292013	10.9	313614	65073	248542	13.3

NOTE: Foreign direct investment figures in millions of dollars.

TABLE C.2
Net Displacement by Industry and Year (Jobs Displaced)

	1977	1978	1979	1980	1981	1982	1983	1984	1985	1986	Total
Food, Feed, and Tobacco	30514	32532	35305	42243	35719	25992	23782	22603	24521	22590	296801
Textile Products and Apparel	9704	10187	20400	12090	10360	7996	5550	6629	7600	7119	87635
Wood Products and Furniture	9641	9456	8815	10005	7716	5298	3348	4383	4718	4525	67905
Paper, Printing and Publishing	25588	26589	26856	30872	25960	17638	12488	14512	16507	15523	212533
Chemicals and Allied Products	32190	28669	34245	36422	33013	30387	19642	23106	24920	26928	289922
Petroleum and Coal Products	9653	9037	9043	10199	9225	7417	2893	5549	6175	6137	75328
Rubber, Plastics, and Leather	10475	10666	10499	11734	9629	14590	10493	12749	14833	13786	119364
Stone, Clay, and Glass Products	4967	5032	5465	6252	5474	6813	4640	5582	6212	5872	56309
Primary and Fabricated Metals	36998	38054	42313	49032	42819	29242	29954	23467	23472	21705	327056
Nonelectrical Machinery	72875	81352	96257	103454	87442	54684	43510	38528	41826	43561	663489
Electrical Equipment and Supplies	16946	18687	21468	24208	20612	17720	15527	18988	18896	17850	190902
Transport Equipment and Ordnance	16859	18271	25133	33419	35805	18814	14785	14070	16889	16300	210345
Other Manufacturing	15617	18290	19235	24205	21259	11950	8535	9515	9533	10330	148469
All Manufacturing	292027	306820	346033	394135	345032	248540	185056	199680	216101	211625	2745049

TABLE C.3
*Jobs Displaced per Million Dollars of Investment
by Industry, 1977 to 1986*

Industry	1977	1986
Food, Feed, and Tobacco	34.5	29.2
Textile Products and Apparel	87.4	125.6
Wood Products and Furniture	94.5	126.8
Paper, Printing and Publishing	49.9	51.2
Chemicals and Allied Products	15.8	15.5
Petroleum and Coal Products	2.4	1.8
Rubber, Plastics, and Leather	24.0	66.6
Stone, Clay, and Glass Products	20.0	43.7
Primary and Fabricated Metals	67.9	106.4
Nonelectrical Machinery	24.6	21.5
Electrical Equipment and Supplies	24.0	28.9
Transport Equipment and Ordnance	10.4	11.9
Other Manufacturing	44.2	28.4
All Manufacturing	18.3	20.8

TABLE C.4
Net Displacement per 1,000 Domestic Employees

Industry	1977 Net Displacement per 1,000 Domestic Employees	1986 Net Displacement per 1,000 Domestic Employees
Food, Feed, and Tobacco	17.3	14.0
Textile Products and Apparel	4.1	6.4
Wood Products and Furniture	8.0	5.2
Paper, Printing, and Publishing	13.7	9.2
Chemicals and Allied Products	32.8	29.5
Petroleum and Coal Products	14.3	37.2
Rubber, Plastics, and Leather	46.1	18.9
Stone, Clay, and Glass Products	1.6	12.7
Primary and Fabricated Metals	14.8	18.1
Nonelectrical Machinery	11.7	24.1
Electrical Equipment and Supplies	6.4	11.4
Transport Equipment and Ordnance	8.8	10.8
Other Manufacturing	14.6	10.8
All Manufacturing	14.9	14.2

TABLE C.5
Total Displacement by Metropolitan Area, 1977
(Twenty-five MSAs with Greatest Displacement)

SMSA Name	Region	State	Displacement
Los Angeles–Long Beach	Far West	CA	5195
Chicago	Great Lakes	IL	4904
Detroit	Great Lakes	MI	3683
Philadelphia	Mideast	PA	2607
San Jose	Far West	CA	2597
Houston	Southwest	TX	2277
Boston	New England	MA	2238
Seattle–Everett	Far West	WA	2132
Dallas–Ft. Worth	Southwest	TX	2035
New York	Mideast	NY	1909
Cleveland	Great Lakes	OH	1696
Milwaukee	Great Lakes	WI	1638
Minneapolis–St. Paul	Plains	MN	1618
Anaheim–Santa Ana	Far West	CA	1560
St. Louis	Plains	MO	1512
Pittsburgh	Mideast	PA	1318
Cincinnati	Great Lakes	OH	1221
Buffalo	Mideast	NY	1182
Peoria	Great Lakes	IL	1172
Hartford	New England	CT	1104
Indianapolis	Great Lakes	IN	1075
Phoenix	Southwest	AZ	1027
Nassau–Suffolk Counties	Mideast	NY	852
Atlanta	Southeast	GA	823
Portland	Far West	OR	823
Total			47275

APPENDIX D

Supplementary State and Regional Data

This appendix provides additional information on inward foreign investment in America's regions and states. In the tables provided in chapter 7, we used BEA data to express the extent of foreign involvement in states. Since we cannot separate these data into "employment-creating" investments (new plants and expansions) and acquisitions and mergers, we used data from the International Trade Administration (ITA) described in appendix A.

The two tables that follow give the number of announced manufacturing transactions recorded by the ITA. The "index" in each table shows a state's relative strength in terms of new plants and expansions, or acquisitions and mergers, in comparison with the U.S. average. The index was constructed by first dividing the number of new plants and expansions (or acquisitions and mergers) by the number of manufacturing workers in a state, in order to adjust, or "normalize" for the varying size of the states. We then divided this "normalized" number by the average U.S. figure, and finally multiplied by 100 to get the index. Hence, a state with an index number above 100 is an attractive site for new plants and expansions, or for acquisitions and mergers.

TABLE D.1
New Plants and Expansions State and Regional Comparisons (1979–1986)

	New Plants/ Expansions	Share of U.S.	Index of New Plants and Expansions (U.S. Average = 100)
New England			
Connecticut	29	2.80%	127.42
Maine	7	0.68%	118.55
Massachusetts	21	2.03%	60.84
New Hampshire	2	0.19%	34.82
Rhode Island	8	0.77%	130.73
Vermont	9	0.87%	356.74
Total	76	7.35%	97.98
Mideast			
Delaware	12	1.16%	328.76
District of Columbia	0	0.00%	0.00
Maryland	27	2.61%	214.96
New Jersey	41	3.97%	101.30
New York	79	7.64%	103.72
Pennsylvania	39	3.77%	61.57
Total	198	19.15%	100.45
Great Lakes			
Illinois	33	3.19%	57.51
Indiana	19	1.84%	60.51
Michigan	26	2.51%	54.79
Ohio	33	3.19%	55.79
Wisconsin	9	0.87%	24.06
Total	120	11.61%	51.55
Plains			
Iowa	6	0.58%	52.48
Kansas	0	0.00%	0.00
Minnesota	5	0.48%	26.61
Missouri	18	1.74%	82.59
Nebraska	0	0.00%	0.00
North Dakota	0	0.00%	0.00
South Dakota	1	0.10%	74.52
Total	30	2.90%	43.94
Southeast			
Alabama	27	2.61%	152.42
Arkansas	10	0.97%	98.05
Florida	21	2.03%	86.17
Georgia	64	6.19%	237.04
Kentucky	25	2.42%	188.56
Louisiana	30	2.90%	276.68
Mississippi	9	0.87%	83.00
North Carolina	81	7.83%	188.86
South Carolina	28	2.71%	141.75
Tennessee	40	3.87%	161.30
Virginia	42	4.06%	200.11
West Virginia	8	0.77%	155.25
Total	385	37.23%	169.00

TABLE D.1 (continued)

	New Plants/ Expansions	Share of U.S.	Index of New Plants and Expansions (U.S. Average = 100)
Southwest			
Arizona	4	0.39%	49.68
New Mexico	1	0.10%	56.45
Oklahoma	6	0.58%	56.74
Texas	82	7.93%	144.25
Total	93	8.99%	120.40
Rocky Mountains			
Colorado	3	0.29%	29.11
Idaho	1	0.10%	38.81
Montana	0	0.00%	0.00
Utah	1	0.10%	22.45
Wyoming	0	0.00%	0.00
Total	5	0.48%	26.39
Far West			
California	98	9.48%	91.06
Nevada	1	0.10%	93.15
Oregon	11	1.06%	110.77
Washington	17	1.64%	108.83
Total	127	12.28%	94.60
Total U.S.	1034	100.00%	100.00

SOURCE: U.S. Department of Commerce, International Trade Administration.

TABLE D.2
Acquisitions and Mergers State and Regional Comparisons (1979–1986)

	Acquisitions/ Mergers	Share of U.S.	Index of Acquisitions and Mergers (U.S. Average = 100)
New England			
Connecticut	55	3.74%	169.75
Maine	5	0.34%	59.48
Massachusetts	62	4.21%	126.18
New Hampshire	12	0.82%	146.76
Rhode Island	13	0.88%	149.23
Vermont	4	0.27%	111.37
Total	151	10.26%	136.75
Mideast			
Delaware	9	0.61%	173.20
District of Columbia	5	0.34%	384.89
Maryland	19	1.29%	106.26
New Jersey	98	6.66%	170.09
New York	220	14.95%	202.89
Pennsylvania	92	6.25%	102.03
Total	443	30.10%	157.88
Great Lakes			
Illinois	89	6.05%	108.95
Indiana	23	1.56%	51.45

TABLE D.2 (continued)

	Acquisitions/ Mergers	Share of U.S.	Index of Acquisitions and Mergers (U.S. Average = 100)
Michigan	46	3.13%	68.10
Ohio	65	4.42%	77.19
Wisconsin	40	2.72%	75.10
Total	263	17.87%	79.36
Plains			
Iowa	8	0.54%	49.15
Kansas	7	0.48%	53.57
Minnesota	22	1.49%	82.26
Missouri	23	1.56%	74.13
Nebraska	2	0.14%	28.45
North Dakota	0	0.00%	0.00
South Dakota	2	0.14%	104.69
Total	64	4.35%	65.84
Southeast			
Alabama	8	0.54%	31.72
Arkansas	3	0.20%	20.66
Florida	48	3.26%	138.36
Georgia	38	2.58%	98.86
Kentucky	16	1.09%	84.77
Louisiana	12	0.82%	77.74
Mississippi	4	0.27%	25.91
North Carolina	32	2.17%	52.41
South Carolina	10	0.68%	35.56
Tennessee	18	1.22%	50.99
Virginia	11	0.75%	36.82
West Virginia	3	0.20%	40.89
Total	203	13.79%	62.59
Southwest			
Arizona	7	0.48%	61.07
New Mexico	3	0.20%	118.97
Oklahoma	7	0.48%	46.50
Texas	59	4.01%	72.91
Total	76	5.16%	69.11
Rocky Mountains			
Colorado	16	1.09%	109.05
Idaho	2	0.14%	54.53
Montana	0	0.00%	0.00
Utah	2	0.14%	31.53
Wyoming	0	0.00%	0.00
Total	20	1.36%	74.14
Far West			
California	222	15.08%	144.90
Nevada	4	0.27%	261.73
Oregon	9	0.61%	63.66
Washington	17	1.15%	76.45
Total	252	17.12%	131.86
Total U.S.	1472	100.00%	100.00

SOURCE: U.S. Department of Commerce, International Trade Administration.

NOTES

Chapter 1. Is America for Sale?

1. "To Serve Man," first aired 2 March 1962. Screenplay by Rod Serling, based on a short story, "To Serve Man," by Damon Knight. © 1950, Quinn Publishing Co. © renewed 1978 by Damon Knight.

2. *The Random House Dictionary of the English Language*, 2nd ed. (New York: Random House, 1987).

3. Smick-Medley and Associates, *Foreign Investment: A Smick-Medley and Associates Public Opinion Survey of U.S. Attitudes* (Washington, D.C.: Smick-Medley, 1988).

4. See, for example, Martin and Susan Tolchin, *Buying Into America: How Foreign Money Is Changing the Face of Our Nation* (New York: Times Books, 1988).

5. See Russell B. Scholl, "International Investment Position of the United States, 1987," *Survey of Current Business*, June 1987, pp. 76–84.

6. William H. Cooper, "Foreign Investments in the United States: Trends and Impacts," Congressional Research Service, Library of Congress, Report 85-932E, 10 September 1985; "Foreign Ardor Cools Toward U.S. Stocks after the Market's Dive," *Wall Street Journal*, October 1987 (no. 83), p. 1.

7. Alison Leigh Cowan, "The Resurgence of Takeovers," *New York Times*, 16 February 1988, pp. 16, 19.

8. "The Top 200 Deals," *Business Week*, special issue on "The Top 1000," 15 April 1988, pp. 47–81.

9. Robert T. Cole, "Seagram to Buy Tropicana Products," *New York Times*, 11 March 1988, pp. 29, 32; and Alix M. Freedman and Ed Bean, "Seagram to Buy Beatrice Unit for $1.2 Billion," *Wall Street Journal*, 11 March 1988, pp. 2, 10.

10. Carl Fischer, "Are Foreign Partners Good for U.S. Companies?," *Business Week*, 28 May 1984, p. 58; and Mike Borum, "How Overseas Investors Are Helping to Reindustrialize America," *Business Week*, 4 June 1984, p. 103.

11. Ned G. Howenstine, "U.S. Affiliates of Foreign Companies: Operations in 1986," *Survey of Current Business*, May 1988, pp. 59–75.

12. Stephen S. Roach, "Hooked on Foreign Investment," Morgan Stanley Special Economic Study (New York: Morgan Stanley, 13 April 1988).

13. Cynthia F. Mitchell, "Pentagon Eases Stand Against Foreign Stakes in U.S. Defense Firms," *Wall Street Journal*, 28 April 1988, p. 1.

14. Alan Murray, "Reagan's Legacy: America for Sale," *Wall Street Journal*, 29 February 1988, p. 1; and Bruce Nussbaum, "And Now the Bill Comes Due," *Business Week*, 16 November 1987, pp. 160–63.

15. Richard J. Barnet and Ronald E. Müller, *Global Reach: The Power of the Multinational Corporations* (New York: Simon & Schuster, 1974).

16. Obie G. Wichard, "U.S. Multinational Companies: Operations in 1986," *Survey of Current Business*, June 1988, pp. 85–96.

17. Raymond Vernon, "Multinationals Are Mushrooming," *Challenge*, May/June 1986, pp. 41–48.

18. Stephen Koepp, "For Sale: America," *Time*, 14 September 1987, pp. 52–62.

19. Elliot L. Richardson, "Why Foreign Investment in the U.S. Is Good for Us," *New York Times*, 8 June 1988, p. 26; "Foreign Money Is Good for USA," *USA Today*, 17 August 1988, p. 10A; "Don't Spurn That Investment," *Legal Times*, 27 June 1988, p. 23; and "Stop Worrying about Foreign Investors," *Connecticut Law Tribune*, 27 June 1988, p. 12.

20. Elliot L. Richardson, "U.S. Policy Towards Foreign Investment," written statement for presentation before the Subcommittee on International Economic Policy and Trade of the Committee on Foreign Affairs, U.S. House of Representatives, 22 September 1988.

21. Quoted in William Glasgall, "Foreign Investors Are Keeping the Pot Boiling," *Business Week*, 24 November 1986, p. 84.

22. Quoted in Frank J. Comes et al., "Europe Goes on a Shopping Spree in the States," *Business Week*, 27 October 1986, p. 55.

23. *New York Times*, 16 September 1985, p. 33.

24. Quoted in Martin and Susan Tolchin, *Buying Into America* (New York: Times Books, 1988), p. 71.

25. Quoted in John S. McClenahen, "Who Owns U.S. Industry?" *Industry Week*, 7 January 1985, p. 31.

26. June M. Collier, "Foreign Money Is Bad for USA," *USA Today*, 17 August 1988, p. 10A.

27. Felix G. Rohatyn, address to the Economic Club of Washington, D.C., 26 January 1988 (mimeo). See also Felix Rohatyn, "Restoring American Independence," *New York Review of Books*, 18 February 1988, p. 8.

28. Malcolm S. Forbes, "Before Japan Buys Too Much of the U.S.A.," *Forbes*, 25 January 1988, p. 17.

29. Larry Armstrong, "What All of America's Japan-Bashing Can't Change," *Business Week*, 31 August 1987, p. 63.

30. On the Fujitsu-Fairchild controversy, see David E. Sanger, "Chip Maker's Sale to Japan Is Ended by Pressure in U.S.," *New York Times*, 17 March 1987, p. 1, 26; and Breton R. Schlender, "Fujitsu Drops Plans to Acquire U.S. Chip Maker," *Wall Street Journal*, 17 March 1987, p. 3.

31. See Ken Wells, "Fujitsu to Invest Initial $70 Million for Oregon Plant," *Wall Street Journal*, 26 August 1987, p. 15; and Jonathan B. Levine, "Why National Came to the Fairchild Fire Sale," *Business Week*, 14 September 1987, pp. 38–39.

32. Reported in Kenneth H. Bacon, "The Jackson Message and Economic Angst," *Wall Street Journal*, 21 March 1988, p. 1.

33. Paul Kennedy, *The Rise and Fall of the Great Powers* (New York: Random House, 1987), p. 533.

34. Peter Kilborn, "Economic Nationalism Shapes Democratic Campaign Debate," *New York Times*, 22 March 1988, pp. 1, 10; and Ethel Klein, "The Number 1 Issue in '88," *New York Times*, 21 March 1988, p. 19.

35. Quoted in Andrew Rosenthal, "Dukakis Says Standard of Living Is Deteriorating," *New York Times*, 4 October 1988, p. 14.

36. Robin Toner, "Ownership of a Speech Site Catches Dukakis Unawares," *New York Times*, 8 October 1988, p. 8.

37. Barry Bluestone and Bennett Harrison, *The Deindustrialization of America* (New York: Basic Books, 1982), p. 6.

38. See Robert Lawrence, *Can America Compete?* (Washington, D.C.: Brookings Institution, 1984).

39. See Office of Technology Assessment, *Technology and the American Economic Transition* (Washington, D.C.: U.S. Congress, Office of Technology Assessment, May 1988; and

Lawrence Mishel, *Manufacturing Numbers: How Inaccurate Statistics Conceal U.S. Industrial Decline* (Washington, D.C.: Economic Policy Institute, 1988).

40. For a discussion of growing inequality, see Bennett Harrison and Barry Bluestone, *The Great U-Turn: Corporate Restructuring and the Polarizing of America* (New York: Basic Books, 1988).

41. Smick-Medley and Associates, *Foreign Investment: A Smick-Medley and Associates Public Opinion Survey of U.S. Attitudes* (Washington, D.C.: Smick-Medley, 1988), p. 4.

42. Quoted in Rick Van Sant, "James Rhodes Laid Groundwork in Japan 10 Years Before Honda Built in Marysville," UPI wire story, 1 June 1987.

43. This assumption runs through much of Martin and Susan Tolchin's *Buying Into America*.

44. Aaron Bernstein et al., "The Difference Japanese Management Makes," *Business Week*, 14 July 1986, pp. 47–50.

45. John S. McClenahen, "Who Owns U.S. Industry?," *Industry Week*, 7 January 1985, pp. 30–34.

46. See Francois Hetman, *Les Secrets des giants américains* (Paris: Seuil, 1969). For other analyses of the "American Challenge" during the 1960s, see S. H. Robock, "The American Challenge—an Inside Story," *Hermes Exchange*, 1 (2 [October 1968]).

47. Jean-Jacques Servan-Schreiber, *The American Challenge* (New York: Atheneum, 1969).

48. On this subject, see Robert B. Reich, "Corporation and Nation," *Atlantic Monthly*, May 1988, pp. 76–81.

49. President's Commission on Industrial Competitiveness, *Global Competition: The New Reality*, vol. II (Washington, D.C.: U.S. Printing Office, 1985), p. 6.

50. Cuomo Commission on Trade and Competitiveness, *The Cuomo Commission Report* (New York: Simon & Schuster, 1988), especially chap. 1; Ray Marshall and Norman J. Glickman, *Choices for American Industry* (Washington, D.C.: Labor Policy Institute, 1987); and President's Commission on Industrial Competitiveness, *Global Competition*.

Chapter 2. Inward Investment: The Essential Facts

1. Milton Moskowitz, *The Global Marketplace: 102 of the Most Influential Companies Outside America* (New York: Macmillan, 1987), p. 322.

2. Quoted in Kenneth Labich, "An Irishman Feasts on American Trees," *Fortune*, 20 July 1987, p. 62.

3. John Bryant, "Our Policy Toward Foreign Investment in the United States: Open Door, But Not Open Book," speech before the Brookings Institute, Washington, D.C., 1 April 1987.

4. Ned G. Howenstine, "U.S. Affiliates of Foreign Companies: Operations in 1985," *Survey of Current Business*, May 1987, p. 36.

5. Rainer Hellman, *The Challenge to U.S. Dominance of the International Corporation* (New York: Dunellen, 1970), p. 168.

6. Further details on the history of inward investment can be found in Peter J. Buckley and Brian R. Roberts, *European Direct Investment in the U.S.A. Before World War I* (New York: St. Martin's, 1982); Lawrence G. Franko, *The European Multinationals* (Stamford, Conn.: Greylock, 1976); David S. McClain, *Foreign Investment in United States Manufacturing and the Theory of Direct Investment*, unpublished Ph.D. dissertation, Massachusetts Institute of Technology, 1974; and Cleona Lewis, *America's Stake in International Investments* (Washington, D.C.: Brookings Institution, 1938).

7. See Edward Craypol, *America for Americans* (Westport, Conn.: Greenwood Press, 1973, p. 92).

8. Lewis, *America's Stake*, p. 87.

9. Quoted in Craypol, *America for Americans*, p. 96.

10. Ibid., p. 112.

11. Buckley and Roberts, *European Direct Investment*, p. 120.

12. Ibid., p. 122.

13. For more on the early history of inward investment, see Lawrence G. Franko, *The European Multinationals* (Stamford, Conn.: Greylock, 1976).

14. Buckley and Roberts, *European Direct Investment*, p. 122.

15. Moskowitz, *Global Marketplace*, p. 47. After World War II, 80 percent of I. G. Farben's Ludwigshafen plant was decimated by the Allies.

16. Franko, *European Multinationals*.

17. Data on FDIUS and USDIA are summarized in U.S. Department of Commerce, International Trade Administration, *International Direct Investment: Global Trends and the U.S. Role*, vol. II (Washington, D.C.: U.S. Government Printing Office, 1988).

18. For further discussion of this point, see Robert E. Lipsey, *Changing Patterns of International Investment in and by the United States*, working paper no. 2240 (Cambridge, Mass.: National Bureau of Economic Research, May 1987), p. 47.

19. Lewis, *America's Stake*, p. 151.

20. Smick-Medley and Associates, "Foreign Investment: A Smick-Medley and Associates Public Opinion Survey of U.S. Attitudes," *Smick-Medley White Paper*, March 1988, p. 12.

21. See William C. Symonds, "Kuwait's Money Machine Comes Out Buying," *Business Week*, 7 March 1988, pp. 94–98.

22. Alan M. Rugman and John McIlveen, "Canadian Foreign Direct Investment in the United States," in H. Peter Gray, ed., *Uncle Sam as Host* (Greenwich, Conn.: JAI Press, 1986), p. 291.

23. Richard E. Caves and Sanjeev K. Mehra, "Entry of Foreign Multinationals into U.S. Manufacturing Industries," in Michael E. Porter, ed., *Competition in Global Industries* (Boston: Harvard Business School Press, 1986), pp. 449–81.

24. Anthony M. Solomon, "Checking the Spread of a New Xenophobia," *New York Times*, 31 May 1988, p. A19.

25. Annual data or employment assets from new foreign acquisitions and establishments are found in the May issues of the *Survey of Current Business*. See, for example, Ellen M. Herr, "U.S. Business Enterprises Acquired or Established by Foreign Direct Investors in 1987," *Survey of Current Business*, May 1988, pp. 50–58. Note that manufacturing exhibits a similar pattern to the one described for total investment in the text.

26. Connie Bruck, *The Predators' Ball: The Junk-Bond Raiders and the Man Who Staked Them* (New York: American Lawyer/Simon & Schuster, 1988), p. 97.

27. For further details see *Mergers & Acquisitions 1988 Almanac & Index* 22 (6 [May/June 1988]).

28. Kevin F. Winch and Sheldon J. Brown, "Foreign Mergers and Acquisitions: Non-U.S. Companies Acquiring U.S. Companies," *Congressional Research Service Report for Congress 87-711 E* (Washington, D.C.: Library of Congress, 12 August 1987), p. 8.

29. William Glassgall, "Foreign Investors Are Keeping the Pot Boiling," *Business Week*, 24 November 1986, p. 84.

30. Moskowitz, *Global Marketplace*, p. 614.

31. Geoffrey Wansell, "Sir James Takes on Goodyear," *Business Month*, July 1987, p. 22.

32. See Jonathan P. Hicks, "Goodyear Will Celeron," *New York Times*, 11 August 1987, pp. 29, 31; Zachary Schiller and John Roussant, "Trying to Beat Sir Jimmy to the Punch," *Business Week*, 17 November 1986, pp. 64–65; and Moskowitz, *Global Marketplace*, pp. 221–27. Goldsmith is the subject of a recent biography: Geoffrey Wansell, *Tycoon, The Life of James Goldsmith* (Atheneum, 1987).

Notes

33. Bruck, *Predators' Ball*, p. 257.

34. "Campeau At Last Gets Federated—Now Can He Make a Go of It," *Wall Street Journal*, 4 April 1988, p. 1.

35. This tally of new plants versus acquisitions was taken from information supplied on computer tape by the U.S. International Trade Administration. See appendix A for a discussion of this data source. The data cited in the text are found in table A.2.

36. "Trickle of Takeovers by the Japanese," *Business Week*, 6 July 1987, p. 19.

37. Barbara Rudolf, "Yen Power Goes Global," *Time*, 8 August 1988, pp. 24–29.

38. Here we borrow from the title of a work by Stephen Cohen and John Zysman: *Manufacturing Matters: The Myth of the Post-Industrial Economy* (New York: Basic Books, 1987).

39. See Buckley and Roberts, *European Direct Investment*, p. 122; and Lewis, *America's Stake*, p. 546.

40. Quoted in Thomas F. O'Boyle, "Germany Beats World in Chemicals," *Wall Street Journal*, 3 May 1988, p. 26.

41. For details, see Josef C. Branda and Jose A. Mendez, "Foreign Direct Investment in the U.S. Pharmaceutical Industry," in H. Peter Gray, ed., *Uncle Sam as Host* (Greenwich, Conn.: JAI Press, 1986), pp. 223–59.

42. See Peter Gumbel and Douglas R. Sease, "Foreign Firms Build More U.S. Factories, Vex American Rivals," *Wall Street Journal*, 24 July 1987, p. 6.

43. See Gene G. Marcial, "Foreigners May Mix It Up with This Cement Maker," *Business Week*, 20 June 1988, p. 134.

44. Moskowitz, *Global Marketplace*, p. 418.

45. Quoted in Leslie Wayne, "Australian Concern to Buy Ms.," *New York Times*, 24 September 1987, p. 29.

46. For more on foreign investment in U.S. media, see Philip Rezin, "Two Publishing Giants Fight for Dominance in Europe of the 1990s," *Wall Street Journal*, 25 January 1988, pp. 1, 15; Deborah Wise, "Hachette: From Zola to a $3 Billion Giant," *New York Times*, 21 March 1988, p. 28; John Marcom, Jr., "Britain's Maxwell Is a Press Baron Who's Always on Deadline," *Wall Street Journal*, 19 November 1987, pp. 1, 12; and Moskowitz, *Global Marketplace*.

47. See Mark Nelson, "NV Philips Bids $50 a Share for the 42% of North American Unit It Doesn't Own," *Wall Street Journal*, 17 August 1987, pp. 3, 6.

48. Jaclyn Fierman, "The Selling Off of America," *Fortune*, 22 December 1986, p. 49.

49. Craypol, *America for Americans*, p. 110.

50. Quoted in Steve Lohr, "The Global Strategy at Grand Met," *New York Times*, 6 October 1988, p. D1.

51. See Moskowitz, *Global Marketplace*, p. 397.

52. Moskowitz, *Global Marketplace*, p. 324.

53. Barbara Buell, with Jonathan B. Levine and Lois Therrien, "American Food Companies Look Yummy to Japan," *Business Week*, 20 June 1988, pp. 61–62.

54. Quoted in Gregory Stricharchuk, "Foreign Tire Firms Want More of Robust U.S. Tire Market," *Wall Street Journal*, 11 November 1987, p. 29.

55. Michael F. Bryan and Michael W. Dvorak, "American Automobile Manufacturing: It's Turning Japanese," *Economic Commentary* (Cleveland, Ohio: Federal Reserve Bank of Cleveland, 1 March 1986); Richard Florida, Martin Kenney, and Andrew Mair, "The Transplant Phenomenon: Japanese Automobile Manufacturers in the United States," Working Paper 88–29, School of Urban and Public Affairs, Carnegie-Mellon University, May 1988.

56. Stephen S. Roach, "Hooked on Foreign Investment," *Morgan Stanley Special Economic Study*, 13 April 1988.

57. Christopher J. Chipello, "Foreign Rivals Imperil U.S. Firms' Leadership in the Service Sector," *Wall Street Journal*, 3 March 1988, p. 1.

58. William E. Sheeline, "Making Them Rich Down Home," *Fortune*, 15 August 1988, pp. 51–55.

59. Yoshi Tsurumi, *Sogoshosha: Engines of Export-Based Growth* (Montreal, Quebec: The Institute for Research on Public Policy, 1980); and Kathleen Wiegner, "Outward Bound," *Forbes*, 4 July 1983, p. 96.

60. Kang Rae Cho, Suresh Krishnan, and Douglas Nigh, "The State of Foreign Banking Presence in the United States," *International Journal of Bank Marketing*, Volume 5, Number 2, 1987, pp. 59–75.

61. Banking figures represent the figures tallied as of April 1988 by the U.S. Federal Reserve Board, which supplied them directly to us.

62. Quoted in *Euromoney*, "Forging Links in California," July 1988 supplement, p. 38.

63. Gary Hector, "The Japanese Want to Be Your Bankers," *Fortune*, 27 October 1986, p. 97.

64. Daniel Burstein, *Yen! Japan's New Financial Empire and Its Threat to America* (New York: Simon & Schuster, 1988), p. 180.

65. Burstein, *Yen!*, p. 168.

66. Gary Hector, "The Japanese Want to Be Your Bankers," *Fortune*, p. 97; Burstein, *Yen!*, p. 32; and Moskowitz, *Global Marketplace*, p. 435.

67. Burstein, *Yen!*, p. 34.

68. James Sterngold, "2 Top Investment Banks to Merge, Giving Swiss a Big Wall St. Stake," *New York Times*, October 10, 1988, p. 1.

69. Prestowitz, *Trading Places*, pp. 11–12.

70. Smick-Medley, "Foreign Investment," pp. 8–9.

71. J. Peter DeBraal, *Foreign Ownership of U.S. Agricultural Land Through December 31, 1987* (Washington, D.C.: United States Department of Agriculture), April 1988.

72. Anthony Downs, "Foreign Capital in the U.S. Real Estate Markets" (New York: Solomon Brothers), April 1987.

73. Coldwell Banker Boston, *Survey of International Investment*, prepared by James B. O'Brien (Boston: Coldwell Banker Commercial Real Estate Services), July 1987.

74. Robert Lindsey, "Japanese Riding Hawaii's Real Estate Boom," *New York Times*, 18 March 1988, pp. 1, 12.

75. Roger Lowenstein and Masayoshi Kanabayashi, "Maverick Tokyo Firm Acquires Office Towers in U.S. at a Fast Pace," *New York Times*, 23 September 1987, p. 12.

76. The real estate figures are total assets held by Canadians in 1986, as reported in Howenstine, "U.S. Affiliates," p. 47.

77. Quoted in Martin Tolchin, "Britons' Buying Spree: Prime Real Estate," *New York Times*, 17 January 1986, p. 14.

78. Quoted in Coldwell Banker Boston, *Survey of International Investment*, p. 5.

79. "Dirt Cheap," *Dollars and Sense*, April 1988, p. 5.

80. "The New Wheeler-Dealers in U.S. Real Estate are Japanese," *Business Week*, 27 October 1986, p. 55.

81. The government outlay figures can be found in Ellen M. Herr, "U.S. Business Enterprises Acquired or Established by Foreign Direct Investors in 1987," *Survey of Current Business*, May 1988, pp. 50–58. Private estimates are reported in Coldwell Banker Boston, *Survey of International Investment*.

82. Coldwell Banker Boston, *Survey of International Investment*.

83. Eric N. Berg, "Japanese Lift Purchases of U.S. Property," *New York Times*, 10 October 1988, pp. 21–22.

84. Joyce Terhaar, "Japanese Investing in U.S. Golf Courses—Is it Fore-Sight?" *Sacramento Bee*, 26 July 1988, p. 1.

85. Coldwell Banker Boston, *Survey of International Investment*, Introduction.

86. Louis J. Sousa, Elizabeth H. Yaremchuk, and Annette P. Graham, *Foreign Direct Investment in the U.S. Minerals Industry* (Avondale, Md.: U.S. Department of the Interior,

Bureau of Mines, 1987), p. 4. The data are for 1985 and are based on the voting security shares held by foreign investors in U.S. firms.

87. Moskowitz, *Global Marketplace*, p. 528.

88. Bryant, "Our Policy Toward Foreign Investment in the United States."

89. Charles Dickens, *The Works of Charles Dickens* (New York: Peter Fenelon Collier), vol. 17, p. 143.

Chapter 3. The Roots of Foreign Multinational Power

1. Stephen Hymer, *The International Operations of National Firms: A Study of Direct Foreign Investment* (Cambridge, Mass.: MIT Press, 1976). For appraisals of Hymer's lasting contribution to the theory of FDI, see John H. Dunning and Alan M. Rugman, "The Influence of Hymer's Dissertation on the Theory of Foreign Direct Investment," *American Economic Review* 75 (2 [May 1985]): 228–32; and David J. Teece, "Multinational Enterprise, Internal Governance, and Industrial Organization," *American Economic Review* 25 (2 [May 1985]): 233–38.

2. "German Investment in the United States: Innocents Abroad?," *German-American Trade News*, July/August 1982, p. 11.

3. For detailed reading on direct investment theory, see Charles P. Kindleberger, *American Business Abroad* (New Haven, Conn.: Yale University Press, 1969); and Richard Caves, *Multinational Enterprise and Economic Analysis* (New York: Cambridge University Press, 1982).

4. See John H. Dunning, *International Production and the Multinational Enterprise* (New York: Praeger, 1981).

5. According to Paul Baran and Paul Sweezy, *Monopoly Capital* (New York: Monthly Review Press, 1968), p. 193.

6. "Special Report: Multinational Companies," *Business Week*, 20 April 1963, pp. 62–86.

7. Raymond Vernon, *Sovereignty at Bay: The Spread of U.S. Enterprises* (New York: Basic Books, 1971), p. 4.

8. Richard J. Barnet and Ronald E. Müller, *Global Reach: The Power of the Multinational Corporations* (New York: Simon & Schuster, 1974).

9. Milton Moskowitz, *The Global Marketplace: 102 of the Most Influential Companies Outside America* (New York: Macmillan, 1987), p. 615.

10. Ibid., p. 615.

11. See Karl Marx and Frederick Engels, "Manifesto of the Communist Party," in Robert C. Tucker, ed., *The Marx-Engels Reader* (New York: W. W. Norton, 1972), p. 338.

12. See Mansfield Williams, "Petrochemicals and Chemicals," in H. Peter Gray, ed., *Uncle Sam as Host* (Greenwich, Conn.: JAI Press), p. 210.

13. "Overseas Mills Seek U.S. Haven," *Textile World News*, January 1987, pp. 25–30.

14. Ibid., p. 26.

15. For a variation on this theme, see Alan M. Rugman, "Risk Reduction by International Diversification," *Journal of International Business Studies*, Fall–Winter 1976, pp. 75–80.

16. Quoted in Pauline Yoshihashi and David B. Hilder, "B.A.T-Farmers Pact is Met with Anger of Outside Groups," *Wall Street Journal*, September 1988, p. 2.

17. Quoted in Barnet and Müller, *Global Reach*, p. 349.

18. Moskowitz, *Global Marketplace*, p. 40.

19. Quoted in Hope Lampert, "Britons on the Prowl," *New York Times Magazine*, 29 November 1987, p. 22.

20. Lampert, "Britons," p. 22; Moskowitz, *Global Marketplace*, p. 246.

21. "Special Report: Multinational Companies," *Business Week*, 20 April 1963, p. 76.

22. Richard E. Caves, "International Corporations: The Industrial Economics of Foreign Investment," *Economica*, 38 (1971): 5.

23. Surveys confirm the disadvantages of Japanese investment in the United States: see, for example, Martin K. Starr and Nancy E. Bloom, "The Performance of Japanese-Owned Firms in America: A Survey Report" (New York: Columbia University Center for Operations, Graduate School of Business, 1985).

24. See David A. Ricks, "International Business Blunders: An Update," *Business and Economic Review*, College of Business Administration, University of South Carolina, 34 (2 [January–March 1988]): 13.

25. Sadami (Chris) Wada, testimony on Japanese investment in California before the California Assembly Committee on International Trade and Intergovernmental Relations, Los Angeles, California, 27 September 1988, mimeo, p. 2.

26. Barry Bluestone and Bennett Harrison, *The Deindustrialization of America* (New York: Basic Books, 1982).

27. "Going Global: You'll Need Lawyers, Lobbyists—and Luck," *Business Week*, 21 March 1988, p. 146.

28. See Charles P. Kindleberger, *American Business Abroad* (New Haven, Conn.: Yale University Press, 1969).

29. See United Nations Centre on Transnational Corporations (UNCTC), *Transnational Corporations in World Development* (New York: United Nations, 1983).

30. Robert E. Lipsey and Irving B. Kravis, "Technological Factors in the Overseas Activities of U.S. Firms," paper presented at the American Economic Association Annual Meetings (Washington, D.C., 1981). For a summary of their results, see John M. Connor, "Determinants of Foreign Direct Investment by Food and Tobacco Manufacturers," *American Journal of Agricultural Economics*, 1983, p. 399. Further statistical tests confirm the role of size in multinational production abroad: see Thomas Horst, "Firm and Industry Determinants of the Decision to Invest Abroad," *Review of Economics and Statistics* 54 (1972): 258–66; and C. F. Bergsten, T. Horst, and T. Moran, *American Multinationals and American Interests* (Washington, D.C.: Brookings Institution, 1978).

31. J.-J. Servan-Schreiber, *The American Challenge* (New York: Atheneum, 1968), p. 153.

32. Stephen Hymer and Robert Rowthorn, "Multinational Corporations and International Oligopoly: The Non-American Challenge," in Charles P. Kindleberger, ed., *The International Corporation* (Cambridge, Mass.: MIT Press, 1970), pp. 57–91.

33. Diana Federman and Margret Studer, "Swiss Go on a European Shopping Spree," *Wall Street Journal*, 31 August 1988, p. 20.

34. "A 'Europe Without Borders' in 1992: The Economic Impact," *European Community News*, 13 April 1988.

35. See "Hands Across Europe: Deals That Could Redraw the Map," *Business Week*, 18 May 1987, pp. 64–65.

36. "How Business is Creating Europe Inc.," *Business Week*, 7 September 1987, p. 40.

37. Barbel (Barbara) Jacob, "The European Perspective on 1992," testimony before the California Assembly Committee on International Trade and Intergovernmental Relations, Los Angeles, California, 27 September 1988.

38. For an exhaustive history of Japanese business enterprise, see Johannes Hirschmeier and Tsunehiko Yui, *The Development of Japanese Business* (Cambridge, Mass.: Harvard University Press, 1975).

39. Figures compiled from "*The Fortune 500*," *Fortune*, August 1959 and 1 August 1988.

40. Geoffrey S. Carroll, "Multinational Reshuffle," in Robert E. Baldwin and J. David Richardson, eds., *International Trade and Finance* (Boston: Little, Brown, 1986). Lawrence Franko was among the first to note that the U.S. share of the top multinational companies was slipping. See Lawrence F. Franko, "Multinationals: The End of U.S. Dominance," *Harvard Business Review* 56 (6 [November–December 1978]).

41. The effect of European industrial integration on overseas production was explained

by Stephen Hymer and Robert Rowthorn, among the first economists to stress the connection between mergers and foreign investment: see Stephen Hymer and Robert Rowthorn, "Multinational Corporations and International Oligopoly," in Charles P. Kindleberger, ed., *The International Corporation* (Cambridge, Mass.: MIT Press, 1970), p. 75.

42. The economic historian Alfred Chandler has thoroughly documented this history: see, for example, Alfred Chandler, "The Evolution of Modern Global Competition," in Michael E. Porter, ed., *Competition in Global Industries* (Boston: Harvard Business School Press, 1986), pp. 408–9.

43. See Mansfield Williams, "Petrochemicals and Chemicals," in H. Peter Gray, ed., *Uncle Sam as Host* (Greenwich, Conn.: JAI Press), p. 199.

44. See U.S. Bureau of the Census, *Selected Characteristics of Foreign-Owned U.S. Firms: 1982* (Washington, D.C.: U.S. Bureau of the Census, 1984).

45. William J. Kahley, "Countervailing Advantages and Foreign Direct Investment in the United States," Federal Reserve Bank of Atlanta Working Paper Series, Working Paper 88–1, March 1988.

46. See Sanjaya Lall and N. S. Siddharthan, "The Monopolistic Advantages of Multinationals: Less from Foreign Investment in the U.S.," *Economic Journal*, September 1982, pp. 668–83.

47. See U.S. Department of Commerce, *Foreign Direct Investment in the United States: Report of the Secretary of Commerce to the Congress in Compliance with the Foreign Investment Study Act of 1974* (Washington, D.C.: U.S. Government Printing Office, 1976), vol. 3, appendix 2, p. 258. On the high profits of large firms, see Joseph Bowring, *Competition in a Dual Economy* (Princeton, N.J.: Princeton University Press, 1986).

48. Quoted in Thomas F. O'Boyle, "Germany Beats World in Chemicals," *Wall Street Journal*, 3 May 1988, p. 26.

49. See Ronald Coase, "The Nature of the Firm," *Economica* 4 (1937): 386–405; Kenneth J. Arrow, "Economic Welfare and the Allocation of Resources for Invention," in Kenneth Arrow, *The Rate and Direction of Inventive Activity* (Princeton: National Bureau of Economic Research, Princeton University Press, 1962); and Harry G. Johnson, "The Efficiency and Welfare Implications of the International Corporation," in Kindleberger, *International Corporation*.

50. Clyde V. Prestowitz, Jr., *Trading Places: How We Allowed Japan to Take the Lead* (New York: Basic Books, 1988), pp. 200–202.

51. On the appropriability theory of direct investment, see Stephen P. Magee, "Information and the Multinational Corporation: An Appropriability Theory of Direct Foreign Investment," in J. N. Bhagwati, ed., *The New International Economic Order* (Cambridge, Mass.: MIT Press, 1977). In addition, Buckley and Casson offer a thorough discussion and critique of how this "internalization" concept is incorporated in the market imperfection/industrial organization approach, an argument derived from established theories about markets for factors such as human capital, knowledge, and marketing/management expertise: see Peter Buckley and Mark Casson, *The Economic Theory of the Multinational Enterprise* (New York: St. Martin's Press, 1985).

52. See Vernon, *Sovereignty at Bay*.

53. See Richard E. Caves, "Multinational Firms, Competition and Productivity in Host Country Markets," *Economica* 41 (May 1974); and "The Causes of Direct Investment: Foreign Firms' Shares in Canadian and U.S. Manufacturing Industries," *Review of Economics and Statistics*, 56 (August 1974).

54. For a review of the literature on the theory of service multinationals, see J. J. Boddewyn, Marsha Baldwin Halbrich, and A. C. Perry, "Service Multinationals: Conceptualization, Measurement and Theory," *Journal of International Business Studies*, Fall 1986, pp. 41–58.

55. Cf. Kahley, "Countervailing Advantages"; and Lall and Siddharthan, "Monopolistic Advantages." See also Wi Saeng Kim and Esmeralda O. Lyn, "Foreign Direct Investment

Theories, Entry Barriers, and Reverse Investments in U.S. Manufacturing Industries," *Journal of International Business Studies*, Summer 1987, pp. 53–65. For a series of case studies that explore the existence of ownership advantages in FDIUS, see Gray, *Uncle Sam.*

56. Douglas F. Lamont, *Foreign State Enterprise: A Threat to American Business* (New York: Basic Books, 1979), p. 9; Lamont's analysis was based on 59 investments by foreign state enterprises from 1957 to 1976. For a stinging critique of Lamont's thesis, see R. Mazolini, "Review of *Foreign State Enterprises: A Threat to American Business,*" *Political Science Quarterly* 94 (4 [Winter 1979–1980]): 712–13.

57. U.S. Department of Commerce, International Trade Administration, *Direct Investment in the United States by Foreign Government-Owned Companies 1974–81*, Technical Report (Washington, D.C.: U.S. Government Printing Office, March 1983), p. 11.

58. Alan M. Rugman and John McIlveen, "Canadian Foreign Direct Investment in the United States," in H. Peter Gray, *Uncle Sam As Host* (Greenwich, Conn.: JAI Press), p. 296.

59. Ibid., pp. 289–307.

60. The survey was conducted by Lippincott & Margulies and reported in Randall Poe, "Fast Forward," *Across the Board*, September 1988, pp. 6–7.

61. For a discussion of these and other examples of FDIUS in the electronics industry, see Frederick A. Moses and Thomas A. Pugel, "Foreign Direct Investment in the United States: The Electronics Industries," in H. Peter Gray, ed., *Uncle Sam as Host* (Greenwich, Conn.: JAI Press, 1986), pp. 111–61. As more data have become available, general empirical evidence demonstrating the connection between advertising and inward investment is beginning to emerge, supporting studies of U.S. investment abroad: see Kahley, "Countervailing Advantages."

62. Eugene Carlson, "How a Major Swedish Retailer Chose a Beachhead in the U.S.," *Wall Street Journal*, 7 April 1987, p. 37; "Shopping Swedish-Style Comes to the U.S.," *Fortune*, 20 January 1986, p. 63.

63. Sherman Gee, *Technology Transfer, Innovation, and International Competitiveness* (New York: John Wiley, 1981), p. 70.

64. Ibid., p. 60.

65. Ibid., p. 60.

66. William J. Broad, "Novel Technique Shows Japanese Outpace Americans in Innovation," *New York Times*, 3 March 1988, p. 1.

67. Ibid., p. 7. See also Francis Narin and Dominic Olivastra, "Identifying Areas of Leading Edge Japanese Science and Technology," Final Report to International Studies Group, National Science Foundation, prepared by CHI Research/Computer Horizons, Inc., Haddon Heights, N.J., 5 April 1988.

68. See, for example, Lawrence G. Franko, *The European Multinationals* (Stamford, Conn.: Greylock, 1976).

69. Moskowitz, *Global Marketplace*, p. 86.

70. Franko, *European Multinationals.*

71. Richard J. Schonberger, *Japanese Manufacturing Techniques: Nine Hidden Lessons in Simplicity* (New York: Free Press, 1982), p. 2.

72. Ibid., p. 11.

73. Ibid., p. vii.

74. Ibid., p. 20.

75. Ibid., p. 101.

76. There is some evidence supporting the defensive reaction theory of FDI flows: see Frederick T. Knickerbocker, *Oligopolistic Reaction and Multinational Enterprise* (Cambridge, Mass.: Harvard University Press, 1973); and Edward M. Graham, "Transatlantic Investment by Multinational Firms: A Rivalistic Phenomenon," *Journal of Post Keynesian Economics* 1 (1978): 82–99.

77. See Edward B. Flowers, "Oligopolistic Reactions in European and Canadian Direct Investment in the United States," *Journal of International Business Studies* (2 [1976]): 43–55.

Notes

For a critique, see David McClain, "Foreign Direct Investment in the United States: Old Currents, 'New Waves,' and the Theory of Direct Investment," in Charles P. Kindleberger and David B. Audretsch, eds., *The Multinational Corporation in the 1980s* (Cambridge, Mass.: MIT Press, 1983), pp. 278–333, especially p. 311.

78. Dennis J. Encarnation, "Cross-Investment: A Second Front of Economic Rivalry," in Thomas K. McCraw, ed., *America Versus Japan* (Boston: Harvard Business School Press, 1986), pp. 130–31.

79. John Maynard Keynes, *The General Theory of Employment, Interest, and Money* (New York: Harcourt, Brace, & World, 1964 [1936]), p. 149.

80. Some of the difficulties and blunders of early direct investment by European multinationals can be found in Robert Heller and Norris Willat, *The European Revenge* (New York: Charles Scribner, 1975).

81. Moskowitz, *Global Marketplace*, p. 590.

82. Quoted in Laurie Hays, "Bronfmans of Seagram Take Increasing Role in Du Pont Co. Affairs," *Wall Street Journal*, 17 July 1987, p. 1.

83. Quoted in Hays, "Bronfmans of Seagram," p. 16.

84. Quoted in Alix M. Freedman and Ed Bean, "Seagram to Buy Beatrice Unit for $1.2 Billion," *Wall Street Journal*, 11 March 1988, p. 2.

85. Quoted in Alix M. Freedman, "An Orange Juice War Is Growing As Makers Vie for Fresh Markets," *Wall Street Journal*, 27 April 1988, p. 32.

Chapter 4. The Appeal of America

1. William J. Holstein, "Japan, U.S.A.," *Business Week*, 14 July 1986, p. 46.

2. George Gilder, *Wealth and Poverty* (New York: Basic Books, 1981), pp. 43–44.

3. Adam Smith, *An Inquiry into the Nature and Causes of the Wealth of Nations* (New York: Modern Library, 1965 [1776]), p. 5.

4. Joseph Grunwald and Kenneth Flamm, *The Global Factory: Foreign Assembly in International Trade* (Washington, D.C.: Brookings Institution, 1985).

5. See Folker Frobel, Jurgen Heinrichs, and Otto Kreye, *The New International Division of Labor: Structural Unemployment in Industrialized Countries and Industrialization in Developing Countries* (Cambridge: Cambridge University Press, 1980). A good critique of the IDOL concept is found in Erica Schoenberger, "Multinational Corporations and the New International Division of Labor: Incorporating Competitive Strategies into a Theory of International Location," paper presented at the annual meetings of the North American Regional Science Association, Denver, Colorado, 10 November 1984.

6. See Stephen Hymer, "The Multinational Corporation and the Law of Uneven Development," in J. N. Bhagwati, ed., *Economics and World Order* (London: Macmillan, 1972).

7. See Cuomo Commission on Trade and Competitiveness, *The Cuomo Commission Report: A New American Formula for a Strong Economy* (New York: Simon & Schuster, 1988), p. 136.

8. See Erica Schoenberger, "Multinational Corporations and the New International Division of Labor: Incorporating Competitive Strategies into a Theory of International Location," mimeo, unpublished manuscript (Johns Hopkins University: Department of Geography and Environmental Engineering, 1986).

9. Akio Morita, "How and Why U.S. Business Has to Shape Up," *New York Times*, 6 June 1987, p. 27.

10. Richard Alm, "America's New Appeal to Foreign Investors," *Dallas Morning News*, 13 March 1988, p. 22H.

11. Smith, *Wealth of Nations*, p. 17.

12. Richard J. Barnet and Ronald E. Müller, *Global Reach: The Power of the Multinational Corporations* (New York: Simon & Schuster, 1974).

13. For a background piece on overcapacity, see "A Global Overcapacity Hurts Many Industries; No Easy Cure is Seen," *Wall Street Journal,* 9 March 1987, pp. 1, 14.

14. See Riad A. Ajami and David A. Ricks, "Motives of Non-American Firms Investing in the United States," *Journal of International Business Studies,* Winter 1981, pp. 25–34.

15. See Enzio von Pfeil, *German Direct Investments in the United States* (Greenwich, Conn.: JAI Press, 1985). See also Erica Schoenberger, "The Logic of Foreign Manufacturing Investment in the United States: Implications for the U.S. Economy," mimeo, unpublished manuscript (Johns Hopkins University, Center for Metropolitan Planning and Research, 1983).

16. See Wi Saeng Kim and Esmeralda O. Lyn, "Foreign Direct Investment Theories, Entry Barriers, and Reverse Investments in U.S. Manufacturing Industries," *Journal of International Business Studies,* Summer 1987, pp. 53–65. A good review of market size and growth as a determinant of FDI is found in Neil Hood and Stephen Young, *The Economics of Multinational Enterprise* (London: Longmans, 1979).

17. For international comparisons of productivity, see Organization of Economic Cooperation and Development, *Historical Statistics* (Paris: Organization for Economic Cooperation and Development, 1987), p. 47. For a complete description of recent trends in international productivity, see Organization of Economic Cooperation and Development, *OECD Economic Outlook* (Paris: Organization for Economic Cooperation and Development, December 1987), pp. 39–48. Finally, for an analysis of productivity and its influence on both inward and outward investment, see David O. Cushman, "The Effects of Real Wages and Labor Productivity on Foreign Direct Investment," *Southern Economic Journal,* July 1987, pp. 174–85.

18. "German Investment in the United States: Innocents Abroad?," *German-American Trade News,* July/August 1982, p. 11.

19. These data are from the *Economic Report of the President,* 1988 (Washington, D.C.: U.S. Government Printing Office, 1988).

20. Consumer and business debt figures are reported in Cuomo Commission, *Cuomo Commission Report,* p. 5.

21. Organization for Economic Cooperation and Development, *Historical Statistics.*

22. See *Economic Report of the President,* 1987 (Washington, D.C.: U.S. Government Printing Office, 1987), p. 104.

23. Thomas F. Boyle, "Siemens, the German Electronics Giant, Belatedly Shoring Up its U.S. Presence," *Wall Street Journal,* 19 July 1988, p. 24.

24. "Why Non-U.S. Companies Vie for U.S. Chemicals," *Chemical Week,* 10 December 1986, pp. 6–8.

25. Quoted in "Rhône-Poulenc's U.S. Strategy," *Chemical Week,* 15 October 1986, p. 10.

26. See *Survey of Current Business,* August 1986.

27. Peter F. Drucker, "From World Trade to World Investment," *Wall Street Journal,* 26 May 1987, p. 26.

28. Quoted in Enzio von Pfeil, *German Direct Investments in the United States* (Greenwich, Conn.: JAI Press, 1985), p. 27.

29. See Sam Kusumoto, "High Yen Forces Japanese to Go American," *Wall Street Journal,* 14 March 1988, p. 26.

30. Quoted in Tony Jackson, "An Inescapable Quest for Critical Mass," *Financial Times,* 1 December 1986, p. 19.

31. Quoted in "The Foreign Invasion," *Industry Week,* 23 February 1987, pp. 37–40.

32. See Raymond Vernon, "International Investment and International Trade in the Product Cycle," *Quarterly Journal of Economics* 80 (1966): 190–207. See also Seev Hirsh, *Location of Industry and International Competitiveness* (New York: Oxford University Press, 1967); Adhip Chaudhuri, "American Multinationals and American Employment," in

Notes

Charles P. Kindleberger and David B. Audretsch, eds., *The Multinational Corporation in the 1980s* (Cambridge, Mass: MIT Press, 1983), pp. 263–77; Louis T. Wells, "International Trade: The Product Life Cycle Approach," in Louis T. Wells, ed., *Foreign Direct Investment in the U.S.: Opportunities and Impediments* (London: British-North America Committee, 1972), pp. 3–33. See also Raymond Vernon, "Location of Economic Activity," in John H. Dunning, ed., *Economic Analysis and the Multinational Enterprise* (London: George Allen & Unwin, 1974), pp. 89–114.

33. Milton Moskowitz, *The Global Marketplace: 102 of the Most Influential Companies Outside America* (New York: Macmillan), p. 564.

34. Morita, "How and Why U.S. Business," p. 27.

35. Sadami (Chris) Wada, testimony on Japanese Investment in California before the California Assembly Committee on International Trade and Intergovernmental Relations, Los Angeles, California, 27 September 1988 (mimeo), p. 4.

36. For an excellent review of these trends, see Cuomo Commission, *Cuomo Commission Report*.

37. Louis Uchitelle, "2 Hard-to-Quit Habits Sustain Trade Deficit, *New York Times*, 14 January 1987, pp. 29, 32.

38. Cuomo Commission, *Cuomo Commission Report*.

39. Quoted in Michel Ghertman and Margaret Allen, *An Introduction to the Multinationals* (New York: St. Martin's Press, 1984), p. 7.

40. See Japan Economic Institute (JEI), "Japan's Expanding U.S. Manufacturing Presence: 1984 Update," *JEI Report*, no. 6A, 15 February 1985. For a further analysis of how Japanese investors respond to trade barriers, see Kiyoshi Kojima, *Japanese Direct Foreign Investment: A Model of Multinational Business Operations* (Tokyo: Tuttle, 1978).

41. Quoted in "German Investment in the United States: Innocents Abroad?," *German-American Trade News*, July/August 1982, p. 11.

42. Quoted in Asger M. Nielsen, *Economic Impact Audit: A Case-Study Approach to Measurement of Costs and Benefits to a Host State in the U.S.A. from Reverse Foreign Direct Investment*, unpublished Ph.D. dissertation, School of Business Administration, University of Michigan, 1977, p. 35.

43. See "The Foreign Invasion," *Industry Week*, 23 February 1987, pp. 37–40.

44. Arnold W. Sametz, "The Foreign Multinational Company in the U.S.," in Jules Backman and Ernest Block, eds., *Multinational Companies, Trade and the Dollar in the Seventies* (New York: New York University Press, 1974), pp. 87–105; and Arnold W. Sametz and Jules Backman, "Why Foreign Multinationals Invest in the United States," *Challenge* 17 (1) [1974]: 43–47.

45. Martin and Susan Tolchin, *Buying Into America: How Foreign Money is Changing the Face of Our Nation* (New York: Times Books, 1988), p. 142.

46. Quoted in Agis Salpukas, "Behind Unilever's Latest Deal," *New York Times*, 3 December 1986, p. 29.

47. "Foreign Fliers on High-Technology Frontiers," *Fortune*, 22 December 1986, p. 50.

48. Ibid.; Michael Schrage, "Venture Capital's New Look," *Wall Street Journal*, 20 May 1988, p. 26; and Udayan Gupta, "More Japanese Firms Provide Venture Funds," *Wall Street Journal*, 3 May 1988, p. 33.

49. National Science Foundation, *Research and Development in Industry* (Washington, D.C.: National Science Foundation, 1985).

50. Among the many who have analyzed international debt and the twin deficits, see, for example, Paul A. Volcker, "Facing Up to the Twin Deficits," *Challenge* 30 (6 [Special Anniversary Issue, 1987]): 31–36.

51. Stephen Marris, *Deficits and the Dollar: The World Economy at Risk*, Policy Analysis in International Economics 14 (Washington, D.C.: Institute for International Economics, 1987), p. 44.

52. See *International Economic Conditions* (Federal Reserve Bank of St. Louis, April 1987).

53. Lawrence Summers, "Time for Inaction," *New Republic* 25 (January 1988): 14.
54. Jeff Faux, "Getting Rid of the Trade Deficit: A Cheaper Dollar Is Not Enough," Economic Policy Institute briefing paper, 1988, p. 11.
55. Christopher L. Bach, "U.S. International Transactions, Fourth Quarter and Year 1986," *Survey of Current Business*, March 1987, pp. 32–53.
56. Quoted in "Foreign Ardor Cools toward U.S. Stocks after Market's Dive," *Wall Street Journal*, 26 October 1987, p. 1.
57. Quoted in Philip Revzin, "Two Publishing Giants Fight for Dominance in Europe of the 1990s, *Wall Street Journal*, 25 April 1988, p. 1.
58. Quoted in Zachary Schiller, "Bridgestone May Try an End Run Around the Yen," *Business Week*, 2 February 1987, p. 31.
59. Walter S. Mossberg, "Cost of Paying the Foreign Piper," *Wall Street Journal*, 18 January 1988, p. 1.
60. "Record Trade Imbalance Is Reported," *New York Times*, 16 December 1987, p. 9D; and Martin Crutsinger, "Debtor America," Associated Press, 23 June 1987.

Chapter 5. The Promise and Reality of the New Competitors

1. Barry Bluestone and Bennett Harrison, *The Deindustrialization of America* (New York: Basic Books, 1982), p. 9.
2. Joseph Schumpeter, *Capitalism, Socialism and Democracy* (London: George Allen & Unwin, 5th ed., 1976).
3. Henry Eason, "The Corporate Immigrants," *Nation's Business*, April 1987, pp. 12–13.
4. Martin and Susan Tolchin, *Buying Into America* (New York: Times Books, 1988).
5. Edwin J. Coleman, "Regional Aspects of Foreign Direct Investment," paper presented at the Southern Regional Science Association (Washington, D.C.: U.S. Department of Commerce, Bureau of Economic Analysis, mimeo). Our comparison of average hourly wages from the Bureau of Economic Analysis, *1980 Benchmark Survey of Foreign Investment in the United States* (Washington, D.C.: Bureau of Economic Analysis, 1983), and roughly comparable figures from the 1980 *Annual Survey of Manufactures* shows much less difference between foreign and domestic companies. As we show elsewhere, the published data are too primitive to make decent approximations between foreign and domestic firms.
6. Quoted in "For Sale: America," *Time*, 14 September 1987, p. 59.
7. Laurent Belsie, "Japanese Steel Companies in U.S. to Stay," *Christian Science Monitor*, 25 March 1987, p. 7.
8. Quoted in Todd Mason and John Hoerr, "Hitachi: Winning Friends and Influencing People in Oklahoma," *Business Week*, 11 July 1988, p. 75.
9. U.S. Congress, House Committee on Banking, Finance, and Urban Affairs, *Establishment of a National Development Bank and Other Matters*, hearings before a Subcommittee on General Oversight and Renegotiation on H.R. 638, 98th Congress, 1983, pp. 367–68. For details, see Sara L. Gordon and Francis A. Lees, *Foreign Multinational Investment in the United States: Struggle for Industrial Supremacy* (New York: Quorum Books, 1986), pp. 110–11.
10. Andrew H. Malcolm, "Foreign Money Changing U.S. Social-Cultural Life," *New York Times*, 31 December 1985, p. 1.
11. William J. Holstein with Amy Borrus, "Japan's Clout in the U.S.: It's Translating Economic Might into Influence," *Business Week*, 11 July 1988, p. 64.
12. Leslie Helm, with Alice Z. Cueno and Dean Foust, "On the Campus: Fat Endowments and Growing Clout," *Business Week*, 11 July 1988, p. 70.
13. John Holusha, "Mixing Cultures on the Assembly Line," *New York Times*, 5 June 1988, section 3, pp. 1, 8.
14. Annual data on employment from new foreign establishments are found in the May issues of the *Survey of Current Business*. See, for example, Ellen M. Herr, "U.S. Business

Enterprises Acquired or Established by Foreign Direct Investors in 1987," *Survey of Current Business*, May 1988, pp. 50–58. We obtained revised data for 1980–84 from the Bureau of Economic Analysis.

15. For example, see Tolchin and Tolchin, *Buying Into America*, p. 3.

16. Candace Howes, "U.S. Auto Jobs: The Problem is Bigger than Japanese Imports," *UAW Research Bulletin*, 1986.

17. Peter Arnesen, Robert Coles, and A. Rama Krishna, "Japanese Auto Parts Companies in the U.S. and Japan: Implications for U.S. Competitors" (Ann Arbor, Mich.: East Asian Business Program, University of Michigan, 1987).

18. Quoted in Kenneth Gooding, "A Trojan Horse in Detroit: Foreign Car Makers in the U.S.," *Financial Times*, 5 September 1985, p. 12.

19. "Japanese Investments in the U.S. Are Riskier Than Many First Suppose," *Japan Economic Journal*, 5 July 1986, p. 13; and Peter Gumbel and Douglas R. Sease, "Many Foreigners Find Building Plants Is Easier Than Making Money in U.S.," *Wall Street Journal*, 24 February 1987, p. 6.

20. We tallied these data from Herr, "U.S. Business," and supplementary information supplied by the Bureau of Economic Analysis.

21. For one assessment of the poor performance records of acquired U.S. firms by foreign multinationals, see Jacobus T. Severiens, "Foreign Buyers of U.S. Firms: Their Performance Records," *Mergers and Acquisitions* 16 (4 [Winter 1982]): 47–51.

22. See Herr, "U.S. Business." The U.S. Department of Commerce provided revised data for 1980–84.

23. Severiens, "Foreign Buyers," p. 48.

24. John S. Keller with Mark Maremont, "Plessey's New Face in the U.S.," *Business Week*, 20 April 1987, p. 32.

25. On the Campeau-Allied deal, see Christopher Power and Edith Terry, "Now Campeau Has to Pay for His Pricey Prize," *Business Week*, 17 November 1986, pp. 66–67; Dan Cook and Edith Terry, "Is Campeau in over His Head at Allied Stores?," *Business Week*, 9 February 1987, pp. 52–53; Robert L. Rose and Ann Hagedorn, "Carson Agrees to Acquire Unit of Allied Stores," *Wall Street Journal*, 28 August 1987, p. 4; and Ann Hogan, "Campeau Won't Sell Allied's Ann Taylor and Brooks Brothers Chains, Sources Say," *Wall Street Journal*, 10 February 1987, p. 4.

26. Power and Terry, "Now Campeau," p. 66.

27. Daniel Benjamin, "New Miracle on 34th Street?," *Time*, 14 March 1988, p. 51.

28. Isadore Barmash, "Canadian Bidder Beats Macy in Fight for Federated Stores," *New York Times*, 2 April 1988, pp. 1, 21; Leslie Wayne, "Deal May Lead to an Industry Restructuring," *New York Times*, 2 April 1988, p. 21; Teri Agins, "Campeau Will Sell $4.4 Billion in Assets to Pay for Costly Federated Acquisition," *Wall Street Journal*, 6 April 1988, p. 4; and Jacquie McNish, "Campeau to Sell Stake in Firm to Reichmanns," *Wall Street Journal*, 2 February 1988, pp. 2, 7.

29. Donna Steph Hansard, "Just What Hath Campeau Wrought?," *Dallas Morning News*, 19 June 1988, pp. H1, H8.

30. Carol Hymowitz, "Bloomingdale's May Reduce Staff by 400 as Parent Company Campeau Continues to Cut Costs," *Wall Street Journal*, 8 June 1988, p. 5.

31. Quoted in Hansard, "Just What," p. H8, and "Campeau Retail Chains Are Heavily in Debt, Facing Rising Troubles," *Wall Street Journal*, 14 December, 1988, p. A1, A4.

32. "For Sale: America," *Time*, 14 September, 1987, p. 59.

33. On the debate, see "Symposium on Takeovers," in the Winter 1988 *Journal of Economic Perspectives*, edited by Hal Varian. See also David Ravenscraft and F. M. Scherer, *Mergers, Sell-offs, and Economic Efficiency* (Washington, D.C.: The Brookings Institution, 1987); and Edward J. Herman and Louis Lowenstein, "The Efficiency Effects of Hostile Takeovers," in John Coffee et al., eds., *Knights, Raiders, and Targets* (New York: Oxford University Press, 1987).

34. Telephone interview with Ned Howenstine of the Bureau of Economic Analysis, June 1988.

35. Jacob Mincer and Yoshio Higuchi, "Wage Structures and Labor Turnover in the United States and Japan," *Journal of the Japanese and International Economies* 2 (1988): 97–133.

36. Robert B. Reich and Eric D. Mankin, "Joint Ventures with Japan Give Away Our Future," *Harvard Business Review*, March/April 1986; and Robert B. Reich, *Tales of a New America* (New York: Times Books, 1987), especially chap. 6.

37. Holusha, "Mixing Cultures," p. 8.

38. Ibid., p. 8.

39. Norman J. Glickman, Amy Glasmeier, Geoffrey Bannister, and William Luker, Jr., *Foreign Investment and Industrial Linkages*, report to the Economic Development Administration and the Aspen Institute for Humanistic Studies (Austin: Lyndon B. Johnson School of Public Affairs, University of Texas, 1989). All further references to our firm survey are from that study.

40. Cathy Trost, "Labor Letter," *Wall Street Journal*, 3 March 1987, p. 1.

41. United States General Accounting Office, *Foreign Investment: Growing Presence in the U.S. Auto Industry* (Washington, D.C.: United States General Accounting Office, Report GAO/NSIAD 88-111, March 1988).

42. Ann Dunkelberg, "Labor Relations Patterns of Foreign-Owned Companies in the U.S." (Austin: Lyndon B. Johnson School of Public Affairs, University of Texas, December 1987, mimeo).

43. William Glaberson, "An Uneasy Alliance in Smokestack U.S.," *New York Times*, 13 March 1988, section 3, pp. 1, 11.

44. Michael J. Jedel and Duane Kujawa, "Industrial Relations Profiles of Foreign-Owned Manufacturers in the United States," in R. Banks and J. Steiber, eds., *Multinationals, Unions, and Labor Relations in Industrialized Countries* (Ithaca N.Y.: Cornell University Press, 1977).

45. "Japanese Companies In U.S. Seen Excelling," *New York Times*, 8 March 1985, p. D8.

46. Haruo Shimada and John Paul MacDuffie, "Industrial Relations and 'Humanware': Japanese Investments in Automobile Manufacturing in the United States," paper presented at the First Policy Forum, International Motor Vehicles Program, 4 May 1987.

47. David Dyer, Malcolm S. Salter, and Alan M. Webber, *Changing Alliances* (Boston: Harvard Business School Press, 1987).

48. Shimada and MacDuffie, "Industrial Relations," especially pp. 44–47.

49. Owen Bieber, "Statement on General Motors Plant Closings," made before the Senate Labor and Human Resources Committee, 26 January 1987, pp. 7–8.

50. Quoted in John Holusha, "A New Spirit at U.S. Auto Plants," *New York Times*, 29 December 1987, pp. 25–26.

51. John Junkerman, "Nissan, Tennessee: It Ain't What It's Cracked Up To Be," *The Progressive*, June 1987, pp. 16–20.

52. Shimada and MacDuffie, "Industrial Relations"; Dunkelberg, "Labor Relations Patterns"; "Life at Nissan: Paradise Lost," *Newsweek*, 10 November 1987, p. 50; and Junkerman, "Nissan, Tennessee."

53. "Mazda Rolls Off First Production Car in the U.S.," UPI wire story, 1 September 1987; Marilyn Enid, James Treece, and Elizabeth Weiner, "Why Mazda is Settling in the Heart of Union Territory," *Business Week*, 9 September 1987; and James Risen, "Obstacles to a U.S. Mazda Plant Removed," *Los Angeles Times*, 2 April 1985, part 2, p. 2.

54. Dan Carmichael, "Labor Wins Major Battle Against Toyota," Associated Press, 27 November 1986; Matt Yancey, "Toyota Plant Contractor, Unions Appear Close to Resolving Differences," United Press International, 25 November 1986; and "Boycott," United Press International, 27 August 1986.

55. Peter Arnesen, Robert Cole, and A. Rama Krishna, "Japanese Auto Parts Compa-

nies in the U.S. and Japan: Implications for U.S. Competitors" (Ann Arbor: University of Michigan, East Asia Studies Program, Working Paper no. 3, 1987); John Holusha, "Japanese Faulted Over Black Hiring," *New York Times*, 27 November 1988, p. 16; and Michel McQueen, "Blacks, Women at Honda Unit Win Back Pay," *Wall Street Journal*, 24 March 1988, p. 2.

56. Many of the layoffs took place in the late 1970s and early 1980s when there were massive cutbacks throughout the industry. This was also before the Japanese and Brazilian firms took over the company. However, there were sharp cutbacks after the buyout.

57. John A. Byrne, "At Sanyo's Arkansas Plant the Magic Isn't Working," *Business Week*, 14 July 1986, pp. 51–52.

58. J. Ernest Beazley, "In Spite of Mystique, Japanese Plants in U.S. Find Problems Abound," *Wall Street Journal*, 22 June 1988, pp. 1, 10.

59. Ibid., p. 1.

60. Dunkelberg, "Labor Relations Patterns."

61. Smick-Medley and Associates, "Foreign Investment: A Smick-Medley and Associates Public Opinion Survey of U.S. Attitudes," white paper, Washington, D.C., 1988, p. 11.

62. See Milton Moskowitz, *The Global Marketplace: 102 of the Most Influential Companies Outside America* (New York: Macmillan, 1987), pp. 481–82. A positive review of Philips's labor record can be found in Robert Heller and Norris Willatt, *The European Revenge* (New York: Charles Scribner, 1975), pp. 126–27.

63. Charles R. Perry, *Union Corporate Campaigns* (Philadelphia: University of Pennsylvania, Wharton School Industrial Research Unit, monograph no. 66), p. 8. See also Bridget O'Brian, "Offer May Not End Long Labor Dispute," *New Orleans Times-Picayune*, 26 September 1987; Moskowitz, *Global Marketplace*, pp. 31–36; Dunkelberg, "Labor Relations Patterns," pp. 33–36; and "Company to Pay State Fine in Pollution," *New Orleans Times-Picayune*, 24 August 1986, p. B-6.

64. Organization for Economic Cooperation and Development, *The OECD Guidelines for Multinational Enterprises* (Paris: OECD, 1986), p. 15.

65. "Unions, Environmentalists Picket BASF," United Press International, 4 June 1987; "BASF," UPI, 14 September 1987; and "BASF Workers Return to Work in Louisiana," PR Newswire, 20 November 1987.

66. Bob Rossi and Marc S. Miller, "Hard Times for Appalachian Coal Miners," *Dollars and Sense*, December 1987, p. 13.

67. Ibid.

68. Quoted from a United Mine Workers of America letter to Clarke N. Ellis, director, Office of Investment Affairs, U.S. Department of State, 26 May 1987.

69. Quoted in a letter from the United Mine Workers of America to the Office of Investment Affairs, U.S. Department of State, 8 June 1988.

70. Ibid.

71. "Global Wrapup," *Business Week*, 2 April 1985, p. 49.

72. "Foreign Owners Spite U.S. Unions," *AFL-CIO News*, 18 June 1988, p. 2.

73. Ibid.

74. Elliot L. Richardson, "Why Foreign Investment in U.S. Is Good for Us," *New York Times*, 8 June 1988, p. 26.

75. John Bussey, "Honda May Announce Plan to Export Cars That It Assembles at U.S. Plants," *Wall Street Journal*, 19 September 1987, p. 2.

76. See Glickman et al., *Foreign Investment*.

77. Lindley L. Clark, Jr., and Alfred L. Malabre, Jr., "Takeover Trend Helps Push Corporate Debt and Defaults Upward," *Wall Street Journal*, 15 March 1988, p. 1.

Chapter 6. The Domestic Effects of American Investment Abroad

1. Cary Putka, "Strong Dollar Has Led U.S. Firms to Transfer Production Overseas," *Wall Street Journal*, 9 April 1985, pp. 1, 18.

2. Bennett Harrison and Barry Bluestone, *The Great U-Turn* (New York: Basic Books, 1988).

3. For a review of the data and history of foreign direct investment, see Robert E. Lipsey, "Changing Patterns of International Investment in and by the United States" (Cambridge, Mass.: National Bureau of Economic Research, working paper no. 2240, May 1987). For additional information on international direct investment, see U.S. Department of Commerce, International Trade Administration, *International Direct Investment: Global Trends and the U.S. Role* (Washington, D.C.: U.S. Government Printing Office, 1984); U.S. Department of Commerce, International Trade Administration, "Direct Investment Update: Trends in International Direct Investment," staff report, Investment Research Division, Office of Trade and Investment Analysis, December 1986; and U.S. Department of Commerce, Office of Trade and Investment Analysis, *International Direct Investment: Global Trends and the U.S. Role*, vol. II (Washington, D.C.: U.S. Department of Commerce, 1988).

4. See Organization for Economic Development and Cooperation, *Recent Trends in International Direct Investment* (Paris: OECD, 1987).

5. Russell B. Scholl, "International Investment Position of the United States in 1987," *Survey of Current Business*, June 1988, pp. 76–84; and Louis Uchitelle, "Overseas Spending by U.S. Companies Sets Record Pace," *New York Times*, 20 May 1988, pp. 1, 29.

6. Peter F. Drucker, "From World Trade to World Investment," *Wall Street Journal*, 26 May 1987, p. 24.

7. William Glaberson, "An Uneasy Alliance in Smokestack U.S.A.," *New York Times*, 13 March 1988, section 3, pp. 1, 11.

8. Among the former are Barry Bluestone and Bennett Harrison, *The Deindustrialization of America* (New York: Basic Books, 1982); while Robert S. Stobaugh, *New Investments Abroad and Their Impact at Home* (Cambridge, Mass.: Harvard University Press, 1976), is among the latter.

9. Lester C. Thurow, "Sustained Economic Growth," in David Obey and Paul Sarbanes, eds., *The Changing American Economy* (New York: Basil Blackwell, 1986), pp. 177–78.

10. Quoted by Norman Jonas, "The Hollow Corporation: The Decline of Manufacturing Threatens the Entire U.S. Economy," *Business Week*, 3 March 1986, p. 57.

11. Quoted by Kenneth Dreyfack and Otis Port, "Even American Knowhow Is Headed Abroad," *Business Week*, 3 March 1986, p. 61.

12. Stephen S. Cohen and John Zysman, *Manufacturing Matters: The Myth of the Post-Industrial Society* (New York: Basic Books, 1987); and Ray Marshall and Norman J. Glickman, *Choices for American Industry* (Washington, D.C.: Labor Institute Press, 1987).

13. Barry Bluestone and Bennett Harrison, *Deindustrialization*; and Carolyn C. Perrucci, Robert Perrucci, Dena B. Targ, and Harry R. Targ, *Plant Closings: International Context and Social Costs* (New York: Aldine de Gruyter, 1988).

14. C. Fred Bergston, Thomas Horst, and Theodore H. Moran, *American Multinationals and American Interest* (Washington, D.C.: Brookings Institution, 1978), p. 3.

15. Council of Economic Advisers, *Economic Report of the President* (Washington, D.C.: Superintendent of Documents, U.S. Government Printing Office, 1987), p. 142.

16. U.S. Department of Commerce, International Trade Administration, *International Direct Investment* (1984).

17. Russell B. Scholl, "The International Investment Position of the United States in 1985," *Survey of Current Business*, June 1986, pp. 26–34.

18. Lipsey, "Changing Patterns."

19. Erica Schoenberger, "American in Europe: Aspects of U.S. Investment Strategies in the European Market," paper presented at the meetings of the Regional Science Associa-

tion, Baltimore, Maryland, November 1987 (Baltimore: Johns Hopkins University, Department of Geography and Environmental Engineering, mimeo).

20. Dori Jones Yang et al., "Can Asia's Four Tigers Be Tamed?" *Business Week*, 15 February 1988, pp. 46–50.

21. Uchitelle, "Overseas Spending," p. 1.

22. Ibid., p. 29.

23. Steven Greenhouse, "Making Europe a Mighty Market," *New York Times*, 22 May 1988, section 3, pp. 1, 6.

24. Robert B. Cohen, Richard W. Ferguson, and Michael F. Oppenheimer, *Nontariff Barriers to High-Technology Trade* (Boulder, Col.: Westview Press, 1985); and Kenneth N. Gilpin, "Local Content: Global Practice," *New York Times*, 23 June 1983, pp. 27, 31.

25. Glaberson, "Uneasy Alliance," p. 11.

26. For details, see Don Benson, "Tax Changes, Relaxed Restrictions Top '87 Global Geo-Political Issues," *Site Selection Handbook*, October 1987, pp. 1190–97.

27. Glaberson, "Uneasy Alliance," p. 11.

28. U.S. Department of Commerce, International Trade Administration, *International Direct Investment* (1984).

29. Joseph Grunwald and Kenneth Flamm, *The Global Factory: Foreign Assembly in International Trade* (Washington, D.C.: Brookings Institution, 1985).

30. Monroe W. Karmin et al., "Will the U.S. Stay Number One?," *U.S. News and World Report*, 23 February 1987, pp. 18–22; and Robert B. Reich and Eric D. Mankin, "Joint Ventures with Japan Give Away Our Future," *Harvard Business Review*, March/April 1986, pp. 78ff.

31. Jeffrey G. Miller and Aleda V. Roth, *Manufacturing Strategies: Executive Summary of the 1987 Manufacturing Futures Survey* (Boston: Boston University, School of Management Manufacturing Roundtable, 1987).

32. United Auto Workers, "Choices for American Industry: Auto" (Detroit: United Auto Workers, 1986, mimeo); Donald B. Thompson, "Where Is U.S. Industry Going? It's Heading Where Many American Manufacturers Have Already Gone—Offshore," *Industry Week*, 6 January 1986, p. 28; and telephone interview with Candace Howes of the United Auto Workers' Research Department, 9 September 1988.

33. "Ford Around the World," press release of the Ford Motor Company, 15 May 1987.

34. Owen Bieber, "General Motors Plant Closings," statement before Senate Labor and Human Resources Committee, 26 January 1987.

35. John Holusha, "Chrysler to Expand Car Output in Mexico," *New York Times*, 23 April 1988, p. 19.

36. Thompson, "Where Is U.S. Industry Going?" See also Alan J. Scott and D. P. Angel, "The U.S. Semiconductor Industry: A Locational Analysis," discussion paper 200, University of California, Los Angeles, Graduate School of Architecture and Urban Planning (Los Angeles: University of California, Los Angeles, n.d.), for a study of semiconductor USDIA during the 1970s and 1980s. Kenneth Flamm, "Internationalization in the Semiconductor Industry," in Joseph Grunwald and Kenneth Flamm, eds., *The Global Factory: Foreign Assembly in International Trade* (Washington, D.C.: Brookings Institution, 1985), pp. 38–136, reports similar findings for 1977.

37. Uchitelle, "Overseas Spending," p. 29 and interview with Candace Howes.

38. Howard LaFranchi, "U.S. Firms Moving Plants to Mexico," *Christian Science Monitor*, 22 December 1986, p. 3.

39. Michael J. Zamba, "In Bid to Diversify, Mexico Seeks U.S. Plants Farther Inland," *Christian Science Monitor*, 24 February 1987, p. 21.

40. Robert E. Lipsey and Irving B. Kravis, "The Competitive Position of U.S. Manufacturing Firms," *Banco Nazionale del Lavoro Quarterly Review*, June 1985, pp. 127–54; and "The Competitiveness and Comparative Advantage of U.S. Multinationals, 1957–1983"

(Cambridge, Mass.: National Bureau of Economic Research Working Paper No. 2051, October 1986); and Lipsey, "Changing Patterns."

41. John Holusha, "Ford Had Record Net of $4.6 Billion in 1987," *New York Times*, 19 February 1988, pp. 25, 28; and John Holusha, "GM Profit Up, Mainly Overseas," *New York Times*, 10 February 1988, pp. 29, 33.

42. Douglas R. Sease, "Taiwan's Export Boom to U.S. Owes Much to American Firms," *Wall Street Journal*, 27 May 1987, pp. 1, 20; and Robert B. Reich, "The Trade Gap: Myths and Crocodile Tears," *New York Times*, 12 February 1988, p. 27.

43. Yang et al., "Asia's Four Tigers."

44. Quoted by Thompson, "Where Is U.S. Industry Going?"

45. Lipsey and Kravis, "Competitive Position"; Lipsey and Kravis, "Competitiveness"; and "Business Holds Its Own as America Slips," *New York Times*, 18 January 1987, p. F3.

46. Quoted by Norman Jones, "The Hollow Corporation," p. 59.

47. Robert B. Reich, "Corporation and Nation," *Atlantic Monthly*, May 1988, pp. 76–81.

48. Ibid., p. 77.

49. See, for example, President's Commission on International Competitiveness, *Global Competition: The New Reality*, vol. II (Washington, D.C.: U.S. Government Printing Office, 1985); Marshall and Glickman, *Choices*; and Cohen and Zysman, *Manufacturing Matters*.

50. Quoted in Thompson, "Where Is U.S. Industry Going?"

51. Obie Whichard, "U.S. Multinational Companies: Operations in 1986," *Survey of Current Business*, June 1988, pp. 85–96.

52. Quoted in Thompson, "Where Is U.S. Industry Going?"

53. Reich, "Trade Gap."

54. Thompson, "Where Is U.S. Industry Going?"

55. Louis Uchitelle, "Business Spending Rises Sharply, But Imports Get Much of the Gain," *New York Times*, 5 May 1988, pp. 1, 37.

56. Quoted by Uchitelle, "Business Spending," p. 1.

57. Dreyfack and Port, "Even American Knowhow."

58. On this debate, see Bergston, Horst, and Moran, *American Multinationals*; and several other studies, such as Robert G. Hawkins, *U.S. Multinational Investment in Manufacturing and Domestic Economic Performance*, occasional paper no. 1 (Washington, D.C.: Center for Multinational Studies, 1972); Thomas Horst, "American Exports and Foreign Direct Investments," Harvard Institute of Economic Research, discussion paper no. 362 (Cambridge, Mass.: Harvard Institute of Economic Research, 1974); Peggy Musgrave, *Direct Investment Abroad and the Multinationals: Effects on the U.S. Economy* (Washington, D.C.: United States Senate, 94th Congress, U.S. Government Printing Office, 1975); Stanley Ruttenberg, *Needed: A Constructive Foreign Trade Policy Abroad and Their Impact at Home* (Cambridge, Mass.: Harvard University Press, 1976); and U.S. Tariff Commission, *Implications of Multinational Firms for World Trade and Investment and for U.S. Trade and Labor* (Washington, D.C.: U.S. Government Printing Office, 1973); and Stobaugh, *New Investments*.

59. For greater detail on the methods and results of the remainder of this section, see the appendix to this chapter and Norman J. Glickman, *The Employment Effects of U.S. Direct Investment Abroad*, paper presented at the North American Meeting of the Regional Science Association in Baltimore, Maryland, 10 November 1987; and Norman J. Glickman and Geoffrey Bannister, *The Regional Effects of U.S. Direct Investment Abroad* (Austin: Lyndon B. Johnson School of Public Affairs, University of Texas, discussion paper 47, 1988). The calculations are technical, and we direct the interested and plucky reader to these studies.

60. Robert Frank and Richard Freeman, *Distributional Consequences of Foreign Direct Investment* (New York: Academic Press, 1978).

61. Frank and Freeman, *Distributional Consequences*; and Bluestone and Harrison, *Deindustrialization*.

62. On the economic position of blacks in the face of economic restructuring, see William Julius Wilson, *The Truly Disadvantaged: The Inner City, the Underclass, and Public Policy* (Chicago: University of Chicago Press, 1987).

63. For details on the MRPIS model, see Barry Bluestone and John Havens, *An Overview of the MRPIS 2.0 System* (Boston: Boston College, Social Welfare Regional Institute, 1985, mimeo). See also Marshall and Glickman, *Choices*.

64. Marshall and Glickman, *Choices*.

65. William E. Geist, "Singer Plant Closing: A Way of Life Ends," *New York Times*, 23 February 1982, p. A1.

66. Odessa Komier, "The Transplants—Threat or Opportunity for U.S. Workers and Suppliers?," in the University of Michigan Transportation Research Institute, *The International Automotive Challenge: Strategy Beyond Cost and Quality* (Ann Arbor: UMTRI, 1986), pp. 15–16.

67. David Armon, "New City Administration Optimistic Despite Plant Closings," UPI wire service, 16 March 1985; and UPI, untitled wire service story from Battle Creek, Michigan, 11 February 1985.

68. Tamer Lewin, "Workers' Rights in a Closing Tested," *New York Times*, 19 July 1984, p. D1.

69. Maura McEnaney, "Tandon Splits Into Two Units," *Computerworld*, 1 September 1986, p. 114.

70. Dana Beyerle, "GTE to Lay Off 1,000 at Phone Plant," UPI wire story, 22 March 1986.

71. On this subject, see Bluestone and Harrison, *Deindustrialization*, especially chap. 3; and Perrucci et al., *Plant Closings*.

72. See Kenneth J. Hicks, "Japan Increases Presence in U.S.; UK Banks Decline," *American Banker*, 23 February 1988, p. 1; and Thierry Noyelle and Thomas M. Stanback, Jr., *The Economic Transformation of American Cities* (Totowa, N.J.: Rowman & Allanheld, 1984).

73. "Tax and Banking Laws an Asset," *Financial Times*, 10 November 1986, p. 17.

74. Whichard, "U.S. Multinational Companies."

75. Ours is the first study to examine comprehensively the regional impacts of USDIA. Previous studies on the relationship between international trade and investment and regional development include Norman J. Glickman, "Cities and the International Division of Labor," in Michael Smith and Joe Feagin, eds., *The Capitalist City* (London: Basil Blackwell, 1978), pp. 66–86; Norman J. Glickman and Douglas P. Woodward, "Foreign Direct Investment and Regional Development: Some Empirical Results," *International Regional Science Review*, Fall 1988; Nils Groes and Karin Peschel, *Regional Research in an International Perspective* (Munich: Verlag V. Florentz, 1984); Peter Mieszkowski, "The Differential Effects of the Foreign Trade Deficit on Regions in the U.S.," in John M. Quigley and Daniel L. Rubinfeld, eds., *American Domestic Priorities: An Economic Appraisal* (Berkeley: University of California Press, 1985), pp. 346–63; Erica Schoenberger, "Multinational Corporations and the New International Division of Labor: Incorporating Competitive Strategies into a Theory of International Location," *International Regional Science Review*, Fall 1988; and Douglas P. Woodward, "Regional Location Patterns of Foreign Direct Investment in the U.S., 1974–1983," unpublished doctoral dissertation, Department of Economics, University of Texas at Austin, 1986.

76. See also Glickman and Bannister, *Regional Effects*.

Chapter 7. Foreign Multinationals and American Communities

1. For the English translation, see Betsey Scheiner, trans., *Japan Inc., Introduction to Japanese Economics (The Comic Book)* (Berkeley: University of California Press, 1988).

2. International Trade Institute, "Outlook and the Problems of International Trade and

Industry of the United States," interim draft report of the research project commissioned by Japan's National Institute for Research Advancement, unpublished, January 1987, p. 13.

3. Lindsey Gruson, "Steel Towns Discharge Police and Reduce Services Sharply," *New York Times*, 6 October 1985, p. 1.

4. Art Pine, "Hard-Hit Tennessee Town Blames Trade Woes on Complacency As Much As Foreign Competition," *Wall Street Journal*, 11 September 1985, p. 58.

5. Quoted in William J. Holstein, "Japan Is Winning Friends in the Rust Belt," *Business Week*, 19 October 1987, p. 54. Chattanooga's attraction to foreign investors was reported by Clyde H. Farnsworth, "Chattanooga Draws Foreign Capital," *New York Times*, 16 April 1986, p. 17. For further details on Chattanooga's wooing of Komatsu and the role direct investment has played in muting trade legislation, see Martin and Susan Tolchin, *Buying Into America: How Foreign Money Is Changing the Face of Our Nation* (New York: Times Books), chap. 5.

6. Edwin Coleman, "Regional Aspects of Foreign Direct Investment," mimeo, unpublished manuscript (paper presented at the 1986 Annual Meeting of the Southern Regional Science Association, 6–8 March 1986, New Orleans, La.), p. 21. Coleman, a researcher for the U.S. Department of Commerce, drew on 1975–82 data found in the U.S. Census estimates of multiestablishment foreign and domestic firms (this data series has been discontinued by the Census); see, for example, U.S. Bureau of the Census, *Selected Characteristics of Foreign-Owned U.S. Firms: 1982* (Washington, D.C.: U.S. Bureau of the Census, 1984). Jane Sneddon Little, an economist at the Federal Reserve Bank of Boston, also found that employees for foreign companies earned more on average than those working for domestic companies. Her estimates are somewhat lower than Coleman's; see Jane Sneddon Little, "Foreign Direct Investment in New England," *New England Economic Review*, March/April 1985, pp. 48–57.

7. "Mowing Down the Invaders," *Time*, 20 June 1988, p. 52.

8. These figures on metropolitan area population are from the Canadian and the U.S. Census for 1981 and 1980, respectively, and are reported in the *1987 Information Please Almanac* (Boston: Houghton Mifflin, 1987), p. 160 and pp. 773–76.

9. William M. Shapiro, "Site Selection: The Japanese Perspective," *Area Development*, August 1987, p. 38.

10. A good description of the industrial recruitment programs provided by one state is E. R. Lanier, ed., *Foreign Investment in Georgia: A Business Reference Guide* (Atlanta, Ga.: Georgia State University Research Monograph no. 93, 1982).

11. "America's Diversity Complicates Task of Choosing Site for Overseas Plant," *Japan Economic Journal*, 25 October 1986, p. 13; and J. B. Blosser, "Advice Offered to South on Improving Foreign Trade," United Press International, 17 August 1984.

12. Quoted in Lamar Alexander, "Well, Saturn finally found its home . . . In Spring Hill, Tennessee," State of Tennessee advertisement in the *Wall Street Journal*, 5 August 1985, p. 11.

13. See A. Blackbourn, "The Impact of Multinational Corporations on the Spatial Organization of Developed Nations: A Review," in Michael Taylor and Nigel Thrift, eds., *The Geography of Multinationals* (New York: St. Martin's Press, 1982), pp. 147–57; and Raymond Vernon, "Location of Economic Activity," in John H. Dunning, ed., *Economic Analysis and the Multinational Enterprise* (London: George Allen & Unwin, 1974), pp. 89–114.

14. International Trade Institute, "Outlook and the Problems of International Trade and Industry of the United States," interim draft report of the research project commissioned by Japan's National Institute for Research Advancement, unpublished, January 1987, p. 15.

15. The "frontier" thesis was attributed to Carol Heim in R. D. Norton, "Industrial Policy and American Renewal," *Journal of Economic Literature* 24 (1986): 25.

16. See Benjamin Chinitz and Raymond Vernon, "Changing Forces in Industrial Loca-

tion," *Harvard Business Review* 38 (1960): 126–36; and Alfred Watkins, *The Practice of Urban Economics* (Beverly Hills, Calif.: Sage Publications, 1980).

17. For a good review of industrial location in the United States, including the basing-point system, see Watkins, *Urban Economics*.

18. For an excellent analysis of domestic restructuring by U.S. oligopolies, and its regional implications, see Ann Roell Markusen, *Profit Cycles, Oligopoly, and Regional Development* (Cambridge, Mass.: MIT Press, 1985).

19. International Trade Institute, "Outlook and Problems," p. 9.

20. Ibid., p. 16.

21. Norton, "Industrial Policy."

22. Douglas R. Sease, "International Efforts Revive a Steel Factory Kaiser Had Shut Down," *Wall Street Journal*, 4 June 1985, p. 1.

23. See Norman J. Glickman and Douglas P. Woodward, *Regional Patterns of Manufacturing Foreign Direct Investment in the United States*, final report prepared for the U.S. Department of Commerce, Economic Development Administration (Austin: Lyndon B. Johnson School of Public Affairs, University of Texas, May 1987).

24. Glickman and Woodward, *Regional Patterns*.

25. See, for example, Cedric L. Suzman, "What Are the Trends for Foreign Direct Investment in the Southeast?" *Economic Review* (Federal Reserve Bank of Atlanta), January 1986, pp. 42–47, especially p. 44.

26. Earl H. Fry, *Financial Invasion of the U.S.A.: A Threat to American Society?* (New York: McGraw-Hill, 1980), p. 123.

27. See Eugene Carlson, "Foreign Firms Help to Offset Southern Setbacks in Textiles," *Wall Street Journal*, 4 April 1986, p. 29.

28. Nicholas Faith, *The Infiltrators: The European Business Invasion of America* (London: Hamish Hamilton, 1971), p. 133. See also Fry, *Financial Invasion*, p. 132.

29. A. K. O'Reilly, "Foreign Firms Flock to Spartanburg," *Journal of Commerce*, 15 October 1985.

30. The figures are tabulated from Division of Research and Information Systems, South Carolina State Development Board, *Trade and Investment Resources in South Carolina*. (Prepared for the Japanese Chamber of Commerce of New York. (Charleston, S.C., 22–24 March 1987).

31. United Press International, "Michelin Wages to Surpass $1 Billion in 1985," 16 September 1984.

32. Ned G. Howenstine, "U.S. Affiliates of Foreign Companies: Operations in 1986," *Survey of Current Business*, May 1988, p. 75.

33. H. I. Chernotsky, "Selecting U.S. Sites: A Case Study of German and Japanese Firms," *Management International Review* 23 (1983): 53.

34. See Division of Research, College of Business Administration, University of South Carolina, *South Carolina: An Economy in Transition* (Columbia, S.C.: University of South Carolina, 1987), pp. 2–51.

35. Calculated from data in U.S. Department of Commerce, Bureau of the Census, *Statistical Abstract of the United States, 1987* (Washington, D.C.: U.S. Government Printing Office, 1986), table 1306, p. 731.

36. Quoted in Eugene Carlson, "Foreign Firms Help to Offset Southern Setbacks in Textiles," *Wall Street Journal*, 4 April 1986, p. 29; and Jaclyn Fierman, "The Selling Off of America," *Fortune*, 22 December 1986, p. 54.

37. See Glickman and Woodward, *Regional Patterns*.

38. Frederick A. Moses and Thomas A. Pugel, "Foreign Direct Investment in the United States: The Electronics Industries," in H. Peter Gray, ed., *Uncle Sam as Host* (Greenwich, Conn.: JAI Press, 1986), p. 118.

39. Survey evidence confirming the role of markets and labor are found in Jeffrey Arpan and David Ricks, *Directory of Foreign Manufacturers in the United States* (Atlanta:

School of Business Administration, Georgia State University, 1975); Erica Schoenberger, "The Logic of Foreign Manufacturing Investment in the United States: Implications for the U.S. Economy," mimeo, unpublished manuscript (Center for Metropolitan Planning and Research, Johns Hopkins University, 1983); and Hsin-Min Tong, *Plant Location Decisions of Foreign Manufacturing Firms* (Ann Arbor, Mich.: University Microfilms International Press, 1979).

40. William F. Fox, "Attracting Foreign Investment as an Economic Development Tool: The Case of Tennessee," paper presented at the 1986 Southern Regional Science Association Meetings, 7–9 March 1986, New Orleans, Louisiana.

41. See Stephen D. Williams and William J. Brinker, "A Survey of Foreign Firms Recently Locating in Tennessee," *Growth and Change*, 16 (3 [July 1985]): 54–63. For a review of similar evidence in South Carolina, see Frank L. DuBois and Jeffrey S. Arpan, "Foreign Investment in South Carolina," *Business and Economic Review* 32 (1 [October 1985]): 30–33.

42. Glickman and Woodward, *Regional Patterns*.

43. Mansfield Williams, "Petrochemicals and Chemicals," in H. Peter Gray, ed., *Uncle Sam as Host* (Greenwich, Conn.: JAI Press, 1986), pp. 191–221.

44. Quoted in California Department of Commerce, Office of Economic Research, *Foreign Direct Investment in California* (Sacramento, Calif.: California Department of Commerce, June 1988), p. i.

45. Ned G. Howenstine, "U.S. Affiliates of Foreign Companies: Operations in 1986," *Survey of Current Business*, May 1988, p. 75.

46. These data were compiled from information collected by the Japan Economic Institute (JEI): Susan MacKnight, *Japan's Expanding Manufacturing Presence in the United States: A Profile* (Washington, D.C.: Japan Economic Institute, n.d.); and Japan Economic Institute (JEI), "Japan's Expanding U.S. Manufacturing Presence: 1984 Update," *JEI Report*, no. 6A (15 February 1985).

47. For details, see Glickman and Woodward, *Regional Patterns*; and Douglas P. Woodward, *Regional Location Patterns of Foreign Direct Investment in the U.S., 1974–1983*, unpublished doctoral dissertation, University of Texas at Austin, 1986.

48. For a detailed discussion of the unitary tax controversy, see Tolchin and Tolchin, *Buying Into America*, chap. 8.

49. Glickman and Woodward, *Regional Patterns*.

50. Sadami (Chris) Wada, "Testimony on Japanese Investment in California," before the California Assembly Committee on International Trade and Intergovernmental Relations," 27 September 1988, Los Angeles, California.

51. Joseph Cortright, "Mitsubishi: Lessons for Oregon," Staff Report, Oregon Joint Legislative Committee on Trade and Economic Development, September 1983 (mimeo).

52. Ibid., p. 18.

53. Joseph Cortright, "Unitary Taxation and Investment in Oregon," Staff Report, Oregon Joint Legislative Committee on Trade and Economic Development, 5 April 1984 (mimeo), p. 4.

54. Mike Tharp, "Once-Insular Oregon Opening its Arms to Japanese Investors," *Wall Street Journal*, 21 July 1987, p. 33.

55. For more on Fujitsu's plant in Hillsboro, Oregon, see Eystein Thordarson, "Cross-Cultural Electronics," *Oregon Business*, October 1987, pp. 109, 111.

56. Jane Sneddon Little, "Foreign Direct Investment in New England," *New England Economic Review*, March/April 1985, pp. 48–57.

57. Changes in state employment data are published by the U.S. Bureau of Labor Statistics and reported in Ann Markusen and Virginia Carlson, "Bowing Out, Bidding Down and Betting on the Basics: Midwestern Responses to Deindustrialization in the 1980s," paper prepared for the UNCRD Symposium, "On Deindustrialization Experiences of the United States and Japan: An Evaluation from a Regional Perspective" (mimeo, July 1988).

58. Quoted in Judith Valente, "Tight Squeeze," *Wall Street Journal*, 13 May 1988, p. 14R.

59. For more on the role of "business climate," see Thomas R. Plaut and Joseph E. Pluta, "Business Climate, Taxes and Expenditures, and State Industrial Growth in the United States," *Southern Economic Journal* 50 (1983): 99–119; and Timothy J. Bartik, "Business Location Decisions in the United States: Estimates of the Effects of Unionization, Taxes, and Other Characteristics of States," *Journal of Business and Economic Studies* 3 (1 [January 1985]): 14–22.

60. See I. J. Smith, "The Role of Acquisition in the Spatial Distribution of the Foreign Manufacturing Sector in the United Kingdom," in Michael Taylor and Nigel Thrift, eds., *The Geography of Multinationals* (New York: St. Martin's Press, 1982), pp. 221–251.

61. Isabel Wilkerson, "Influx of Japanese Changing Style of Midwest," *New York Times*, 15 February 1987, pp. 1, 26.

62. Details of the Mazda deal were reported in "Why Mazda Is Settling in the Heart of Union Territory," *Business Week*, 9 September 1985, pp. 94–95.

63. "UAW, Mazda Reach Agreement for Plant at Flat Rock, Michigan," *Wall Street Journal*, August 7, 1988, p. A7.

64. The advertisement appeared in the *New York Times*, 16 October 1987, p. D4. For more on Mazda's painstaking recruitment process, see William J. Hampton, "How Does Japan Inc. Pick Its American Workers?" *Business Week*, 3 October 1988, pp. 84, 88.

65. "America's Diversity," *Japan Economic Journal*.

66. Quoted in Thomas J. Lueck, "Kawasaki Initiative Revives Old Plant," *New York Times*, 17 April 1987, p. 14.

67. John Paul Newport, Jr., "An Italian Money Loser Bets on the Bronx," *Fortune*, 22 July 1985, p. 55.

68. Ibid., p. 55.

69. See Coleman, "Regional Aspects," p. 1, and Urban Institute, *Directory of Incentives for Business and Development in the United States: A State-by-State Guide* (Washington, D.C.: Urban Institute Press, 1983), p. 6.

70. Quoted in Peter Gumbel and Douglas Sease, "Foreign Firms Build More U.S. Factories, Vex American Rivals," *Wall Street Journal*, 24 August 1987, p. 1.

71. United States General Accounting Office, *Foreign Investment: Growing Japanese Presence in the U.S. Auto Industry* (Washington, D.C.: United States Government Printing Office), March 1988.

72. Quoted in Mike Livingston, "Pride and Resentment Run Deep in Winnsboro," *The State* (Columbia, S.C.), 25 July 1987, p. C1.

73. Quoted in James Young, "Mack Chief Calls for Better Job Training," *The State* (Columbia, S.C.), 2 August 1987.

Chapter 8. The Mad Scramble for the Crumbs

1. John Junkerman, "Nissan, Tennessee: It Ain't What It's Cracked Up to Be," *Progressive*, June 1987, pp. 16–19.

2. Quoted in William K. Stevens, "Governors Are Emerging as a New Political Elite," *New York Times*, 22 March 1988, p. 8.

3. For a good review of some of the more successful state efforts, see David Osborne, *Economic Competitiveness: The States Take the Lead* (Washington, D.C.: Economic Policy Institute, 1988).

4. William Luker, Jr., " 'Buying Payroll': Industrial Development Incentives and the Privatization of Economic Development," paper given at the Annual Meetings of the Western Social Science Association (Austin: Lyndon B. Johnson School of Public Affairs, University of Texas, April 1988, mimeo).

5. See Marianne K. Clarke, *Revitalizing State Economies: A Review of State Economic Development Policies and Programs* (Washington, D.C.: National Governors Association, 1986).

6. Susan Warren, "Collins Defends Toyota Package; Reports Nothing on Japan Trip," United Press International, 22 September 1986.

7. Marshall Ingwerson, "Counting Cost of Japanese Investments," *Christian Science Monitor*, 9 May 1986, p. 3.

8. Roger W. Schmenner, *Making Location Decisions* (Englewood Cliffs, N.J.: Prentice-Hall, 1982), p. 51; see also Michael Kieschnick, *Taxes and Growth: Business Incentives and Economic Development* (Washington, D.C.: Council of State Planning Agencies, 1981); on foreign companies, Jeffrey Arpan, "The Impact of State Incentives on Foreign Investors' Site Selections," *Economic Review* 66 (8 [1981]): 36–42; and William Wheaton, "Interstate Differences in the Level of Business Taxation," *National Tax Journal* 36 (1983): 83–94.

9. Blaine Liner and Larry Ledebur, *Foreign Direct Investment in the United States: A Governor's Guide*, prepared for the 79th Meeting of the National Governors' Association (Washington, D.C.: Urban Institute, July 1987), p. 5.

10. Takeshi Nakabayashi, *A Study of Locational Choices of Japanese Manufacturing Companies in the U.S.: Guidelines for State and Local Governments to Attract Japanese Firms' Investments* (Cambridge, Mass.: John F. Kennedy School of Government, Harvard University, 13 April 1987).

11. Norman J. Glickman, Amy Glasmeier, Geoffrey Bannister, and William Luker, Jr., *Foreign Investment and Industrial Linkages*, report to the Economic Development Administration of the U.S. Department of Commerce and the Aspen Institute for Humanistic Studies, 1989.

12. John M. Kline, *State Government Influence in U.S. International Economic Policy* (Lexington, Mass.: Lexington Books, 1983), p. 67.

13. William M. Shapiro, "Site Selection: The Japanese Perspective," *Area Development*, August 1987, p. 45.

14. Reported in "Washington State Scores a High-Tech Goal," *Business Week*, 8 July 1985, p. 31.

15. Kline, *State Government*, pp. 67–68.

16. Michael R. Gordon, "With Foreign Investment at Stake, It's One State Against the Others," *National Journal*, 18 October 1980, pp. 1746–47.

17. U.S. General Accounting Office, *Foreign Direct Investment in the United States—The Federal Role*, report to the Congress by the Comptroller General of the United States, 3 June 1980, p. 62.

18. Marianne K. Clarke, *Revitalizing State Economies: A Review of State Economic Development Policies and Programs* (Washington, D.C.: National Governors' Association Center for Policy Research and Analysis, 1987), p. 82.

19. Martin Tolchin, "U.S. Cities Seeking Foreign Investing," *New York Times*, 20 January 1985, p. 17.

20. "Chinese to Build Soybean Processing Plant in Joliet, Illinois," *Industrial Development*, July/August 1986, p. 26.

21. Tom Towslee, "Oregon Tries to Retool with a Foreign Look," United Press International, 20 July 1984; and Clarke, *Revitalizing State*, p. 84.

22. Price Waterhouse, *Strategies for Developing Effective State International Business Development Programs*, report to the Economic Development Administration of the U.S. Department of Commerce, June 1986, pp. IV–29.

23. Telephone interview with Spyro Mitrokostas of Massachusetts Industrial Finance Agency, 15 August 1987.

24. Kline, *State Government*, p. 64.

25. Quoted in Donald L. Henry. "How Japanese Executives Select U.S. Sites," *Area Development*, August 1987, p. 122.

Notes

26. Glickman et al., *Foreign Investment*; Johnny L. Ballesteros, "Effectiveness of State Incentives to Attract Foreign Direct Investment"; and Leonel Gomez, "Public Incentives and Location Factors: Which Are Most Important in Site Selection Decisions?," both from the Lyndon B. Johnson School of Public Affairs, University of Texas, May 1988 (mimeo).

27. J. Ernest Beazley and Jacob M. Schlesinger, "Planned Plant Closing Stuns Town, Though End Long Had Been Expected," *Wall Street Journal*, 23 November 1987, p. 16; and Michael F. Crowley, *Foreign Direct Investment in the U.S.: Job Creation and Stimulation of Economic Linkages* (Austin: Lyndon B. Johnson School of Public Affairs, University of Texas 1987), p. 105.

28. Quoted in Gordon, "With Foreign Investment," p. 1746.

29. Beazley and Schlesinger, "Planned Plant."

30. Crowley, *Foreign Direct Investment*, p. 106; Gordon, "With Foreign Investment," p. 1746; and Kline, *State Government*, p. 66.

31. Gordon, "With Foreign Investment," p. 1746; and Kline, *State Government*, p. 66.

32. "Tears Mix With Optimism for Town's Future," *New York Times*, 22 November 1987, p. 19.

33. Ibid.; and Beazley and Schlesinger, "Planned Plant."

34. Quoted in Beazley and Schlesinger, "Planned Plant."

35. Joseph B. White and Thomas F. O'Boyle, "Volkswagen AG to Close or Sell Its U.S. Plant," *Wall Street Journal*, 23 November 1987, p. 2.

36. Bureau of National Affairs, "Scott County, Kentucky Selected for First U.S. Toyota Assembly Plant," *Daily Report for Executives*, 12 December 1985.

37. Quoted in "Toyota Makes Formal Announcement on $800 Million Assembly Plant," United Press International, 11 December 1985.

38. Quoted in Mark R. Chellgren, "Kentucky Took High Road in Courting Toyota, Official Says," Associated Press, 12 December 1985.

39. Quoted in Martin Tolchin, "Influx of Foreign Capital Mutes Debate on Trade," *New York Times*, 8 February 1987, p. 13.

40. Roger Calantone et al., *The Estimated Impact of Toyota on the State's Economy* (Lexington, Ky.: College of Business and Economics, University of Kentucky, 1986), p. 7; and Eugene Carlson, "What's a Toyota Plant Worth to Kentucky? Possibly Plenty," *Wall Street Journal*, 9 June 1987, p. 15.

41. Nonetheless, state office holders claim that this is a good deal for Kentucky since if the number of jobs pan out as expected—not necessarily a good assumption—the state will take in nearly twice as much in revenues.

42. Quoted in "Business Briefs," United Press International, 17 January 1986.

43. Maria E. Recio, Naoaki Usui, and William G. Krizan, "Toyota Flip-flops, Signs Union Pact at Kentucky Plant," *Engineering News-Record*, 4 December 1986, p. 10.

44. Quoted in "Business Briefs," United Press International, 14 October 1986.

45. Quoted in Neal Peirce, "Governors and Trade: Selling Off the Rock?," Washington Post Writers Group, 21 February 1988.

46. Martin and Susan Tolchin, *Buying Into America* (New York: Times Books, 1988).

47. Alex Kotlowitz and Dale D. Buss, "Localities' Giveaways to Lure Corporations Cause Growing Outcry," *Wall Street Journal*, 24 September 1986, p. 1.

48. Quoted in Pierce, "Governors and Trade."

49. Quoted in Mark Vererka, "The Morning After: Critics Charge Incentives Make Poor Jobs Policy," *Chicago Enterprise* 1 (11 [May 1987]): 2.

50. Ibid.; Brian Bremner and Barbara Marsh, "The False Promise of Diamond-Star," *Crain's Chicago Business*, 13 April 1987, pp. 17–20; and Kotlowitz and Buss, "Localities' Giveaways," p. 1, 21.

51. Kotlowitz and Buss, "Localities' Giveaways," p. 21.

52. For discussions of the costs and benefits of foreign investment to communities, see Blaine Liner and Larry Ledebur, *Foreign Direct Investment in the United States: A Governor's*

Guide (Washington, D.C.: National Governors' Association, 1987); and Cedric L. Suzman, "Foreign Direct Investment in the Southeast United States: A Comparative Analysis," in Cedric L. Suzman, ed., *The Costs and Benefits of Foreign Investment: A State Perspective* (Atlanta, Ga.: Southern Center for International Studies, August, 1982).

53. See Rachel McCulloch and Robert F. Owen, "Linking Negotiations on Trade and Foreign Direct Investment," in Charles P. Kindleberger and David B. Audretsch, *The Multinational Corporation in the 1980s* (Cambridge, Mass.: MIT Press, 1983), p. 335.

54. See Douglas Yuill and Kevin Allen, eds., *European Regional Incentives, 1980: A Survey of Regional Incentives in the Countries of the European Community* (Glasgow, Scotland: Centre for the Study of Public Policy, University of Strathclyde, 1980).

55. Osborne, *Economic Competitiveness*, especially chap. 6.

Chapter 9. The Political Economy of Foreign Investment and the Limits of Laissez-Faire

1. Monica Langley, "Protectionist Attitudes Grow Stronger in Spite of Healthy Economy," *Wall Street Journal*, 16 May 1988.

2. Dukakis, Bush, Phillips, and Schneiders are quoted in Langley, "Protectionist Attitudes."

3. See, for example, U.S. Department of Commerce, *Foreign Direct Investment in the United States: Report of the Secretary of Commerce to the Congress in Compliance with the Foreign Investment Study Act of 1974* (Washington, D.C.: U.S. Government Printing Office, 1976), appendix 2, p. 254. Some of the examples cited in this section draw on an excellent professional report by Michael Crowley, *Foreign Direct Investment in the U.S.: Job Creation and Stimulation of Economic Linkages* (Austin, Texas: Lyndon B. Johnson School of Public Affairs of the University of Texas, 1987).

4. Quoted in Michael V. Seitzinger, "Foreign Investment in the United States: Major Federal Restrictions," Congressional Research Service (CRS), Library of Congress, CRS Report 88-164 A, 23 February 1988, p. 5.

5. Quote by William Eberle of the Council on International Economic Policy, in *Foreign Investment Review Act of 1974*, Hearing Before the Subcommittee on Foreign Commerce and Tourism of the Committee on Commerce, United States Senate, Ninety-Third Congress, Second Session on S. 3955, 18 September 1974, serial no. 93-113, p. 30.

6. See, for example, C. Fred Bergsten, *The International Economic Policy of The United States: Selected Papers of C. Fred Bergsten, 1977–1979* (Lexington, Mass.: Lexington Books, 1980), p. 241.

7. These guidelines, which have been updated periodically since 1976, can be found in Organization of Economic Cooperation and Development (OECD), *The OECD Guidelines for Multinational Enterprises* (Paris: OECD, 1986).

8. OECD, *Guidelines*, p. 9.

9. Milton and Rose Friedman, *Free to Choose: A Personal Statement* (New York: Avon Books, 1979), p. 42.

10. Clyde V. Prestowitz, Jr., *Trading Places: How We Allowed Japan to Take the Lead* (New York: Basic Books, 1988), p. 316.

11. Felix Rohatyn, "Address to the Economic Club of Washington," 26 January 1988 (mimeo), p. 10.

12. Ibid.

13. See Eli F. Hecksher, "The Effect of Foreign Trade on the Distribution of Income," in H. S. Ellis and Lloyd A. Metzler, eds., *Readings in the Theory of International Trade*

(Homewood, Ill.: Richard D. Irwin, 1964); and Bertil Ohlin, *Interregional and International Trade* (Cambridge, Mass.: Harvard University Press, 1933).

14. Quoted from Voltaire by Willem Buiter, "The Macroeconomics of Dr. Pangloss: A Critical Survey of the New Classical Macroeconomics," *Economic Journal* 90 (1980): p. 34.

15. On Hymer's proposals, see, for example, David McClain, "FDI in the United States," in Charles Kindleberger and David Audretsch, eds., *The Multinational Corporation in the 1980s* (Cambridge, Mass.: MIT Press, 1983), pp. 326–27.

16. Quoted in Thomas F. O'Boyle, "Germany Beats World in Chemicals," *Wall Street Journal*, 3 May 1988, p. 26.

17. Adam Smith, *An Inquiry into the Nature and Causes of the Wealth of Nations* (New York: Modern Library, 1937), p. 128.

18. Prestowitz, *Trading Places*, p. 234.

19. For example, Peter J. Buckley and Mark Casson, *The Future of Multinational Enterprise* (London: Holmes & Meier, 1976); and Alan M. Rugman, *New Theories of Multinational Enterprise* (New York: St. Martin's Press, 1982).

20. See William J. Kahley, "Direct Investment Activity of Foreign Firms," *Economic Review* 72 (3/4 [Summer 1987]): 41.

21. Barry Bluestone and Bennett Harrison, *Capital and Communities: The Causes and Consequences of Private Disinvestment* (Washington, D.C.: Progressive Alliance, 1980), p. 210.

22. For an exhaustive list of international investment restrictions based on a private survey, see Earl H. Fry, *The Politics of International Investment* (New York: McGraw-Hill, 1983). A good summary of recent restrictions can also be found in Linda Spencer, *American Assets: An Examination of Foreign Investment in the United States* (Arlington, Va.: Congressional Economic Leadership Institute, 1988).

23. Sara L. Gordon and Francis A. Lees, *Foreign Multinational Investment in the United States: Struggle for Industrial Supremacy* (New York: Quorum Books, 1986), pp. 234–35; and Rachel McCulloch and Robert F. Owen, "Linking Negotiations on Trade and Foreign Direct Investment," in Charles P. Kindleberger and David B. Audretsch, eds., *The Multinational Corporation in the 1980s* (Cambridge, Mass.: MIT Press, 1983), pp. 337–45.

24. Transcript of news conference on Foreign Investment Disclosure and Reciprocity Act, Congressman John Bryant, 22 May 1985.

25. Fry, *Politics of International Investment*, p. 133.

26. Seitzinger, "Foreign Investment."

27. Spencer, *American Assets*, p. 15.

28. Langley, "Protectionist Attitudes," pp. 1, 8.

29. See S. Benjamin Prasad, "American Executives' Perception of Foreign State Enterprises," *Journal of International Business Studies* (Summer 1986): 145–51.

30. Quoted in Crowley, *Foreign Direct Investment*, p. 175.

31. For further details on the Santa Fe Petroleum case, see Martin and Susan Tolchin, *Buying Into America: How Foreign Money Is Changing the Face of Our Nation* (New York: Times Books, 1988), chap. 17.

32. Crowley, *Foreign Direct Investment*.

33. Sara L. Gordon and Francis A. Lees, *Foreign Multinational Investment in the United States: Struggle for Industrial Supremacy* (New York: Quorum Books, 1986), p. 212.

34. Quoted in Peter T. Kilborn, "2 in Cabinet Fight Sale to Japanese," *New York Times*, 12 March 1987, p. D1.

35. Ibid., p. D1.

36. Peter T. Kilborn, "Curb Asked on Foreign Takeovers," *New York Times*, 18 March 1987, p. D1.

37. Cynthia F. Mitchell, "Pentagon Eases Stand Against Foreign Stakes in U.S. Defense Firms," *Wall Street Journal*, 28 April 1988, pp. 1, 14.

38. Quoted in Peter Gumbel and Douglas R. Sease, "Foreign Firms Build More U.S. Factories, Vex American Rivals," *Wall Street Journal*, 24 July 1987, p. 1.

39. John Bryant, "Testimony Before the Senate Committee on Commerce, Science, and Transportation, Hearings on Foreign Investment in the United States, 24 March 1988. Also, see James K. Jackson, "Foreign Direct Investment in the United States," Economics Division, Congressional Research Service, Library of Congress, 13 April 1988 (mimeo).

40. Anthony M. Solomon, "Checking the Spread of a New Xenophobia," *New York Times*, 31 May 1988, p. 27.

41. Bryant, "Testimony," p. 3.

42. Monica Langley and Walter S. Mossberg, "White House, Trade Conferees, Reach Accord," *Wall Street Journal*, 28 March 1988, p. 3; Martin Tolchin, "200 Politicians Deal For One Trade Bill," *New York Times*, 27 March 1988, p. E5; and Eileen M. Doherty, "Reagan Vetoes Trade Bill," *JEI Report* (Washington, D.C.: Japan Economic Institute, report no. 21B), 27 May 1988.

43. Pat Choate, "Money Talks: How Foreign Firms Buy U.S. Clout," *Washington Post*, 19 July 1988, pp. C1, C4.

44. Maxwell Glen, "The Foreign Connection," *National Journal*, 26 July 1986, p. 1832; Bruce Stokes, "Foreign Owners," *National Journal*, 19 September 1987, pp. 2333–36; Martin Tolchin, "Foreigners' Political Roles in U.S. Grows by Investing," *New York Times*, 29 December 1985, pp. 1, 12; and Thomas M. Durbin, "Foreign Participation in Federal Elections: A Legal Analysis" (Washington, D.C.: Congressional Research Service, Library of Congress, 28 April 1987, mimeo).

45. Bruce Stokes, "Foreign Owners."

46. Martin Tolchin, "Influx of Foreign Capital Mutes Debate on Trade," *New York Times*, 8 February 1987, p. 13.

47. Thomas M. Durbin, "Foreign Participation in Federal Elections: A Legal Analysis" (Washington, D.C.: Congressional Research Service, Library of Congress, 28 April 1987), p. 8.

48. Stokes, "Foreign Owners"; and Durbin, "Foreign Participation."

49. Durbin, "Foreign Participation"; Stokes, "Foreign Owners"; and Glen, "Foreign Connection."

50. "They're All Coming," *Economist*, 30 April 1988, pp. 11–12.

51. Peter E. Peterson, "The Morning After," *Atlantic Monthly*, October 1987, pp. 43–69. I. F. Stone, "End of a Profligate Era," *Nation*, 31 October 1987, pp. 469, 471–72.

52. See Karen Penner, "The Productivity Paradox," *Business Week*, 6 June 1988, pp. 100–102.

53. William C. Norris, "Raiders Sour Workplace, Lower Competitiveness," *Los Angeles Times*, 14 October 1987, part 2, p. 7.

Chapter 10. A Program for Economic Security in the Age of International Capital

1. Malcolm Forbes, "Fact and Comment," *Forbes*, 25 January 1988, p. 17.

2. For details, see Kevin F. Winch and Sheldon J. Brown, "Foreign Mergers and Acquisitions: Non-U.S. Companies Acquiring U.S. Companies," Congressional Research Service, Report for Congress 87-711 E (Washington, D.C.: Congressional Research Service, Library of Congress, 12 August 1987).

3. Stephen S. Roach, "Hooked on Foreign Investment" (New York: Morgan Stanley Special Economic Study, 13 April 1988), p. 10.

4. Wassily Leontief, "An Information System for Policy Decisions in a Modern Economy," in Wassily Leontief, ed., *Input-Output Economics* (New York: Oxford Press, 1986), pp. 418–428.

5. Association for Foreign Investment in America, "Elliot L. Richardson Condemns

House-Passed Foreign Investment Bill as Contrary to U.S. Interests," press release, 5 October 1988.

6. Organization for Economic Cooperation and Development, *The OECD Guidelines for Multinational Enterprises* (Paris: OECD, 1986), especially pp. 13–14.

7. Testimony of Robert Ortner, Under Secretary for Economic Affairs, U.S. Department of Commerce, Before the Subcommittee on International Economic Policy and Trade, Committee on Foreign Affairs, U.S. House of Representatives, Washington, D.C., 22 September 1988 (mimeo).

8. Norman J. Glickman, Amy Glasmeier, Geoffrey Bannister, and William Luker, Jr., *Foreign Investment and Industrial Linkages*, Report to the Economic Development Administration and the Aspen Institute for Humanistic Studies (Austin: Lyndon B. Johnson School of Public Affairs, University of Texas, 1989).

9. Quoted in Hobart Rowen, "Rohatyn Says U.S. May Have to Eye Limits on Foreign Investment in Firms," *Washington Post*, 27 January 1988, p. F1.

10. Forbes, "Fact and Comment."

11. Martin and Susan Tolchin, *Buying Into America: How Foreign Money Is Changing the Face of Our Nation* (New York: Times Books), pp. 272–73.

12. Speech by Robert Dean, Conference on Foreign Investment in the United States: Diagnosis and Prognosis, sponsored by the Association for Foreign Investment in America, Inc. and the Bureau of National Affairs, Inc., Washington, D.C., 7 October 1988.

13. Adam Smith, *An Inquiry Into the Nature and Causes of the Wealth of Nations* (New York: The Modern Library, 1937), p. 431 (as quoted in James R. Schlesinger's keynote speech, Conference on Foreign Investment in the United States: Diagnosis and Prognosis, sponsored by the Association for Foreign Investment in America, Inc. and the Bureau of National Affairs, Inc., Washington, D.C., 7 October 1988).

14. Felix G. Rohatyn, "Address to the Economic Club of Washington, D.C.," 26 January 1988, p. 10.

15. See Cuomo Commission on Trade and Competitiveness, *The Cuomo Commission Report* (New York: Simon & Schuster, 1988), especially chap. 1.

16. David Osborne, *Laboratories of Democracy* (Boston: Harvard Business School Press, 1988).

17. We base these calculations on Congressional Budget Office, *Reducing the Deficit: Spending and Revenue Options* (Washington, D.C.: Congressional Budget Office, March 1988); and on data from the Joint Committee on Taxation, *Descriptions of Possible Options to Increase Revenues* (Washington, D.C.: U.S. Government Printing Office, June 1987).

18. Jeff Faux, "Reducing the Deficits: Send the Bill to Those Who Went to the Party," briefing paper (Washington, D.C.: Economic Policy Institute, November 1987).

19. We base these calculations on Congressional Budget Office, *Reducing the Deficit: Spending and Revenue Options* (Washington, D.C.: Congressional Budget Office, March 1988); and on data from the Joint Committee on Taxation, *Descriptions of Possible Options*.

20. Congressional Budget Office, *The Changing Distribution of Federal Taxes: 1975–1990* (Washington, D.C.: Congressional Budget Office, October 1987).

21. Paul Kennedy, *The Rise and Fall of the Great Powers: Economic Change and Military Conflict from 1500 to 2000* (New York: Random House, 1987), p. 515.

22. For a discussion of the Fed's policies, see William Greider, *Secrets of the Temple* (New York: Simon & Schuster, 1987). On the goals of low real interest rates, see Ray Marshall and Norman J. Glickman, *Choices for American Industry* (Washington, D.C.: Labor Policy Institute, 1987); and the Cuomo Commission, *Cuomo Commission Report*.

23. Lester C. Thurow, "A Briefing for the Next President," *New York Times*, 21 August 1988, p. F2.

24. David R. Francis, "Volcker Says It's Time to Anchor Floating Exchange Rates," *Christian Science Monitor*, 16 March 1988.

25. Marshall and Glickman, *Choices*.

26. James K. Galbraith, "Let's Try Export-Led Growth," *Challenge*, May/June 1988, pp. 37–41.

27. Quoted in Peter Coy, "Gradually Foreign Bosses Are Learning American Ways," *The State* (Columbia, S.C.), 29 March 1988, p. 7B.

28. Clyde V. Prestowitz, *Trading Places: How We Allowed Japan to Take the Lead* (New York: Basic Books, 1988), pp. 308–9.

29. Robert B. Reich and Eric D. Mankin, "Joint Ventures with Japan Give Away Our Future," *Harvard Business Review*, March/April 1986.

30. See William C. Norris, "Raiders Sour Workplace, Lower Competitiveness," *Los Angeles Times*, 14 October 1987, p. 38.

31. See Connie Bruck, *The Predators' Ball: The Junk-Bond Raiders and the Man Who Staked Them* (New York: Simon & Schuster, 1988), p. 261.

32. Senator J. James Exon, letter to members of Congress, 13 November 1986, mimeo.

33. Speech by Christopher A. McLean, Legislative Assistant to Senator J. James Exon, Conference on Foreign Investment in the United States: Diagnosis and Prognosis, Sponsored by the Association for Foreign Investment in America, Inc. and The Bureau of National Affairs, Inc., 6 October 1988, Washington, D.C.

34. Andrea L. Woolard, "States Try to Build Court-Proof Takeover Defenses," *Christian Science Monitor*, 3 March 1988, p. 12; Bruce Mendelsohn and Andrew Berg, "Tender-Offer Battles In Legislative Arena Shift to Pre-emption," *Legal Times*, 14 September 1987, p. 26; and Jeanne Reall, "Goodyear Legislation May Resurface," United Press International, 25 January 1987.

35. U.S. General Accounting Office, *Foreign Investment: Country Differences in Accounting for Takeover Costs* (Washington, D.C.: U.S. General Accounting Office, December 1987).

36. See Larry Mishel, "Advance Notice of Plant Closings: Benefits Outweigh the Costs," Economic Policy Institute Briefing Paper, 1988.

37. Ibid.

38. Marshall and Glickman, *Choices*.

39. Robert B. Reich, "Corporation and Nation," *Atlantic Monthly*, May 1988, pp. 76–81.

40. The advertisement was carried in the *Wall Street Journal*, 3 May 1988, p. 29, and elsewhere in the business press.

Appendix A. Data Sources and Problems

1. For more background on foreign investment data issues and problems, see James K. Jackson, "Foreign Direct Investment in the United States: Data Collection, Disclosure, and Effects," Congressional Research Service Report for Congress, 88-79 E (Washington, D.C.: Congressional Research Service, Library of Congress, 25 January 1988).

2. Robert Ortner, under secretary for Economic Affairs, Department of Commerce, Testimony Before the Subcommittee on International Economic Policy and Trade Committee on Foreign Affairs, U.S. House of Representatives, Washington, D.C., 22 September 1988 (mimeo), p. 2.

3. For example, see Ellen M. Herr, "U.S. Business Enterprises Acquired or Established by Foreign Direct Investors in 1987," *Survey of Current Business*, May 1988, pp. 50–58.

4. See, for example, Ned G. Howenstine, "U.S. Affiliates of Foreign Companies: Operations in 1986," *Survey of Current Business*, May 1988, pp. 59–75.

5. Robert Ortner, "Testimony," p. 11.

6. See the 1980 benchmark study, U.S. Department of Commerce, Bureau of Economic Analysis, *Foreign Direct Investment in the United States, 1980* (Washington, D.C.: U.S. Government Printing Office, October 1983), p. 17.

7. U.S. Department of Commerce, Bureau of Economic Analysis, "National Income and Product Accounts," *Survey of Current Business*, July 1987, Table 6.6B, p. 60.

8. Howenstine, "U.S. Affiliates."

9. Edwin Coleman, "Regional Aspects of Foreign Direct Investment," *U.S. Department of Commerce Working Paper on Structural Changes in the U.S. Economy* (Washington, D.C.: U.S. Department of Commerce, Bureau of Economic Analysis, 1986).

10. See Russell B. Scholl, "International Investment Position of the United States in 1987," *Survey of Current Business*, June 1988, pp. 76–84.

11. Howenstine, "U.S. Affiliates."

12. See International Trade Administration, Office of Trade and Investment Analysis, *International Direct Investment: Global Trends and the U.S. Role*, vol. II (Washington, D.C.: U.S. Government Printing Office, 1988).

13. A summary compilation of all foreign transactions from 1974 to 1983 can be found in U.S. Department of Commerce, International Trade Administration, *Foreign Direct Investment in the United States: Completed transactions, 1974–1983* (Washington, D.C.: U.S. Government Printing Office, 1985).

14. See, for example, U.S. Department of Commerce, International Trade Administration, *Foreign Direct Investment in the United States, 1983 Transactions* (Washington, D.C.: U.S. Government Printing Office, 1984).

15. Ibid., p. 85.

16. Ibid.

17. For published records of the JEI, see Susan MacKnight, *Japan's Expanding Manufacturing Presence in the United States: A Profile* (Washington, D.C.: Japan Economic Institute, no date); and Japan Economic Institute, "Japan's Expanding U.S. Manufacturing Presence: 1984 Update," *JEI Report*, no. 6A, 15 February 1985.

18. See U.S. Bureau of the Census, *Selected Characteristics of Foreign-Owned U.S. Firms* (Washington, D.C.: U.S. Bureau of the Census, 1984).

19. See, for example, Jeffrey Arpan and David Ricks, *Directory of Foreign Manufacturers in the United States* (Atlanta: School of Business Administration, Georgia State University, 1985).

20. U.S. Bureau of the Census, *Statistical Abstract of the United States* (Washington, D.C.: U.S. Government Printing Office).

21. For the latest (1987) figures, see *Mergers & Acquisitions, 1988 Almanac & Index* 22 (6 [May/June 1988]).

22. For a further description of the data on foreign merger and acquisition activity, see Kevin F. Winch and Sheldon J. Brown, "Foreign Mergers and Acquisitions: Non-U.S. Companies Acquiring U.S. Companies," Congressional Research Service Report for Congress, 87-711 E (Washington, D.C.: Congressional Research Service, Library of Congress, 12 August 1987).

23. National Association of Realtors, *Foreign Investment in U.S. Real Estate: The New International Landlords* (Washington, D.C.: National Association of Realtors, 1987); and Coldwell Banker Boston, *Survey of International Investment* (Boston, Mass.: Coldwell Banker Commercial Real Estate Services, July 1987).

Appendix B. Estimates of Employment Change for U.S. Affiliates of Foreign Companies

1. Ned G. Howenstine, "U.S. Affiliates of Foreign Companies: Operations in 1983," *Survey of Current Business*, November 1985, table 2, p. 37; Michael A. Shea, "U.S. Affiliates of Foreign Companies: Operations in 1984," *Survey of Current Business*, May 1987, table 2, p.

38; Ned S. Howenstine, "U.S. Affiliates of Foreign Companies: Operations in 1986," *Survey of Current Business*, May 1988, table 2, p. 51.

2. For our criticisms, see Norman J. Glickman and Geoffrey Bannister, "The Regional Effects of U.S. Direct Investment Abroad" (Austin: Lyndon B. Johnson School of Public Affairs University of Texas, Working Paper No. 47, 1988); and Donald J. Roussland, "Comment," in William G. Dewald, ed., *The Impact on International Trade and Investment on Employment* (Washington, D.C.: U.S. Government Printing Office, 1978), pp. 175–76.

3. Ibid.

Appendix C. Calculating Displacement

1. Robert Frank and Richard Freeman, *Distributional Consequences of Foreign Direct Investment* (New York: Academic Press, 1978).

2. For our criticisms, see Norman J. Glickman and Geoffrey Bannister, "The Regional Effects of U.S. Direct Investment Abroad" (Austin: Lyndon B. Johnson School of Public Affairs, University of Texas, Working Paper No. 47, 1988); and Donald J. Roussland, "Comment," in William G. Dewald, ed., *The Impact on International Trade and Investment on Employment* (Washington, D.C.: U.S. Government Printing Office, 1978), pp. 175–76.

3. Roussland, "Comment."

4. Ronald E. Miller and Peter D. Blair, *Input-Output Analysis: Foundations and Extensions* (Englewood Cliffs, N.J.: Prentice-Hall, 1985).

INDEX